Visualizing the Body in Art, Anatomy, and Medicine since 1800

This book expands the art historical perspective on art's connection to anatomy and medicine, bringing together in one text several case studies from various methodological perspectives. The contributors focus on the common visual and bodily nature of (figural) art, anatomy, and medicine around the central concept of modeling (posing, exemplifying and fabricating). Topics covered include the role of anatomical study in artistic training, the importance of art and visual literacy in anatomical/medical training and in the dissemination (via models) of medical knowledge/information, and artistic representations of the medical body in the contexts of public health and propaganda.

Andrew Graciano is Professor
of Art History and the Director of Graduate Studies
(Studio Art, Media Arts, Art History, and Art Education)
at the University of South Carolina's School of
Visual Art and Design.

Cover image: François Sallé (France, b.1839, d.1899). *The anatomy class at the École des beaux-arts*, 1888. Oil on canvas, 218 × 299 cm. Art Gallery of New South Wales. Purchased 1888. Photo: AGNSW, Diana Panuccio.

Science and the Arts since 1750

Series Editor:

Barbara Larson, University of West Florida

This series of monographs and edited volumes explores the arts—painting and sculpture, drama, dance, architecture, design, photography, popular culture materials—as they intersect with emergent scientific theories, agendas, and technologies, from any geographical area from 1750 to now.

Visualizing the Body in Art, Anatomy, and Medicine since 1800

Models and Modeling

Edited by
Andrew Graciano

LONDON AND NEW YORK

First published 2019
by Routledge
52 Vanderbilt Avenue, New York, NY 10017

and by Routledge
2 Park Square, Milton Park, Abingdon, Oxon, OX14 4RN

Routledge is an imprint of the Taylor & Francis Group, an informa business

Library of Congress Cataloging-in-Publication Data
A catalog record for this title has been requested

ISBN: 978–1-138–54437–6 (hbk)
ISBN: 978–1-351–00402–2 (ebk)

Typeset in Palatino by
Servis Filmsetting Ltd, Stockport, Cheshire

For my children, Estella and Gavin, with love.

r

Contents

List of Illustrations

PLATES

Acknowledgements

Pondering and writing about *An Academy by Lamplight* (1769) by the famed artist, Joseph Wright of Derby (1734–1797), in 2012, sparked my interest in the intersection of art pedagogy and anatomical study. Around the same time, I accompanied a colleague's life-drawing class on a visit to the University of South Carolina School of Medicine's Gross Anatomy Laboratory, where medical students dissect and study cadavers gifted to the school. To witness the students sketching open and desiccated corpses, and to listen to the dialogue among art and medical students, was an inspiration that compelled me to develop a course about the role of art in anatomy and medicine and *vice versa*. Researching the materials for the course led me to consider the breadth and depth of scholarship on the subject, in multiple disciplines. In 2015, I was awarded a Provost's Humanities Grant from my institution to fund a two-day symposium, "Art, Anatomy, and Medicine since 1700," which was held at the Columbia Museum of Art in 2016. The symposium brought together a dozen scholars from North America and Europe, as well as over 200 engaged audience members. Many thanks are owed to the speakers, whose scholarly participation made the event a great pleasure for all. I would also like to thank the University of South Carolina's Provost's Office for funding my symposium idea so generously; the Columbia Museum of Art and its staff, especially the Deputy Director, Joelle Ryan-Cook, and Event Planning Intern, Caroline Negus, for hosting and promoting the event so effectively; Dr. Erika Blanck at the School of Medicine for allowing access to the Anatomy Lab; Ruth Riley, Director of Library Services at the School of Medicine; and Robin Simon, editor of the *British Art Journal*, who published my piece on Wright's academy painting.

The symposium, of course, led directly to this book project, which includes five symposium speakers among the eleven contributors. The contributing authors have been an amazing group with which to work and I am forever grateful for their cooperation and patience, intellectual inspiration, and professional support. For reading and discussing with me much of the recent scholarship, including several chapter drafts for the present volume, I thank the undergraduate and graduate students in the several seminars devoted

to the topic since 2015. There are too many to list, but each influenced the outcome of the book in their own way and I am grateful for their contribution to the improvement of significant portions of the text.

Many thanks are also due to Isabella Vitti, at Routledge, and Barbara Larson, series editor for 'Science and the Arts since 1750', for their feedback and advice, for their professionalism and courtesy, and for guiding this book to publication.

Finally, I owe a great debt of gratitude to my wife and children. Without their support, patience, and encouragement, none of the above would have been possible.

About the Contributors

Antoine Gallay is a doctoral candidate at the University of Geneva and the University Paris-Nanterre. He is currently investigating the relationship between art and science in Louis XIV's reign, especially in the work of the engraver Sébastien Le Clerc. His larger research interests include artistic and scientific practices from the seventeenth to the nineteenth centuries, the history of optics, perspective and visual apparatuses, and the history of scientific illustration.

Andrew Graciano is Professor of Art History in, the Director of Graduate Studies for, and the Associate Director of the University of South Carolina's School of Visual Art and Design. He has published a monograph, two book chapters, and several articles on the artist Joseph Wright of Derby (1734–1797) and an annotated edition of the memoirs of painter and electrical scientist, Benjamin Wilson (1734–1797) in the *74th Volume of the Walpole Society* (2012). He is editor of the anthology, *Exhibiting outside the Academy, Salon, and Biennial, 1775–1999: Alternative Venues for Display* (Ashgate/Routledge, 2015).

Josh Hainy is Visiting Assistant Professor of Art History at Truman State University. He received his Ph.D. in art history from the University of Iowa. His dissertation explores the ways in which John Flaxman visualized narratives from classical literary sources, especially Flaxman's line drawings representing episodes from the *Iliad*.

Rose Holz is Associate Professor of Practice at the University of Nebraska-Lincoln, where she serves also as Associate Director of the Women's & Gender Studies Program and Director of the Humanities in Medicine Program. Her research focuses on the history of reproduction in America, with particular emphases on the medical and commercial provision of birth control, the history of Planned Parenthood, and, more recently, the use of art to teach the process of *in utero* development. She is the author of *The Birth Control Clinic in a Marketplace World* (University of Rochester Press, 2012), "The 1939 Dickinson–Belskie Birth Series Sculptures: The Rise of Modern Visions of Pregnancy,

the Roots of Modern Pro-Life Imagery, and Dr. Dickinson's Religious Case for Abortion" (*Journal of Social History*, 2018) and "Why the Classroom Is a Sacred Place for Me and Why I'll Keep Venturing Out Into 'No-Man's' . . . Even During These Abortion Wars" (*The American Historian*, 2017).

Dorothy Johnson is Roy J. Carver Professor of Art History in the School of Art and Art History at the University of Iowa. She specializes in eighteenth- and nineteenth-century French art, and has published widely in the field. She is the author of *Jacques-Louis David: Art in Metamorphosis* (Princeton University Press, 1993), *Jacques-Louis David: The Farewell of Telemachus and Eucharis* (Getty Museum Monograph Series, 1997), and *David to Delacroix: The Rise of Romantic Mythology* (UNC Press, 2011). She is the editor of, and contributor to, *Jacques-Louis David: New Perspectives* (University of Delaware Press, 2006). She has also published articles in *The Art Bulletin*, *Art History*, *Gazette des Beaux-Arts*, *Eighteenth-Century Studies*, and *Master Drawings*, among others. Currently, she is preparing a book on art and anatomy in France from 1750–1830.

Niria E. Leyva-Gutiérrez is Assistant Professor of Art History and Museum Studies in the College of Arts, Communications and Design at Long Island University, Post. She earned her doctorate from the Institute of Fine Arts, New York University in 2012, where her dissertation examined ecclesiastical images of power in New Spain. Her areas of specialization include the art and architecture of early modern Europe, as well as of colonial and modern Latin America and the Caribbean. Her essay on Rubens and his Spanish patron, Isabel Clara Eugenia is forthcoming in *Spanish Royal Patronage 1412–1804: Portraits as Propaganda* (Cambridge Scholars, 2018) and her article, "Conflict and Imagery: Saint Michael and Ecclesiastical Power in New Spain," was published in *Hispanic Research Journal* (October 2014). Currently, she is preparing a volume entitled *Female Piety and Visual Culture in the Early Modern Hispanic World* (Oxford University Press) for which she will serve as contributing author and co-editor.

Brittany Lockard is Assistant Professor of Art History and Creative Industries at Wichita State University. Her research interests include body diversity, identity politics, and the social dimensions of food and eating. Her work investigates the ways in which depictions of large bodies resonate with cultural constructions of fatness. Among her recent publications is "American Culture, Fat, and Photography: Joel-Peter Witkin's Bizarre Vision," in *Bodies and Culture: Discourses, Communities, Representations, Performances*, edited by Damon Talbott, Marike Janzen, and Christopher E. Forth (Cambridge Scholars, 2012).

Rebecca Messbarger is Professor of Italian and founding director of Medical Humanities at Washington University, St. Louis. Her research centers on the cultural history of the Italian Enlightenment, specifically the intersection of

anatomy and art, transformations in public health, and the shifting roles of women in civic and academic life during the age. She is the author of *The Century of Women: Representations of Women in Eighteenth-Century Italian Public Discourse* (University of Toronto Press, 2004), and *The Lady Anatomist: The Life and Work of Anna Morandi Manzolini* (University of Chicago Press, 2010), and co-editor, with Christopher Johns and Phil Gavitt, of *Benedict XIV and the Enlightenment: Art, Science and Spirituality* (University of Toronto Press, 2016). Among her many articles is "The Re-birth of Venus in Florence's Royal Museum of Physics and Natural History," *Oxford Journal of the History of Collections*, awarded the James L. Clifford Prize for best article in 2012–2013.

Natasha Ruiz-Gómez is Senior Lecturer in Art History in the School of Philosophy and Art History, University of Essex in the UK. She specializes in French art of the nineteenth and early twentieth centuries, with a particular focus on the oeuvre of Auguste Rodin, and is especially interested in the intersection of art and medicine. She has published in *Art History* and *Medical Humanities*, among others, and in several anthologies, as well as in a recent exhibition catalogue for the Statens Museum for Kunst, Copenhagen. She is finishing a book manuscript entitled *The Scientific Artworks of Doctor Jean-Martin Charcot and the Salpêtrière School: Visual Culture and Pathology in fin-de-siècle France*.

Wei Yu Wayne Tan is Assistant Professor of History at Hope College. He received his Ph.D. in East Asian Languages and Civilizations from Harvard University in 2015 and was an Andrew W. Mellon Postdoctoral Fellow in the Humanities at Dartmouth College from 2015 to 2016. His forthcoming book *The Most Remarkable Disability: Blindness and the Making of Modern Japan* (University of Michigan Press, Corporealities series) focuses on blindness as a case study for the exploration of the social, cultural, and political meanings of disability in early modern and modern Japan.

Amanda S. Wangwright is Assistant Professor at the University of South Carolina's School of Visual Art and Design. She earned a Ph.D. at the University of Kansas (2011), where she wrote a dissertation on the Republican-period female oil painter Qiu Ti 丘堤 (1906–1958). She has published in *Oxford Bibliographies in Chinese Studies* and *Southeastern College Art Conference Review*, and contributed an article on Western patronage of modern Chinese art to the peer-reviewed journal, the *Register*. Currently, she is preparing a book about women artists of the *avant-garde* scene in Republican China (1911–1949).

Prologue:
Modeling the Modern Body

Rebecca Messbarger

Renaissance Bodies of Truth

At the western edge of the city of Bologna in January 1540, the annual public anatomical dissection unfolded over two and a half weeks during the season of Carnival. Approximately 200 medical students, hailing from all corners of Europe and the Italian peninsula, flocked to the Church of San Salvatore to attend the anatomy lectures based on Mondino de' Luzzi's Medieval interpretation of Galenic practical anatomy.[1] They then jostled for a place in the front at the subsequent dissections held nearby in the Church of San Francesco. Baldasar Heseler, a 31-year-old medical student from Silesia—in modern day Poland—was among the medical students present that year, having been drawn to the ancient University of Bologna, like his peers, because of its long-standing international esteem as a center of medical science. He is rightly credited with immortalizing this historic public anatomy by recording his eyewitness account of each of the 25 anatomy lectures and 26 dissection demonstrations he attended over those 16 wintry days.[2]

It is a description remarkable for its detail as well as its drama. In it, he recounts the execution by hanging in an adjacent piazza of the three criminals subsequently used for the public dissection. He tells how, after the sexton announced to students in the lecture hall that the cadaver was now ready and the dissection could commence, mayhem broke out among those "mad Italians," and the frenzy continued as they made their way into the candle-lit theater, paying 20 *soldi* for a place at the spectacle.[3] He writes of the stench and desiccation of the putrefying bodies during the course of dissection, of his excitement at an upcoming execution that would yield a fresh cadaver, and of the pitiless vivisections of six live dogs. Yet, these spectacles of gore and bloodlust are, in truth, atmospheric backdrop to the central drama taking place between the two principal actors in the historic 1540 dissection.

On one side of the epistemological and generational divide was Matheus Curtius (Matteo Corti), the venerable, if pedantic, 65-year-old professor of Theoretical Medicine and former physician to Pope Clement VII;[4] on the other side, the 25-year-old Andreas Vesalius, whose celebrity as an anatomical

virtuoso at the Universities of Leuven and Padua had inspired Bologna's medical students to summon him that year to conduct the Public Anatomy. Corti adhered to a fervent Galenic orthodoxy, the teaching of anatomy based strictly on the anatomical observations and medical theories of the second-century CE Greek physician, Galen of Pergamon. Vesalius was instead a trailblazer in the so-called New Anatomy, the study of the structures and functions of the human body founded primarily on direct exploration of the dissected body as opposed to knowledge strictly received from authorized books. Tensions between Corti and Vesalius increasingly mounted during the back-and-forth from lecture to dissection until, in the dusky light of the anatomy theater on the evening of January 26, they finally erupted into a verbal fight across the dismembered criminal corpse.

According to Heseler's account, when the elderly Professor Corti had finished his anatomy lecture on the procedure of venesection by harshly refuting the arguments Vesalius had presented the previous day, the young anatomist demanded that Corti accompany him to the anatomy theater. Here, Vesalius sought to prove his claims by means not of Galenic books, but by the viscera of the two cadavers he was in the midst of dissecting. He repeatedly commanded the students before him: "Feel with your hands and believe!"

As Martin Kemp has observed, "the real body becomes with Vesalius the book to be read . . . rather than the set text sanctioned by traditional learning."[5] The irony of course is that Vesalius, who disparaged book-based knowledge in the scene immortalized by Heseler, created the most magnificent book—the premier canonical text of anatomy in Western history—*De Humani Corporis Fabrica* (1543).

With the *Fabrica*, Vesalius simultaneously visualizes the painstaking, gruesome toil of human dissection and sublimates it by means of fine art. The *Fabrica*'s title page dramatizes the chaos and carnage of a dissection scene in which Vesalius, the professor anatomist, is principal actor, hands immersed in the lower torso of the female cadaver at center stage within the crowded Renaissance anatomy theater (Figure P.1). The illustrated pages of the *Fabrica*, however, perform an extravagant ontological, aesthetic, and topographical re-contextualization of the moldering body splayed on the marble table. As Hans Belting has noted, "images make a physical (body's) *absence* visible by transforming it into iconic presence."[6] The scene is recast with western idols, *homo absolutus*, as Vesalius calls him, dominating classical landscapes in heroic postures as an ideal embodiment of the anatomized human form, while the practical signs of anatomy are cloistered on their own pages or implied from behind the scenes (Figure P.2).

Created under Vesalius's strict supervision, likely by the Flemish artist and Titian pupil Jan Stephan van Kalkar along with several other artists,[7] the illustrated plates depicting the noble *écorché* posed on the Veneto landscape, as well as torsos and discrete parts demonstrating the various anatomical systems throughout the *Fabrica*, elevate both the unmade body and the anatomist who unmakes it to the universal level of sublime art and artist, respectively.

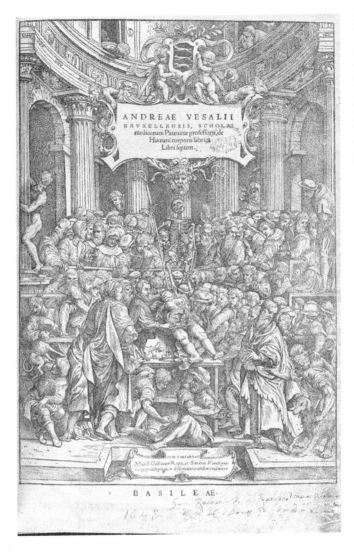

P.1 Andreas Vesalius, Frontispiece, *De Humani Corporis Fabrica* (Basel, 1543). Courtesy of Becker Rare Book Library, Washington University Medical School, Saint Louis.

According to some historians, Vesalius chose the word *fabrica* for the title of the book to evoke simultaneously the creative power of God, of Nature, and the modern anatomist to model or fashion (fabricate) the human body, as well as the body's fabric or tangible substance. In Sachiko Kusukawa's important analysis, pictures solidified Vesalius's authority to reconceive "a canonical body, a teleological method and an adjudicating authority."[8] The anatomist author repeatedly highlighted the superior power of images of the body over the written word and the dissected corpse both to attain perfect mathematical accuracy and to delight the senses, which would otherwise be revolted in the presence of the putrefying cadaver. As Vivian Nutton reminds us, the *Fabrica* is the first book of anatomy where the illustrations surpass the importance of the written text, forever changing the relationship of fine art to medical science.[9]

P.2 Andreas
Vesalius's *Écorché
De Humani Corporis
Fabrica* (1543),
page 184. Photo
credit, Wellcome
Library, London.
Wellcome images,
images@wellcome.
ac.uk http://
wellcomeimages.
org

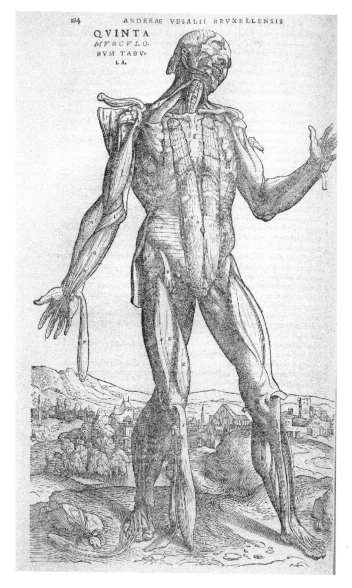

With its appearance in 1543, the *Fabrica* served and sublimated the science of empirical anatomy, upending an ancient hierarchy for which knowledge, including illicit knowledge, of the dissected body underpinned ideal studies of the nude in painting and sculpture by such lights as Donatello, Masaccio, and Michelangelo. Leonardo's public art and private notebooks, however, show the shifting position of the dissected body at the height of the Renaissance from auxiliary to primary subject of study, a position that Vesalius and those who followed him radically reinforced. Viewed as a microcosm of orderly nature, the empirical study of the body and, more importantly, its naturalistic illustration made visual an ancient philosophical stance.[10] Undergirding

medical texts that privileged visual illustrations of anatomical and physio-
logical truths was the desire to expose the divine design hidden from sight. It
was a possessive desire for knowledge of the unseen whose aim was control
of Nature and, more urgently, the nature of ourselves.

Enlightenment Re-modeling

Two hundred years after Vesalius's historic dissections, Bologna again
became the site of groundbreaking innovation in anatomical science. And
once more the modernization of human anatomy was defined by a singular
partnership between art and anatomy. However, the new model of anatomy
was now in three dimensions. The 3-D model, in fact, became during the
Enlightenment Age a defining means of producing knowledge and repre-
senting bodies in the material world. As the eighteenth century progressed,
a proliferation of models came into use as tools and attractions:[11] scale archi-
tectural models, models of monuments, machines, zoological and botanical
specimens, models of tumultuous natural events such as electrical storms,[12]
even self-moving, mechanical models—automata—of such variety as a defe-
cating duck, a female organ player, and a draughtsman writing letters.[13] On
exhibit in public and private displays, crafted and put into operation in sci-
entific academies, and even featured as plot devices in popular novels such
as Laurence Sterne's *Tristram Shandy*,[14] models provided literal insight and
practical hands-on control of myriad mechanical and natural phenomena.
During the "Century of Things," an epithet coined by Francesco Algarotti,
author of the international best-seller, *Newtonianism for Ladies* (1737),[15] which
translated Newtonian experimental philosophy, specifically optics, into
the stuff of the country villa and the boudoir—fountains, gardens, mirrors,
crystals, and lights—3-D models proved uniquely practicable tools for
enlightening the wider culture. The increased dimensionality of these figures
amplified pleasure and understanding in equal measure, revising the age-old
ideal of *docere et dilectare*. They objectified knowledge, made it palpable and
pleasurable,[16] something to be experienced by the eye, but, most especially,
possessed by the hand.[17] As first, Algarotti, and then Condillac, argued in
leading allegorical treatises on the distinct faculties and bounds of percep-
tion and cognition, the eye might discern, but only the hand could know the
where, the what, and the how of an object in space via the sense of touch.[18] At
the height of the Enlightenment, the facility of the hand was seen not merely
in terms of the acquisition of knowledge by means of touch, but as a singular
means to analyze and synthesize knowledge: to take things apart and put
them back together. As Soraya De Chadarevian and Nick Hopwood observe
in the introduction to the volume they edited on the ascent of the three-
dimensional model beginning in the eighteenth century, "New disciplines
of the age of revolutions were sciences of collections that presented objects
as compounds, ripe for analysis into elements."[19] And the most celebrated

collections of composite models of the eighteenth century were of the human body itself.

Contested Embodiment

In 1742, Pope Benedict XIV Lambertini (1675–1758) reached deep into the Vatican coffers to fund one of most elaborate museums of human anatomy in Europe. Housed in the prestigious Institute of Sciences in his hometown of Bologna, the museum proffered a spectacular new vision of the anatomical body, no longer splayed in black and white across the pages of a grand book, but towering in heroic, lifelike color and three dimensions atop faux marble pedestals and encased in crystalline cabinets. The Pope's artist, Ercole Lelli (1702–1766), painstakingly cast, colored, and grafted waxen muscles onto actual human skeletons to form the flayed models for the new museum (Plate P.1). As Benedict had intended, along with natives and citizens from other Italian states, Grand Tourists flocked from all over Europe to see this unique demonstration of the living fabric beneath the skin, signaling a resurgence of Bologna as a center of science and medicine after a near century-long decline.

In accordance with the papal commission, Lelli created eight figures representing the complete muscular and skeletal structures of the body as a permanent artistic counterpart to the Public Anatomy—the dissection of a criminal or indigent body—held annually for two weeks during Carnival in the university anatomy theater.[20] Lelli's extravagant dissection scene included an intact, classically posed Adam and Eve, followed by four male figures demonstrating the surface to deep musculature (Plate P.2), and completed by a male and a female skeleton, each holding a large iron scythe. The tableau demonstrated the anatomical structures of motion and emotion, the muscles and bones that animate the body, within the sacred narrative of man's mortal nature after the Fall.[21] The figures conjured and extended into the common living space the two-dimensional anatomical illustrations from Vesalius' *Fabrica* on which Lelli modeled his anatomical art, as well as on the works of Bartolomeo Eustachi and Juan Valverde de Humasco.[22] Of course, each of these visions of the anatomical body echoed in turn sacred and profane heroic bodies from the classical and humanist traditions. Indeed, the three-dimensional models of the eighteenth century are in continual dialogue with canonical two-dimensional figures on canvas and the page. However, despite quoting from the classical and Christian figural canon, Lelli's musclemen nevertheless precipitated a crisis among Bologna's academicians over the propriety of the dissected body as a subject of fine art. In Bologna's Clementine Academy of Art, where Lelli had studied and risen as a prize-winning sculptor, many vehemently decried the artist's transgressive bloody toil at the dissection table in order to create his graphic and spectacular waxworks.

Each of Lelli's flayed figures had indeed comprised the macerated bones of more than fifty cadavers, whose use Pope Benedict had explicitly authorized.[23]

In accordance with Giorgio Vasari's standards of ideal design that required "combining the most perfect members, whether hands, heads, bodies or legs, to produce the finest possible figure as a model,"[24] Lelli reassembled the 200 bones of the body to construct ideally proportioned skeletal frames posed in classical contrapposto. To each archetypal osteological structure, he then attached waxen muscles and tendons, and the intricate weave of veins, arteries and glands, all colored to life. But, Lelli's own teacher, Giampietro Zanotti (1674–1765), Secretary of Bologna's Academy of Art, chastised him publicly in a poem that warned, "I trust you no longer flay cadavers to learn anatomy."[25] Lelli's exchange of his paint brush and chisel for forceps and dissecting knives in the pursuit of expert anatomical knowledge was seen as transgressing the bounds of propriety, which restricted anatomical knowledge solely to what was necessary for representing the male nude. Lelli's most strident detractors accused him of exceeding those bounds of propriety, but for two opposing reasons: on the one hand, for acting the barber surgeon sullying his hands and the artistic ideals of the Accademia di Belle Arti with the gore of the dead, and, on the other, for seeking to rise above his station by impersonating the professor anatomist. Whether or not he was an imposter in the field of anatomy, Lelli did impersonate his critics in order to ridicule them in his written apologia and training manual, *Anatomical Compendium for Use in the Art of Design*.[26] Three times in the foreword to his manual, Lelli ironically reviled as "pernicious" ("perniciosa") the training of young artists in human anatomy. Ranting in the voice of his opponents, he declared that anatomical instruction would leave art students "ruined and broken," blind to beauty, and unable to envision the nude figure, either with their eyes or their paintbrushes, as anything other than flayed and frozen flesh. Then, in answer to these attacks and in defense of the training his *Compendium* offered to young artists, Lelli evoked the authority of ancient to Renaissance masters—from the three Rhodian sculptors to Michelangelo and Raphael—for whom the study of anatomy was, he averred, a necessary facet of artistic training precisely because it underlay a more accurate, and thus more perfect, rendering of the nude.[27] First and foremost an artist, Lelli thus cast his anatomical waxworks, and the cadaverous parts that literally and metaphorically underpinned them, as a modern advancement, a new chapter in the long, venerable history of artistic embodiment.

Con+texts

In his review of the volume *Ephemeral Bodies: Wax Sculpture and the Human Figure*, Ivan Gaskell iterates a leitmotif of his philosophy of art: "art is so difficult to deal with because its definition at any given time is contingent and because any given object inevitably changes in status."[28] Martin Kemp has similarly stressed, in *Spectacular Bodies: The Art and Science of the Human Body from Leonardo to Now*, that anatomical art requires "deliberate contextual looking because different contexts, different juxtapositions make things look

different."[29] I would add that contexts that designate or deny anatomical figures the status of art are generated by distinct epistemic cultures. Julius von Schlosser, Ernst Gombrich, Mario Praz, David Freedberg, Max Beerhbohm, Barbara Stafford, Hans Belting, Christopher Wood, Georges Didi-Huberman, to name a critical core, have, like Gaskell and Kemp, taken up the devious question: When is the visual rendering of the anatomical body art? And its complement: When is it not art? To fully *grasp* the matter, as in both books, *Ephemeral Bodies* and *Spectacular Bodies*, these critics have not only focused their gaze but also their feeling hands on the illustration of human anatomy in that aesthetically gummy material of tinted wax. Uncanny, malleable beeswax, with its ancient ties to funerary masks and modern links to lowbrow tourist attractions, serves in each case to push the art question to its limits. And over and again the case is decided by context—from the Latin *con* + *texere*, to weave together. The answer to the question, "when is anatomy art?" is determined by the texts to which the body is tied. The art of the anatomical body is, in fact, a textual matter that rests on narrative incorporation.

The anatomical figures in the Pope's museum demonstrated the inner workings of the musculoskeletal system and revealed the natural order and physics of the human body for the instruction of artists, medical practitioners and natural philosophers, as well as a broader, untutored public. Nonetheless, an overarching Christian allegorical framework enclosed this exhibition of the new empirical science of anatomy. Lelli's wax musclemen and the executed and dissected criminal bodies they evoked were subsumed symbolically within the interdependent high Christian dramas of the Fall, the Passion and the Last Judgment. The Pope's wax *écorché* brought together what Jeffrey Hamburger has described as the "charged book and body of Christian doctrine."[30] Grand sacred narratives served to constrain the extra-naked truths of the body, whether in the actual or virtual anatomical dissections of the anatomy theater and the museum, and acted as a moral fortress against the body's ambiguous connotations and the heterodoxy of witnesses to its anatomical exegesis. As Umberto Eco has noted, "without text the image lies or gives way to a multitude of interpretations."[31]

Nevertheless, as the eighteenth century and the Enlightenment revolt against received knowledge progressed, the human body began to slip the bonds of grand textual frameworks and became ever more a site of knowledge and awe in its own right and with its own narrative structure and lexicon. Indeed, one fierce critic of Lelli's, who accused him of instigating among Bologna's artists an obsession with the rhetorical pretentions of anatomical science, proclaims this new body even as he derides it:

That artists have need to talk about the ilium, the pubis, the ischium, the acetabulum, and about how many muscles move the eye, and how these muscles have their origin in the orbital tissue and their insertion in the orneal tunic, and . . . that painters must talk anatomically about these internal parts of the body is a grave fraud that in the end brings them nothing but a pact with fools and some self-serving ideas about their own merit.[32]

Dialectical Body Models

It is no coincidence that the current volume takes the eighteenth century as a starting point for a re-examination of the historic relationship between art and anatomy. It is the era when that relationship underwent a stark transformation. The authority of empiricism reached new heights during the Enlightenment age as a structuring principle not merely for investigating nature, but for seeking and assigning meaning and order across human experience and culture. The consequence for the anatomical figure was that it was increasingly classified in purposely anti-aesthetic terms against the work of art. As Lyle Massy has observed,

> To redefine anatomical illustrations in this way—to insist that they be understood as instantiations of practical knowledge—authors not only had to make a show of erasing aesthetic traces, but also of establishing new ideological parameters for the act(s) of anatomical representation.[33]

Martin Kemp has called these transformations in the representation of the anatomical body during the eighteenth century a self-conscious departure from artistic style toward an emergent 'scientific non-style,' or 'proto-photographic method' that was "designed to guarantee objectivity and clarity."[34] The empirical body dismembered by the anatomist's hand as opposed to remembered aesthetically by the artist's eye comes fully into view in the illustrated medical texts of such practitioners as the British surgeon and professor of anatomy William Cheselden (1688–1752), who guaranteed the accuracy and objectivity of the anatomical image by using a camera obscura. Other anatomical 'truth-tellers' included the obstetricians William Smellie (1697–1763) and William Hunter (1718–1783), the Swiss physiologist Albrecht von Haller, and the Scottish surgeon and anatomist John Bell (1763–1820), who illustrated his own *Anatomy of the Human Body*.[35] Indeed, Bell went furthest with his grim anatomies in wresting the dismembered, putrefying corpse from what he called "the capricious interference of the artist, whose rule it has too often been to make all beautiful and smooth, leaving no harshness" (Figure P.3).[36]

Returning to the Bolognese context of anatomical design, Ercole Lelli's rivals, the expert artist/anatomist partners Anna Morandi Manzolini (1714–1774) and her husband Giovanni Manzolini (1700–1755), cast from cadavers they had dissected scrupulously accurate, anti-heroic wax models of all the parts of the living anatomy for use by medical practitioners and informed connoisseurs (Plate P.3). It was their commitment, however, to representing the wondrous truths of nature over a classical aesthetic and moral effect that not only left their work even more marginalized than Lelli's among Bologna's artist class, but also nearly erased them from the annals of history.[37]

The new narrative increasingly foregrounded the facts of the body and, far more than Vesalius could have imagined, made of the body the text to be read. What emerged from an ever finer, more intimate penetration of

P.3 John Bell,
Etching of the
bones, muscles,
and joints,
illustrating the
first volume of
the *Anatomy of
the Human Body*.
2nd ed. London,
1804. Etching.
National Library of
Medicine.

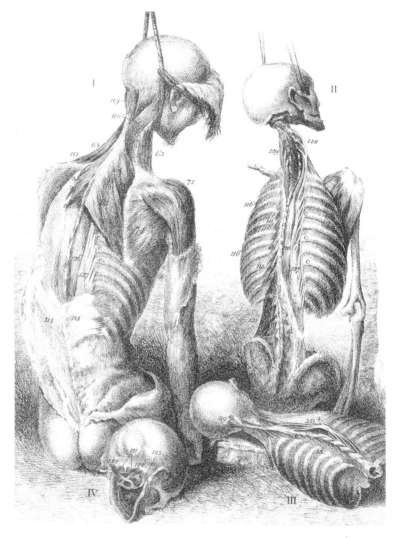

flesh by the scalpel, the syringe, the microscope, and advancing technolo-
gies in body imaging were new linguistic and visual lexicons, tropes, and
rhetorical structures that carry us from the eighteenth century to the present.
In the modern institutional scientific and laboratory context, the narrative
framework for anatomical embodiment, an embodiment itself produced by
advancing automated technologies, is in Kemp's judgement, "self-evident
truth."[38] The unremitting truth imperative of science will relentlessly work
to separate medical illustrations of the body not only from representations
of anatomy in art, but also from the subjective vantage of the individual
hand and eye. As this volume's array of essays demonstrates, through an
interrogation of the relationship between art and anatomy across temporal
and cultural divides, however, that separation is more conceit than com-
plete.

The English philosopher and critic, William Hazlitt, indicates at the dawn of the nineteenth century the overlapping poetics, truth value, indeed, pleasure of the anatomical body for the two cultures: science and art.

The anatomist is delighted with a coloured plate, conveying the exact appearance of the progress of a certain disease, or of the internal parts and dissections of the human body . . . The learned amateur is struck with the beauty of the coats of the stomach laid bare, or contemplates with eager curiosity the traverse section of the brain . . . It is the same in art as in science. The painter sees the picture in nature before he transfers it to a canvas. He refines, he analyzes, he remarks fifty things, which escape common eyes, and this affords a distinct source of reflection and amusement. Art is the microscope of the mind . . . and converts every object into a little universe in itself.[39]

Visions of the anatomized human body—whole and partial, healthy and ill, living and dead, symbolic and real—continue to be a principal currency of exchange for and between art and medical science. How this traffic in concepts and representations of the body evolves and influences the integrated economies of each sphere is the fascinating subject of the chapters that follow.

Notes

1 Mondino de Luzzi (ca. 1270–1326), known as Mundinus, taught anatomy and human dissection in Bologna and authored the most important practical anatomy text of the era. See Prioreschi (2003) pp. 392–400.

2 Heseler (1959).

3 Heseler (1959), pp. 85–86.

4 Heseler (1959) for Eriksson's introductory biography of Matteo Corti, pp. 37–41.

5 Kemp (2000), p. 23.

6 Belting (2014), p. 3.

7 Kusakawa (2012) mentions Campagnolo, Serilio, and Titian, pp. 204–209. Kemp (1970) believes the prints to be by one artist, possibly Van Kalkar, under Vesalius's painstaking supervision, while he argues that the title page, Venetian landscapes, and such details as the hair of the écorché as well as the engraving was done by Domenico Campagnola.

8 Kusakawa (2012), p. 227.

9 Nutton (2014).

10 See Kemp (2004), pp. 132–141

11 For a learned analysis of philosophical questions underpinning representation via models for science and art, see the "Introduction" by Frigg and Hunter (2010, pp. xv–xxx). See also Baker (2004), pp. 19–42.

12 See Schaffer, (2004), pp. 71–105. See also Bensaude-Vincent and Blondel (2008), and Graciano (2012): 165–243.

13 On eighteenth-century automata, see Kang (2011) and Bredekamp (1995), 1–10.

14 Gysin (1983).

15 Algarotti (1737). On Algarotti's contributions to scientific and philosophical discourse and popularization of Newtonian optics, see Arato (1991), Mazzotti (2004), and Dacome (2007).

16 On the varied intellectual and physical pleasure of models, see Jordanova (2004) and especially Dacome (2007).

17 On the significance of touch in the context of the anatomical figure on display in the public museum, see Mazzolini (2004), and Maerker (2015).

18 Algarotti (1739): 89–103; *Condillac* (1754).

19 De Chadarevian and Hopwood, "Dimensions of Modelling," Introduction to *Models: The Third Dimension of Science*, 20004, p. 5.

20 Ercole Lelli had first established his reputation as Bologna's foremost anatomical sculptor by carving in linden wood the anatomical musclemen that upheld the lector's throne in the University of Bologna Archiginnasio Public Anatomy theater. See Messbarger (2010), pp. 28–33.

21 See the following series of documents in the first proposal for the museum in 1732. The definitive commission would not come until 1742, when Lambertini could pay for the immense project from papal funds: Archivio di Stato di Bologna.

22 Messbarger (2010), p. 40.

23 Messarger (2010), pp. 31–32.

24 Vasari (2006), pp. 52–53.

25 "Io credo che non scortichi / Più per apprender notomia, cadaveri" Giampietro Zanotti, "Al Sig. Ercole Lelli da Giampietro Zanotti" in Bottari (1822–25). 3

26 Biblioteca Comunale dell'Archiginnaseo di Bologna, ms B. 1562.

27 Biblioteca Comunale dell'Archiginnaseo di Bologna, ms B. 1562

28 Gaskell (2009).

29 Kemp and Wallace (2000), p. 19.

30 Hamburger (2004).

31 Eco (1996), p. 31.

32 Crespi (1769), pp. 159–60.

33 Massey (2017), pp. 69–70.

34 Kemp (2010) p. 201.

35 The stark realism of anatomical illustration of the eighteenth century finds certain inspiration in the famous and connected late seventeenth century atlases, *Anatomia Humani Corporis* (1685) by the Dutch physician Govert Bidloo, and *The Anatomy of Human Bodies* (1698) of William Cowper, who reused 105 engravings of artist Gerard de Lariresse, illustrator of Bidloo's atlas. As Rina Knoeff has shown, however, the extreme realism of representations of putrefying and dismembered corpses reflects the tenets of artistic realism and the vanitas morality of Dutch Golden Age art as well the emphasis on suffering and death so central to Bidloo's Mennonite faith. See Knoeff (2007).

36 Bell (1810), p. iv.

37 See Messbarger (2010), pp. 52–98.

38 Kemp (2010) 195.

39 Hazlitt (1902), pp. 72–73.

References

Algarotti, Francesco. *Il Neutoniansimo per le dame: Ovvero dialoghi sopra la luce e i colori*. Naples [Milan], Italy: n.p., 1737.

Algarotti, Francesco. *Il Newtonianismo per le dame ovvero dialoghi sopra la luce i, colori e l'attrazione*. Naples, Italy: Giambattista Pasquali, 1739.

Arato, Franco. *Il secolo delle cose. Scienza e storia in Francesco Algarotti*. Genova, Italy: Marietti, 1991.

Archivio di Stato di Bologna, Assunteria d'Istituto, *Atti*, n. 3 (1727–1734): foglio 652, 7 febbraio 1732; foglio 658, febbraio 1732; fogli 697–700 17 luglio 1732. From this last document, "Si consider di nuovo il Progetto fatto dal Sig.r Card.le Arcivescovo di ordinare la Muscolaggine dell'Uomo in cera in Quattro diverse figure al natural . . ."

Baker, Malcolm. "Representing Invention, Viewing Models." In *Models: The Third Dimension*, edited by Soraya de Chadarevian and Nick Hopwood, 19–42. Stanford, CA: Stanford University Press, 2004.

Bell, John. *Anatomy of the Bones Muscles and Joints, vol. 1*, 3rd ed. London, UK: Longman, Hurst, Rees and Orme, 1810.

Belting, Hans. *An Anthropology of Images: Picture, Medium, Body*. Princeton, NJ: Princeton University Press, 2014.

Bensaude-Vincent, Bernadette, and Christine Blondel, eds. *Science and Spectacle in the European Enlightenment*. Aldershot, UK: Ashgate, 2008.

Biblioteca Comunale dell'Archiginnaseo di Bologna, MS B. 1562, *Compendio Anatomico per Uso delle Arti di Disegno*.

Bidloo, Govert. *Anatomia Humani Corporis*. Amsterdam, the Netherlands, 1685.

Bottari, Giovanni. *Raccolta di lettere sulla pittura, scultura, ed architettura scritte da' più celebri personaggi dei secoli XV, XVI, e XVII, pubblicata da M. Gio. Bottari e continuata fino ai nostri giorni da Stefano Ticozzi [1757]*. Milan: G. Silvestri, 1822–1825.

Bredekamp, Horst. *The Lure of Antiquity and the Cult of the Machine*, translated by Allison Brown. Princeton, NJ: Marcus Wiener, 1995.

Condillac, Etienne Bonnot de. *Traité des sensations a Madame la comtesse de Vassé*. Paris, France, 1754.

Cowper, William. *The Anatomy of Human Bodies*. Oxford, UK, 1698.

Crespi, Luigi. *Felsina pittrice: Vite de' pittori bolognesi*. Rome, Itay: Stamperia di Marco Pagliarini, 1769.

Dacome, Lucia. "Women, Wax and Anatomy in the 'Century of Things.'" *Renaissance Studies* 21 (2007): 522–550.

De Chadarevian, Soraya, and Nick Hopwood, eds. *Models: The Third Dimension of Science*. Stanford, CA: Stanford University Press, 2004.

Eco, Umberto. *Icons, Texts Iconotexts: Essay on Ekphrasis and Intermediality, Volume 6* of *European Cultures Studies in Literature and the Arts*, edited by Peter Wagner. Berlin, Germany: Walter de Gruyter, 1996.

Frigg, Roman, and Matthew C. Hunter, eds. *Beyond Mimesis and Convention: Representation in Art and Science*. New York: Springer Science and Business Media, 2010.

Gaskell, Ivan. "The 'singularity of sculpture'" (review of Roberta Panzanelli, ed., *Ephemeral Bodies*, 2008, and Jacqueline Lichtenstein, *The Blind Spot*, 2008). *Oxford Art Journal* 32 (2009): 303–306.

Graciano, Andrew. "The Memoir of Benjamin Wilson, FRS (1921–1788): Painter and Electrical Scientist." *74th Volume of the Walpole Society* (2012): 165–243.

Gysin, Fritz. *Model as a Motif in Tristram Shandy*, The Cooper Monographs. Berne: Francke Verlag, 1983.

Hamburger, Jeffrey F. "Body vs. Book: The Trope of Visibility in Images of Christian–Jewish Polemic." In *Ästhetik des Unsichtbaren: Bildtheorie und Bildgebrauch in der Vormoderne*, edited by David Ganz and Thomas Lentes. Berlin, Germany: Reimer, 2004.

Hazlitt, William. "On Imitation." In *The Collected Works of William Hazlitt*. London: J. M. Dent, 1902.

Heseler, Baldasar. *Andreas Vesalius' First Public Anatomy at Bologna 1540: An Eyewitness Report*. Edited and Translated by Ruben Eriksson. Uppsala: Almquist &Wiksells Boktryckeri AB, 1959.

Jordanova, Ludmilla. "Material Models as Visual Culture." In *Models: The Third Dimension of Science*, edited by Soraya de Chadarevian and Nick Hopwood, 443–451. Stanford, CA: Stanford University Press, 2004.

Kang, Minsoo. *Sublime Dreams of Living Machines: The Automaton in the European Imagination*. New Haven, CT: Harvard University Press, 2011.

Kemp, Martin. "A Drawing for the *Fabrica*: Some Thoughts on Vesalian Musclemen." *Cambridge Journal of Medical History* 14, no. 3 (1970): 277–288.

Kemp, Martin. "Men at Work: The Rituals of Dissection." In *Spectacular Bodies: The Art and Science of the Human Body from Leonardo to Now*, edited by Martin Kemp and Marina Wells. London, UK: Hayward Gallery, 2000.

Kemp, Martin. *Leonardo*. Oxford, UK: Oxford University Press, 2004.

Kemp, Martin. "Style and Non-Style in Anatomical Illustration: From Renaissance Humanism to Henry Gray." *Journal of Anatomy* 216, no. 2 (2010): 192–208.

Kemp, Martin, and Marina Wallace, eds. *Spectacular Bodies: The Art and Science of the Human Body from Leonardo to Now*. London, UK: Hayward Gallery, 2000.

Knoeff, Rina. "Moral Lessons of Perfection: A Comparison of Mennonite and Calvinist Motives in the Anatomical Atlases of Bidloo and Albinus. In *Medicine and Religion in Enlightenment Europe*, edited by Ole Peter Grell and Andrew Cunningham, 121–44. Farnham, UK: Ashgate, 2007.

Kusakawa, Sachiko. *Picturing the Book of Nature: Image, Text and Argument in Sixteenth-Century Human Anatomy and Medical Botany*. Chicago, IL: University of Chicago Press, 2012.

Maerker, Anna. "Toward a Comparative History of Touch and Spaces of Display: The Body As Epistemic Object," *Historical Social Research/Historische Sozialforschung* , no. 1 (151), Special Issue: *Law and Conventions from a Historical Perspective* (2015): 284–300.

Massey, Lyle. "Against the 'Statue Anatomized': The 'Art' of Eighteenth-Century Anatomy on Trial." *Art History* (February 2017): 69–103.

Mazzolini, Renato. "Plastic Anatomies and Artificial Dissections." In *Models: The Third Dim*ension, edited by Soraya de Chadarevian and Nick Hopwood, 43–70. Stanford, CA: Stanford University Press, 2004.

Mazzotti, Massimo. "Gentility, Gender and Radical Culture." *British Journal of the History of Science* 32, no. 2 (June, 2004): 119–146.

Messbarger, Rebecca. *The Lady Anatomist: The Life and Work of Anna Morandi Manzolini (1714–1774)*. Chicago, IL: University of Chicago Press, 2010.

Nutton, Vivian. "Introduction." In Vesalius, *The Fabric of the Human Body: An Annotated Translation of the 1543 and 1555 Editions of "De Humani Corporis Fabrica Libri Septem"*, translated and edited by Daniel Garrison and Malcolm Hast, lxxv–ciii. Basel, Switzerland: Karger, 2014.

Prioreschi, Plinio. *A History of Medicine: Medieval Medicine*. Omaha, NB: Horatius Press, 2003.

Schaffer, Simon. "Fish and Ships: Models in the Age of Reason." In *Models the Third Dimension of Science*, edited by . Soraya de Chadarevian and Nick Hopwood, 71–105. Stanford: Stanford University Press, 2004.

Vasari, Giorgio. Preface to Part III of *Lives of the Painters, Sculptors and Architects*. In *Visual Culture in Media Studies, vol. 2*, edited by Joanne Morra and Maquard Smith. London: Routledge, 2006.

Introduction:
Models and Modeling in Art, Anatomy, and Medicine

Andrew Graciano

"[A]ll the interesting things about the knowledge of any subject happen
within, and sometimes at the edges of, disciplines."[1]

The visual culture of anatomy and medicine has been the subject of several
scholarly publications since the 1980s. Ludmilla Jordanova's groundbreak-
ing work, *Sexual Visions: Images of Gender in Science and Medicine between the
Eighteenth and Twentieth Centuries* (1989),[2] incorporated the methodologies of
feminism, gender studies, and art history (visual analysis) into the histories of
science and medicine to assess critically and specifically how the *female* body
is treated, understood, and visualized differently in medical imagery and
what that means for us. Jordanova's work spawned a resurgence of scholarly
interest and attention to the body in general and to anatomy in particular, not
only in the history of science and related disciplines, but also in art history. For
example, Anthea Callen's *The Spectacular Body: Science, Method and Meaning in
the Work of Degas* (1995) applies many of Jordanova's points to late nineteenth-
century art, scientifically focusing on physiognomy as a branch of continued
human understanding and its not unproblematic application to issues of race,
class, and gender in both science and art of the period.[3]

The similarly titled exhibition and catalogue, *Spectacular Bodies: The Art and
Science of the Human Body from Leonardo to Now* (2000), curated–authored by
Martin Kemp and Marina Wallace, broadens Callen's artistic and scientific
considerations of the body across a much more comprehensive timeline.[4]
Divided into several parts, its first is perhaps of greatest congruence to the
present volume. It is a brief, but sweeping, discussion of visual representa-
tions of anatomists, anatomized bodies, models drawn from life, dissected
models and *écorchés*, and idealized physiques. Its second part focuses almost
exclusively on physiognomy and the external facial/cranial expression of
internal mental states and illnesses, which harkens back to Sander Gilman's
landmark book, *Seeing the Insane* (1982).[5] In its final part, perhaps the most
innovative, it extends the historical consideration of the body well into the
contemporary period with a collection of brief biographical essays on a selec-
tion of late twentieth-century artists whose works seem to respond in many

ways to the history of anatomical and bodily imagery in art and science. But, like Callen's work, the overall focus of Kemp and Wallace's is on the body generally, rather than anatomy specifically.

Corinne Saunders, Ulrika Maude, and Jane Macnaughton's *The Body and the Arts* (2009) is perhaps more to the point.[6] The essays within are certainly focused on anatomical, anatomized, medical, and pathologized bodies in aesthetic theory, in literature, and in visual art. Most especially pertinent to the present volume is Jane Macnaughton's chapter, "Flesh Revealed: Medicine, Art and Anatomy."[7] It is commonly acknowledged that artists have historically performed a valuable service to anatomy and medicine by illustrating their disciplinary texts. Macnaughton, however, argues that the increased use of artists as anatomical tutors in medical and health science programs and the encouragement of medical, nursing, and public health students to supplement their studies with drawing classes in the late twentieth century have the potential to change medical and health science education for the better. Art is valued as a tool with which to learn and to create anatomical and medical knowledge and it has restored the sense of awe and reverence for the beauty of the human body to the medical profession. Macnaughton argues further that the common visual nature of art and medicine has led to advances in medical education that include a move away from dissecting corpses and towards direct engagement with living patients that is simultaneously visual, empirical, social, personal, and professional.

Andrew Cunningham's *The Anatomist Anatomis'd: An Experimental Discipline in Enlightenment Europe* (2010) is essentially a history of anatomy in the long eighteenth century, although it occasionally refers back as far as the fifteenth. It is written for the historian of science and medicine and explains in great detail the roles of public dissections (anatomical education, social control, and criminal punishment); the professionalization of anatomy; anatomy as experimental science and as demonstrative performance; and eventually anatomy as a core subject in surgical and medical education. Not to overlook the visual culture of anatomy, Cunningham also treats briefly the role of anatomical study in artistic education, as well as the use of art to visualize and disseminate anatomical knowledge within Europe, its colonies and trading partners.

Kaat Wils, Raf de Bont, and Sokhieng Au's *Bodies Beyond Borders: Moving Anatomies, 1750–1950* (2017)[8] is largely focused on anatomical and medical imagery. It, too, builds upon Jordanova's work in *Sexual Visions*. Jordanova argues that medical and anatomical imagery and their accompanying texts are inherently private, meant for a very circumscribed audience for professional inquiry and reference, while art is more public—the problematics of this term notwithstanding. She further states that medicine and science are ambivalent to the public—socially, culturally, professionally, and ideologically.[9] The dichotomy of private vs. public anatomical knowledge is at the structural heart of *Bodies Beyond Borders*, which relates it to similar ones—center/periphery and academic/public—leading one to the conclusion that the duty of art is to be less ambivalent towards its public.

It is, however, Jordanova's argument in *Sexual Visions* that medical imagery treats women's bodies as symbols/signs of national vigor and *morality*,[10] which perhaps forecasts her own later, succinct discussion of art and anatomy: "It is helpful to have *a more specific focus on art and anatomy* and to recognise that both art and anatomy involve self-conscious discipline—in varying degrees *intellectual, empirical, and moral.*"[11]

The present volume is focused on the common visuality of art, anatomy, and medicine, as it applies to artistic training and representation; anatomical inquiry, knowledge, and engagement; public health education and political propaganda; and macro-anatomical (as opposed to microscopic/cellular) medical diagnostics. Jordanova's tripartite division—intellectual, empirical, and moral—is a useful lens through which to view the historical narrative told in Rebecca Messbarger's prologue, which sets the stage for the rest of this volume.

Jordanova's categories are also helpful in considering how each of the following chapters relates to one another, and to the whole, by establishing the themes carried throughout: intellect–theory, empiricism–practice, and morality–body. The theoretical underpinnings of academic art pedagogy rely on an *intellectual* understanding of ideal aesthetic exemplars, the role of art to imitate Nature by close *empirical* observation, and subsequently to improve upon Nature because ideal forms were thought to align with higher *moral* character. The intellect here corresponds to art theory, empiricism involves observation and imitation, and morality connects to idealization/generalization as well as to emulation.

Likewise, anatomical theory called upon an *intellectual* familiarity with its own history—its discoveries and debates—while anatomical practice applied that intellectual knowledge to the *empirical* dissection and observation of cadavers for anatomical, medical, and artistic training. Less concerned with new discoveries or major debates after ca. 1800, anatomists utilized dissection to demonstrate, to teach, to display, and for autopsy (literally, 'to see for oneself') to determine the cause of death.[12] Great care was usually taken to preserve the *moral* integrity of the bodies—although many scholars have revealed egregious examples to the contrary, which have only reaffirmed the moral seriousness of the undertaking through their violations of convention, ethics, morals, professional standards, and/or law.[13] Furthermore, the physical and visual presence of the cadaver (whole, dissected, skeletonized, modeled, or represented) is a constant *moral(izing)* reminder of the inevitable—death itself. On the other side of the same coin, moreover, the medically healthy living body intellectually equates to the artistic ideal figure as exemplifying higher moral character, while its opposite—the unidealized, grotesque, diseased, or pathologized body (or parts thereof)—is often seen to encode moral failings or weaknesses; in either case such interpretations are certainly complex and not unproblematic.

Rebecca Messbarger's thrilling account of Vesalius, elbow-deep inside a dissected corpse, righteously exclaiming, "Feel with your hands and believe!"

demonstrates that the sixteenth-century anatomist understood the dead body to be not only a visual model, but also a tangible one in three dimensions, to be physically and visually explored, inside and out, for pedagogical purposes. While much scholarly attention has been paid to two-dimensional anatomical illustrations of the sort that appear in Vesalius's famed *De Humani Corporis Fabrica*, the role of three-dimensional models in anatomy and medicine has been but little explored. This is odd, perhaps, given the widespread use of (and acknowledgement of the usefulness of) three-dimensional models/ modeling in the sciences generally, not to mention the prestige of sculpture as three-dimensional objects within the history of art.

This book fruitfully explores the notion that it is the concept of the model that underpins the common visuality of art, anatomy, and medicine. The verb 'to model' means not only to pose, but also to exemplify and/or embody an ideal, a behavior, or an abstract concept in a way that can be seen. The noun 'model' refers not only to the one who poses for a viewer, but also to the person who (or object that) exemplifies and/or embodies visually the modeled ideal, behavior or concept. 'To model' may also mean to demonstrate visually, as in a process or theorem, or to fabricate—to create a visible object by imitation (a copy after an original model) or to create a finished product, prototype or scaled schematic (yet another kind of model). The model demonstrates. The model is a fabrication—either an original, an imitation, or direct mimesis (e.g., a plaster cast). 'To model' is to visualize. The model is the visible, the tangible. It is designed, posed, and/or displayed for the purpose of being seen and, potentially, touched.

Models and modeling are common across the arts and sciences—and not only in obscure academic, specialized corners of particular disciplines. In the visual arts, we are quite familiar with models who pose for paintings or who model *haute couture* clothing lines for fashion photographers. We may also recall the childhood game, *Operation*™,[14] which features a three-dimensional, reduced scale, artistic model of a cartoonish human body, partially nude and surgically open. Players examine and explore the body's exterior and interior, finding and removing the necessary parts without touching the edges of the 'incisions' and setting off the buzzer. Students of chemistry will also be familiar with rod and ball molecular models, which help visualize in three dimensions the chemical structure of elemental ionic bonds. Artistic renderings of the nanoscale are models that show what is not actually there. Artificial shadow and color are introduced to such representations so that the images make sense to our eyes, but the nanoscale is so small that shadow and color do not exist. Turning something real (at the nano or molecular scales) into a virtual representation for pedagogical purposes is the inverse of 'virtual reality', which uses technology to visualize a 'real' illusion of a three-dimensional, experience that does not exist. However, virtual reality technology has progressed from the realm of technological wonder and entertainment, and gaming, to become scientifically, industrially and commercially useful. It can be used to run algorithmic models in virtual space and time to predict a variety of outcomes.

The place of the three-dimensional model in historical and disciplinary context in the sciences is the subject of Soraya de Chadarevian and Nick Hopwood's excellent edited volume, *Models: The Third Dimension of Science* (2004), which was very influential in solidifying the conceptual structure of the present work.[15] Although this book was nearly complete even before I read De Chadarevian and Hopwood's volume, I have begun to (re)think it as a kind of response to their work in many ways. They write that, "even for anatomy, we lack work on the status of models in the discipline and accounts of what difference they made, more generally, to images of the body."[16] Many of the chapters within the present volume address this issue from multiple disciplinary points of view—medical humanities, women's and gender studies, and the history of art. Also in the 2004 volume, Ludmilla Jordanova cites art history and material culture studies as particularly well situated to conceptualize relationships between ideas and material objects.[17] In this way, she posits, these disciplines could help bridge a dimensional gap that typifies the history and philosophy of science on the one hand, which prioritize the ideas and concepts derived from the two-dimensional (text and image), and the history of scientific instruments on the other, which prioritizes the three-dimensional material objects (instruments, apparatus, models) as artifacts of science. The present volume, then, employs the discipline of art history primarily to investigate the status and effects of bodily models in art, anatomy, and medicine since ca. 1800.

In *Bodies Beyond Borders*, Wils, de Bont, and Au point out, "as the medical arts increasingly pushed the growth of anatomy as a discipline [in the eighteenth and nineteenth centuries], it also expanded into other cultural expressions."[18] Such cultural expressions certainly included a variety of visual representations in two and three dimensions for artistic and medical purposes. Similarly, they continue, "anatomy was also embraced beyond its role in medicine, gaining interest through myriad other cultural valences that the interior of the human body evoked." Hence, its incorporation into artistic instruction, which had a direct effect on how the body was visualized by artists, anatomists, and medical professionals alike.

The multiple meanings of 'model', in its verb, noun, and gerund forms, focus our attention precisely on that liminal,[19] visual space shared by art, anatomy, and medicine within artistic training in the first part of this book, "Anatomical Models in Artistic Training: Sculpted, Living, and Dissected." In academic art pedagogy, artists train by copying canonical works of art—often classical sculpture (originals, copies, and casts)—which serve as formal *models* of aesthetic beauty, ideal proportions, and masterful technique. Their subjects—especially true for historical paintings and classical sculpture—serve likewise as *models* of exterior and interior beauty, connecting ideals of physical perfection to higher moral and intellectual character, which are to be noted and emulated by art students. After these pupils master imitation of such fixed models, they apply the theoretical lessons learned to their representations of *living* models, who pose for academic life-drawing

sessions. The life model, often nude and male, is commonly posed to recall a specific classical sculpture—for example, *Apollo Belvedere*. Thus, the model models another known model while modeling for student art.

Life-drawing classes were also an opportunity for anatomical instruction. The living model, in classicizing pose, was often juxtaposed with a skeleton, an *écorché* figure, and/or a cast of ancient sculpture. The skeleton and *écorché* provided an anatomist's view of the human body—the cadaver—with the latter frequently posed to recall sculptural models. The living model provided a direct understanding of potential and kinetic motion and of how such movement of bone and muscle affected the surface contour of the skin. Such anatomical knowledge theoretically gave greater insight to the masterfulness of canonical examples of ancient sculpture, a deeper appreciation for the ancients' powers of empirical observation (of models) and imitation (modeling).

In Chapter 1, Andrew Graciano demonstrates how, in Adriaan de Lelie's *Anatomy Lesson of Dr. Andreas Bonn in the Drawing Department of Felix Meritis* (1792), the ordinariness of the male model, posed to recall the *Apollo Belvedere*, indicates a tension between a cultural tendency to emulate the Dutch Golden Age and a desire to look towards a modern Neoclassical aesthetic that was informed by close anatomical study. Graciano points out a discrepancy between the anatomical lesson for the amateur artists underway in De Lelie's painting and the painter's own treatment of the anatomical/artistic model. De Lelie's insistence on the exactitude of observed details of the life-model's body is also at odds with prevailing art theory and practice among European art academies and, as Graciano demonstrates, at Felix Meritis as well. By painting the life-model with such human specificity while posed as the *Apollo Belvedere*, De Lelie shows the model as caught between the artist's practice of particularity and the idealizing goals of academic art theory.

Dorothy Johnson discusses Théodore Géricault's painted studies of severed heads and limbs in Chapter 2. Already well known and widely considered to be preparatory sketches for the artist's acclaimed masterpiece, *Raft of the Medusa* (1819), these paintings are nonetheless highly finished works of art. Johnson points out that, while there is some visual connection to *Raft*, these finished paintings were the product of close anatomical study of cadavers and body parts—much of which took place in Géricault's studio—and that their detailed depiction of dead bodies, dissected and dismembered, bears little aesthetic relation to the heroic figuring of even the sickly and dying in *Raft of the Medusa*. But rather than see these paintings of cadaver parts as odd singularities of Romantic morbidity or products of an increasingly disturbed imagination, Johnson situates them within a standing tradition of cadaver study recommended in French academic art since at least 1795. In this sense, the cadaver—dissected and/or dismembered—doubles as a model for anatomical inquiry and demonstration, and as an artistic model (of the anatomized body) posed as subject.

The role of anatomy in the career of the British Neoclassical sculptor, John Flaxman, is the subject of Chapter 3. Josh Hainy considers Flaxman's peda-

gogical role as a professor at the Royal Academy of Arts to revise the general understanding of the sculptor as someone concerned exclusively with the line of contour—that is, with literally only the surface (and superficial) aspects of anatomical form, favoring idealized aesthetics and stylization over corporeal naturalism. Instead, Hainy reveals an artist who is deeply knowledgeable about human anatomy and who prioritizes it in his academic teaching. The anatomical lessons, however, were taught alongside the aesthetic privileging of ancient Greek sculptural models. It is, subsequently, through close attention to Flaxman's lectures, publications, and drawings that Hainy demonstrates the sculptor's ability to bring together a scientific understanding of human anatomy (what is beneath the surface, under the skin, the empirically observed) and the idealized contours (the perfected surface, the intellectual, theoretical, and moral ideal) of Greek aesthetics.

Part II, "Visual Models in Anatomy and Medicine: Illustrative, Radiographic, and Sculptural," considers several types of visual modeling in anatomy and medicine. The dissected cadaver serves as both theoretical and direct model for illustrated anatomical texts, while the illustrations in turn model the organization and processes of both dissection and the body itself, in whole and in part. Wei Yu Wayne Tan considers, in Chapter 4, the collection, translation, and use of seventeenth-century Dutch anatomical texts by anatomists and medical practitioners in late eighteenth-century Japan. The Dutch texts, extensively illustrated with images created by artists from empirical observation of dissections, challenged received ideas about human anatomy and medicine, including the causes of death, in traditional Chinese-based medicine practiced in Japan at the time, and encouraged the usefulness of dissection for anatomical knowledge in the face of long-held taboos.

The invention of radiography allowed medical practitioners to see inside the human body without dissection or exploratory surgery. It also created X-ray images, which used the body (or a part thereof) as a model, posed and placed amid a mechanical apparatus for imaging. The radiograph itself is a model—a fabricated image object of an original subject. Much of the nineteenth-century debate surrounding the mechanical vs. mediated (artistic) nature of photography is echoed in the medical implementation and criticism of radiographic imagery at the same time. In Chapter 5, Antoine Gallay discusses how the medical co-option in various forms of the popular photographic toy, the stereoscope, which created the illusion of a three-dimensional image for the viewer, resulted in what is known as stereoscopic radiography—the creation of theoretically more precise (and therefore useful) three-dimensional X-ray images. Gallay argues that the increasing acceptance of radiography in medicine and the desire for greater precision, resulted in an intentional distancing of stereoradiography from its stereoscopic origins to ensure and affirm its seriousness within medical imaging diagnostics in the late nineteenth and early twentieth centuries.

The medical field and, more generally, public health initiatives often employ three-dimensional models for pedagogical (in professional training)

and public educational purposes. One surely recalls seeing, for example, plastic models of the heart and/or lungs in a pediatrician's office, or similar representations of the eye in the ophthalmologist's. Such models, though mass-produced fabrications, are essentially artistic renderings of human anatomy. But, despite their clearly mediated and abstract(ed) appearance, they are useful to demonstrate basically the existence, design, and processes of specific organs and/or anatomical systems (circulatory, respiratory, digestive, neurological, reproductive, etc.). Rose Holz, in Chapter 6, presents the fascinating story of Dr. Robert L. Dickinson—obstetrician, gynecologist, and artist—who not only valued drawing within his own medical practice and in medical pedagogy, but also went on to collaborate with the sculptor Abram Belskie to create *The Birth Series* (1939). The New York Maternity Center Association commissioned the sculptural series for an exhibit about women's health and reproduction at the World's Fair of 1939–1940 in New York City. Although he supported early efforts to legalize abortion, advocated contraception, and was a founding member of Planned Parenthood, Dickinson (like the Maternity Center) saw the commission as an opportunity to educate the public (especially women) about the fundamental importance of pre-natal care. Dickinson and Belskie's sculptural series, Holz says, visualized the stages of embryonic development of the fertilized egg into a fetus and an unborn baby. Despite humanizing the fetus in beautiful sculptural renderings as a living being in a popular and public display, as well as in a long afterlife of related visual models and images, Holz argues that Dickinson perceived no conflict among his artistic, medical, and religious convictions related to embryonic development and the beginning of life, and his sustained advocacy for contraception and legal abortion. In fact, Holz says, he argued for the latter often from the vantage point of his devout Episcopalianism, evidencing that the religious–secular polarity that exists in modern abortion debates is a later and unfortunately oversimplified phenomenon.

Part III, "Modeling Public Health: The Healthy Body in Art and Propaganda," considers the role of art in communicating ideas of health and healthy bodies in the contexts of both public health and national politics. In Chapter 7, Niria Leyva-Gutiérrez discusses Diego Rivera's medical and public health imagery in several early twentieth-century murals in Mexico and the United States. The imagery includes depictions of medical professionals whose researches led to cures and vaccines to ensure public health; the importance of nationalized health care systems (in Mexico) to advance the treatment and education of the public; and the healthy bodies of the indigenous Mexican peoples whose traditional medicines and communal existences were romantically visualized as the forerunners of modern national healthcare. The indigenous people, in particular, simultaneously modeled a remarkable ancient knowledge about natural (botanical) medicines, and the roots of national health itself—medical *and* political.

Art and public health—medical and political—similarly coincide in Amanda Wangwright's discussion of Republican-era China in Chapter 8. In

an effort to counter the international perception of China as the 'sick man of Asia', the Republican government began to advance the achievement of what it deemed to be healthy bodily ideals. Wangwright demonstrates that, in many cases, the Republican ideal of female health was a remarkably curvaceous figure, one whose anatomy is arguably derived from Western prototypes (models). Moreover, Wangwright traces this figure through government propaganda, popular culture, and advertising, as well as contemporary fine art theory and depictions. The curvier woman was not only seen as physically and medically healthier than previous Chinese types, she argues, but also as modern and as modeling, most significantly, a higher ideal for the nation itself.

Instead of anatomo–medical imagery modeling public health, Part IV, "Modeling Disease: The Pathologized Body in Art and Medicine," is concerned with anatomies that seemingly model—artistically and pathologically—disease, distortion, disfigurement, or dysfunction. Natasha Ruiz-Gómez, in Chapter 9, discusses the creation, collection, and display of models of pathology in the so-called Musée Charcot. Ruiz-Gómez focuses primarily on two unpublished albums from the museum's collection—folios whose haphazard scrapbook-like arrangement of drawings, photographs, graphs, and diagrams masks what was undoubtedly a carefully edited selection of mediated and 'objective' visual models related to pathology of the living and dead. She argues that the albums' organizational structure mirrors the larger institutional *Wunderkammer*—the pathological museum at the Salpêtrière hospital, established by Dr. Jean-Martin Charcot. His passions caught between medicine and art, Charcot (like Dickinson, above) sought to combine the two in his practice of what would become neurology. As a physician and teacher, he advocated careful, prolonged, and repeated observation—especially of living patients' nude bodies—to assist in the recognition and identification of symptoms, diagnosis (and classification) of diseases/disorders, and assessment of treatment effectiveness. To that end, he compiled such albums as collected examples of his ideas and findings, as files of visual models that might be used either for comparative reference, or for more creative musing in the process of the creation of medical knowledge. Ruiz-Gómez points out, however, that many of the drawings and photographs (especially the latter because of the mechanical nature of photography), while perhaps attempting to capture objective renderings of anatomo–medical facts, are nonetheless artistically mediated images at the liminal junction of art and medicine. They serve less as models of objective reference data (of case studies recorded for universal understanding) than as complex and problematic models of a subjective vision of pathology, according to Ruiz-Gómez.

The problematics of the pathologized body are, similarly, the subject of Chapter 10. Brittany Lockard contextualizes Lucian Freud's several paintings of Sue Tilley amid the context of the medicalization of 'fatness' and the pathologizing of 'the fat body', particularly in the UK since the 1990s.[20] Tilley's body, as the model, is represented in unflattering ways not only in the paintings, but also in art media, where her form and depiction are inseparably elided

to stand in public judgement of her appearance and its suggestions of moral failing, personal weakness, and illness. Freud's painterliness, too, models Tilley's flesh in ways that suggest bruising, rot, and symptoms of underlying sickness and even death. The model's pose, moreover, undoubtedly dictated by the artist, likens her often to the oversized, overused, cushioned furniture—simultaneously suggesting a stereotype of laziness while dehumanizing Tilley's social relevance and agency by objectifying her as inanimate and eroticizing her as fetish. Lockard argues that such modeling (in pose, in paint, and in the press) unfortunately paralleled contemporaneous social and medical attitudes about the fat body as "unhealthful, unaesthetic, asexual, and morally repugnant."

Notes

1 Cunningham(2010), 8.

2 Jordanova (1989).

3 Callen (1995).

4 Kemp and Wallace (2000).

5 Gilman (1982).

6 Saunders, Maude, and Macnaughton (2009).

7 Macnaughton (2009), 72–86.

8 Wils, de Bont, and Sokhieng (2017).

9 Jordanova (1989), chapter 7 passim.

10 Ibid., 135–136.

11 Jordanova (1997), 100–101, my emphasis.

12 Cunningham (2010), 6.

13 For scholarship about the public use and misuse of cadavers in the eighteenth and nineteenth centuries, see Richardson (2011), 9–28. Many of the ethical and legal debates of these centuries are remarkably revived in the late-twentieth century in the critical reception of Gunther von Hagens's *Body Worlds* exhibition(s) and its imitators. See Jespersen, Rodriguez, and Starr (2009).

14 *Operation*™ was originally made and sold by Milton Bradley, but is now produced by Hasbro.

15 De Chadarevian and Hopwood (2004). Although I had conceived of the volume's concept around the idea of the model and modeling at the stage of proposal in 2017, Rebecca Messbarger brought De Chadarevian and Hopwood's book to my attention in early 2018 and I found it immediately relevant, inspiring, and revelatory. My loose conceptual connections, about which I was admittedly initially uncertain, were suddenly legitimized and reified.

16 De Chadarevian and Hopwood (2004), 3.

17 Jordanova (2004), 443–451, especially 443–445.

18 Wils, De Bont and Au (2017), 9–10.

19 Slipp (2017), 223.

20 I use the terms 'fat' and 'the fat body' to echo Lockard's own use of them, which she does purposely as a descriptive alternative to the medicalized terms 'obese' and 'overweight'.

References

Brauer, Fae, and Anthea Callen, eds. *Art, Sex, and Eugenics*. Abingdon, UK: Routledge, 2008.

Callen, Anthea. *The Spectacular Body: Science, Method and Meaning in the Work of Degas*. New Haven, CT: Yale University Press, 1995.

Cunningham, Andrew. *The Anatomist Anatomis'd: An Experimental Discipline in Enlightenment Europe*. Farnham, UK: Ashgate, 2010.

De Chadarevian, Soraya, and Nick Hopwood, eds. *Models: The Third Dimension of Science*. Stanford, CA: Stanford University Press, 2004.

Gilman, Sander. *Seeing the Insane*. New York: John Wiley, 1982.

Jespersen, T. Christine, Alicita Rodriguez, and Joseph Starr, eds. *The Anatomy of Body Worlds: Critical Essays on the Plastinated Cadavers of Gunther von Hagens*. London, UK: McFarland, 2009.

Jordanova, Ludmilla. *Sexual Visions: Images of Gender in Science and Medicine between the Eighteenth and Twentieth Centuries*. New Haven, CT: Yale University Press, 1989.

Jordanova, Ludmilla. "Happy Marriages and Dangerous Liaisons: Artists and Anatomy." In *The Quick and the Dead: Artists and Anatomy*, edited by Deanna Petherbridge and Ludmilla Jordanova, 100–113. Berkeley, CA: University of California Press, 1997.

Jordanova, Ludmilla. "Material Models as Visual Culture." In De Chadarevian and Hopwood (2004): 443–51.

Kemp, Martin, and Marina Wallace. *Spectacular Bodies: The Art and Science of the Human Body from Leonardo to Now*. Berkeley, CA: University of California Press, 2000.

Larson, Barbara. "Curing Degeneration: Health and the Neoclassical Body in Early Twentieth-Century France." In *In Sickness and in Health: Disease as Metaphor in Art and Popular Wisdom*, edited by Laurinda S. Dixon, 166–186. Newark, DE: University of Delaware Press, 2004.

MacDonald, Heather. "A Body Buried is a Body Wasted: The Spoils of Human Dissection." In *The Body Divided: Human Beings and Human 'Material' in Modern Medical History*, edited by Sarah Ferber and Sally Wilde, 9–28. Burlington, VT: Ashage, 2011.

Macnaughton, Jane. "Flesh Revealed: Medicine, Art and Anatomy." In *The Body and the Arts*, edited by Corinne Saunders, Ulrike Maude, and Jane Macnaughton, 72–86. New York: Palgrave Macmillan, 2009.

Richardson, Ruth. *Death, Dissection and the Destitute*. London, UK: Routlege, 1987.

Saunders, Corinne, Ulrika Maude, and Jane Macnaughton, eds. *The Body and the Arts*. New York: Palgrave Macmillan, 2009.

Slipp, Naomi. "International Anatomies: Teaching Visual Literacy in the Harvard Lecture Hall." In *Bodies Beyond Borders: Moving Anatomies, 1750–1950*, edited by KaatWils, Raf de Bont, and Sokhieng Au. Leuven, 197–230. Belgium: Leuven University Press, 2017.

Wils, Kaat, Raf de Bont, and Sokhieng Au, eds. *Bodies Beyond Borders: Moving Anatomies, 1750–1950*. Leuven, Belgium: Leuven University Press, 2017.

PART I
ANATOMICAL MODELS IN ARTISTIC TRAINING:
SCULPTED, LIVING, AND DISSECTED

Anatomy in the Drawing Room at *Felix Meritis Maatschappij* in Amsterdam: Between Skin and Bones, Theory and Practice

Andrew Graciano

Adriaan de Lelie (1755–1820) painted *Dr. Andreas Bonn's Anatomy Lecture before the Department of Drawing at Felix Meritis* (Plate 1.1. Amsterdam Museum, 1792), one of four paintings he created between 1792 and 1808 for the Felix Meritis Maatschappij (Happiness through Merit Association) of Amsterdam to commemorate the learned society's activities.[1] The organization was a remarkable microcosm of the sort of polymathic interests that typified the Age of Enlightenment. A privately funded society of middle-class, educated male burghers, Felix Meritis occupied in 1789 its new, purpose-built Neoclassical building on Keizersgracht, which still stands. The structure included a concert hall; an auditorium; a physics room (for scientific experimentation and demonstration) with space for a sizeable instrument collection; a gallery of plaster casts of ancient sculpture; an observatory; and a drawing classroom. The association itself was divided into five departments—*Natuurkunde* (Physics or Natural Philosophy); *Letterkunde* (Literature); *Koophandel* (Commerce); *Muziek* (Music); and *Tekenkunde* (Drawing).[2]

The portrait and genre painter, Adriaan de Lelie, became a member of Felix Meritis in 1787. In the spirit of social community, members were obligated to contribute their time, money, and/or talents to the good of the organization. It was for this reason that De Lelie painted *Dr. Andreas Bonn's Anatomy Lecture.* The painting depicts portrait likenesses of the Drawing Department members—mostly amateur artists, likely of varying skill levels—observing and listening to the esteemed surgeon and obstetrician discuss the anatomy of the human body, using a live nude model and a skeleton as visual aids. A professor of obstetrics and surgery at the nearby Athenaeum Illustre,[3] Andreas Bonn (1738–1817) was also an art-lover, who had delivered the inaugural speech on the opening of the Drawing Department's room on 3 November 1789.[4] His lengthy discourse evidences a broad awareness of art and its cultural historical significance, as well as a deeper understanding of classical art theory from Antiquity to the eighteenth-century present.

De Lelie's *Anatomy Lecture* displays an anatomy lesson within a life-drawing class, the skeleton included to reaffirm the scientific nature of the moment depicted. Chosen undoubtedly for his superlative anatomical physique, the live

model—intentionally posed in the attitude of (i.e., modeling) the famed *Apollo Belvedere*—simultaneously recalls the prized ancient sculpture and, indeed, academic art theory in practice. In light of Dr. Bonn's anatomical expertise *and* art-theoretical knowledge, I argue that it is the representative simultaneity of anatomical/mortal reality and of artistic/timeless ideals that creates a site of conflict around the model, and an ambiguity of purpose, both anatomically and artistically. This ambiguity allows the model, and the painting as a whole, to oscillate within art-theoretical and anatomo–surgical debates that seem to parallel one another in the Netherlands in the late eighteenth century.

Dutch artists in the 1700s long labored under the looming shadow cast by the Golden Age of the preceding century.[5] At the same time, the sale of a number of key collections of seventeenth-century Dutch art to foreign collectors also affected artistic life in the eighteenth-century Dutch Republic. While some art-lovers, like Bonn, had mixed feelings about the movement of great collections of seventeenth-century Dutch art to foreign lands—a sense of pride in the popular appreciation of, and demand for, such work on the one hand, and one of mournfulness about diminished cultural patrimony on the other[6]—others took greater issue with the state of contemporary art and taste. For example, in *Study of the Causes of the Decline of Painting in the Netherlands*, E. M. Engelberts wrote, "No time has been less auspicious for art than our own." He went on to theorize the reasons why eighteenth-century Dutch artists lagged behind their Golden Age counterparts.[7] As Koolhaas and De Vries explain, Engelberts' arguments are macroeconomic at their core, blaming the Dutch themselves for preferring the status afforded by imported finery in the fine and decorative arts, while allowing national treasures to be exported (and, thus, domestically undervalued). The title of his 'study', however, also strongly hints at a dissatisfaction with the (declining) quality and quantity of contemporary artistic production and innovation at home. The pervasive tastes and collecting habits of wealthy Dutch burghers led artists to find gainful employment copying or very closely emulating either seventeenth-century Dutch art or an international Rococo aesthetic, rather than to innovate within an existing tradition and according to their individual aesthetic proclivities. This phenomenon only further served to feed a cultural nostalgia for past greatness. In many ways, Felix Meritis was a product of such a longing. Engelberts, a member of this association, is depicted in De Lelie's *The Opening of the Felix Meritis Building in 1788* (Amsterdam Museum, ca. 1800).

De Lelie himself was not exempt from working within the cultural economy of nostalgia. The figural painter was equally renowned for portraits and genre paintings,[8] many of which were similarly dependent, on some level, on seventeenth-century artistic traditions, while other conversation pictures such as *The Art Gallery of Jan Gildemeester Jansz.* (Rijksmuseum, Amsterdam, 1795) attest to his practiced skill at reproducing Golden Age masterworks.[9] For his part, the art collector Gildemeester collected and displayed high quality old master pictures and *also* commissioned contemporary work from artists like De Lelie.

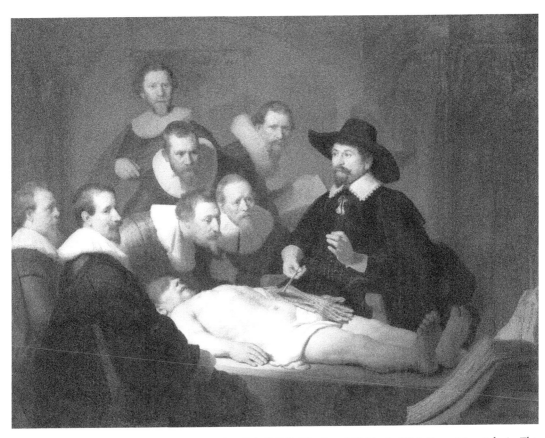

1.1 Rembrandt, *Anatomy Lesson of Dr. Nicolaes Tulp* (1632). The Royal Cabinet of Paintings, Mauritshuis, The Hague.

De Lelie's *Anatomy Lecture* is itself arguably indebted to the long-standing tradition—especially in the Netherlands—of anatomy lesson pictures, considered a sub-genre of seventeenth-century Dutch group portraiture.[10] Anatomy lesson paintings depict a well-known, ambitious medical practitioner in the act of dissecting a cadaver for the edification of the equally ambitious onlookers—students and other successful medical professionals. They often memorialize the anatomist's particular achievements or contributions to the field. Julie V. Hansen discusses some of the best-known examples, commissioned by the Amsterdam Surgeons' Guild (*Amsterdamse Chirurgijnsgilde*) between 1603 and 1758, especially Rembrandt's *Anatomy Lesson of Dr. Nicolaes Tulp* (Figure 1.1, 1632); Rembrandt's *Anatomy Lesson of Dr. Joan Deyman* (1656); Adriaen Backer's *Anatomy Lesson of Dr. Frederik Ruysch* (1670); and Jan van Neck's *Anatomy Lesson of Dr. Frederik Ruysch* (1683).[11] These and three others were displayed in the meeting rooms of the surgeons' guild to commemorate the social prestige afforded the guild members and the didactic significance of their public dissections. The earlier examples, such as Aert Pieters' *Anatomy Lesson of Dr. Sebastiaen Egberts* (1603), primarily maintain the social artifice of

other Netherlandish group-company portraits seen also in works by artists like Frans Hals. Rembrandt's *Dr. Tulp*, however, is distinctly different in its visual focus on the anatomical demonstration—for sitters and viewers alike. According to Hansen, it marked a new standard for such anatomical lesson paintings in the seventeenth and early eighteenth centuries.

While De Lelie's anatomy lesson follows Rembrandt's lead by contriving to show a candid assembly of men—most of whom are visually focused on the anatomist and his demonstration—it departs from the anatomy lesson genre in some very significant ways. The portrayal of Dr. Bonn at work, as it were, does not highlight his expertise in either obstetrics or surgery or dissection. Rather, it shows him as a lecturing member of the Drawing Department at Felix Meritis. Moreover, the anatomical body under consideration in Bonn's lesson is not a cadaver, but a *living* nude male, modeled after a well-known but unseen marble sculpture and, more immediately, its plaster mimesis in an adjacent room.[12] Finally, Bonn's audience is not composed of medical peers, but artists, who necessarily represent the membership of the Drawing Department, not the surgeons' guild.

If we allow that Felix Meritis, a private corporation of learned men, established the Drawing Department to teach and develop artistic and practical drawing skills in a setting that mimics an academic situation,[13] then we should also consider De Lelie's painting (in its departure from the seventeenth-century anatomy lesson genre) as a distinctly modern subject. It is at once a group portrait of a kind of academic membership and a scene of a life-drawing class led by an appointed anatomy professor. It recalls certainly and most immediately—though perhaps unwittingly—Johann Zoffany's *The Royal Academicians* (Royal Collection, 1771–1772) and his *William Hunter Lecturing* (Royal College of Physicians, ca. 1770–1772). Both of Zoffany's works depict Dr. William Hunter, who was Professor of Anatomy at the Royal Academy of Arts in London. Hunter and Bonn seem to have been cut from the same cloth—both obstetricians, surgeons, and anatomists with deep personal affinities for the visual arts. *The Royal Academicians* was known widely via engraved prints; Jan Gildemeester's collection contained an example that would almost certainly have been known to De Lelie.[14] It shows the membership of the Royal Academy of Arts attending a life-drawing class—although no one is drawing—in which one male nude model is being carefully posed, while the other undresses in preparation. Although Hunter stands next to the RA president, his role as anatomy professor is not overtly indicated.[15] Zoffany's unfinished *William Hunter lecturing*[16] (Plate 1.2), however, depicts the surgeon instructing the academicians, using an *écorché* figure, a living male model (shirtless)—posed to mimic the *écorché*—as well as a skeleton as visual aids.

The fact that Hunter gestures to the muscular back and scapula of the life model, proximal to the similarly posed *écorché* figure—a sculptural model cast from a mold that was created directly from an actual flayed corpse, posed prior to *rigor mortis*—indicates that the anatomical lecture is particularly focused on the structure and mechanics of the shoulder (muscles and bones).

The living model's body, moreover, demonstrates how shoulder movement affects the surface of the skin. Hunter's lecture is, therefore, comprehensive in its analysis of the three basic layers of the human form—bone, muscle, and skin—around one particular bodily component.

De Lelie's *Anatomy Lecture*, however, does not include an *écorché*. Felix Meritis did not obtain one until November 1792, after the painting was completed, having perhaps realized in tandem with Dr. Bonn that it was a necessary and valuable learning tool for artists. It was a gift from Drawing Department member Dirk Versteegh and was a copy of Jean-Antoine Houdon's 1769 anatomical sculpture in the French Academy in Rome.[17] It seems likely that Bonn's lecture, as depicted, must have been limited in both anatomical and artistic scope without the flayed model to demonstrate the muscles and tendons. As I mentioned earlier, the limp and obscured skeleton seems to be merely a prop, used to confirm that the painting depicts an anatomical lecture, not a routine life-drawing session, which further points to Bonn's expert role in the performance. The visual and intellectual focus is, however, rather on the life model and, in the absence of an *écorché* to model the musculature, particularly on his skin.

Such a focus on the exteriority of the model is anatomically less surprising when we realize that Bonn's anatomical thesis, *De Continuationibus Membranorum* (University of Leiden, 1763), is about the tissues of the dermal and mucous membranes—that is, basically, the skin. According to Daniel de Moulin, Bonn thus "entered the new field of histology," which is the microscopic study of tissue.[18] Although Bonn went on to practice and to teach obstetrics and anatomical dissection, his thesis was still cited in numerous medical texts and courses in Britain, France, and the United States of America well into the nineteenth century.[19]

Bonn's lecture and De Lelie's painting are, therefore, quite different from Zoffany's rendering of Hunter in terms of anatomical content. The anatomical difference further suggests a divergence in artistic practice within the life-drawing space. Hunter's lecture about one aspect of the whole body, albeit in depth, considering the interrelation of skin, muscles, and bones, provided his audience with an opportunity to draw what they directly observed with a focused accuracy informed by science. Bonn's lecture on the whole body, by contrast, suggests the (French) academic practice of creating *académies*, or *academy-beelden* in Dutch, finished drawings of the life model, whose anatomical form is filtered through the lens of antiquity. His particular focus on the skin, moreover, suggests the artistic study of surface, of contour and form, which had become a foundational element of Neoclassical art theory.

Bonn's art-theoretical knowledge was likely informed by his time spent studying anatomy and surgery in Paris, and, unsurprisingly, reflects French academic attitudes about classical aesthetics and the roles of anatomy and life-drawing in artistic training. He also demonstrated a similar affinity for French methods in surgical training. In a 1793 speech to his surgical peers in Amsterdam, delivered in Dutch rather than the customary Latin,[20] Bonn

criticized the state of surgery and obstetrics in the Republic, indicating that it was presently inferior to that in other nations, where once it had been at the forefront. Dutch surgical training continued to languish in the vestiges of the guild system, associated with barbers and other tradesmen, failing to attract young students to the field. Indeed, many Dutch students of anatomy and surgery, like Bonn, supplemented their training abroad. Daniel de Moulin writes that Bonn likely had the Collège de Chirurgie in Paris in mind as a better model of anatomical and surgical education, which had resulted from the greater social and professional prestige of the surgical profession in that country.[21] One might argue that it stands to reason that Bonn similarly endorsed French academic attitudes about the interrelation of antiquity, life models, and anatomical education within artistic training.

Whether one considers a large and venerable institution, such as the Académie Royale in Paris, or a smaller and less formal drawing school, academic art pedagogy in the long eighteenth century seems remarkable for its fundamental consistency. After mastering the skill of drawing after casts or examples of classical sculpture, students were encouraged to draw from life, to depict the nude (male) figure. Such experiences improved, through repetition, students' skills in the observation and imitation of Nature; that is, in the close inspection and copying of aspects of the three-dimensional world (in this case, the human form) on a two-dimensional surface.

Since formal academies throughout Europe had long privileged historical subjects, looking to antiquity for narrative and aesthetic inspiration, most also perpetuated the desire for students to correct Nature, to perfect and to idealize it as the ancients had done by applying to the living model the formal and aesthetic lessons learned from canonical (ideal) sculptural examples, such as the *Apollo Belvedere*. Through repetitive imitation of sculptural models, artists were expected to internalize a vast repertoire of canonical poses, graceful contours, and examples of masculine and feminine beauty.[22] This catalogue of perfection, as it were, was thus useful to 'correct' the inevitably flawed living model. As aesthetics in the later part of the eighteenth century morphed into an ever more linear and archaizing Neoclassicism, the less formal drawing schools often embraced the same or similar goals.[23]

Art historian Carl Goldstein, however, reminds us that things were not always so simple.[24] He points out the paradox inherent in the apparent incongruity between academic theory and practice. While the study of the life model at the French Académie Royale "was considered indispensable if figures were *not to become static*," the details of Nature were "to be manipulated according to a vision grounded in the antique," that is, in *static ancient sculptural models*.[25] Moreover, anatomical lessons and the information gleaned from them do not seem, in many cases, to have had an effect on the antique foundations of life drawings. Even in instances where such anatomical study was required, Goldstein argues that there is not much compelling evidence that anatomical knowledge ever superseded or affected the aesthetical goals of academic art.[26]

However, such was not the case at every academy. For example, in his first discourse, Joshua Reynolds takes some pleasure in pointing out that Continental academies had one "principal defect." Their students were not required to draw exactly what they saw in the life-drawing class. Reynolds disagreed with this practice, at least for students in an earlier stage of development. He continues:

Their drawings resemble the model only in the attitude [pose]. They change the form according to their vague and uncertain ideas of beauty, and make a drawing rather of what they think the figure ought to be, than of what it appears. . . . He who endeavours to copy nicely the figure before him, not only acquires a habit of exactness and precision, but is continually advancing in his knowledge of the human figure; and though he seems to superficial observers to make a slower progress, he will be found at last capable of adding (without running into capricious wildness) that grace and beauty, which is necessary to be given to his more finished works, and which cannot be got by the moderns, as it was not acquired by the ancients, but by an attentive and well compared study of the human form.[27]

Hunter's anatomy lessons at the Royal Academy were designed to reinforce this idea of "attentive and well compared study of the human form," connecting direct observation to anatomical (and sometimes cadaverous) reality. For students at the French Academy, however, life-drawing was an exercise in artistic interpretation—in transforming instantaneously what was observed into timeless art, "stripping away anything fleeting or accidental and noting only what was permanent and essential."[28] Of course, later, Reynolds would similarly advocate for the practice of generalizing over the depiction of minute naturalistic detail. Nevertheless, the question about the purpose of the life-drawing course viz. the model and student creativity continues to be unresolved to the present day, even among my own colleagues.[29] Are students supposed to draw, as Reynolds recommended in 1768, what they see? Or, are students supposed to draw, as was perhaps more typical in continental Europe, what they know; that is, what they have internalized by repeatedly copying canonical examples of ancient sculptural models?

When we interrogate De Lelie's scene of Dr. Bonn lecturing with a life model among the Drawing Department members at Felix Meritis, we must inquire not only what the student-members are learning, but also how they are to utilize that knowledge. Are they to draw what they see? Should they draw the life model and his anatomy with an unforgiving precision and exactitude that renders him not as the *Apollo Belvedere*, but as the fairly ordinary human who stands before them? Or are they to draw what they know, correcting the model and idealizing his form to be more like the ancient sculpture?[30] If the latter, we should examine why De Lelie conspicuously does the former.

In De Lelie's rendering, despite the model's pose, he is *neither Apollo the god, nor the Apollo Belvedere*. He is human and, although in possession of a decent physique, undeniably ordinary, mortal, and specific. Rather than 'correct' the model to conform more closely to Neoclassical ideals, De Lelie

embraces an insistent and directly observed naturalism in his painting. The artist includes such physical details as the awkward model's flushed cheeks (from embarrassment, one assumes), Morton's toe (where the second one is longer than the first), and pubic hair, as well as part of the muslin pouch that conceals his genitals. Such (dare I say) vulgar naturalistic details, bordering on a kind of Dutch realism, seen equally throughout the painting, were appropriate to the insistent genre-painting character of the scene,[31] with a specificity of detail for which the Golden Age Dutch and their eighteenth-century copyists were renowned. The result is that the model's pose gives us a glimpse of Neoclassical art theory that is immediately undermined by the specific humanity of the body; that is, by De Lelie's choice to paint the model rather than what the model represents. Although it simultaneously visualizes the creation (in class) and incorporation (into the painted image) of *academy-beelden*, De Lelie's *Anatomy Lecture* is, nonetheless, 'stuck' in the transition from practical to theoretical, just as the life model within it is some-where between mortal and timeless, ordinary and Apollo.

One finds such detailed humanity and materiality in the works of genre painters from Jan Steen to William Hogarth and Jean-Baptiste Greuze. However, Frans Grijzenhout and Carel van Tuyll van Serooskerken's land-mark work on Dutch Neoclassicism points out that Classicism was not new to the Netherlands in the eighteenth century.[32] While there were relatively few Dutch history painters in the preceding period, following the dogmatic Classicism of Nicolas Poussin, there were several painters of historical subjects who predated, were contemporaries of, and followed Peter Paul Rubens. The detailed humanity of the body of classical figures, like the one in De Lelie's painting who models Apollo, may recall instead such 'Dutch Classicism' (as Paul Knolle and Roger Mandle have dubbed it), physical specimens that typify Golden Age Netherlandish history painting.[33] Painters such as Cornelis Cornelisz van Haarlem, for example, cast mythological figures with a similar painterly suppleness of flesh that we find in De Lelie's life model (Figure 1.2), while Van Haarlem's and Rubens's historical nude male figures are muscular in appearance, sometimes overly so, that muscularity seems formed by, and encased in, a soft flesh that removes the figures from the realm of classical sculpture and places them among (albeit some of the best) examples of mortal men. By contrast, artists like Gerard de Lairesse and Karel van Mander, whose art theories upheld the work of Poussin, strove to advance intellectual, academic historical painting in the Netherlands modeled more directly on classical statuary.[34]

As many scholars have affirmed, the *Apollo Belvedere* was celebrated in the eighteenth century as the embodiment of ideal masculine beauty. Its elements of grace and elegance found scattered across Nature, brought together into one sculptural object, exceed anything found in the natural world.[35] Like many sculptural works of antiquity, it was appreciated for its "noble sim-plicity," to use Winckelmann's words,[36] not only of attitude and emotion, but also of form. The statue's formal simplicity is shown through smooth

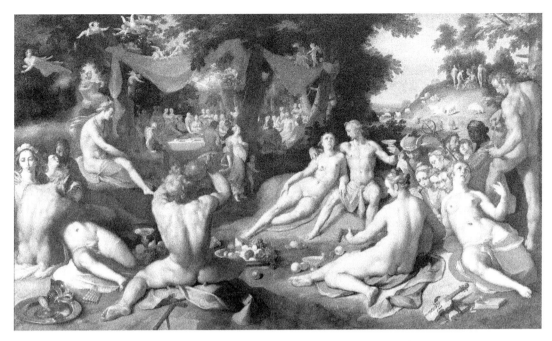

1.2 Cornelis Cornelisz van Haarlem, *The Wedding of Peleus and Thetis* (1592–1593). Frans Hals Museum, Haarlem, long-term loan from the Royal Cabinet of Paintings, Mauritshuis, The Hague. (Photography René Gerritsen.)

contours that shape a rigid muscularity that was understood to be connected to Apollo's masculinity and physical beauty, which was related in turn to virtue and moral character. We find similarly smooth contours in Poussin's and Lairesses's figures and later in the works of Jacques-Louis David and his students, in which muscles and skin are almost fused into a single rigid surface. De Lelie's life model, however, although posed to model *Apollo*, is not shown to have the sculpture's smooth contours or noble simplicity, but rather the supple muscles and fleshiness of (long) seventeenth-century historical painters like Van Haarlem and Rubens, as well as the material details (flushed cheeks, pubic hair, etc.) worthy of that century's genre paintings. The bodily distinction I am making here is comparable to the visual difference between the bodies of Jean-Honoré Fragonard's Endymion and Anne-Louis Girodet Trioson's figure of the same.[37] Fragonard's is much fleshier and more human, while Girodet's appears to be a reclining Neoclassical sculpture, worthy of Bertel Thorvaldsen, emulating the ancient ideals of noble simplicity and quiet grandeur with the cold, solid smoothness of marble polished to lunar reflection.

Moreover, the flushing and fleshiness of De Lelie's model's skin, over his muscles and bones, is not too far from the shirtless model in Zoffany's *William Hunter Lecturing*, and was very apropos Bonn's research expertise—the skin—which, as I mentioned, seems to be the subject and the limit of his anatomical lecture. But the question remains about what the audience was

supposed to do with the received anatomical knowledge and the model's body: draw what they see or draw what they know?

Joop van Roekel, Paul Knolle, and Marjolijn van Delft's *Haags Naakt: Geschiedenis van het tekenen naar naakt model op de Haagse Academie van Beeldende Kunsten* (1982) provides a valuable glimpse into eighteenth-century Dutch academic life-drawing practice. It seems that the Haagse Academie students drew what they saw, and if it was at all embellished, it was perhaps only in keeping with a classical aesthetic similar to that found in Van Haarlem's work. For example, Theodoor van der Schuer (1634–1707) and Willem Doudijns (1630–1697) carefully observed their muscular models, sitting and reclining, in vaguely classicizing attitudes, but the models' bodies are far from any sculptural ideals of Lairesse and Poussin or what would become the norm in the latter decades of the eighteenth century. Augustinus (II) Terwesten's (1711–1781) drawing of a female nude, half-reclining and partly covering her face with her hand, conforms to the Rubensian aesthetic of fleshy and voluptuous female figures, but in this case it is also infused with a bit of Rococo coyness. She does not model the ideal proportions and smoothed curves of a (Neo)classical Venus, Diana, or Psyche, but appears more like Boucher's *Mademoiselle O'Murphy* or the mythical queen in *Hercules et Omphale*.[38]

E. A. de Klerk, however, reminds us that the Haagse Academie was not so successful in its achievement of lofty academic goals. Student interest in drawing after the nude model was so low at times that classes were canceled.[39] De Klerk asserts that academic study was not an influential feature in the Netherlands, as it had been in France and Italy. Rather, several art theorists in the seventeenth century indicate that smaller drawing groups were organized privately on their own initiative to draw after the (often nude) life model. De Klerk cites the publications of Chrispijn de Passe and Willem Goeree, which explain that drawing after prints, drawings, paintings, and plaster casts was done by apprentices in the studio under a master's guidance, while the more advanced stage of drawing after the life model was done separately in a privately arranged drawing class, which they called a 'college'. These private model-classes were common in larger towns of the Dutch Republic in the latter half of the seventeenth century, making it possible for artists to draw after the nude model without having to resort to an institutionalized (national/royal) academy. It appears, de Klerk argues, that while also social, the pedagogical purpose of such drawing 'colleges' was the collective improvement of practical skills in drawing the human figure in varied poses and lighting conditions. The artistic emphasis was on the *practical* application of drawing in the general training of the hand and eye, and not on any sort of elevation of art itself or of the intellect of the artists.

Gerard de Lairesse, an artist and later theorist whose career spans the turn of the eighteenth century and whose work was mentioned earlier, lamented the prosaic focus of such model-classes. He advocated instead for a more intellectual and theoretical training in the visual arts, through drawing based on ancient sculptural models. De Lairesse and others, such as Karel van Mander

and Samuel Dirksz van Hoogstraten were the exceptions among Dutch art theorists in the seventeenth century, as most were more concerned with practical drawing skill and less with elevating the prestige of the nation's visual arts through the encouragement of history painting and academicism. This was the case at least until the late eighteenth century. Felix Meritis's Drawing Department, crucially, found itself in the midst of a paradigm shift—from model-classes to mini-academy—in its production of drawings after the nude life model, known as '*academy-beelden*'.

The Rijksmuseum collection contains a number of surviving drawings produced by members at Felix Meritis in the 1780s and 1790s. The drawings evidence a variation in skill level among members as well as differences in the visualization of the body from an art-theoretical point of view. Jan Tersteeg's 1782 drawing of a nude male reclining depicts a very carefully observed anatomy with great attention to the figure's ideal muscularity and youth. He appears quite sculptural in his repose. The image is an early example of an *academy-beeld* at Felix Meritis. Tersteeg's later drawings from 1784 and 1787, however, show nude figures that are overly muscular and rather fleshy in appearance, less reminiscent of classical sculpture than of Cornelis van Haarlem's nudes. His seated male nude of 1784 has greater affinity with Fragonard's *Endymion*, with muscles that appear to hang from the bones of the leg. Tersteeg's 1789 drawing of a nude shepherd boy, whose waist is draped with an animal skin to obscure his genitalia, conforms to the stylistic and pictorial tradition of shepherds at leisure within the seclusion of nature. Therefore, Tersteeg's drawing trajectory moves from something sculptural and ideal in form towards a distinctly Rococo aesthetic.

Other artists, such as Jan Swart and Hendrik de Flines, depict nude male figures in *academy-beelden* that are very sculptural in appearance. De Flines's 1789 standing male nude (Figure 1.3) is shown with head in profile, complete with a stylized aquiline nose and classicizing hair. The figure presents an ideal of classical beauty and surely departs from the reality of the life model. Swart's standing nude (Figure 1.4) of the same year poses near a classical plinth, with head in profile. His figure's body is not as linear as De Flines', but shows greater physical volume created by cross-hatching that indicates Swart's facility with chiaroscuro effects (and possibly also with printmaking). Nonetheless, Swart's figure displays a similarly ideal muscularity that was undoubtedly distinct from the mortal model.

Cornelis van Heurn's 1789 drawing of a standing male nude with a cape and shield (Figure 1.5) resides somewhere between Swart and Tersteeg. While Van Heurn's figure has muscular arms that indicate a closely observed anatomy, his face is in three-quarter profile, which reduces the linear aesthetic. Additionally, the figure's legs are smooth to the point of shapelessness, indicated by vertical outlining alone. Moreover, while the figure is intended clearly to model the famed *Belvedere Antinous*, the artist's lesser skill level makes the sculpture's famously exaggerated contrapposto unconvincing in the drawing. The legs, hips, and shoulders do not seem to work in tandem,

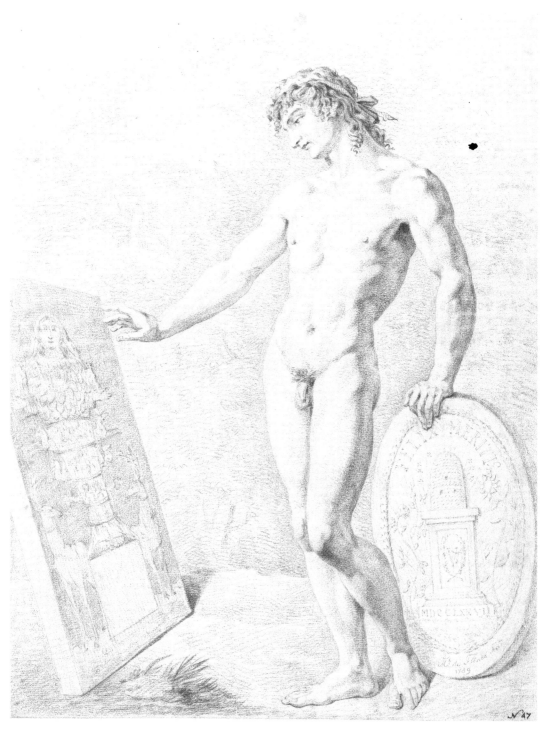

1.3 Hendrik de Flines, *Standing male nude, with a relief of a fertility goddess (Isis?) and a shield with the emblem of Felix Meritis* (*Staand mannelijk naakt, met een reliëf waarop een vruchtbaarheidsgodin (Isis?) en een schild met het embleem van Felix Meritis*), 1789, object number RP-T-FM-237. Rijksmuseum, Amsterdam.

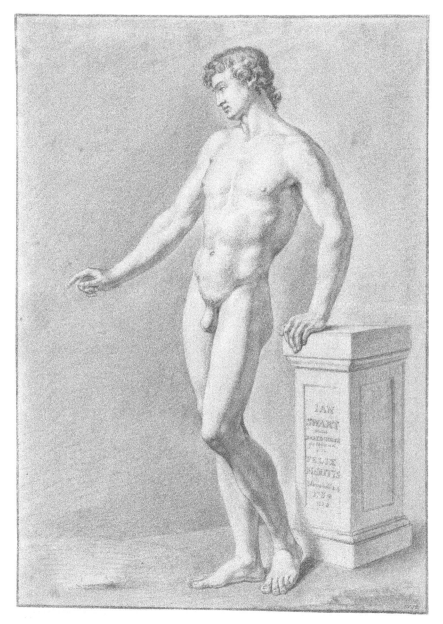

1.4 Jan Swart, *Standing male nude by a plinth* (*Staand mannelijk naakt bij een zuiltje*), 1789, object number RP-T-FM-213. Rijksmuseum, Amsterdam.

denying both human anatomical reality and the successful imitation of classical aesthetics.

Tersteeg's, De Flines', Swart's, and Van Heurn's drawings, nonetheless, provide crucial evidence that Felix Meritis's Drawing Department was engaged in creating *academy-beelden* even before (and shortly after) taking occupancy in the society's new building on Keizersgracht in late 1789. The fineness of these drawings after the life model, their degree of finish (skill variation notwithstanding), and focus on the nude male figure, clearly show that

1.5 Cornelis van Heurn, *Standing male nude with cape and shield* (*Staand mannelijk naakt met mantel en schild*), 1789, object number RP-T-FM-228. Rijksmuseum, Amsterdam.

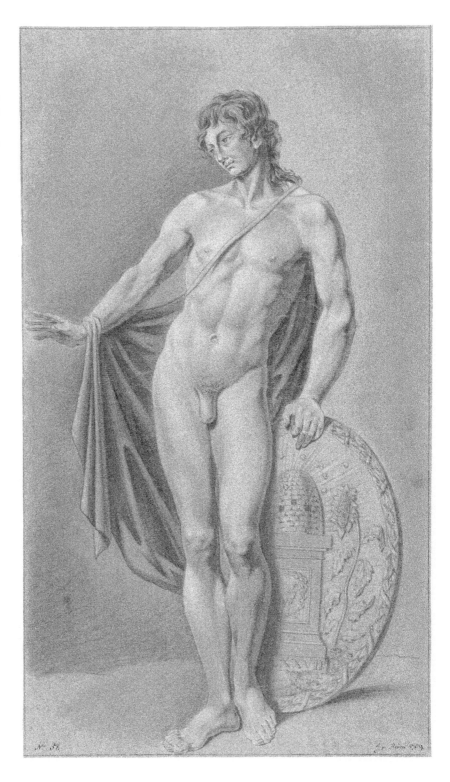

art-theoretical principles had been applied in order to move drawing from the practical emphasis on draftsmanship, still suggested in the word '*teken-kunde*',[40] into the 'higher' realms of fine art dilettantism and artistic training.[41]

To be clear, Felix Meritis was not an academy per se, nor was its focus solely on the visual arts. It makes sense, then, to consider its drawing program to have been born out of the same social and pragmatic impetus that was common in earlier 'colleges' and that informed its other departments—most notably those of natural philosophy or physics (*natuurkunde*) and commerce (*koophandel*). The society is essentially the Enlightenment version of similar private organizations of the previous era, brought together in one group, in one building, as one might have organized various collections into a *Wunderkammer*. Each collection of objects and specimens has its own tax-onomy and visual arrangement, but the overall *Wunderkammer* often had a larger, unifying agenda. For Felix Meritis, the larger organization's purposes were social, commercial, and practical. Each of its departments fulfilled at least one of these purposes. Drawing could connect to all three. However, as Felix Meritis's membership and social prestige increased, its general goals grew more ambitious. The Drawing Department followed suit, incorporating art theory into its *academy-beelden* practice.

In his opening lecture for the Drawing Department (1789), Bonn discusses Winckelmann's ideas about the superiority of Greek art, particularly sculp-ture, and Greek influence on the Etruscans and subsequent civilizations, most notably the Romans. He further discusses the aesthetic ideas of the Comte de Caylus, as well as the art-theoretical ideas, filtered through Roger de Piles, that underpin Passeri's and Bellori's concepts of classical or ideal beauty, which were understood to surpass Nature and had come to be the basis for the French academic notion of the *beau idéal*. He then goes on to trace the history of academies, leading up to the foundation of the Drawing Department at Felix Meritis. The Department had clearly begun to think of itself in academic terms.

Only two years before Bonn's lecture, Roeland van Eynden entered an essay competition sponsored by the Teylers Stichting in Haarlem. His text asserts the primacy and didactic function of history painting, but acknowledges that the Dutch were not strong in this category of art. He makes recommendations for the improvement of academic art study in the Netherlands, which have been summarized by Koolhaas and De Vries:

[Dutch drawing academies] would do well to acquire copies of ancient statues and famous classicist Italian and French pictures, and pay more attention to proportion, anatomy, perspective, and theory. By combining the 'noble simplicity and beauty of the contours of the Ancients' with the Dutch school's 'execution and truthful imitation,' he thinks it should at least be possible to create more alluring cabinet pieces.[42]

Van Eynden's recommendations may have influenced Felix Meritis's decision to purchase plaster casts of canonical sculptures from the French Academy

in Rome for display in the society's reverent sculpture gallery. The gallery's function as a collection of pedagogical models for Drawing Department members (and others) is made clear in Adriaan de Lelie's painting of it—*The Sculpture Gallery of Felix Meritis Maatschappij* (Plate 1.3). The cast gallery was initially formed in January 1792 with the arrival of several large plaster models from the French Academy in Rome, made directly from ancient sculptures, including *Apollo Belvedere, Laocöon, Venus Praxiteles* (*Capitoline Venus*), *Venus Callipyge*, and *Belvedere Torso*, all of which are prominently placed in the painting. The purchase was made possible by a major financial donation from Drawing Department member, Dirk Versteegh, who later personally gifted additional plaster works in November 1792, including the copy of Houdon's anatomical sculpture (*écorché*) from the French Academy. The cast collection was later augmented in 1808 when Louis-Napoléon, King of Holland, made a generous gift to Felix Meritis, which included a complete set of plaster replicas of ancient statuary, busts, and reliefs from the Musée Napoléon in Paris—the commission and delivery overseen by Dominique-Vivant Denon.[43] De Lelie depicts several of these casts along the room's perimeter in his painting of the gallery.

There was a clear pedagogical connection between the sculpture gallery and the drawing classroom. Both spaces and their contents fell under the auspices of the Drawing Department, which suggests that the gallery was not merely a museum, but, rather, a functional collection of antique drawing models. Adriaan de Lelie's painting, completed in 1809 after the acquisition of Louis-Napoléon's gift, shows three members (including the painter himself) drawing after the sculptural models, while others congregate around finished drawings, comparing them to the plaster figures. The importance of the sculpture gallery and, especially the recent arrival of the king's gift, is indicated by the variety of Felix Meritis members depicted. They represent not only the Drawing Department, but also the Departments of Commerce and Literature, as well as the larger institution's board members and president. De Lelie's painting also further attests to the social aspect of drawing and of connoisseurship, and the commercial benefits of artists intermingling with wealthy collectors and dealers. What is particularly frustrating, especially for the present chapter and its author, is that none of the drawings in De Lelie's *Anatomy Lesson* and *Sculpture Gallery* is visible. While the paintings convey the theoretical connection between sculpture and drawing, they nevertheless obscure the actual practice of drawing. But the gradual success of the cast collection, if not anatomical instruction, in advancing art-theoretical knowledge and application is evident in De Lelie's second painting of the Drawing Department.

In 1801, Felix Meritis's president, the bookseller and publisher Cornelis Roos, commissioned De Lelie to paint the Drawing Department again.[44] Although Bonn is present among the sitters, no anatomical lecture is taking place. Similarly, there is also no *écorché*, and not even a skeleton. *The Drawing Room at Felix Meritis* (Plate 1.4) depicts members observing, drawing, and

painting after the draped nude model, in addition to socializing and connoisseurship. I believe the model is posed to recall Phidias's *Herakles* from the Parthenon pedimental frieze and, therefore, sits in a slightly awkward semi-reclining manner. *Herakles* is part of what are now known as the Elgin Marbles in the British Museum, the result of an unscrupulous process of appropriation that began also in 1801, but the sculptural works *in situ* would have been known to Dutch *cognoscenti* via engraved reproductions in James Stuart and Nicholas Revett's *Antiquities of Athens* (1762).

Like 'Apollo' in the earlier painting, 'Herakles', too, was undoubtedly chosen for his muscular physique. On this occasion, De Lelie uses the drapery to obscure any pubic hair, and smooths out the muscular contours of the body, perhaps in keeping with a desire to replicate the archaizing linear interpretation of Classical Greek form by such modern artists as John Flaxman, Anne-Louis Girodet-Trioson, and Berthel Thorvaldsen. One sees such linearity particularly in the pectoral muscles and in the arms and legs. Despite the genre-like quality of the painting and its visual connections to Dutch Golden Age group portraits, as in De Lelie's *Anatomy Lecture*, the painter's treatment of the model evidences in this case a more sophisticated understanding of, and commitment to, Neoclassical principles. The artist further underscores the classicizing goals of the drawing class by including the classical bust above the doorway at the left, the head of which is turned slightly, echoing that of the model, and simultaneously overlooking the scene with apparent approbation.

Felix Meritis's *academy-beelden* of the 1780s and early 1790s indicate that the Drawing Department was already developing the 'college' tradition of model classes to advance drawing from practical draftsmanship to fine art instruction by incorporating the nude life model alongside classical art theory. The availability of the sculpture gallery as pedagogical tool after January 1792 seems to have pushed the drawing curriculum at Felix Meritis towards a fuller embrace and application of Neoclassical art theory. Moreover, Dr. Bonn's anatomical lectures that focused on the external body, on contour and form, undoubtedly helped to integrate the empirical observation and the theoretical interpretation of the life model. Nevertheless, De Lelie's 'Apollo' seems ambiguously poised between his own specific humanity and the sculptural ideal—caught between its indebtedness to an earlier age and a modern deployment of the *beau idéal*. While classicism in general was not new to the Dutch, it seems that Bonn's (and others') French-leaning academicism and anatomical training contributed to Felix Meritis's increasing desire to advance its fine art production and sophisticated connoisseurship, grounded in classicizing art theories. However, Bonn's motives, like those of Felix Meritis, were to improve the Republic.[45] The Dutch had begun, finally, to renew and redefine their visual culture by simultaneously becoming more global in referential scope, and more nationalistic in natural practice.

Acknowledgements

Two anonymous peer reviewers read an earlier draft of this chapter and their feedback was extremely valuable and instrumental in guiding my research and revision of the work toward its present state. To these anonymous scholars I owe the greatest and most direct gratitude for their constructive criticism and suggestions for further investigation. I am also grateful to all of the scholars cited throughout, whose work continues to inform and inspire my own. Many thanks especially are due to Tom van der Molen, Roger Mandle, Dorothy Johnson, Christopher M.S. Johns, Carl Goldstein, and Joshua Hainy for their conversations and correspondence related to the present work. I am also indebted to a number of institutions for their support, be it intellectual and/or financial, including the University of South Carolina (especially my colleagues in the Office of the Provost, Office of Research, College of Arts and Sciences, and School of Visual Art and Design); Rijksbureau voor Kunsthistorische Documentatie: Nederlands Instituut voor Kunstgeschiedenis; Rijksmuseum; Amsterdam Museum; Mauritshuis; and the Gemeente Amsterdam Stadsarchief.

Notes

1 Tom van der Molen has written an excellent article about the four pictures. See Van der Molen, (2009), 58–85.

2 For the history of Felix Meritis, see: Gompes and Ligtelijn (2007). For a concise history of the Drawing Department, in particular, see Knolle (1983).

3 The Athenaeum Illustre is also known as the Doorluchtige School, and is considered the institutional predecessor of the University of Amsterdam.

4 Bonn (1790).

5 See: Koolhaas and de Vries (1999), 69–90; Mandle (2002); Grijzenhout and van Tuyll van Serooskerken (1989).

6 Bonn, quoted in Grijzenhout and Van Veen (1999), 22. See also Bonn (1790), 50.

7 Quoted and discussed in Koolhaas and De Vries (1999), 69. See also Koolhaas-Grosfeld (1982).

8 For recent scholarship on De Lelie, see de Fouw (2014).

9 Golden Age works identified in the Gildemeester painting: Peter Paul Rubens, *Young Man with Falcon* (Buckingham Palace, London); Gerard Ter Borch, *The Letter* (Buckingham Palace, London); Aelbert Cuyp, landscape; Gerrit Dou, *Kitchen Girl* (a.k.a. *Dame aan het Spinettino*) (private collection); P. Potter, *Landscape with a Stable*; Rembrandt, *Shipwright*; A. Van de Velde, Koeiemelkster (1669, National Trust, London); Ph.Wouwerman, *Riding School*; Jacob van Ruisdael, *Buiten de wallen van Amsterdam* (Collection of the Duke of Sutherland, Mertoun House, Scotland); Jacob Ochtervelt, *Het Triktrakspel* (private collection); Dirck van Bergen, *Landschap met vee* (Dienst voor 'sRijks verspreide kunstvoorwerpen, Den Haag); Rubens, *Mercury geleidt Psyche naar de Olympus* (collection, Duke of Sutherland, Scotland); Gabriël Metsu, *Pancake-maker* (Rijksmuseum); David Teniers, *Boerendeel* (known only through an engraving, Rijksmuseum print room); Pieter de Hooch, *De boterham* (Thuyssen Collection, Lugano); Rubens, *Portrait of a geestelijk* (1637, Collection of Duke of Sutherland, Scotland); Meindert

Hobbema, *Landscape met boerenerf* (Wallace Collection); Ludolf Bakhuizen, *Seascape* (private collection).

10 I am grateful to my graduate student, Caroline Negus, for making this connection and for sharing her research on anatomy lesson paintings.

11 Hansen (1996), 663–679. See also Cunningham (2010), 48–50, and Margócsy (2009), 187–210.

12 Felix Meritis's building, as mentioned, included a gallery of sculptural casts, obtained in January 1792. I discuss the collection and its depiction in De Lelie's *The Sculpture Gallery at Felix Meritis* (Rijksmuseum, 1806–1809) in greater detail in due course.

13 Knolle (1983).

14 I am grateful to an anonymous reviewer for pointing this out to me. See: De Bruyn Kops (1965).

15 *The Royal Academicians* has been compellingly compared to Raphael's *School of Athens*—Hunter is Aristotle to Reynolds's Plato. Such a comparison of the two men summarizes their art-theoretical differences, Reynolds preferring to develop closely observed drawings into increasingly 'generalized' works of art, and Hunter emphasizing the importance of empirical observation of the body—living and dead.

16 Unlike *The Royal Academicians*, Zoffany's unfinished painting is not known to have been engraved.

17 Many thanks to Tom van der Molen for suggesting a closer look at the Drawing Department's minutes, located in the Gemeente Stadsarchief in Amsterdam. See also this meticulously researched doctoral thesis: Godin (2009), 115–137. Ruiz-Gómez discusses Houdon's anatomical sculpture in "Shaking the Tyranny of the Cadaver: Doctor Paul Richer and the 'Living Écorché'" in Wils et al. (2017), 240–42.

18 De Moulin (1988), 179.

19 See: *Edinburgh Medical and Surgical Journal, vol. 15* (Edinburgh: George Ramsay, 1819), 563; G. M. de Felici, "Hints of a new Idea of the Nature of the Cellular Tissue," *The New-England Journal of Medicine and Surgery* (vol. 9, 1820), 164; A. L. J. Bayle and H. Hollard, *Manuel d'Anatomie Générale* (Paris: Chez Gabon, 1827), pp. 92 and 276; A. L .J. Bayle and H. Hollard, *A Manual of General Anatomy*, trans. S. D. Gross (Philadelphia: John Grigg, 1828), 231; and *Annual Announcement of Lectures etc. etc. etc. by the Trustees and Professors of the Jefferson Medical College* (Philadelphia: Clark and Raser, 1832), 82 and 231.

20 De Moulin mentions this in passing, but I think it is a significant detail. It may hint at Bonn's participation in a kind of cultural nationalism. His critical remarks about the state of Dutch anatomo–surgical training were intended clearly to be constructive, in order to keep promising students from needing to study abroad and to regain Dutch primacy in the field. While he looked to France as a successful model (based on his own experience), his goal was the betterment of the Dutch system *for the Dutch*. It is tempting here to connect this to the Patriots' movement of the 1780s, whose lingering resentment of the Stadhouder House of Orange led to an enthusiasm for revolutionary events underway in France in the early 1790s. Such enthusiasm was likewise seen as a model to emulate for the betterment of the Dutch Republic, leading to the creation of the Batavian Republic in 1794. French military assistance in the Batavian revolution

led eventually to French dominance, which was exploited later by Emperor Napoléon, who made his brother, Louis-Napoléon, king of Holland. To his credit, Lodewijk I (as he was known) defended the sovereignty of his kingdom even to the point of defying his emperor brother. This led to his removal and to the imperial annexation of the kingdom of Holland. Napoléon's eventual defeat resulted in the subsequent creation of the Kingdom of the Netherlands with a return of the House of Orange as the monarchical dynasty.

21 De Moulin (1988), 179–180.

22 Dutch academies functioned quite similarly. See: Mandle (2002), 3; and Cunningham (2010), 265ff.

23 I have discussed Joseph Wright of Derby's depiction of an informal drawing academy in the context of academic pedagogy in Graciano (2013).

24 See Goldstein (1996), especially pp. 118–178, in which he discusses art theory and practice viz. life-drawing.

25 Goldstein (1996), 173, my emphasis: "The assumption, in other words, is that research into the antique was channeled into studies of the model."

26 Ibid., 176–178. See also Brugerolles, Brunel, and Debrabant (2013), p.23: "After [Jacques] Friquet's death in 1716 the [anatomy] classes were taught by professors of medicine, with disappointing results, as students found themselves overwhelmed with details they could not relate to the problems they encountered in drawing. No formula was ever found to ensure the lessons were really useful."

27 Reynolds (1992).

28 Brugerolles et al. (2013), 22.

29 I thank my colleague, David Voros, professor of painting at the University of South Carolina's School of Visual Art and Design, for his insight into the pedagogical variation in our own figure-drawing courses.

30 The Sculpture Gallery at Felix Meritis was created in January 1792 with casts purchased from the French Academy in Rome and included a copy of the *Apollo Belvedere*.

31 That is to say, it depicts an activity that occurred with frequent regularity at Felix Meritis, making the painting a scene drawn from everyday life.

32 Grijzenhout and Van Tuyll van Serooskerken (1989), passim.

33 Mandle (2002), 4: "As the century wore on, however, academies came to terms with the discrepancy between their teachings and the prevailing tastes of their patrons, as they began to define and present through the art of their members, what became identified as a Dutch 'style' or 'taste'." See also: Ibid., pp. 86–87 and Koolhaas-Grosfeld, (1982), 605–636.

34 It should be noted, in the context of the present chapter, that Lairesse created the drawings for the large folio engravings in Govert Bidloo's *Anatomia humani corporis* (1685). On first glance, his imagery appears derived from observed dissections, intended to make Bidloo's publication an improvement upon Andreas Vesalius's *De humani corporis fabrica* (1543), whose illustrations unnaturally depicted the dissected and flayed cadavers as sculptural figures set among idealized landscapes. Although the illustrations in Bidloo's atlas were celebrated for their innovative details of the practice of dissection that enhanced a viewer's experience akin to virtual reality, this was nonetheless achieved by

Lairesse's adherence to the artistic conventions of still-life painting. Moreover, many of Lairesse's designs for Bidloo include iconographic references to allegorical meaning, such as a skeleton shown holding an hourglass, appealing to the artistic intellect of his viewer/reader. Lairesse was more faithful to his art-theoretical principles than to the aims of the author. See Massey (2017).

35 See, for example, Chard (2004). On the notion of selecting 'scattered beauties,' see Bellori (1672).

36 Winckelmann, *Reflections on the Imitation of Greek Works in Painting and Sculpture* (1755), excerpt reprinted in translation in *Art in Theory, 1648–1815* (2000), pp. 455–456.

37 J.-H. Fragonard, *Diana and Endymion* (ca. 1753, Timken Collection, National Gallery of Art, Washington, DC) and A.-L. Girodet Trioson, *The Sleep of Endymion* (1791, Musée du Louvre, Paris).

38 Van Roekel, Knolle, and Van Delft (1982), pp. 15–29, especially Figures 21–23. See also François Boucher, *Mademoiselle O'Murphy* (c.1752, Alte Pinakothek, Munich) and *Hercules et Omphale* (1734, Pushkin Museum, Moscow).

39 De Klerk (1989).

40 '*Teken*' means 'sign' and '*kunde*' means 'science'. Therefore, '*tekenkunde*' implies a systematized process of image making. Although it means 'drawing', it is closely related to '*tekenkunst*', which means 'draftsmanship'.

41 For a key discussion of amateur artists in eighteenth-century Dutch drawing academies, see Knolle (1989).

42 Koolhaas and De Vries (1999), 76. See also Van Eynden (1787), 179–180; Koolhaas-Grosfeld (1982), 615; Knolle (1989), 39–42.

43 For information about the Felix Meritis cast collection, see Godin (2009), 115–137.

44 See Van der Molen (2009) for a thorough analysis of De Lelie's Felix Meritis pictures for Cornelis Roos.

45 See note 20.

References

Bellori, Giovanni. *Idea del pittore, del sculptore, e del architetto* (1672), excerpt reprinted in translation in *Art in Theory, 1648–1815*, edited by Charles Harrison, Paul Wood, and Jason Gaiger, 96–101. Oxford, UK: Blackwell, 2000.

Bonn, Andreas. *Redevoeringen ter inwijding der volbouwde tekenzaal voor het Departement der Tekenkunde, en van de gehoorzaal en schouwplaats voor het Departement der Natuurkunde, in het gebouw der Maatschappijë Felix Meritis te Amsterdam, gehouden den III. en XX. November MDCCLXXXIX.* Amsterdam, the Netherlands: J.C. Sepp and A. Fokke Simonsz, 1790.

Brugerolles, Emmanuelle, Georges Brunel, and Camille Debrabant. *The Male Nude: Eighteenth-century Drawings from the Paris Academy*. London, UK: The Wallace Collection, 2013.

Chard, Chloe, "Effeminacy, pleasure and the classical body." In *Femininity and Masculinity in Eighteenth-Century Art and Culture* (2004): 142–161.

Cunningham, Andrew. *The Anatomist Anatomis'd: An Experimental Discipline in Enlightenment Europe*. Farnham, UK: Ashgate, 2010.

De Bruyn Kops, C. J. "De Amsterdamse verzamelaar Jan Gildemeester Jansz." *Bulletin van het Rijksmuseum*, 13 (1965): 79–114.

De Fouw, Josephina. *Adriaan de Lelie (1755–1820): het achttiende-eeuwse familieportret*. Amsterdam, the Netherlands: W Books for the Museum Van Loon, 2014.

De Klerk, E. A. "'Academy-beelden' and 'teeken-schoolen' in Dutch seventeenth-century treatises on art." In *Academies of Art: Between Renaissance and Romanticism*, edited by Anton Boschloo et al., 283–288. 'sGravenhage [The Hague]: SDU, 1989.

De Moulin, Daniel. *A History of Surgery with Emphasis on the Netherlands*. Dordrecht, the Netherlands: Nijhoff, 1988.

Godin, Frederik Theodor Johannes. "Antiquity in Plaster: Production, Reception and Destruction of Plaster Copies from the Athenian Agora to Felix Meritis in Amsterdam." Ph.D. dissertation, University of Amsterdam, 2009.

Goldstein, Carl. *Teaching Art: Academies and Schools from Vasari to Albers*. Cambridge, UK: Cambridge University Press, 1996.

Gompes, Loes, and Merel Ligtelijn. *Geschiedenis van Felix Meritis: Spiegel van Amsterdam*. Amsterdam, the Nethlands: Felix Meritis and Rozenberg, 2007.

Graciano, Andrew. "Observation, Imitation and Emulation in *An Academy by Lamplight* by Joseph Wright of Derby (1734–97)." *British Art Journal* XIV, no. 3 (2013): 36–41.

Grijzenhout, Frans, and Carel Van Tuyll van Serooskerken, eds. *Edele eenvoud: Neo-classicisme in Nederland, 1765–1800*. Zwolle, the Netherlands: Uitgeverij Waanders, 1989.

Grijzenhout, Frans and Henk van Veen, eds. *The Golden Age of Dutch Painting in Historical Perspective*. Cambridge, UK: Cambridge University Press, 1999.

Hansen, Julie V. "Resurrecting Death: Anatomical Art in the Cabinet of Dr. Frederick Ruysch." *Art Bulletin* (December 1996): 663–679.

Knolle, Paul. "Het Departement der Tekenkunde van Felix Meritis, 1777–1889." *Documentieblad Werkgroep Achttiende Eeuw* 15 (1983): 141–196.

Knolle, Paul. "Dilettanten en hun rol in 18de-eeuwse Noord-Nederlandse tekenacademies." In *Academies of Art: Between Renaissance and Romanticism*, edited by Anton Boschloo et al., 289–301. 'sGravenhage [The Hague]: SDU, 1989.

Koolhaas, Eveline, and Sandra De Vries. "Back to a Glorious Past: Seventeenth-Century Art as a Model for the Nineteenth Century." In *The Golden Age of Dutch Painting in Historical Perspective*, edited by Frans Grijzenhout and Henk van Veen, 69–90. Cambridge, UK: Cambridge University Press, 1999.

Koolhaas-Grosfeld, Eveline. "Nationale versus goede smaak: Bevordering van nationale kunst in Nederland, 1780–1840." *Tijdschrift voor geschiedenis* 95 (1982): 605–636.

Mandle, Roger. "Aesthetics and Exhortations: Dutch Artists' Academies in the Eighteenth Century." Ph.D. dissertation, Case Western Reserve University, 2002.

Margócsy, Dániel. "Advertising cadavers in the republic of letters: anatomical publications in the early modern Netherlands." *British Journal for the History of Science* (June 2009): 187–210.

Massey, Lyle, "Against the 'Statue Anatomized': The 'Art' of Eighteenth-Century Anatomy on Trial." *Art History* (February 2017): 68–103.

Reynolds, Joshua. *Discourses*. New York: Penguin, 1992.

Ruiz-Gómez, Natasha, "Shaking the Tyranny of the Cadaver: Doctor Paul Richer and the 'Living Écorché'." In *Bodies Beyond Borders: Moving Anatomies, 1750–1950*, edited by Kaat Wils, Raf de Bont, and Sokhieng Au, 231–257. Leuven, Belgium: Leuven University Press, 2017.

Van der Molen, Tom. "De ene groep is de andere niet: Het onstaan en de vroege geschiedenis van de Felix Meritis-groepsportretten door Adriaan de Lelie." *Jaarboek van het Genootschap Amstelodamum* 101 (2009): 58–85.

Van Eynden, R. "Antwoord op de vraag van Teylers Tweede Genootschap voor den jaare MDCCLXXXII uitgeschreven over den nationaalen smaak der Hollandsche school in de teken- en schilderkunst." In *Verhandelingen uitgegeeven door Teylers Tweede Genootschap*, part 5. Haarlem, the Netherlands, 1787.

Van Roekel, Joop, Paul Knolle, and Marjolijn van Delft. *Haags Naakt: Geschiedenis van het tekenen naar naakt model op de Haagse Academie van Beeldende Kunsten*. Utrecht, the Netherlands: Impress, 1982.

Winckelmann, Johann-Joachim. *Reflections on the Imitation of Greek Works in Painting and Sculpture* (1755), excerpt reprinted in translation in *Art in Theory, 1648–1815*, edited by Charles Harrison, Paul Wood, and Jason Gaiger, 455–456. Oxford, UK: Blackwell, 2000.

Fabulations of the Flesh:
Géricault and the Praxis of Art and Anatomy in France

Dorothy Johnson

Théodore Géricault's 1819 *Raft of the Medusa* (Plate 2.1) is considered to be the epitome of the Romantic sublime with its emphasis on extreme states of psychological and physical suffering, deprivation, morbidity, and death.[1] The French frigate *Medusa* ran aground and was wrecked during clement weather off the coast of Mauritania on July 2, 1816. The event was a political, moral, and human catastrophe and the result of an incompetent captain who was a political appointee of the newly reinstalled Bourbon government. As is well known, Géricault was specifically informed by the account of the tragedy published by two survivors: the naval surgeon, Jean-Baptiste-Henri Savigny and the geographical engineer, Alexandre Corréard.[2] In 1817, they published an account of their experiences in what they hoped would be an objective, scientific narrative of the effects on the human mind and body of the terror of being adrift at sea, the force of the elements (brutal sun and sea water severely damaged and literally eroded the skin), famine, and thirst. After 13 days of horror that included madness, mutiny, murder and cannibalism, and extreme examples of cruelty, suffering, and barbarism, only fifteen emaciated survivors remained of the 147 people overcrowded onto the makeshift raft. The published account provided graphic details, a type of daily log of the degeneration from civilized behavior that still prevailed at the moment of the shipwreck to the atavistic madness and barbarism on the raft.

Géricault met with the authors in order to learn more about the details and they asked him to provide illustrations for their book, to which he agreed.[3] Numerous sketches and oil sketches of differing episodes of the ordeal attest to his exploration of various significant moments described by Savigny and Corréard for the monumental history painting he decided to create (prints were made from some of his compositions for the 1821 edition).[4] In these initial compositions, as well as in the final painting, the artist eschewed the descriptions of the emaciated and badly damaged bodies of the survivors (seen in prints of the period)[5] and depicted instead heroic figures, some dead and dying, but nonetheless muscular and strong. The group is a community of sorts led by the African, the strongest of all, who tries to attract the attention of the rescue ship, *Argus*.

A very copious literature exists on this painting, upon which I do not wish to elaborate here.[6] What I would like to do in this essay is to revisit one of the often mentioned episodes in the genesis of the *Raft of the Medusa*, namely Géricault's practice of bringing cadaver parts acquired from the nearby Hôpital Beaujon into his atelier and the studies he made of them that led to independent paintings of severed heads and limbs (Plates 2.2, 2.3). These studies and the circumstances surrounding them, in which the artist transformed his studio into a type of charnel house, are largely adduced in the scholarly literature as evidence of a morbid imagination and the brainchild of the artist's psychological perturbations.[7] And, indeed, to a certain extent, they are. But I would like to consider these works, which record Géricault's embrace of cadaver study, in a different context. For, in engaging in the practice that led to the depictions of severed heads and limbs, the artist was, in fact, following prevailing academic precepts and practices that had been in place since 1795 and that played a fascinating role in the historical and aesthetic developments of art and anatomy in eighteenth-century France.

The paintings of severed heads and limbs reveal Géricault's profound involvement with cadaver studies as he planned his first major Salon history painting. While live models posed for figures on the *Raft* and prototypes from the works of artists such as Michelangelo, Rubens, and Gros inspired his aesthetics of the heroic body, many of which conform in their muscular beauty to academic conventions of the ideal corporeal form,[8] his studies of the body in death constituted a parallel conceptualization of his monumental composition. Several drawings of cadavers, as well as sketches of anatomized limbs and half-length anatomized figures, provided the underlying anatomical structure for several of the figures on the Raft (we will return to this later in the essay).[9] The influence of cadaver study on the muscular and idealized figures on the Raft, was recognized by Ingres, who wrote:

I want them to remove from the Louvre the painting of the *Medusa*. I want no part of this *Medusa* and these other paintings from the dissection theater that show us nothing of a man but the corpse, that merely depict what is ugly, hideous.[10]

When the *Raft* was exhibited in London in 1820, an English critic also recognized the elements inspired by cadaver study: "The Morgue seems to have been studied as far as it could without exciting horror."[11]

The strange and rebarbative smaller-scale paintings created while he was working on the *Raft* have often been considered as preparatory studies and are signalized as the embodiment of the morbid Romantic imagination.[12] These include the disquieting and beautifully composed still-lifes of severed limbs (Plate 2.2) and the decapitated heads, horrifying in the quiescence of a fabulation, a factitious narrative, of a couple asleep in their bed (Plate 2.3). In the latter image, the physiognomy of the man and woman inscribe them as individuals from the lower classes.[13] Executed criminals, typically those of the hapless poor, provided the subjects for dissection and medical study at the charity hospitals. Several drawings of the male head that Géricault made

from differing angles of the cadaverous model survive, but we know that a *living* model actually posed for the female head that Géricault then imagined in a decapitated state of incipient decomposition.[14] The image shocked its first observers, as did his paintings of severed limbs. These works were considered unique, *sui generis*. This perception entered, and has remained in, the art historical literature ever since. Delacroix had seen them in Géricault's atelier (he had posed for his friend as one of the figures on the *Raft*).[15] He greatly admired in particular the composition of fragments of severed limbs, which he later famously described as not having a subject.[16] Delacroix remembered them as being "sublime": "subject of the dissection theater, arms, feet, etc., of cadavers, of an admirable power and modeling . . . this fragment of Géricault's is truly sublime."[17]

Whether these paintings are without a subject is still a matter of debate.[18] I believe the works adhere to conventions in some respects and do convey narrative and metaphorical content, as I briefly discuss below. But what I emphasize and seek to demonstrate in this essay is that these remarkable and disturbing compositions actually have a long backstory, a multivalent pedagogical context that involves the teaching and practice of art and anatomy in France, a context with which Géricault was familiar, for anatomical propaedeutics constituted an essential part of the artist's education.[19] This takes us to novatory anatomical illustrations and three-dimensional models in eighteenth-century and early nineteenth-century France and to the use of cadavers not only in dissection for artists, but also as sculpted effigies through the means of plaster casts. Géricault serves as a type of ideal case study of how art and anatomy became confluent in the early years of the nineteenth century. Even what appears to be a singular act of bringing cadavers into the atelier was not unique to Géricault, but actually had been recommended to artists in the 1790s in a prize-winning essay written by the archaeologist and art critic Émeric-David, who expanded it into a manual for sculptors published in 1805.[20]

According to Toussaint-Bernard Émeric-David and surgeons such as Jean-Joseph Sue *fils*, who advocated the study of anatomy via dissection for artists, the ultimate goal of anatomical study via dissection was the creation of beauty, for prevailing conventions of 'ideal' and 'real' beauty were still the goals of academic art.[21] The eloquent human figures on the *Raft of the Medusa*, inspired by studies of the live model as well as famous prototypes in art, certainly embody the beautiful in corporeal form. In looking at the paintings of body fragments that Géricault made, however, the question arises: did the artist intend for them to express some type of beauty or were they meant to be merely explorations of the grotesque aspects of the body in deliquescence? Were these personal works for the artist to contemplate or did he from the beginning intend them to take their place in the world of art?

In many ways, the compositions conform to conventions governing still-life and portraiture. When we look at the care given to the compositional structure, particularly the eloquent arrangement of body fragments and the narratives that can be construed from the contemplation of these compositions,

we recognize the seriousness of effort that Géricault put into these works, the choices he made, and the uncanny effects and multiple meanings he achieved. Géricault was known to be a serious, thoughtful, and deliberative artist and so we might expect that he considered these paintings to be gravid with thought and aesthetical significance. Géricault has arranged the heads of the man and woman, for example, both of whom have physiognomic markers of the lower class as mentioned above, on a white sheet that has been bloodied and dirtied, in proximity so that the viewer can conjure up the image of a couple in bed. These effects recall earlier anatomical illustrations, such as those created by the artist and innovative anatomical illustrator, Jacques-Fabien Gautier d'Agoty for his 1748 *Anatomy of the head . . .* (Figure 2.1).[22] Gautier d'Agoty, prefiguring Géricault, presents a type of narrative through his placement of the adjacent severed heads of the younger and older man who seem to be engaged in a type of conversation. The young man, with skull opened to reveal the brain within, seems to be whispering something to the older man, whose face is

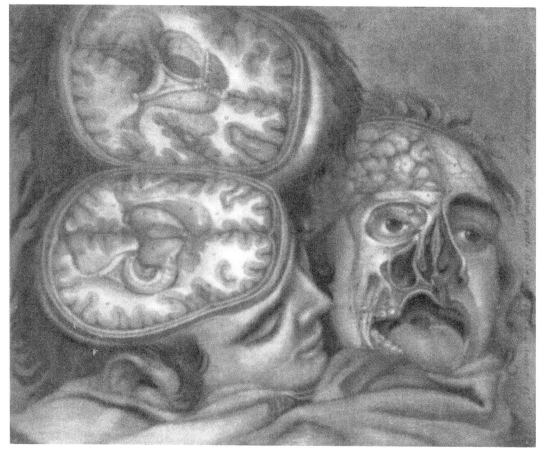

2.1 Jacques-Fabien Gautier d'Agoty. *Two Heads. Anatomie de la tête . . .* Pl. 9 (Paris: Quillan, 1748). Public domain.

flayed. The heads are portrait-like and both seem to be still alive in spite of their dissected condition, recalling the picturesque elements of anatomical illustrations from those of Vesalius' urtext of 1543, *The Fabric of the Human Body* to Albinus's 1749 *Tables of the Skeleton and Muscles of the Human Body*.[23] Géricault studied and drew from anatomy bookplates, a fact we will return to, for these studies inflected his compositions.

The severed heads also belong to a new category in popular art that arose from the Revolution: namely, the guillotine portraits that abounded in French visual culture during this period, in print and wax formats, and that have been admirably studied by Daniel Arasse.[24] One thinks of the many prints of the period, including decapitated portraits of Louis XVI, and the Curtius–Tussaud wax collections as prime examples.[25] In the nineteenth century, the heads of guillotined criminals were often preserved for scientific study, in the attempts to discern criminal character through phrenology and physiognomy, considered scientific pursuits in this period.[26] One can see that Géricault took the macabre popular genre of severed heads into a different category by creating cadaver portraits.

Similarly, the fragments of limbs, hands, and feet, arranged in his still-life compositions made from dissected body parts, seem to possess lingering effects of life, what Gregor Wedekind has recently described as "the person in the body fragment."[27] Dissected and recomposed, they depict an intermingling after death. Géricault demonstrates that the traces of the individual, the unique qualities associated with mind and body that were of such signal importance during this period, and that seem to become disassociated with these ideas in the anonymity and ignominity of the dissection room or morgue, nonetheless perdure. These precepts were especially related to the discourses of Vitalist medicine with which Géricault was engaged, as will be discussed in due course.[28]

In thinking about the genesis of these paintings and the impact on the artist of his anatomical studies, we need to return to the scene of the atelier he rented in 1818 on the Rue Faubourg-du-Roule (now Saint-Honoré) and to review briefly the practices he engaged in while there. His atelier was near the Hôpital Beaujon. This fortuitous proximity gave him the opportunity to study the sick and moribund and then acquire cadaver fragments and bring them to his studio where he famously sketched them in various states of decomposition from spring to fall of 1818.[29] In 1868. Géricault's biographer, Charles Clément, who made the first *catalogue raisonné* of the artist's works, describes the artist's frequentation of the hospital:

Thus, he lived just a few steps away from the Beaujon Hospital. There he was going to follow with an ardent curiosity all the phases of suffering and their traces imprinted on the human body, from the first signs to the final agony. There he found models who did not need to wear make-up in order to show him all the nuances of suffering and moral anguish, the ravages of illness and the terrors of death. He had made arrangements with the interns and nurses who supplied him with cadavers and severed limbs.[30]

It is important to keep in mind that Géricault studied and observed the psychological and physiological aspects of those suffering from terrible illness who were in the process of dying. Bringing body fragments of those who had just died into the atelier for further study seems like a continuum of this empirical exploration of dying and death. An artist's studio was then still considered a public space, and Géricault's atelier was frequented by students (such as the devoted Montfort), models, friends, fellow artists (such as Delacroix), supporters, etc. Clément describes the state of the atelier during this period (a description which has made an indelible impact on art historical narratives ever since):

For several months his atelier was a type of morgue. We are told for certain that he kept cadavers there until they were half decomposed. He insisted on working in this charnel house the pestilence of which his most devoted friends and his most intrepid models could endure with great difficulty and only for a moment.[31]

The great Romantic sculptor, Théophile Bra, who was a young art student in the atelier of the sculptor Bridan in the early years of the nineteenth century, provides a description of studio practice during this period in which the presence of cadaver parts as well as casts made from them was not uncommon. The experiences he describes had a morbid impact on his imagination and we can only imagine the same for Géricault and the visitors to his atelier:

The appearance of the atelier made one tremble. Heads cut off, trunks without a head, arms, legs separated from the body, hands, feet, ears, noses, even thumbs. One heard students speaking about ideal beauty, of several Gods which supposedly had lived previously amongst ruined people erased from the book of the living . . . but why did they make us cling to this debris? . . . They took us to what had once been a spacious chapel at the Feuillants . . . a humid, dilapidated, cold place covered with saltpeter, completely filled with debris, cut-off heads, trunks without a head, detached ears, severed feet and hands. Then for us began the added burden of expression and fatigue: the linear design of the debris of the interior machine of man, nothing, nothing about its mechanics, nothing that would explain how this machine functions.[32]

Here we recognize the deliberate echo of Descartes and La Mettrie, both prepotent in Vitalist investigations of the biology of man.[33] While Bra was repelled by the "debris" of the body, Géricault seems to have embraced it as a means of understanding the organism after death.

Géricault is an early example of an artist who studied the dying and the dead as a form of empirical knowledge, in his case, knowledge about the ravages of illness, the death of the individual, and decomposition. Further evidence of his quest to understand the processes of decomposition is provided by his visits to the morgue located on the Quai des Orfèvres. One account of the time attests to Géricault's frequentation of this "sinister" site: "For more than one long year the young master went there to work for many hours, face to face with the cadaver in this macabre place."[34] He apparently had access to the unclaimed bodies and body fragments, the debris of bodies of both sexes

and all ages from infants to the aged.[35] His pursuit of these studies parallel the interests of the Vitalist School of Medicine in Montpellier, which exerted such an important impact on art and the natural sciences during this period.[36] By the end of the eighteenth century, Paris had become known as a center of anatomical study via dissection as a result of the impact of the Vitalist School, which was profoundly involved with a "scientific" study of man. In particular, they sought to understand the principal of vitality, or life itself. The Vitalists were doctors and research scientists. In tandem with the Idéologues, their goal was to understand what constituted human identity, behavior, and diversity in physiological terms. A leading figure of this movement in Paris, Xavier Bichat, sought to discover the boundaries between life and death. He was especially interested in how the living organism resists constant threats and attacks upon its vitality before it succumbs. To this end, he performed dissections obsessively. Bichat's famous and influential *Recherches physiologiques sur la vie et la mort* of 1800 records his study of the transitional moments from life to death based on observation and dissection.[37]

Géricault seems to have adhered to a Vitalist conception of the human body in which all of its elements—bone, muscles, tissue, skin, organs, blood, etc.—are alive and in constant states of flux, motion, and becoming, as opposed to stasis. We also see this, of course, in his anatomical drawings of horses and his sculpted *écorché* of a trotting horse.[38] This helps to account for the vitality of Géricault's anatomical illustrations of bones and muscles, for example, that differ from their sources in anatomical plates by their uncanny sense of movement, vibration, and life.[39] The Vitalists attempted to understand human behavior in physiological terms based on advances in the domain of medicine and the natural sciences during the Enlightenment period. By the end of the eighteenth century, this quest extended to seeking the identity of the self in material, or corporeal, terms. Arguments by Vitalists against the "torture" of the guillotine in the 1790s, for example, were based on the premises that individuals could suffer in differing parts of the body and that consciousness could continue briefly after death as evinced in the convulsions of the face, twitching, and blushing that was observed in the few seconds after decapitation by the guillotine. Jean-Joseph Sue *fils*, a proponent of Vitalist medicine and ideas, who not only taught artists and medical students anatomy, but also provided public demonstrations, wrote in his *Opinion on the Torture of the Guillotine* in 1795, that it was a horrible and torturous form of death because suffering continues to take place in the "lieu même où l'on souffre", and, at the same time, consciousness suffers from this sensation.[40] Thus, when the head is decapitated by the guillotine, for a few moments the brain, seat of consciousness, experiences an awareness of pain and at the same time the headless body (nonetheless still part of the Vitalist idea of the self) also suffers. Thus, the guillotine was a form of double torture in which the victim experienced horrific pain in the detached body as well as the head. Sue was joined by others in his denunciation of the guillotine as an inhumane form of capital punishment, such as the German physician Samuel Sömmering.[41]

Géricault, because of his intense studies of decapitated heads, which led to his painted compositions of the subject, like many of his contemporaries, was aware of these ideas. During the same period there was still much excitement about Luigi Galvani's experiments in animal electricity and the potential for the process of biological galvanization to reinstitute vitality into dead matter.[42] Honoré Fragonard, cousin of the famous Rococo painter, had famously revivified cadavers as dynamic three-dimensional works mimicking monumental sculpture. A surgeon and anatomist who worked at the veterinary school in Chateau d'Alfort beginning in 1766, he dissected obsessively and created thousands of preserved anatomical pieces of animals and humans that he sometimes used to fashion works of narrative sculpture, as in his *Horse and Rider* or *Man with a Mandible* (*Samson with the Jawbone of a Horse*).[43] Thus, cadavers of humans and animals that he injected with wax and resin and other materials to preserve and introduce color into them could serve as their own effigies in narratives he created. These ghastly cadaver sculptures were on exhibit and attracted a great deal of attention by visitors to Alfort. After he was dismissed from the Cabinet d'Alfort, he sold his pieces to wealthy collectors who were amateurs of natural history and kept many for his vast private collection that he offered in 1792 to the Assemblée Nationale as the basis for a Cabinet national d'anatomie that he would direct. This would be a type of huge factory for processing and providing cadavers for the benefit of the Nation.[44]

This is the broader milieu that inflected the praxis of art and anatomy in the period of Géricault's training. Many of these influences, especially the ideas and practices of the Vitalists, are seen in his anatomical studies made from illustrations of anatomy books for artists. Many surgeon/anatomists of the period wrote manuals of anatomy for artists, replete with illustrations based on dissections.[45] Gericault, in accord with academic precepts and practices of the late eighteenth and early nineteenth centuries, like many of his fellow artists, studied anatomy from large-scale anatomical plates as well as from cadavers. He owned and copied from several of these manuals, including those by Charles Monnet and Giuseppe del Medico, among others, to which many of his early anatomical studies attest (he also owned illustrated anatomy books by François Tortebat and Edme Bouchardon).[46] The drawings he made in ink, graphite, and wash of muscles and bones are painterly interpretations of the plates he studied. He imbues them with an intense type of vitality that is absent from the illustrations. He often juxtaposes a skeletal hand or foot, for example, with a mimetic representation as he tries to understand what is hidden beneath the appearance of the corporeal form in nature. Géricault was sensitive to the expressive potential of anatomical fragments as signs of the absent body. He was also influenced by one of the most idiosyncratic of anatomical illustrators, the artist Jacques Gamelin, whose imaginative 1779 *Nouveau recueil d'ostéologie et de myologie dessiné d'après nature . . . pour l'utilité des sciences et des arts* was *sui generis*.[47] Gamelin's poetics of the expressive flayed body influenced many French Romantic artists and seems to have

made an indelible impact on Géricault's artistic imagination. The painter copied and reinterpreted several of Gamelin's figures, as seen in this example (Figures. 2.2, 2.3). Depicted from the back, the flayed male nude seems to be suffering and still alive as he attempts to hoist himself up from the dissection table, shown in a tilted perspective through a few notional lines. In his copy, Géricault imparts a heightened intensity and vitality to the figure through his use of rapid, agitated lines.

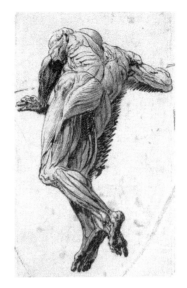

2.2 Théodore Géricault, *Ecorché*, drawing, ca. 1818/1819 Musée Bonnat, Bayonne. Photo: RMN-Grand Palais/Art Resource, New York.

Training in anatomy, through study of anatomical plates as well as dissection, was intended to give artists the foundational knowledge required to perfect their depictions of the body and make them anatomically accurate. This was a signal precept of art education of the period, as Graciano and Hainy also discuss in the present volume. And Géricault put these precepts into practice while working on the *Raft*, as seen in several studies in which figures are anatomized.[48] Earlier observers, including Delacroix, pointed out Géricault's license with anatomical accuracy, his tendency to distort anatomy for expressive effect. We see this occur in his drawings based on anatomical illustrations as well as in his paintings of anatomical fragments. Géricault drew and painted his emotional responses to anatomy. For him, it seems to have been a means of understanding the expressive potential of the body from the inside out.[49]

It is likely that Géricault began thinking about body fragments as expressive entities in themselves, rather than as parts of a whole that have been broken up, while creating studies from anatomy plates as a student in the atelier of Pierre-Narcisse Guérin, in accord with academic practice. Anatomical plates from which he made studies typically show a view of a part of the torso, parts of limbs, flayed or semi-flayed, usually isolated on a page and accompanied by text identifying the different muscles, tendons, etc. As mentioned above, Géricault transforms the visual source through use of expressive line and shading, which makes it appear as living material. The practice of visualizing the interior structures and makeup of the body informs the anatomized drawings he made of figures for the *Raft*.

Géricault was known for his extensive visual and written documentation in his preparations for the painting of *The Raft*.[50] Visual evidence and descriptions from his early biographers suggest that he followed the same procedures in creating the paintings of severed heads and limbs, and likely used his own anatomical drawings from plates as visual referents for dissected fragments. We also learn from early sources that Géricault, like his fellow art students of the period, attended dissections, but likely as an observer rather than a

2.3 Jacques
Gamelin, *Ecorché*
from Jacques
Gamelin, *Nouveau*
recueil d'ostéologie et
de myologie dessiné
d'après nature . . .
pour l'utilité des
sciences et des arts,
p. 96. Toulouse:
J. F. Desclassan,
1779, p. 96. Public
domain.

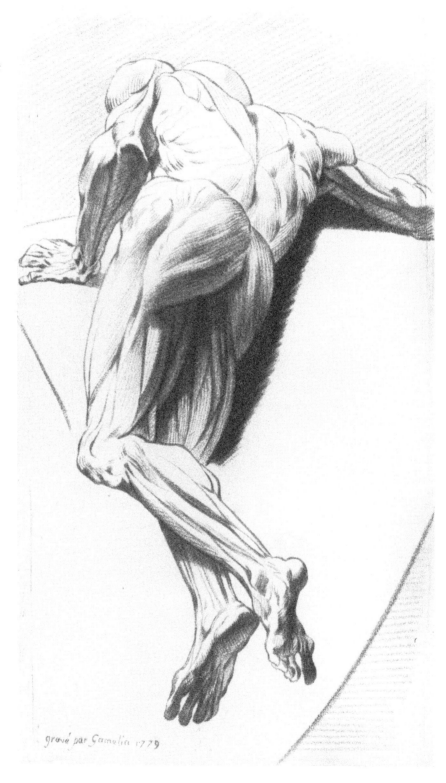

grané par Gamelia 1779

participant.[51] Such practice was part of his empirical observations of the body post-mortem, which he then transmuted into painted compositions. After 1795, as mentioned earlier, participating in dissections became a *requirement* for student artists at the *Classes des Beaux-Arts* at the Institut.

It is important to keep in mind that in his cadaver studies, Géricault was following precepts and practices of the Institut that had replaced the Académie royale de peinture et de sculpture after its abolition in 1793. In order to realize his goal of becoming a history painter, the young Géricault followed the curriculum of the *Classes des Beaux-Arts* at the Institut, even though he was not a student there.[52] The mid to late eighteenth century in France witnessed the renascence of anatomical study in art education after a long period that corresponded with the Rococo in art when it had been disparaged by the Académie Royale. By 1800, the study of anatomy was considered vital to students of painting and sculpture, who were required to learn it from a variety of sources.[53] One of the sources that became accepted by the former Académie was the study of anatomy via the three-dimensional *écorché*, a propaedeutic tool that was rehabilitated in the 1760s. Houdon's famous *Écorché* from 1768 (begun as an anatomized version of his *St. John the Baptist*), because it combined art and anatomy in remarkable ways, had quickly become the preferred model for art academies in France and throughout Europe in the late eighteenth century.[54]

The surgeon Jean-Joseph Sue *fils*, who followed the Vitalist school of medicine, as mentioned above, like his father before him, offered anatomy classes to art students. In 1795, he famously introduced dissection classes into the curriculum of the newly established *Classe de la littérature et des beaux-arts* at the Institut.[55] Like William Hunter at the Royal Academy of Arts in London—discussed in chapters 1 and 3—he believed that artists needed to learn about the interior of the human body first hand in order to create naturalistic simulacra of the human figure in painting and sculpture. He advocated, in fact, for a type of training in anatomy for artists that would parallel that of medical students. Such training would provide an empirical experience of the body that involved not only visual but also tactile experience. Art students would participate in dissections, not merely observe them. This was in radical contradistinction to the eighteenth-century curriculum of the Académie Royale de peinture et de sculpture which had advocated observation from life, from the exterior appearance of nature and the antique and discouraged direct study from the cadaver. When the Académie Royale was abolished in 1793, Sue became part of the quest for a modernized curriculum that was needed to supplant the teachings of the *ancien régime*.[56] During this same period, as mentioned above, the influential archaeologist and theorist, Émeric-David, inspired by Sue, wrote an essay in which he attributed the *beau réel* of ancient Greek sculpture to a study of beauty found in nature combined with anatomy via dissection. Modern art students, in order to attain a similar beauty and naturalism, were enjoined to follow this method. His essay, written between 1797 and 1799, would become the basis for *Recherches sur l'art*

statuaire of 1805, a sculpture manual that would have a profound influence on the making of art in France.[57]

Sue literally brought the study of anatomy via dissection into the art pedagogical setting. In 1795, he created the first anatomy theater for art students in the Louvre itself: the dissection of cadavers in which students themselves participated, the main feature of Sue's lessons, became central to the art curriculum for the first time.[58] Thanks to Sue's emphasis on dissection, art students became captivated with the investigation itself and this extended, of course, into the early years of the nineteenth century when Géricault was learning his craft. The Vitalist emphasis on dissection as they searched for the quiddity of the body informed Sue's theory and practice that he taught to art students. In his *Elémens d'anatomie à l'usage des peintres, des sculpteurs and des amateurs* of 1788, Sue explained why the art student should actively participate in dissections as a method of tactile, empirical experience of the cadaver:

> He needs to have inserted the scalpel into the labyrinth of this admirable machine, taken a tour, visited, questioned all the pathways, contracted and relaxed the muscles, confirmed through the sense of touch all the objects and the slightest protrusions, to have gone up and down the different parts of the skeletal structure, to have disjoined and rejoined the articulations, to have moved the bones using the muscles, in order to finally know the interior mechanism and to grasp the changes they can effect on the exterior. The more a painter is learned in anatomy, the more this veil is transparent to him.[59]

Émeric-David, in his manual for sculptors, *Recherches sur l'art statuaire* of 1805, affirms Sue's propadeutics and practice of dissection. According to Émeric-David, with the models of ancient Greek sculpture in mind, modern artists must seek to replicate *le beau réel, le beau visible*. But the only way for students to truly rival the *beau réel* of Greek sculpted figures is through dissection and they must dissect directly from cadavers themselves. He refers to the sculptor and collector Giraud, who, in the late 1790s, displayed his collection of casts from antique sculpture with casts of body fragments from live and dead models.[60] Émeric-David even recommends that students bring the cadaver into the atelier, for he believed that the Greeks could only have attained their remarkable knowledge of the human form, evinced in their sculptures, from the study of anatomy through dissection. He, therefore, recommends a type of archaeological excavation of the body. He even provides a description of how to proceed once the cadaver is in the atelier:

> The sculptor does not sufficiently learn anatomy from books; you must dissect with your own hands. Take into your atelier the masterpiece of the divine workman that has become prey to death. Arm your probing hand with a knife. Tear open the veil that covers the interior mechanism. Study the form of the muscles, their position, their intersections and particularly their attachments. Lift off the top muscles, raising them up by the two extremities. Study the shape of those placed below. Lift those up. Keep going, keep going until you reach the skeleton. Sculptors, there is your figure![61]

After learning from dissection, Émeric-David asserts, they must immediately turn to the live model as well as examples of antique sculpture to avoid creating human figures in art that might manifest a surfeit of anatomization:

Each time that you will have studied one of the limbs of a dissected man, model or draw the same part after the live model . . . keep ancient art close to you during this exercise so it can serve as a mediator between dissected nature and living nature. Antiquity is an admirable translator.[62]

In his practice of attending, if not practicing, dissections and in bringing pieces of cadavers into his atelier, Géricault was following precedents in theory and practice. He also had a very recent example of a surgeon–artist, Jean-Galbert Salvage, who used cadaver casts of hand-selected, able-bodied dead soldiers and described his process in detail for his treatise on the anatomized *Borghese Gladiator*.[63] The book itself was not printed until 1814, but the work-in-progress was well known in the early years of the nineteenth century, for some of its casts and anatomical plates were exhibited at the Salons. Salvage considered himself a médecin-artiste. Salvage chose the *Borghese Gladiator* as the embodiment of the principles and practices of ancient Greek art and his demonstration of its anatomization and transformation into anatomical plates was useful for artists seeking to combine heroic form with anatomical correctness. The *Borghese Gladiator* was a paragon of the athletic figure in dynamic motion. It was unthinkable for Salvage that the Greeks could have achieved this combination of beauty and vitality unless they understood the mechanics of the body from the inside out.[64] The belief that Greek sculptors followed this methodology and based their perfected effigies of human beings on a study of beautiful exterior forms of the live model combined with a scientific understanding of anatomy learned through the practice of dissection informed Salvage's treatise. To prove his thesis, Salvage took an unusual step. He acquired a plaster cast of the *Borghese Gladiator* and carved the cast itself into an *écorché* version of the Gladiator figure. He then acquired the corpses of muscular, healthy, youthful soldiers killed in fights in Paris. He placed the cadavers in the pose of the Gladiator and had cadaver casts made in wax and plaster of parts of their bodies. From these three-dimensional studies, he had colored plates made, anatomical illustrations of osteology and myology that followed the large-scale format of anatomical plates, similar to those from which Géricault had studied and drawn.[65] Jacques-Louis David was one of the committee members at the Institut who reviewed Salvage's project and enthusiastically endorsed it for pedagogical use in 1804.[66] Salvage hoped his plates would be used by artists in their quest to produce beautiful and anatomically accurate human figures. His plates are themselves works of art. And although they are based on a work of sculpture recreated in three-dimensional cadaver casts, the results of his investigations are transfigured into the two-dimensional format of the anatomy book illustration.

One sees the impact of these ideas on Géricault, especially in terms of the transmutation from the three-dimensional tactile and visual experience of

the human body—dead or alive, whole or in part—into sculpted figure or cadaver cast, and subsequently into the two-dimensional format of the anatomical illustration and painting. We know that Géricault himself was very interested in the art of sculpture. Early in his student career he had carved a small-scale *écorché* of a trotting horse (inspired by earlier precedents) and later sculpted psychologically expressive, erotic small-scale human figures, typically couples who were sometimes mythological in theme.[67] The practice of sculpting had been recommended by Jacques-Louis David to all students of painting as a means of better understanding the human figure in space. David, himself, as a student at the French Academy in Rome, had transformed his style based on his study of the contours and volumes of antique sculpture.[68] Géricault, although associated with the studio of Guérin and later Horace Vernet, profoundly admired David, who was a towering figure during the Empire.[69] He visited David when the artist was in exile in Brussels.[70] While he was working on the *Raft*, in moments of discouragement, we are told by Géricault's young student Montfort, who frequented his atelier, that Géricault visited David's paintings, *The Intervention of the Sabine Women* and *Leonidas at Thermopylae*, in order to study the figures.[71] Géricault followed David's practice of making bold outlines of figures and forms on the canvas and painting in the details later. Montfort describes the sculpturesque quality of the canvas as forms began to emerge: "What relief! When a part of the painting was not yet finished, it resembled a fragment of sculpture in a roughhewn state."[72]

In 1818, while beginning his various types of documentation and drawings for *The Raft* and immersing himself in studies of the dead, the dying, and corporeal debris, Géricault was also thinking in terms of other types of three-dimensional models. When he rented his large studio on the Rue Faubourg-du Roule he brought with him six small-scale copper armatures, and modeling wax.[73] Géricault had a small replica of the raft in his studio made by the carpenter who had fashioned the original and who was one of the survivors of the catastrophe.[74] The artist modeled small wax figures that he could manipulate into differing poses and attitudes and place in different positions on the scaled-down model of the raft. This was a means of visualizing the effects and placement of the figures in three-dimensional values, in spatial relationships. Several plaster casts and a bronze version of one of the figures have been identified and attributed to Géricault.[75] In 1973, J. A. Schmoll Eisenwerth studied a cast at the Wallraf-Richartz-Museum in Cologne that he identified as possibly an original cast made after the wax model (Plate 2.4).[76] The anatomized figure, a partial *écorché*, is extremely eloquent and can be considered the fructive result of the artist's many meditations on, and studies of, the human body as it dies and then decays. It manifests the confluence of his studies of art and anatomy. The figure is male, nude, and recumbent on an irregular, curvilinear piece of earth that echoes the body's fluidity of forms. The figure's position on this piece of natural terrain into which it has succumbed and into which it has begun to merge, suggests that although it may have begun as a wax model for a dying or dead figure on the *Raft* in its small-scale three-dimensional man-

ifestation in the atelier, the artist fashioned it into an independent work of sculpture. It resembles in pose the recumbent dead African who is face down, lying atop another figure in the final painting.

Scholars have also pointed out the filiations between two studies of an *écorché* figure made for *The Raft* that bear similarities to the sculpted figure (Plate 2.4).[77] The small sculpture conveys a heart-rending pathos as the once muscular and powerful body has collapsed from evident weakness and deprivation onto the earth to die. Géricault's figure recalls in its pathos and emotion that of Stouf's 1784–1785 reception piece, *The Dying Abel*, in the Louvre. Abel has fallen to the ground after Cain has struck him with a rock and, like Géricault's figure, he seems to embrace the earth to which he will return in death. Stouf represents Abel as child with a thin body and protruding ribs at the moment of death. The sculpture profoundly influenced David's image of the child martyr, *Bara*.[78] Géricault's figure is an adult with the face pressed into the earth and, thus, no features are visible. A large left hand still in the position of grasping something no longer there serves as a sign of the loss of the vital principal. The figure conveys an immense sadness because all struggle has been relinquished and yet the body retains much of the sense of life in its curvilinear forms, the muscles that remain visible, and the beautiful rendering of the torso and limbs. The visible tendons of the neck reveal the process of the body's desiccation as it turns into an *écorché*. The sculpted figure, unlike the artist's paintings of body fragments, is represented as a whole body, although in the process of decomposition. Thus, it becomes a type of universal symbol of the suffering and death of man on earth. For there is much more being expressed in this example (as well as in the other examples we have looked at) than the biological status of the body. In Géricault's eloquent fabulations of the flesh, the body retains the traces of the last moments of the individual, a human being with whom we can identify. The sculpted figure encapsulates the meaning of Géricault's hapless victims on the *Raft of the Medusa*, and the entire tragedy of the human condition.

Notes

1 Translations are the author's unless otherwise noted. Eitner (1983), 136–207. Eitner (1972); Bazin (1994). For a discussion of cannibalism on the raft, see Grigsby (2002), 165–235.

2 Savigny and Corréard (1817).

3 Bazin (1994), vol. 6, 71–91.

4 Ibid.

5 Ibid.

6 See note 1. See also Clément (1974); Courthion (1947).

7 This idea permeates the literature. See Guédron (1997). Athanassouglou-Kallmyer (2009) discusses the possible impact of Géricault's encounters with anatomists and physiologists.

8 See Wedekind and Hollein (2013), 77.

9 Bazin (1994), vol. 6: 134–136, 148.

10 "Je voudrais qu'on enlevât du Musée du Louvre ce tableau de la Méduse . . . Je ne veux pas de cette *Méduse* et de ses autres tableaux d'amphithéâtre qui ne nous montrent de l'homme que le cadavre, qui ne réproduisent que le laid, le hideux." Cited in Delaborde (1970), 166–167 and in Wedekind and Hollein (2013), 81.

11 Anonymous, "Wreck of the Medusa", *Literary Gazette*, vol. 4, no. 177 (June 10, 1820), 380. Cited in Wedekind and Hollein (2013), 81.

12 Athanassouglou-Kallmyer (1996).

13 Athanassouglou-Kallmyer (1992).

14 Bazin (1994), vol. 6: 151–153.

15 Ibid., 137.

16 Hannoosh (2009), vol. II: 1080.

17 "sujet d'amphithéâtre, bras, pieds, etc., de cadavres, d'une force, d'un relief admirable . . . ce fragment de Géricault est vraiment sublime." Ibid., II: 1119–1120.

18 Athanassouglou-Kallmyer (1992). See also Wedekind and Hollein (2013),83–93; Clair (2010).

19 Géricault included anatomy as part of a list he made of subjects he studied, as is often discussed in the historiography. See Courthion (1947), 33.

20 Émeric-David (1805); Shedd (1992).

21 Johnson (2015).

22 Gautier-d'Agoty (1748), Plate 9. Discussed in Johnson (2017), 48–50.

23 Discussed in Johnson (2017), 37–38.

24 Arasse (1989).

25 Lemire (1990).

26 Géricault was likely acquainted with the famous phrenologist, Alexandre Dumoutier, who worked at the Beaujon hospital and may have provided him with access to body parts. See Comar (2008), 236 and also Wedekind and Hollein (2013), 118. See further Clair (2010), 94–103.

27 Wedekind and Hollein (2013), 93.

28 Williams (1994, 2003).

29 Clément (1974), 131–132. Discussed in Guédron (1997), 89–92.

30 "Il était ainsi à deux pas de l'hôpital Beaujon. C'est là qu'il allait suivre avec une ardente curiosité toutes les phases de la souffrance, depuis les premières atteintes jusqu'à l'agonie, et les traces qu'elle imprime sur le corps humain. Il y trouvait des modèles qui n'avaient pas besoin de se grimer pour lui montrer toutes les nuances de la douleur physique, de l'angoisse morale: les ravages de la maladie

et les terreurs de la mort. Il s'était arrangé avec les internes et les infirmiers qui lui fournissaient des cadavres et des membres coupés". Clément, ibid.

31 "Pendant quelques mois son atelier fut une manière de morgue; il y garda, assure-t-on, des cadavres jusqu'à ce qu'ils fussent à moitié décomposés; il s'obstinait à travailler dans ce charnier, dont ses amis les plus dévoués et plus intrépides modèles ne bravaient qu'à grand'peine et pour un moment l'infection". Ibid., 130–131.

32 "L'aspect de l'atelier faisait frémir. Des têtes coupées, des troncs sans tête, des bras, des jambes séparées du corps, des mains, des pieds, des oreilles, des nez, jusqu'à des pouces. On entendait des élèves parler du beau idéal, de plusieurs Dieux lesquels auraient vécu autrefois chez des peuples ruinés effacés du livre des vivants . . . mais alors, pourquoi nous clouer à ces débris? . . . on nous conduit dans une ancienne grande chapelle des Feuillants [. . .] Lieu humide, délabré, froid, salpêtré, tout rempli de ruines, des têtes coupées, des troncs sans tête, des oreilles détachées, des pieds, des mains coupées. Alors commence pour nous un surcroît d'expression et de fatigue: le dessin linéaire des ruines-de la machine intérieure de l'homme, rien; rien de son mécanisme". Cited in de Caso (2008), 111.

33 Williams (2003).

34 "pendant plus d'une longue année le jeune maître était venu la travailler de longues heures, face à face avec le cadavre, en cet endroit macabre". Cited in Courthion (1947); and Guédron (1997).

35 Guédron, ibid., 91.

36 Williams (2003).

37 Bichat (1955).

38 Schmoll Eisenwerth (1973), 320–21.

39 Comar (2008), 236–9; Wedekind and Hollein (2013), 58–63.

40 See Arrasse (1989), 2. See also Jordanova (1989).

41 Soemmering (1793), 468–477; Sue (1795), Vol. iv, 178–189. See also Jordanova, ibid.

42 Pierre Sue (1802). For other discussions see Pera (1992), and Carol (2012).

43 See Ellenberger (1981); Lemire (1990), 168–174; Degueurce (2011); Simon (2002); Johnson (2017), 39–41.

44 Johnson, ibid.

45 Comar (2008), 236–9. Géricault made copies from del Medico (1811), and Monnet (1774).

46 Ibid. and also, Wedekind and Hollein (2013), 63. See further Debord (1997).

47 Gamelin (1779).

48 Bazin (1994), vol. 6: 136, 145, 146.

49 Wedekind and Hollein (2013), 51–52.

50 Bazin (1994), vol. 6: 7–57.

51 Clément (1974), 129–132.

52 Ibid., 131–2, Courthion (1947), 33.

53 Johnson (2017), 29–35.

54 Ibid.

55 Ibid., 35.

56 Johnson (2015), 177–8. See also Guédron (2004).

57 Émeric-David (1805). See also Shedd (1992).

58 Johnson (2015), 177.

59 "Il faut avoir porté le scalpel dans le dédale de cette machine admirable, en avoir parcourir, visité, interrogé toutes les routes; avoir contracté, relâché des muscles; avoir confirmé par le sens du toucher toutes les figures, et les plus légères éminences; avoir démonté et remonté les différentes pièces de la charpente osseuses; avoir disjoint et rejoint des articulations; avoir mis les os en jeu par le moyen des muscles, connaître enfin tout le mécanisme intérieur afin de mieux saisir tous les changements qu'il peut amener à l'extérieur . . . On rend beaucoup plus fidèlement la nature, lorsqu'on voit agir sous le voile dont elle se couvre. Plus un peintre est instruit de l'anatomie, plus ce voile est transparent pour lui." Sue (1788), avant-propos, p. 2, cited in Comar (2008), 33.

60 Shedd (1984).

61 "Le Statuaire n'apprend pas suffisamment l'anatomie dans des livres: il faut disséquer de votre propre main. Que le chef-d'oeuvre de l'ouvrier divin, devenu la proie de la mort, se déploie dans votre atelier. Armez-vous d'un fer studieux. Déchirez le voile qui couvre les resorts intérieurs. Etudiez la forme des muscles, leur position, leur entrecroisement, et particulièrement leurs attaches. Enlevez les premier muscles, en les soulevant par les deux extrémités; étudiez la forme de ceux qui sont places au-dessous; enlevez-les encore; avancez, avancez, allez au squelette; Statuaires, votre figure est là." Émeric-David (1805), 501.

62 "Chaque fois que vous aurez étudié quelqu'un des membres de l'homme disséqué, modelez ou dessinez la même partie d'après l'homme vivant. . . . Que l'antique, durant ce travail demeure constamment auprès de vous; qu'il serve de médiateur entre la nature disséquée et la nature vivante. L'antique est une admirable traduction." Ibid.

63 Salvage (1812). See also Lifchez (2009), and Johnson (2017), 56–58.

64 Salvage, Ibid.

65 Ibid.

66 Bonnaire, (1937), vol. II: 288.

67 Schmoll Eisenwerth (1973), 320–321.

68 Johnson (1993), 36–60.

69 Courthion (1947), 80–81.

70 Johnson (1993), 235–236.

71 Clément (1974), 142.

72 "Quelle saillie! Surtout lorsqu'une partie n'était pas encore que preparé; cela ressemblait à un fragment de sculpture à l'état de l ébauche." Ibid., 141.

73 Schmoll Eisenwerth (1973), 324–327.

74 Clément (1974), 130; Bazin (1994), vol. I: 112.

75 Schmoll Eisenwerth (1973), 324–327; Bazin, ibid., vol. I, doc. 369A, vol. V: 23–28, 138, and vol. VI: 26–27.

76 Ibid.

77 Bazin (1994), vol. VI: Figure 2014, p. 136.

78 Johnson (2017), 53.

References

Arasse, Daniel. *The Guillotine and the Terror*. Translated by Christopher Miller. London, UK: Allen Lane, Penguin, 1989.

Athanassouglou-Kallmyer, Nina. "Géricault's Severed Heads and Limbs: The Politics and Aesthetics of the Scaffold." *The Art Bulletin* 74, no. 4 (December 1992): 599–618.

Athanassouglou-Kallmyer, Nina. "Géricault. Politique et aesthétique de la mort." In *Géricault*, edited by Régis Michel, *Vol. 1*: 121–36. Paris, France: La Documentation française, 1996.

Athanassouglou-Kallmyer, Nina. "Géricault médicale: savoir scientifique et savoir de soi sous la Restauration." In *Naissance de la modernité:mélanges offertes à Jacques Villain*, edited by Henry-Claude Cousseau, Christina Buley-Uribe, and Véronique Mattiussi, 129–40 Paris, France: Editions du Relief, 2009).

Bazin, Germain. *Théodore Géricault: Étude critique, documents et catalogue raisonné*. 7 vols. Paris, France: Wildenstein Institute, 1994.

Bichat, Xavier. *Recherches physiologiques sur la vie et la mort*. Paris, France: Gauthier-Villars, 1955.

Bonnaire, Marcel. "La Création de l'Institut National." In *Procès-verbaux de l'Académie des Beaux-Arts*, edited by Marcel Bonnaire. 3 vols. Paris, France: Armand Colin, 1937.

Carol, Anne. "Le galvanisme et les recherches sur la vie et la mort." In *Physiologie de la veuve: Une histoire médicale de la guillotine*, edited by Anne Carol, 80–97. Seyssel, France: Champ Vallon, 2012.

Clair, Jean. *Crime et Châtiment*. Catalogue publié à l'occasion de l'exposition "Crime et châtiment", Paris, Musée d'Orsay, 16 mars–27 juin 2010. Paris, France: Editions Gallimard, 2010.

Clément, Charles. *Géricault: Étude biographique et critique*. 1867. Reprint, New York: Da Capo Press, 1974.

Comar, Philippe. "Une leçon d'anatomie à l'Ecole des Beaux-arts." In *Figures du corps. Une leçon d'anatomie à l'École des Beaux-Arts*, edited by Philippe Comar, 19–65. Catalog of an exhibition held at the École nationale supérieure des beaux-arts de Paris, Oct. 21, 2008–Jan. 4, 2009. Paris: Beaux-Arts de Paris, les Éditions, 2008.

Courthion, Pierre. *Géricault raconté par lui-même et par ses amis*. Geneva, Switzerland: Pierre Cailler, 1947.

Debord, Jean François. "A propos de quelques dessins anatomiques de Géricault." In *Géricault. Dessins et estampes des collections de l'Ecole des Beaux-Arts*. Paris: ENSBA, 1997.

De Caso, Jacques. "Une cristallisation du romantisme: L'acopie de Théophile Bra d'après *La Révolte du Caire* de Girodet." In *La Sculpture au XIXe siècle: Mélanges pour Anne Pingeot*, edited by Catherine Chevillot and Laure de Margerie, 104–113. Paris, France: Nicolas Chaudun, 2008.

Degueurce, Christophe. *Fragonard Museum. The Ecorchés. The Anatomical Masterworks of Honoré Fragonard*. New York: Blast Books, 2011.

Delaborde, Henri. *Ingres: Sa vie, ses travaux, sa doctrine d'après les notes manuscrites et les lettres du maître*. Paris, France: H. Plon, 1870.

Del Medico, Giuseppe. *Anatomia per uso dei pittori e scultori*. Rome, Italy: Presso Vincenzo Poggioli, 1811.

Eitner, Lorenz. *Géricault, His Life and Works*. London, UK: Orbis, 1983.

Eitner, Lorenz. *Géricault's Raft of the Medusa*. London, UK: Phaidon, 1972.

Ellenberger, Michel. *L'Autre Fragonard: Son oeuvre à l'Ecole Vétérinaire d'Alfort*. Paris, France: Jupilles, 1981.

Émeric David, Toussaint-Bernard. *Recherches sur l'art statuaire considéré chez les anciens et chez les modernes, ou Mémoire sur cette question proposée à l'Institut de France: Quelles ont été les causes de la perfection de la Sculpture antique et quels seroient les moyens d'y atteindre*. Paris, France: Le veuve Nyon, 1805.

Gamelin, Jacques. *Nouveau recueil d'ostéologie et de myologie dessiné d'après nature par Jacques Gamelin de Carcassonne, Professeur de Peinture, de l'Académie de Saint Luc. Pour l'utilité des sciences et des arts, divisé en deux parties. Dédié à M. le baron de Puymaurin, etc.* Toulouse, France: J. F. Desclassan, 1779.

Gautier-d'Agoty, Jacques-Fabien. *Anatomie de la tête, en tableaux imprimés, qui représentent au naturel le Cerveau sous différentes coupes, la distribution des Vaisseaux dans toutes les Parties de la tête, les Organes des Sens, & une partie de la Névrologie; d'après les pièces disséquées & préparées par M. Duverney, Maître en Chirurgie, à Paris, Membre de l'Académie de Chirurgie, & Démonstrateur en Anatomie au Jardin Royal; en Huit Grandes Planches, Dessinées, Peintes, Gravées, & Imprimées en Couleur & Grandeur naturelle, par le sieur Gautier, seul privilégié du Roy pour cet ouvrage; avec des Tables relatives aux Figures. Dédiée au Roy.* Paris, France: Quillan, 1748.

Grigsby, Darcy Grimaldo. *Extremities: Painting Empire in Post-revolutionary France*. New Haven, CT: Yale University Press, 2002.

Guédron, Martial. *La plaie et le couteau: La sensibilité anatomique de Théodore Géricault*. Paris, France: Editions Kimé, 1997.

Guédron, Martial. "L'enseignement de l'anatomie artistique en France et la question de la dissection (XVIIIe–XIXe siècles)." *Les cahiers d'histoire de l'art* 2 (2004): 33–40.

Hannoosh, Michèle, ed. *Eugène Delacroix: Journal (1822–1857)*. 2 vols. London, UK: José Corti, 2009.

Johnson, Dorothy. *Jacques-Louis David: Art in Metamorphosis*. Princeton, NJ: Princeton University Press, 1993.

Johnson, Dorothy, "Anatomie, réalité, idéalité dans l'art français autour de 1800", in *Ecrire les Sciences*, edited by Martial Guédron and Isabelle Laboulais, special issue of *Etudes sur le 18e siècle*, vol 42, (2015): 177–192.

Johnson, Dorothy. "The Body Speaks: Anatomical Narratives in French Enlightenment Sculpture." In *Body Narratives: Motion and Emotion in the French Enlightenment*, edited by Susanna Caviglia, 29–62. Turnhout, Belgium: Brepols, 2017.

Jordanova, Ludmilla. "Medical Mediations: Mind, Body and the Guillotine." *History Workshop* 28, no. 1 (1989): 39–52.

Lemire, Michel. *Artistes et mortels*. Paris, France: Raymond Chabaut, 1990.

Lifchez, Raymond. "Jean-Galbert Salvage and his *Anatomie du gladiateur combattant*: Art and Patronage in Post-Revolutionary France." *Metropolitan Museum Journal* 44 (2009): 163–184.

Monnet, Charles. *Etudes d'anatomie à l'usage des peintres*. Paris, France: Gilles Demarteau, 1774.

Pera, Marcello. *The Ambiguous Frog: The Galvani–Volta Controversy on Animal Electricity*. Princeton, NJ: Princeton University Press, 1992.

Salvage, Jean-Galbert. *Anatomie du Gladiateur combattant, applicable aux beaux-arts ou: Traité des os, des muscles, du mécanisme des mouvemens, des proportions et des caractères du corps humain; ouvrage orné de 22 planches*. Paris, France: Savigny, 1812.

Savigny, Jean Baptiste Henri and Corréard, Alexandre. *Naufrage de la frégate la Méduse, faisant partie de l'expédition du Sénégal en 1816: relation contenant les événemens qui ont eu lieu sur le radeau, dans le désert de Sahara, à Saint-Louis et au camp de Daccard: suivie d'un examen sous les rapports agricoles de la partie occidentale de la côte d'Afrique, depuis le Cap-Blanc jusqu'à l'embouchure de la Gambie*. Paris, France: Hocquet, 1817.

Schmoll Eisenwerth, Josef A. "Géricault sculpteur: a propos de la découverte d'une statuette en plâtre d'un moribond." *Bulletin de la Société de l'Histoire de l'art français* (1973): 319–331.

Shedd, Meredith. "A Neoclassical Connoisseur and his Collection: J.B. Giraud's Museum of Casts at the Place Vendôme." *Gazette des Beaux-Arts* (June 1984): 198–296.

Shedd, Meredith. "Un dialogue entre archéologie et sciences anatomiques: les Recherches sur l'art statuaire d'Émeric-David." In *Le progrès des arts réunis: 1763–1815: mythe culturel, des origines de la Révolution à la fin de l'Empire: Actes du colloque international d'histoire de l'art, Bordeaux, Toulouse, 22–26 mai 1989*, edited by Daniel Rabreau and Bruno Tollon, 345–352. Bordeaux, France: CERCAM, 1992.

Simon, Jonathan. "The Theater of Anatomy: The Anatomical Preparations of Honoré Fragonard." *Eighteenth-Century Studies* 36, no. 1, (2002): 63–80.

Soemmering, Samuel. "Sur le supplice de la guillotine." *Le Magasin encyclopédique* (1er Thermidor, an 2, 1793): 468–477.

Sue, Jean-Joseph. *Élémens d'anatomie à l'usage des peintres, des sculpteurs et des amateurs: ornés de quatorze planches en taille-douce, représentant au naturel tous les os de l'adulte et ceux de l'enfant du premier âge, avec leur explication*. Paris, France: Méquignon, 1788.

Sue, Jean-Joseph. "Opinion de J.J. Sue sur la douleur qui survit à la décolation." *Le Magasin encyclopédique* 4 (1795): 178–189.

Sue, Pierre. *Histoire du galvanisme*. Paris, France: Bernard, 1802.

Wedekind, Gregor and Max Hollein. *Géricault: Images of Life and Death*. Munich, Germany: Hirmer Verlag, 2013.

Williams, Elizabeth. *The Physical and the Moral: Anthropology, Physiology and Philosophical Medicine in France, 1750–1850*. Cambridge, UK: Cambridge University Press, 1994.

Williams, Elizabeth. *A Cultural History of Medical Vitalism in Enlightenment Montpellier.* Burlington, VT: Ashgate, 2003.

"Wreck of the Medusa." *Literary Gazette* 4, no. 177 (June 10, 1820): 380.

Grecian Theory at the Royal Academy: John Flaxman and the Pedagogy of Corporeal Representation

Josh Hainy

Four decades after the founding of the Royal Academy of Arts in London in 1768, the institution established the position of Professor of Sculpture. British sculptor John Flaxman received the honor of filling this new role, which he held until his death in 1826.[1] Professorships in anatomy, architecture, painting, and perspective and geometry had existed since the Academy's inception, but there had not been one for sculpture, although sculptors had enrolled from the start. In fact, Flaxman himself became a student in 1769. Despite lacking a designated professor for their particular medium, sculpture students learned their art form nonetheless. Without someone holding a professorship, however, there were no public lectures—Academy professors had to deliver six per year—in which to present an official sculpture pedagogy. Sir Joshua Reynolds, the first president of the Academy, discussed sculptural principles in his tenth discourse, but his remarks were limited. Thus, when Flaxman addressed his audience for the first time in 1811, he had the added responsibility of formulating the first sculptural curriculum for the Royal Academy.[2] His pedagogical focus placed corporeal idealization at the very heart of British art education, just as Reynolds had done. He did not, however, simply uphold traditional academic principles. Flaxman's pedagogy publicly presented the Academy as an institution that endorsed what he termed 'Grecian theory', which depended on the apprehension of scientific principles—namely, anatomy, geometry, motion, and proportion—and their application to observations from nature in order to render the idealized sculpted human form, following the approach undertaken by Greek sculptors.

Flaxman promoted this so-called Grecian theory in his lectures at the Academy in the hopes of educating a generation of Academy students in their practice of creating perfected works in the manner of Greek sculptors. Students were to uphold the ancients as a model because "the excellence of the Grecian theory was the real foundation of excellent practice."[3] This was the only documented time that he specifically used the term 'Grecian theory' in his lectures, but I will use the terminology when discussing his pedagogy because it best categorizes his theoretical principles. The theory is a synthesis

of information Flaxman gleaned from ancient texts, Early Modern discourses about ancient art, and ancient art itself. Flaxman never completely articulates a definition of this theory; however, the ideas making up his Grecian theory of idealization, and the principles that come from it, recur throughout his lectures, so we may determine the specifics of this theory ourselves. Flaxman's emphasis on a Grecian theory and its scientific principles is the distinguishing feature of his academic pedagogy.

For Flaxman, Grecian theory depended on scientific investigation and visual observation. He frequently presented the narrative that Greek art achieved its characteristic perfect and beautiful forms only when artists utilized science to render the figure. He said in one lecture, "Greek sculpture did not rise to excellence until anatomy, geometry and numbers had enabled the artist to determine his drawing, proportions, and motion then, and not before."[4] Therefore, Flaxman believed that Greek artists did not rely solely on mentally selecting the best examples from the world around them as Reynolds, or even Johann Winckelmann, had supported;[5] rather, they utilized, in conjunction with their superficial observations of the human form, what Flaxman considered the 'sciences'. These sciences provided the underlying principles that aided in the creation of the sculpted body.[6] Applying such principles to the creation of idealized figures was a fundamental part of Flaxman's artistic practice and academic pedagogy.

An essential part of Greek corporeal study, according to Flaxman, was a thorough familiarity with human anatomy—interior as well as exterior. The Academy had always supported some form of anatomical study, but Flaxman stressed the Greek origins of anatomical knowledge.[7] The extent to which Greek artists relied on anatomy was a topic of serious debate around the turn of the nineteenth century, as I discuss later. Flaxman's lectures, therefore, engaged in that discourse. Anatomy was not the only scientific principle Greek artists learned, according to Flaxman. A full understanding of the geometry and proportion of body parts, as well as their range of motion, also informed Greek mastery of the sculpted human figure. Due to this emphasis on theory grounded in scientific principles, the first Professor of Sculpture takes a more empirical approach than the first president of the Academy.

Therefore, as Professor of Sculpture, Flaxman taught a corporeal pedagogy focused on replicating scientific principles utilized by the Greeks.[8] The study of anatomy, geometry, and the like, in addition to the observation and copying of classical sculpture and life models, provided Academy students with the tools to render flesh and visible muscle in such a way that it went beyond any specific example in nature. However, the prioritizing of the study of ancient sculptural examples in conjunction with that of the living model was not new to art academic training, nor was anatomical study. Although Flaxman's pedagogy seems to follow academic tradition, it was by emphasizing Greek art's reliance on scientific principles to visualize a body that was at once anatomically truthful and of universal beauty that Flaxman positioned the Royal Academy as the inheritor of Greek artistic tradition.

Greek art figured prominently in efforts by British artists to develop a distinctive artistic style. The Royal Academy was founded to cultivate the national taste and the skill of native British artists, both of which were perceived as lacking for much of the eighteenth century. Late eighteenth-century attempts to formulate a British school of sculpture promoted the aesthetics of Greek examples. The simplicity of Greek sculpture was the goal of British sculptors, including Flaxman, intended to contrast continental trends, which British artists and critics considered to be imitative of Roman works, as has been discussed by Matthew Craske.[9] But Flaxman's professorial lectures advocated more than merely imitating the surface simplicity of Greek sculpture. He developed a theory that established principles, which in turn led to a studio practice that, he believed, replicated that of Greek sculptors. Flaxman refashioned academic teachings by incorporating a theory and practice of Greek methods in a sincere effort to (re)make the Academy into an institution producing British art in the tradition of the ancient Greeks.[10] As he noted in the lecture entitled "Modern Sculpture,"

Thus the student of the present day has the most satisfactory assurance that the ancient arts of Greece were carried to perfection, and the modern arts of Italy restored, by the same system of education established in this institution; and we may with certainty predict, that a race of painters and sculptors will be produced by our Royal Academy, whose merits will secure the admiration of their own time, and of future ages, as effectually as their great predecessors have done.[11]

His pedagogy cast the Academy as a new center of artistic achievement through the emulation of Greek theory and practice.

A fundamental aspect of Flaxman's teaching at the Academy was the mastery of the human body. His instruction focused on corporeal analysis because he considered the human form "the great and principal object of study in the arts of design."[12] To assist in obtaining the necessary knowledge to depict the body, the Professor of Sculpture advised students to study ancient sculptural and living models.[13] The Greeks had supposedly mastered the representation of the idealized human form by taking numerous corporeal observations and selecting the best examples of each body part to construct the perfect figure.[14] Flaxman continues this line of thinking by making idealization, resulting from abstracting observations made from nature (but executed with scientific principles), the ultimate goal of artistic representations of the human form.

The prioritizing of those two pedagogical models—living and sculptural—was not foreign to the Academy. Reynolds and Academy professors espoused similar advice in their lectures; Flaxman's pedagogy did not offer new guidance in that respect.[15] In fact, these models of corporeal study had been common since the Renaissance.[16] Flaxman, then, followed a long tradition of art instruction that focused on the examination and representation of the body. Although Flaxman reiterated such established formulae as the first Professor of Sculpture, his specific approach warrants further investigation.

His ten posthumously published lectures offer insight into his theories and principles of sculpture at the Academy, but scholars have only recently begun to examine the ideas expressed in them.[17]

In a rare explanation of his educational philosophy, Flaxman divides education into two parts—the theoretical and the practical:

Theory supplies our minds with principles of science, from which rules are deduced for our future practice, and indeed, the latter must be considered as immediately succeeding the former by natural connexion and certain consequence, rather than as distinct and independent of theory.[18]

It is clear from this passage that he considered theory the essential part of art education, for it provides the foundation for the principles, rules, and practice of art making. The principles not only clarify theory, but also furnish the rules that provided artists with parameters in the creation of their own works. For a theory to be implemented in practice, students needed to master its principles and rules. Although he acknowledged that the two categories of education, theoretical and practical, do not exist independently, Flaxman prioritizes theory above practice. Thus, the foundation of Flaxman's pedagogy in his lectures relies on not telling students *how to make art*, but, rather, the theoretical underpinnings of *how to think about making art*.

An example from Flaxman's lectures shows the connection between theory and principles. To explain how Greek sculptors rendered their figures with idealized bodies (the product of applied Grecian theory in practice), Flaxman continually stressed one principle: Greek sculptors' knowledge of, and reliance on, anatomy. He believed that Greek artists gained extensive anatomical knowledge through examining the body's more superficial anatomy as well as from information from ancient medical writers such as Hippocrates and Alexandrian physicians of the fourth century BCE.[19] Informed by discussions of interior anatomical instruction in such treatises, sculptors expanded their knowledge from the visible exterior to the unseen interior, which informed their attempts to render the perfected human form.[20] The principle of anatomical study, then, benefited artists in their sculptural practice. By articulating the principles and rules of Greek art, Flaxman developed a theoretical model for students to follow. Reynolds, too, had focused on principles of sculpture in one of his lectures to the Academy. His tenth discourse provides insight into how the Academy taught basic principles germane to the practice of sculpture before the establishment of the Professorship.[21] Reynolds, however, was not a sculptor, nor was he trying to provide detailed instructions for sculpture students. Instead, Reynolds categorized sculpture as a simpler and more uniform medium than painting before outlining its basic principles.[22]

The two main sculptural principles of concern for Reynolds are form and character—the former conveying the latter.[23] Form, or the basic shape or outline of the figures, is the foundational principle for a sculpture, a point Flaxman himself iterates.[24] At the time, it was understood that sculpture concerned itself predominantly with the representation of the human figure. Since

form and figure were one, it followed that the body, not the face, exhibited character. Thus, the modelling of the human body in a way that maintained the connection between form and character, that is, between anatomical perfection and high moral intellect, was paramount.[25] Because sculpture was 'simpler' than painting, sculptors executed figures in one style only, according to Reynolds.[26] He most likely meant the style of ancient artists, for he upheld antique sculpture as an appropriate model of idealized bodies in an earlier lecture.[27] Reynolds only addressed the sculptures, the final products, rather than the principles that informed Greek artistic practice. Therefore, one point of Reynolds's discourse was to present students with a theoretical justification for the role of ancient statuary (or casts of) in academic instruction.

Flaxman also encouraged students to draw after ancient sculptural models (including casts) to comprehend better the human body. Since many of the great works of antiquity were abroad or in private collections, the Academy acquired plaster casts of canonical sculptures for the students to examine. Flaxman talked about the importance of those plaster casts in his introductory lecture.[28] He felt that students should observe them so the works might "imprint on the younger student a strong sense of the excellence which may be transplanted into his own mind from such examples."[29] The casts were the first things students studied after enrolling. They had to prove their aptitude at sketching ancient sculpture before advancing to the next part of their education. Although drawing after plaster casts had long been an important activity for students in art academies, by the second and third decade of the nineteenth century, criticisms about the practice had arisen.[30] Flaxman, however, considered their pedagogical role so vital to artistic training that he petitioned the academy on more than one occasion to purchase additional casts for the Academy.[31] But the study of classical works was only one part of the students' study of the human body.

From its inception, the Royal Academy required students to draw the human form. To develop that skill, the Academy established a life drawing school for students.[32] Sketching directly from a live nude (male) model received mention in Reynolds's first discourse as a distinguishing feature of the Academy. As Andrew Graciano points out in Chapter 1, other European institutions certainly required the observation of a life model, but Reynolds criticized their encouragement of students to make corrections "according to their vague and uncertain ideas of beauty, and make a drawing rather of what they think the figure ought to be, than of what it appears."[33] Instead, the president advised students to replicate exactly what they saw in front of them. This method taught students precision and to be aware of the specificity of the model. We must keep in mind that Reynolds's advice here was for those in the early stages of their education.[34] More advanced pupils were to move beyond direct corporeal depictions. Direct imitation was never to appear in a finished work.[35]

As is well known, Reynolds advised skilled students to take what they had learned through observation and repeated imitation and generalize (his term

for 'idealize') forms in the final creative act of emulation. To briefly summa-
rize Reynolds's theory of generalization, the careful observation of numerous
figures enabled the more advanced student to identify central forms free of
individual features and deformities that artists then used when executing
their works. It was, as has been mentioned, an adaptation of conventional
Classical art theory distilled through Bellori and Winckelmann, among others.
Mastery of the human form through close examination of the living model
was fundamental for Reynolds; but in the end, artists had to perfect what they
saw in front of them. Direct copying of a model leads theoretically to the deci-
sive emulation of modelled principles through other ideal forms. Learning to
identify these ideal forms required time, but he offered ancient sculptures as a
model that could accelerate the process.[36] Such aesthetic theory was essential
to academic training. Before they could idealize, however, students had to
study the human body through observation as well as anatomical instruction.

The anatomical lessons that the Academy provided helped students under-
stand the physical relations between the exteriority and the interiority of the
body. By the latter half of the eighteenth century, many art academies had
recognized the necessity of anatomical study in the training of young artists.[37]
To aid in corporeal instruction, the Academy named the respected anatomist
and physician William Hunter as its first Professor of Anatomy.

Hunter believed an artist had to study the body's individual parts as well
as their structural relation to one another. His method for anatomical instruc-
tion, therefore, depended on a systematic study of the body. When lecturing,
he isolated parts of the body to discuss their functions.[38] For example, as
Andrew Graciano points out in the present volume, Johann Zoffany's *William
Hunter, Lecturing* (Plate 1.2) shows its subject lecturing to the academicians
specifically about the shoulder, including the scapula and clavicle. However,
he did not treat every system with equal importance. Only those he thought
an artist truly needed to know received emphasis. As is typical for advice to
artists regarding anatomical study, Hunter stressed knowledge of the bones
and the muscles: the bones for their structural importance and the muscles
for their role in movement.[39] He even used an assortment of pedagogical
tools, such as diagrams, skeletons, *écorché* figures, anatomical drawings, and
live models during his lectures to provide his students with visual models
of human anatomy.[40] He also advocated dissection, bringing cadavers to the
Academy for students to observe the practice. The practical difficulties of
acquiring bodies were overcome easily enough through unethical and illegal
acts and were only ameliorated by the Anatomy Act of 1832, although ethical
and legal challenges persisted.[41]

Hunter believed that students should use the anatomical knowledge they
gained through direct observation to copy nature faithfully. For Hunter, the
closer an artist got to recording nature, the more striking the work would be.
Hunter warned the students not to manipulate corporeal proportions because
doing so distorted the appearance of nature and its pleasing effects.[42] This
position challenged Reynolds's promotion of generalizing natural forms in

completed works based on external observation. While both Hunter and Reynolds supported direct observation of the human body, they differed in the degree to which an artist should adhere to it.

Flaxman continued the practice of corporeal study by advocating a thorough anatomical understanding of the body in his lectures:

The human figure cannot be represented without an accurate acquaintance with the structure of the bones, muscles, tendons, veins, and nerves, together with a knowledge of the several organs which contribute their functions to the continuation of life whether the subject is in action or at rest. This information is generally understood to be gained by the science of anatomy.[43]

Artists must learn about the parts of the body through individual investigation as well as in relation to one another.[44] Flaxman also stressed learning the geometry of bones (their shapes and proportional relations), movement of joints, and extension and contraction in muscles. Together, they helped artists comprehend the body's interior and how it affects the appearance of its exterior.[45] Flaxman's sculptural pedagogy at the Academy thus stressed familiarity with exterior and interior corporeal elements.

Flaxman's anatomical drawings reveal that his artistic practice coincided with his pedagogy. His drawing of a flayed torso demonstrates his study of the various parts of the body (Plate 3.1). Flaxman most likely drew from either a cadaver or an *écorché* figure in order to gain greater understanding of the muscles ordinarily covered by skin on a live model. Although he represents an anterior view of the right arm and torso, his more prominent application of red chalk on the exposed muscles of the arm suggests that he was concerned with that particular area. Muscles on the torso do have articulation, but only in basic outline. Striations formed by the chalk give texture and depth to the biceps and the brachioradialis, contrasting with the flatness of the oblique and pectoral muscles. In the drawing, now in the collection of the Royal Academy, Flaxman concentrates on only one segment of the body in order to examine it in detail. The confident, sharp precision with which he draws reveals a close, scientific observation of anatomical detail. Flaxman delineated the body demonstrating a meticulous study of its *interior* anatomy, just as he advocated in his lectures.

After becoming a full Academician in 1800, Flaxman's actions to increase students' familiarity with corporeal forms further evidence the importance he placed on anatomical study. By that time, anatomical learning had become less prominent at the Royal Academy. As Martin Postle noted, following the death of Hunter in 1783, the Academy became decreasingly invested in anatomical training, especially in the use of dissection for artistic education.[46] Anthony Carlisle, Professor of Anatomy at the Academy from 1808 to 1824, thought that, while anatomical knowledge did have some use for artists, it was not essential. Art was to "shew nature under the most interesting and graceful forms, always concealing her internal machinery."[47] Carlisle's ideas about corporeal instruction differed from those of the concurrent Professor of Sculpture. The Hunter–Reynolds paradigm had reversed.

In contrast, Flaxman acted to reinforce anatomy as central for artistic edu-cation. Before his appointment as Professor of Sculpture, Flaxman worked with John Sheldon, Hunter's immediate successor as Professor of Anatomy, to reform anatomical instruction at the Academy in order for it to be more accessible to the students.[48] What Flaxman did with these reforms, which Anne Carol Darlington and Rhodri Windsor-Liscombe have discussed, was close the spatial gap between life drawing class and anatomical instruction that had existed despite both having been part of the curriculum since the institution's inception. He requested anatomical models be placed in the life drawing classroom to help students understand the body more clearly. In the past, Hunter's lectures, where he utilized anatomical aids and live models to compare inner and outer corporeal features, happened only on scheduled days. Life drawing classes, on the other hand, took place daily.[49] Without ana-tomical reminders, it would be easy for students to focus on the exterior of the model at the expense of the skeleton and muscles underneath. To remedy this situation, Flaxman donated visual aids for the life drawing room in 1809. Now, in addition to the live model in front of them, a skeleton, painted tables of muscles, and anatomical casts taken from life—including *écorchés*—pro-vided visual reminders of what existed beneath the skin of the live model.[50] Flaxman's provision of anatomical models, then, brought a version of ana-tomical study back into prominence at the institution that students could incorporate into their artistic practice.

While Flaxman's focus on anatomical study revived a lagging aspect of academic tradition, there was another, more central, reason for emphasizing corporeal knowledge: his belief that the Greeks learned human anatomy. A central principle for Flaxman's discussion of the Grecian theory, as developed in his lecture "On Science," is the proposition that Greek artists possessed ana-tomical knowledge. Citing Pliny, Flaxman determined that the first depictions of tendons and veins in Greek sculpture appeared right after Hippocrates and other physicians active during the time of Pericles shared their corporeal discoveries.[51] Before that period, Greek anatomical knowledge was scant and offered no real help for artists. Any corporeal information artists did possess, Flaxman claimed, came from superficial observation of living bodies, physicians, dead bodies on battlefields, animals used for sacrifice or food, or animals dissected by philosophers, but these sources led only to simple anatomical depictions. It was not until the investigations of Hippocrates, who Flaxman was certain had performed dissections on body parts, that artists began incorporating more anatomical detail and accuracy in their works.[52] Heinrich von Staden's discussion of dissection in ancient Greece, on the other hand, mentions that Hippocrates mostly performed incisions for blood-letting and that Herophilus of Chalcedon and Erasistratus, active in Alexandria in the third century BCE, were the only ancients to perform dissections on human cadavers.[53] Assertions made by Flaxman were not unsubstantiated, accord-ing to the Professor of Sculpture, for he reminded his audience that he relied on ancient texts to support beliefs about Hippocrates and Greek anatomical

knowledge in general.[54] Regardless, I do not intend here to analyze the accu-
racy of Flaxman's historical knowledge, but rather to focus on the fact that
Flaxman believed and promoted the narrative that ancient anatomical dissection
brought advancement in Greek art.

In Flaxman's account, Greek artists utilized anatomical information from
medical investigation to supplement their understanding of corporeal struc-
ture and to assist in their rendering of the human form. According to Flaxman,
Hippocrates's writings discussed the body with a simplicity, elegance, and
greatness that he also found in sculpture from the same period, specifically
in the works of Phidias.[55] Texts disseminated anatomical information, and
Flaxman asserted that artists were informed by those writings. The knowledge
found in texts contributed to the advancement of art by providing sculptors
with more extensive anatomical understanding.

For example, Flaxman described a statue of a young Hercules from the
period after Alexander the Great in terms of its anatomical structure:

> The acromion is distinctly seen, and the rounded top of the humerus is indicated
> in the deltoides, which is strongly divided from the muscles of the arm beneath.
> The protuberance of the triceps is bold; the biceps is bold, broad, and squared
> towards the bottom. The bones which form the elbow are carefully distinguished;
> the head of the ulna in the middle, on the inside of the lower point of the
> humerus, and on the outside; the lower condyle or swelling of the same bone at
> its union with the radius.[56]

The sculpture, which Flaxman attributed to Lysippus, displays an intimate
knowledge of human anatomy. (Flaxman demonstrated his familiarity with
anatomy by identifying the corporeal features with proper terminology.) His
description likewise displays Greek interest in corporeal geometry by noting
the shapes of the parts: the rounded head of the humerus or the square biceps.
Comprehending the basic shape of anatomical features is what Flaxman
meant by the principle of geometry when mentioning it in the context of
the Grecian theory. A sculpture with this level of corporeal detail could only
result from familiarity with anatomical forms, Flaxman believed. While the
bones and muscles he mentions are visible through superficial observation,
the way they relate to one another evidences a grasp of anatomy most likely
augmented by deeper study.[57] A grounding in corporeal study, including
information gleaned from texts, he reasoned, allowed Greek artists to create
their figures with exact anatomical detail.[58] He does not seem to consider how
the artists might have accessed those texts. Instead, he takes it as fact that
they did.[59] But his strong conviction that Greek sculptors had an extensive
anatomical knowledge is part of contemporary discourses about Greek artists
and anatomy.

Flaxman's opinion that Greek artists studied anatomy to create their
sculptures placed him amid an important discourse of the period. With the
increased role of classical art as the model for artists in the second half of the
eighteenth century, the exact process with which the ancients created sculpted
bodies became a topic of intense debate. One side maintained that ancient

artists relied solely on idealization to create their figures, a type of Platonic exercise.[60] This approach was called the *beau idéal*. The other side—the *beau réel*—argued that the ancients looked directly to nature as their model, and its followers supported the belief that the ancients participated in empirical investigations of the material world, specifically human anatomy. It is important to note that the two sides were divided about the level and source of ancient artists' corporeal knowledge.[61]

The *beau idéal* initially avoided discussions of anatomy, preferring to envision Greek artists relying on their intellect to create ideal forms based on observations of the body's surface, which Greek artists could have easily studied due to a temperate climate and an interest in athleticism, an idea advanced by Winckelmann.[62] This belief put them at odds with the practitioners of the *beau réel*, who claimed that intentional anatomical study was a fundamental part of ancient renderings of the human body.[63] To support his argument that Greek artists had extensive anatomical knowledge, Jean-Galbert Salvage published anatomized representations of the *Borghese Gladiator*.[64] Removing the flesh through visual flaying, Salvage attempted to prove that the ancient sculptor had a learned understanding of muscles.[65] Salvage's anatomization of classical sculptures evidenced and reinforced a close link between anatomical knowledge and the modeling of ancient art. Flaxman did something similar when he described the sculpture of the young Hercules. While he might not have used the exact terminology utilized by French theoreticians, Flaxman engaged with similar ideas, as evinced in his verbal dissection of a classical statue for the benefit of Academy students and in his own drawings.

Other individuals defended the anatomical knowledge of Greek artists. The Scottish anatomist Charles Bell considered ancient sculptures to be so anatomically informed that he used the main figure of the *Laocoön* group to counter Winckelmann's famous interpretation of the Trojan priest. By consulting the position of the Laocoon's body, Bell determined that the Trojan could not vocalize his pain because his raised chest and inflated throat would hinder the production of sound.[66] Therefore, Laocoön's expression has less to do with Winckelmann's conception of the priest suffering in silence—a visual example of Greek art's supposed "noble simplicity and quiet grandeur"—and more to do with human anatomy.[67]

Therefore, supporters of the *beau réel* found evidence of Greek anatomical knowledge in ancient sculptures themselves. The perception of an adroit handling of anatomy in Greek sculpture gained support after Lord Elgin first publicly exhibited the Parthenon Marbles in London in 1807. Viewers of these sculptures now experienced Greek art directly, not via Roman replicas or plaster casts. The high degree of anatomical naturalism exhibited in them captivated viewers.[68] For Flaxman, the Parthenon sculptures confirmed that the Greeks had anatomical knowledge, which aided in the creation of their sculptures. When called before the Select Committee of the House of Commons to testify in 1816 whether or not the British government should purchase the

marbles, Flaxman said, "they are as perfect nature as it is possible to put into the compass of the marble in which they are executed."[69] He clearly thought highly of the statues and supported their purchase.[70]

It was the rendering of the human form that set the Parthenon Marbles apart from many ancient works in Flaxman's estimation. His testimony mentioned the simplified manner with which the artists articulated the anatomy. He asserted that the anatomical information "in" the sculptures aligned perfectly with ancient writers who discussed anatomy, such as Hippocrates and Galen—a point also expressed in his lectures.[71] In fact, his responses to the committee on the use of anatomy in the Parthenon Marbles reads like one of his lectures, indicating that his testimony iterated and confirmed in a circular logic his academic sculptural pedagogy, which emphasized the scientific principle of anatomical study.

In addition to the role of anatomy in his educational theory, another core principle of Flaxman's curriculum is the examination of the movements of various body parts. He cited Archimedes and Vitruvius as written sources that evince the implementation of science by Greek artists in the rendering of the human figure.[72] Ancient artists who had a grasp of geometry and arithmetic used it to conceive how the body moved or stayed in balance. Flaxman's own analysis of bodily motion derived partly from observation and partly from information gathered from various treatises on corporeal motion. His formulation of locomotive principles relied on Early Modern sources, specifically investigations of motion by Leonardo da Vinci and Giovanni Alfonso Borelli. Flaxman, then, followed the model of the Greeks by complementing visual observation with textual learning.

Some of his personal drawings specifically diagram corporeal motion. He later used them to visualize the discussion of bodily motion in his public addresses to the Academy. *Extent of Motion in the Skeleton*, a print after a drawing by Flaxman, illustrated the published version of his lectures (Figure 3.1).[73] The image demonstrates how the spine and selected joints move. Flaxman plotted the range of motion with dotted lines. Line "C" charts the course of the arm as it travels from the side of the figure to its highest extension. "A" shows the angle of the spine as it moves laterally. The inclusion of only the head of the femur informs the viewer of the source of movement for "D" without having to represent the entire bone. Flaxman used the information in this image to mark how specific parts move independently and, simultaneously, in relation to one another.

The sculptor further explored corporeal motion by analyzing body positions in different activities relative to its center of gravity, a concept fundamental to depicting motion. For students to learn locomotive principles, Flaxman not only verbally described these movements in his lectures, but also used drawings to illustrate his points, as seen in the print published with his lectures, *Balance: Preparing to Run, Running, and Striking* (Figure 3.2). The top figure demonstrates balance in a body about to run. Flaxman described the image in this way: "Preparing to run is throwing the balance beyond the standing

3.1 John Flaxman
(after), *Extent
of Motion in the
Skeleton*, Plate
XXVII in *Lectures
on Sculpture, as
Delivered before
the President and
Members of the
Royal Academy*,
1865, print,
175 mm × 109 mm.
Public domain.

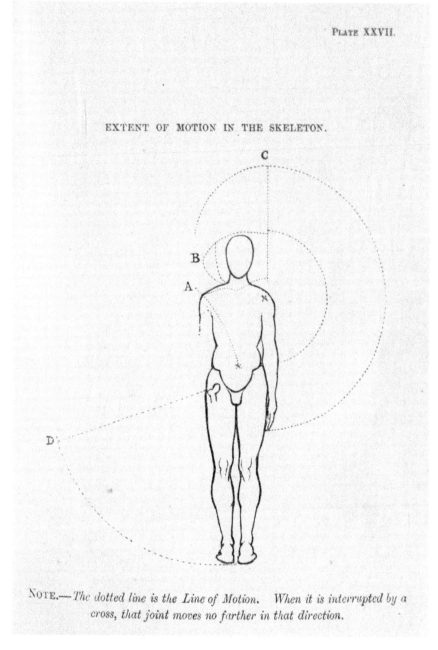

PLATE XXVII.

EXTENT OF MOTION IN THE SKELETON.

NOTE.—*The dotted line is the Line of Motion. When it is interrupted by a
cross, that joint moves no farther in that direction.*

3.1 John Flaxman (after), *Extent of Motion in the Skeleton*, Plate XXVII in *Lectures on Sculpture, as Delivered before the President and Members of the Royal Academy*, 1865, print, 175 mm × 109 mm. Public domain.

foot."[74] He explained the change in the center of gravity for a figure striking as follows: "When the action begins, the figure is thrown back to give force to the blow, and springs forward to the lighter line when the fall of the blow ends the actions."[75] Viewers are able to identify the movement of a particular figure by how the artist positions the body, keeping the center of gravity in mind. Initial movement studies, such as *Extent of the Motion in Skeleton*, certainly

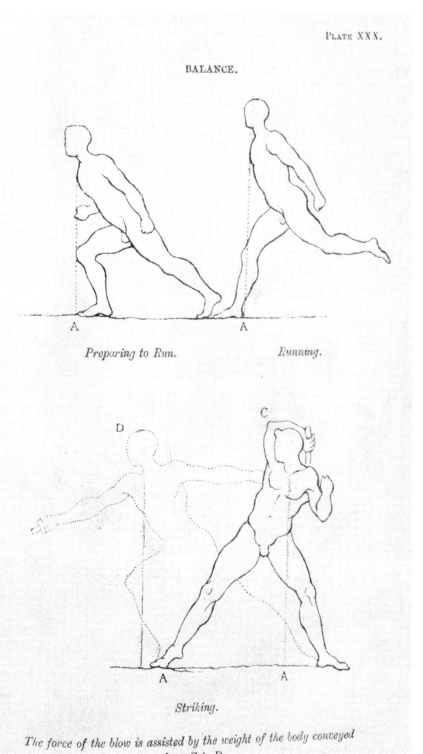

3.2 John Flaxman (after), *Balance: Preparing to Run, Running, and Striking*, Plate XXX in *Lectures on Sculpture, as Delivered before the President and Members of the Royal Academy*, 1865, print, 175 mm × 109 mm. Public domain.

acted as the foundation for these more complex actions. Knowing how the body moves enabled artists to position their figures in anatomically logical ways.

Proportion was another scientific principle that Flaxman determined Greek artists utilized in their works. Observation and measurements of actual bodies led artists to identify a set of general proportions that aided in the construction of the sculpted form.[76] Proportions, in other words, formed rules that guided sculptors. This system of proportions used body parts as basic units of measure. For example, Flaxman noted that the Greeks made figures eight heads high.[77] Other examples of corporeal proportions listed by Flaxman include the shoulders being two heads in the width; the loins one head and one nose (or five noses) in breadth; and the glutes one head deep.[78] Flaxman told students to employ the proportions described in Vitruvius's writings, which the Latin writer had gathered from treatises by Greek artists. Such proportions of ancient sculptures provided modern sculptors the measurements to which they should adhere.

Professor of Painting Henry Fuseli had previously addressed Greek proportions in one of his lectures, but he determined that the ones required for sculpture would not work in painting. If a painter were to use sculptural proportions, the figures "would appear meagre and scanty on a flat surface, in comparison of the mass they circumscribe in perspective."[79] While Flaxman stressed the importance of proportional rules in rendering the human form, Fuseli considered painters to have greater freedom in corporeal representation.[80] Flaxman, however, recognized that in sculpture, "the ancients varied the proportions only according to the character and age of the person."[81] But such differences in rendering the human form, particularly in regards to sex, still had their origin in observed proportions and geometry, as he mentioned in a lecture entitled "Beauty." Male hands are square while female hands are rounded.[82] Note that these variations relate to geometric shapes. While there must be modifications for different kinds of figures, Flaxman nevertheless asserted that the standards established by the ancients still work as an overall general model. Thus, the principle of proportion aided in artistic practice.

Informed by anatomy, geometry, motion, and proportions, Greek artists took the next step and used those principles to help them execute bodies that were free from defects or deformities, thus creating beautiful sculptures. In Flaxman's context, beautiful equates to ideal forms. His lecture "Beauty" provides the clearest exploration of the topic. In their composing of idealized figures, Flaxman noted that Greek sculptors utilized "a choice selection of those simple geometrical forms which in bone, muscle and tendon are strongest, most efficient and elegant."[83] Once Greek artists learned anatomical features, they began to recognize the essence of those parts in their most perfect manifestation. These geometrical forms were simplifications, free from particulars, although still rooted in anatomical knowledge. Greek idealization was a process that came from diligent study, endowing artists with the ability to execute perfected forms based on direct observation.[84]

It is important to note that Flaxman believed Greek artists learned how to select their examples for idealization by observing nature. The numerous examples of beautiful bodies supposedly existing in ancient Greece—a vision of antiquity that had (re)gained traction after Winckelmann wrote about it in his famous treatises on ancient art in the second half of the eighteenth century—offered Greek artists plenty of superior forms to study.[85] Exercise had developed these bodies, so the ones on display exhibited power and beauty. The pleasant climate meant that the Greeks only wore light clothing, thus presenting more of the human form for contemplation, as has been mentioned.[86] From these quotidian models came the sculptures that Flaxman believed were proof that the ancients had copied nature rationally and justly.[87] Observable phenomena in nature, then, played an important role in Flaxman's formulation of Grecian theory and directed artistic practice, both the one he presented to the Academy's students and the one he undertook in his own work, as we have seen. Flaxman is not typically associated with studying from nature due to dominance of ideal forms in his oeuvre, especially those that emphasize linear contour, but his personal drawings demonstrate that nature and anatomy were vital components of his artistic practice.[88]

While the study of nature is a necessary pedagogical element of his artistic practice, idealization, a core tenet of the Academy, Greek art, and Neoclassicism, was the ultimate goal for Flaxman. In spite of the great value he placed on the naturalism of the Parthenon Marbles, he could not rank them above the *Apollo Belvedere* because that statue was the best example of ancient idealization, although he acknowledged it was a copy.[89] While Flaxman had great respect for the anatomy of the Parthenon marbles, his training and investment in a Grecian theory of idealized forms required him to acknowledge that ideal beauty was still the standard to which sculpture—ancient and modern—should be held. To shape that process of idealization, though, Flaxman relied on empirical data, as I have demonstrated.

The utilization of scientific principles in the creation of ideal sculptures reflects the concessions that each side of the debate about Greek anatomical knowledge had to make. The *beau idéal* realized that naturalism appears in the works of the Greeks, while the *beau réel* acknowledged that there is a certain level of idealization in ancient art.[90] These compromises created a situation where classical bodies are neither sole products of the artist's intellect nor exact depictions of nature, but the integration of natural observation and idealization, which is what Flaxman said the greatest of all Greek sculptors, Phidias, had done. While artists after Alexander the Great had greater skill in articulating anatomical details (remember the findings of Herophilus and Erasistratus aided artists in this period), Flaxman considered works from the time of Phidias as the most perfect manifestation of the human form. That is when artists included anatomical details, but they had been simplified to their essence after observation and rational inquiry.[91] The Greeks had originally found the compromise between ideal and real that Flaxman's contemporaries had been debating. This synthesis of the two sides at the heart of the pedagogy

Flaxman advanced as Professor of Sculpture had its roots in Greek theory, principles, and practice.[92]

Scientific principles could even be extended, at least in Flaxman's estimation, to include a connection between Platonic philosophy and the quality of art. The best periods of art—whether fifth-century BCE Athens or the Italian Renaissance—occurred when the ideas of Plato flourished or underwent a revival.[93] Plato's philosophy focuses on the beautiful and its characteristics, so it makes sense that artists would be more interested in thinking about and depicting ideal beauty, since the role of art was not to imitate nature, but to perfect it. By referencing in his lectures a kind of Platonic philosophy in conjunction with other scientific principles, Flaxman envisioned Academy sculpture students reviving the practices of Greek artists to create works embodying and modelling the interior and exterior, formal and moral, and natural and ideal qualities of antiquity.

From the very beginning of his tenure as Professor of Sculpture, Flaxman advocated practices that he had learned as a student and developed as an artist. Although he continued what Postle called "an idealized Reynoldsian perspective,"[94] which preferred ancient models over contemporary ones, we have seen that Flaxman presumed and emphasized the ancients' use of scientific principles in the designing of their sculpture. Reynolds had endorsed a system where students learned to abstract qualities from objects in order to create the idealized body, but Flaxman specifically located idealization in the Greek's reliance on science. Therefore, Flaxman wanted students to use their anatomical investigations and other scientific knowledge to inform their art. The Professor of Sculpture, then, offered a more quantifiable approach—a rational logic—in emulating the idealization of his ancient models. By emphasizing the Greek origins of his pedagogy, Flaxman cast the Royal Academy as inheritor and reviver of the Greek artistic tradition.

Notes

1 Flaxman explained the need for the position in his initial address: "but as the study of Sculpture was at that time confined within narrow limits, so the appointment of a Professorship in that art [sculpture] was not required, until the increasing taste of the country had given great popularity to the art itself, and native achievements had called on the powers of native Sculpture to celebrate British Heroes and Patriots." Flaxman (1838), 17.

2 In contrast, Reynolds and Professors of Painting such as Henry Fuseli and James Barry had expounded on the nature of painting in their lectures, so the principles of painting, as endorsed publicly by the Academy would have been familiar. See Reynolds (1997); Fuseli (1831); Barry (1809). Fuseli took over from Barry as Professor of Painting in 1799, when Barry was expelled from the institution.

3 Flaxman (1838), 109.

4 Flaxman (1838), 103.

5 Giovanni Bellori's notion of 'scattered beauties' is also relevant in this context viz. selection and certainly informed both Winckelmann's and Reynolds's thoughts on the matter. See Bellori, *Idea del pittore, del sculptore, e del architetto* (1672), excerpt reprinted in translation in Harrison, Wood, and Gaiger (2000), 96–101.

6 "The Greeks were enabled to represent the figure with precision, boldness, and character, from their general knowledge of its internal structure and parts, the harmony of its proportions, and the laws of its mechanical motion." Flaxman (1838), 108–109.

7 Attempts by earlier artists from Egypt to represent the human form had some demonstration of principles, as Flaxman noted, but their articulation of corporeal parts lack anatomical knowledge. The same holds true for early Greek art. Flaxman (1838), 61, 71.

8 "Such general hints concerning science, employed by the ancients in painting and sculpture, may assist the young artist in forming principles for the course of his studies, and precede the investigation of the nature and qualities of beauty." Flaxman (1838), 122.

9 Craske (2006), 25–45.

10 Flaxman's interest in using Greek art to present Great Britain as the inheritor of ancient Greece, both artistically and politically, can be seen in *Britannia Triumphant*, a proposed design from 1799 for a naval monument on Greenwich Hill. Flaxman published a pamphlet in the same year to explain his concept, and William Blake engraved Flaxman's design for the pamphlet. A plaster model of the sculpture, shown in the 1801 Royal Academy Exhibition, is now in the collection of the Sir John Soane Museum. He designed the colossal marble statue to look like the statue of Athena on the Athenian Acropolis. By envisioning a statue that emulated a famous work from antiquity, Flaxman intended to show that British works could reach the level of Greek art. The association made between Athena watching over Athens, the center of an imperial power, and Britannia at the heart of British imperial rule, would have symbolically made London the new Athens. In the end, however, the project was not completed.

11 Flaxman (1838), 238–239.

12 Flaxman (1838), 102.

13 Flaxman's introductory lecture reinforces the importance of ancient sculpture in art education. He thanks George III and the Prince Regent for their generous gifts of plaster casts of works from antiquity, which he proceeds to list and describe. Flaxman (1838), 24–29.

14 This approach to idealization has its origins in antiquity. For example, an account goes that the painter Zeuxis took the best features from different women and brought them together to compose his image of Helen. See also note 5.

15 Reynolds encouraged students to study the ancients because "being indefatigable in the school of nature, have left models of that perfect form behind them." Reynolds (1997), 45.

16 For a discussions of art academies from the formation of the *Campagnia ed Accademia del Disegno* in Florence in the early 1560s to the early nineteenth century, see Boschloo, Hendrikse, Smit, and van der Sman (1989).

17 The response to his lectures has been largely critical. William Hazlitt (1933, Vol. 14: 338) reviewed the lectures when first published in 1829. While noting they

are good for directing the student, he doubts "whether there is much in them that is likely to interest the public. They may be characterised as the work of a sculptor by profession—dry and hard; a meagre outline, without colouring or adventitious ornament." Margaret Whinney (1988, 344) finds them dull and the ideas confused, but offers minimal analysis. Other scholars have taken a less critical tone. Irwin (1979, 204–215) summarizes the lectures with a brief commentary, but does not apply them to the analysis of any of his works. Bindman (2013, 9–16) examines the connection between Flaxman's use of line and meanings it can convey as discussed in his Academy lectures.

18 Flaxman (1838), 19.

19 While Flaxman does reference Galen as evidence of Greek anatomical knowledge, Galen's texts date from the Roman Empire, and therefore would not have informed the fifth- and fourth-century BCE sculptors that Flaxman discusses in his history of Greek sculpture.

20 Flaxman (1838), 108–109, 235.

21 For a brief analysis of Reynolds's "Discourse X," see Craske (2006), 38ff.

22 Reynolds (1997), 182–188. For example, Reynolds tells sculptors not to detach drapery from the figure, a particular fault of the Italian artist Gian Lorenzo Bernini, or to employ perspective in bas-relief.

23 Flaxman also sees the two art forms joined in general principles. Flaxman (1838), 99.

24 Flaxman (1838), 31.

25 Reynolds noted how the figures in the *Laocoön* convey the pain they experience not through their faces (he acknowledged they emote more than any other ancient work) but rather through the reactions of their bodies. Reynolds (1997), 180. He echoes here Winckelmann (1765, 30–32), who talked about the "noble simplicity and quiet grandeur" of *Laocoön*'s gesture and expression. Winckelmann connected the tranquil pose to Laocoön's ennobled soul. The relationship of exterior perfection and moral perfection had been a major tenet of classicism and then Neoclassicism.

26 In Reynolds's view, sculpture's limited style contrasts with painting, which has a multiplicity of inspirational sources. Reynolds (1997), 175.

27 Reynolds (1997), 45.

28 The casts that he talks about are canonical works that the eighteenth century praised such as the *Laocoön*, *Apollo Belvedere*, and *Capitoline Venus*.

29 Flaxman (1838), 24–25.

30 Windsor-Liscombe (1987), 234.

31 When the Academy expressed interest in buying casts owned by George Romney to expand its collection, its Council asked Flaxman and Thomas Banks to review the plasters, which Flaxman had collected for Romney during his seven-year stay in Rome. The two sculptors recommended their purchase. In late 1815, Flaxman offered a motion to purchase new casts of ancient sculpture for the Academy. The Professor of Sculpture even helped decide which Parthenon metopes to cast for the Academy's collection. Windsor-Liscombe (1987), 229, 231–234.

32 Reynolds stressed in his first discourse that the Academy had many models of various types for the students to draw. Reynolds (1997), 21.

33 Reynolds (1997), 19.

34 Reynolds (1997), 41.

35 Fuseli advised students to utilize the knowledge learned from the study of plaster casts of ancient works when finally given the opportunity to draw from the live model; students began their training with drawing from plaster casts. Students were to use the idealized forms of ancient art when in front of the model, thereby avoiding direct copying of the model's body. Fuseli (1831), Vol. 2, 319–320. See also Graciano's chapter in the present volume, which deals with the conflicts inherent in disjunction between observing the life model and drawing a 'corrected' representation at the same time, in the same space.

36 Reynolds (1997), 45.

37 Joly (2008), 25.

38 Darlington (1990), 319. See also Darlington (1986); , McCormack (2018).

39 Hunter (1975), 36.

40 The Academy did not record the attendance at Hunter's lectures, so we cannot say with certainty if Flaxman attended them. Darlington (1990), 267, 334. Zoffany's *William Hunter Lecturing* (ca. 1770–1772) depicts Hunter using different visual aids during his lectures.

41 For more information on the Anatomy Act, see Richardson (1987); MacDonald (2011).

42 Hunter (1975), 38–39. The effect the artwork has on the spectator is a consideration in which Hunter puts much stock. In order to engage the viewer, he promotes an empirical approach to art. Art that varies even slightly from nature will be distracting to a viewer.

43 Flaxman (1838), 99.

44 Fuseli (1831, Vol. 2, 321) also supported anatomical study, saying in one of his lectures that artists should become masters of "the muscles, tendons, and ligaments that knit the bones or cover and surround them, their anatagonismus of action and reaction."

45 Flaxman (1838), 99.

46 Postle (2004), 60.

47 Carlisle (1807), 10.

48 John Sheldon served as Professor of Anatomy from 1783–1808.

49 Darlington (1990), 186–187, 342, 611.

50 Windsor-Liscombe (1987), 230; Darlington (1990), 187.

51 Flaxman (1838), 69. Métraux (1995), discusses the interaction between sculptors and physicians with some attention to the depiction of veins.

52 Flaxman (1838), 71.

53 Von Staden (1992), 230, 223. Flaxman mentioned Herophilus and Erasistratus and their dissections in his narrative of Greek art. Flaxman (1838), 110.

54 In addition to the treatises of Hippocrates, Flaxman also mentions Pliny as an ancient source that "proves" Greek anatomical knowledge. While he does list a

particular section from Pliny's 34th book—the first expression of tendons and veins—Flaxman does not typically provide specific citations in his lectures.

55 Flaxman (1838), 106.

56 Flaxman (1838), 111.

57 Unlike Greek art, nude figures in Gothic art do not have proper anatomical proportions because Flaxman claimed there was no scientific study of anatomy, proportion, or motion at that time. Flaxman (1838), 108–109. Literacy was also low in the Medieval period and much ancient knowledge had been lost, forgotten, or purged.

58 Flaxman claimed that the Farnese Hercules had the most distinct use of anatomical detail of all the known works from antiquity. Flaxman (1838), 229.

59 Flaxman (1838), 235. For example, Flaxman stated that sculptor's knowledge of anatomy, harmonious proportions, and mechanical motion "derived from the instructions of Hippocrates, and the schools of Pythagoras and Plato." Flaxman (1838), 109.

60 Johnson (1993), 161. The writings of Winckelmann fit within this category. Potts (1994), 155.

61 Joly (2008), 113.

62 While not the first to express the sentiment that the bodies Greek sculptors observed were beautiful due to climate as well as social and political factors, Winckelmann emphasized their role. The political freedom Winckelmann and others ascribed to the Greeks—particularly the Athenians after the Persian Wars—permitted them time to develop, among other things, their bodies at the gymnasium. The genial climate of Greece meant sculptors had the opportunity to view nude bodies engaging in exercise, unencumbered by heavy garments. See Winckelmann (1765), 9–10 and Winckelmann (1880), Vol. 1, 292–293. For an analysis of Winckelmann's discussion of Greek art's relationship to freedom, see Potts (1994), 54–59.

63 Johnson (1993), 113.

64 See Lifchez (2009). Salvage was not the first to anatomize ancient sculpture. See Kornell (1996), 64–68 for a discussion of classical sculpture and anatomical illustrations.

65 Salvage's project recalls Hunter having the sculptor Agostino Carlini posing the fresh corpse of a criminal as the ancient sculpture *The Dying Gaul* to create the *écorché* "Smugglerius" for the Royal Academy to use. Postle (2004), 174 discusses the *écorché*. It also conjures Houdon's *écorché* at the French Academy in Rome, which Graciano discusses in relation to its (cast) inclusion among the pedagogical cast collection at Felix Meritis in Amsterdam in Chapter 1.

66 Bell (1885), 174.

67 See note 25.

68 See Leoussi (2015).

69 *Report from the Select Committee of the House of Commons on the Earl of Elgin's Collection of Sculpted Marbles; &c* (1816), 71.

70 *Report from the Select Committee* (1816), 74.

71 *Report from the Select Committee* (1816), 75.

72 Flaxman (1838), 115–116.

73 The drawing on which the print is based originally appeared in one of Flaxman's sketchbooks titled "The Motion & Equilibrium of the Human Body," now in the collection of the Fitzwilliam Museum. This sketchbook was never published, but it is highly likely that it was the early stages of an anatomical work meant for publication. Flaxman used this sketchbook when drafting his lectures since its text and images reappear in the one entitled "On Science." Kornell (1996), 54 briefly mentions the sketchbook.

74 Flaxman (1838), 118.

75 Flaxman (1838), 118–119.

76 Flaxman (1838), 72.

77 Flaxman (1838), 119.

78 Flaxman (1838), 120.

79 Fuseli (1831), Vol. 2, 377.

80 Fuseli (1831), Vol. 2, 377.

81 Flaxman (1838), 121.

82 Flaxman (1838), 138.

83 Flaxman (1838), 111.

84 "Such characteristics assist the mind in rising towards the contemplation of real perfection, which is simplicity and unity itself." Flaxman (1838), 112.

85 For example, Winckelmann (1765), 9–10. Flaxman continues the belief advanced by Winckelmann; he calls the factors institutions and climate. Flaxman (1838), 174–175.

86 Flaxman (1838), 174–175.

87 Flaxman (1838), 112.

88 Some of his drawings even have "from Nature" underneath the image.

89 *Report from the Select Committee* (1816), 72.

90 Joly (2008), 124. For additional discussions of the Émeric-David and Quatremère debate, consult Johnson (1992); Johnson (1993), 160–161; Joly (2008), 124–129.

91 Flaxman (1838), 106, 109–111.

92 Joly (2008), 129. Dorothy Johnson calls this approach "réalisme classique," but identifies it within the category of the *beau réel*. Johnson (1992), 337.

93 Flaxman (1838), 259.

94 Postle (2004), 60.

References

Barry, James. *The Works of James Barry, Esq. Historical Painter*. Vol. 1. London, UK: T. Cadell and W. Davies, 1809.

Bell, Charles. *The Anatomy and Philosophy of Expression as Connected with the Fine Arts*. 8th ed. London, UK: George Bell and Sons, 1885.

Bindman, David. "Line into Contour: Flaxman's Drawing in Practice and Theory." In *John Flaxman: Line to Contour*, 9–16. Birmingham, UK: Ikon, 2013.

Boschloo, Anton W. A., Elwin J. Hendrikse, L. C. Smit, and Gert Jan van der Sman, eds., *Academies of Art between Renaissance and Romanticism*. 's-Gravenhague [The Hague]: SDU Uitgeverij, 1989.

Carlisle, Anthony. "On the Connection between Anatomy and the Arts of Design." *The Artist*, July 4, 1807.

Craske, Matthew. "Reviving the 'School of Phidias': The Invention of a National 'School of Sculpture' in Britain (1780–1830)." *Visual Culture in Britain* 7, no. 2 (2006): 25–45.

Darlington, Anne Carol. "The Teaching of Anatomy." *Journal of Art and Design Education* 5, no. 3 (1986): 263–271.

Darlington, Anne Carol. "The Royal Academy of Arts and Its Anatomical Teachings; With an Examination of the Art–Anatomy Practices during the Eighteenth and Early Nineteenth Centuries in Britain." Ph.D. dissertation, University of London, 1990.

Flaxman, John. *Lectures on Sculptures, as Delivered before the President and Members of the Royal Academy*. 2nd ed. London, UK: Henry G. Bohn, 1838.

Fuseli, Henry. *The Life and Writings of Henry Fuseli*. Edited by John Knowles. 2 vols. London, UK: Henry Colburn and Richard Bentley, 1831.

Harrison, Charles, Paul Wood, and J. Geiger, eds. *Art in Theory 1648–1815*. Oxford, UK: Blackwell, 2000.

Hazlitt, William *The Complete Works of William Hazlitt*. Edited by P. P. Howe. Vol. 14. London, UK: J. M. Dent and Sons, 1933.

Hunter, William. *Dr. William Hunter at the Royal Academy of Arts*. Edited by Martin Kemp. Glasgow, UK: University of Glasgow Press, 1975.

Irwin, David. *John Flaxman 1755-1826: Sculptor, Illustrator, Designer*. New York: Rizzoli International, 1979.

Johnson, Dorothy. "Le réalisme classique ou le 'Beau réel' dans la sculpture française, 1790–1816." In *Les progrès des arts réunis 1763–1815 Mythe culturel, des origines de la Revolution à la fin de l'Empire*, edited by Daniel Rabreau and Bruno Tollon, 337–344. Bordeaux, France: CERCAM, 1992.

Johnson, Dorothy. *Jacques-Louis David: Art in Metamorphosis*. Princeton, NJ: Princeton University Press, 1993.

Joly, Morwena. *La leçon d'anatomie: Le corps des artistes de la Renaissance au Romantisme*. Paris, France: Hazan, 2008.

Kornell, Monique. "The Study of the Human Machine: Books of Anatomy for Artists." In *The Ingenious Machine of Nature: Four Centuries of Art and Anatomy*, edited by Mimi Cazort, Monique Kornell, and K. B. Roberts, 43–70. Ottawa, Canada: National Gallery of Canada, 1996.

Leoussi, Athena S. "The Shock of the New: The Reception of the Parthenon Sculptures in Nineteenth-Century Europe." In *Defining Beauty: The Body in Ancient Greek Art*,

edited by Ian Jenkins, Celeste Farge, and Victoria Turner, 50–63. London, UK: British Museum, 2015.

Lifchez, Raymond. "Jean-Galbert Salvage and His *Anatomie du gladiateur combattant*: Art and Patronage in Post-Revolutionary France." *Metropolitan Museum Journal* 44 (2009): 162–184.

MacDonald, Heather. "A Body Buried is a Body Wasted: The Spoils of Human Dissection." In *The Body Divided: Human Beings and Human 'Material' in Modern Medical History*, edited by Sarah Ferber and Sally Wilde, 9–28. Farnham, UK: Ashgate, 2011.

McCormack, Helen. *William Hunter and His Eighteenth-Century Cultural Worlds: The Anatomist and the Fine Arts*. Abingdon, UK: Routledge, 2018.

Métraux, Guy P. R. *Sculptors and Physicians in Fifth-Century Greece: A Preliminary Study*. Montreal, Canada: McGill-Queen's Press, 1995.

Postle, Martin. "Flayed for Art: The Écorché Figure in the English Art Academy." *British Art Journal* 5, no. 1 (2004): 55–63.

Potts, Alex. *Flesh and the Ideal: Winckelmann and the Origins of Art History*. New Haven, CT: Yale University Press, 1994.

Report from the Select Committee of the House of Commons on the Earl of Elgin's Collection of Sculpted Marbles; &c. London: W. Bulmer, 1816.

Reynolds, Joshua. *Discourses on Art*. Edited by Robert R. Wark. 1957. Reprint, New Haven, CT: Yale University Press, 1997.

Richardson, Ruth. *Death, Dissection and the Destitute*. London, UK: Routledge & Kegan Paul, 1987.

Von Staden, Heinrich. "The Discovery of the Body: Human Dissection and Its Cultural Contexts in Ancient Greece." *Yale Journal of Biology and Medicine* 65 (1992): 223–241.

Whinney, Margaret. *Sculpture in Britain, 1530 to 1830*. 2nd ed. London, UK: Penguin, 1988.

Windsor-Liscombe, Rhodri. "The 'Diffusion of Knowledge and Taste': John Flaxman and the Improvement of the Study Facilities at the Royal Academy." *Volume of the Walpole Society* 53 (1987): 226–238.

Winckelmann, Johann Joachim. *Reflections on the Painting and Sculpture of the Greeks: With Instructions for the Connoisseur, and an Essay on Grace in Works of Art*. Translated by Henry Fuseli. London, UK: A. Millar, 1765.

Winckelmann, Johann Joachim. *The History of Ancient Art*. Translated by G. Henry Lodge. 2 vols. Boston, MA: James R. Osgood, 1880.

PART II

VISUAL MODELS IN ANATOMY AND MEDICINE:
ILLUSTRATIVE, RADIOGRAPHIC, AND SCULPTURAL

The Brain in Text and in Image: Reconfiguring Medical Knowledge in Late Eighteenth-Century Japan

Wei Yu Wayne Tan

Introduction

As a complex entity united by physiological functions and physical materialities, the human body is also at once a site composed of competing (and complementary) readings of these same functions and materialities through different frames of analysis. By interrogating the critical modalities of knowledge, the truths about the body can be derived (or at least, approximated), but what knowledge would be gleaned and how it would be organized and presented is, historically speaking, less certain. Taking issue with the cultural determinacy and indeterminacy of medical boundaries, Florike Egmond and Robert Zwijnenberg, in their introduction to the early modern European contextual constructs of meaning, argue that "a study of bodily extremities in the past therefore cannot but deal with the boundaries of the rhetorical and stylistic rules that governed such representations at the time."[1] Whatever the mode of representation, the body is far from the ubiquitous body of unchanging proportions and static realism; rather, it is abstracted and excerpted not only in predictable ways consistent with the imagery of traditional models, but also sometimes in surprising ways that yield new insights into cultural approaches.

Of particular concern to this study is the early modern Japanese transformation of Chinese medical thought through the medium of translation, specifically the translation of European works into Japanese from the late eighteenth through the early nineteenth centuries. And, if modernity in medicine were measured by the degree of compatibility with current anatomical models, a representative organ, and a touchstone of this dramatic shift in Japanese medical discourses toward modernity, was the brain. The roots of modernity would be found in the early modern period of Japan under the Tokugawa regime (1603–1868).

The quest for the hegemonic organ, rooted in the Greco-Roman medical traditions that contested theories of the heart and brain, animated debates in Western medicine.[2] According to Nancy Siraisi, anatomists labored under Galen's influence even as they found fault with the traditions they had

inherited to assert their authority.[3] As the practice of dissection was revived and ideas of body images transformed, as Rebecca Messbarger discusses in the prologue of the present volume, Andreas Vesalius's widely circulated sixteenth-century treatise *De Humani Corporis Fabrica* was hailed as the archetype of medical illustrations, initiating a new vantage point on representations of the body through the art of direct observation. In today's modern context of biomedicine, studies of the brain, from neuroscience to psychology and in disciplines as far afield as literature, continue to yield new understandings of the cognitive functions of the brain. Interest tends to be not only in the physiological, chemical, and biological functions, but also in a holistic sense that places new emphasis on the hidden brain–mind connection within embodied experiences of health. In other words, if the broad strokes of the history of the brain were drawn, it would appear that the brain has been, historically, the centerpiece of all medical investigations.

For much of Japanese medical history, by contrast, the brain only occupied a marginal status, it seemed, until the birth of modern psychiatry and psychology during the Meiji period (1868–1912), after Japan had officially opened its borders to the West.[4] Under the dominant influence of Chinese Confucian philosophical constructs and methodologies, the brain in the Japanese context was construed differently—its nature, complexion, and functions did not square with modern anatomy. This account, however, too often accentuates the modernizing story of Japan at the expense of an in-depth understanding of the unique conditions that gave birth to early modern Japanese medicine. Throughout most of the Tokugawa period, because Dutch merchants were the only Europeans with formal permission to trade with Japan, European science and medicine was introduced to Japan through the conduit of Dutch intermediaries. The field of *rangaku* (literally, "Dutch studies") took off in the intellectual scene by the late eighteenth century and inaugurated a shift from a Chinese-based paradigm to a European-based one—the climax of Japanese–Dutch medical and scientific ventures in Tokugawa society.

This study explores the textual discourses and visual representations of the brain at the intersection of anatomical art and medical thought at two junctures: in the earliest context of Chinese medical theories and, later, the appropriation of them by *rangaku* scholars. With a focus on Sugita Genpaku's landmark *Kaitai shinsho* (*A New Treatise on Anatomy*) and by comparing it with surrounding *rangaku* texts, I draw particular attention to the role of illustrations in the mediation of medical knowledge in the *rangaku* lineage. These new styles of representation did not simply present an alternative outlook; they appeared at a crucial time in Tokugawa intellectual history when traditional methodologies of scholarship were increasingly under challenge. Building on Daniel Trambaiolo's analysis of Tokugawa medicine, the study looks beyond the straightforward (and often misleading) dichotomy between native and foreign, and instead investigates the triangulation of *rangaku*, Chinese, and European epistemologies. My argument positions the *rangaku* movement, first of all, as indigenous in every sense—an indigenous mode of

inquiry that was as much a reaction against uncritical Chinese-based learning as it was a complex response to the foreignness of European ideas.[5] In their emergent capacity as artists–anatomists, *rangaku* scholars deemed it necessary for the lofty ideal of aesthetic vision to go hand in hand with the avowed goal of anatomical precision. Through their concerted efforts at translating European sources, they introduced a new visual vocabulary and grammar in their artistic renderings of anatomy and invoked the legitimacy of the visual medium in medical studies.

The Brain in Traditional Chinese Sources

Japanese medical thought developed within the framework of Chinese medicine and was organized around the pillars of blood and *qi* ("breath"; Japanese: *ki*). The appearances of blood and *qi* would seem to resemble those of blood and breath respectively in modern medicine, or perhaps blood and *pneuma* in Galenic traditions. According to *Suwen* (*Basic Questions*) from the *Huangdi Neijing* (*The Yellow Emperor's Inner Classic of Medicine*; henceforth *Neijing*), a foundational corpus of Chinese medical texts compiled during the Western Han dynasty (206 BC–AD 9), "the blood is connected with the heart; and the breath is connected with the lungs."[6] However, their functions and composition in the Chinese and Japanese contexts resist easy definition. In recent studies, the medical historians Shigehisa Kuriyama and Bridie Andrews shed light on how blood and *qi* constantly intermingled along conduits and were mutually constituted.[7]

(*Suwen*: "Blood and *Qi*, Physical Appearance and Mind")

The major yang [conduits] regularly [contain] much blood, little *qi*.
The minor yang [conduits] regularly [contain] little blood, much *qi*.
The yang brilliance [conduits] regularly [contain] much *qi*, much blood.
The minor yin [conduits] regularly [contain] little blood, much *qi*.
The ceasing yin [conduits] regularly [contain] much blood, little *qi*.
The major yin [conduits] regularly [contain] much *qi*, little blood.

This expansive network of conduits, divided into *yin* and *yang*, transported blood and *qi* through organs (Chinese: *zang*; Japanese: *zô*) and viscera (Chinese: *fu*; Japanese: *fu*). In modern interpretations of Chinese and Japanese medical thought, the five core organs would consist of the heart, liver, lungs, kidneys, and spleen, alongside six major viscera made up of the gall bladder, urinary bladder, large intestines, small intestines, stomach, and triple burner (an amorphous entity linked to the body's metabolism).[8] In the style of *Neijing* illustrations, the anatomy was depicted on a superficial plane; the lungs enveloped the internal structures at the top, linked to the throat and trachea, and the large intestines gathered as a folded trail at the bottom (Figure 4.1). More accurately, the ancient Chinese medical terminologies were underpinned by references to bureaucratic institutions of the feudal context. By introducing his

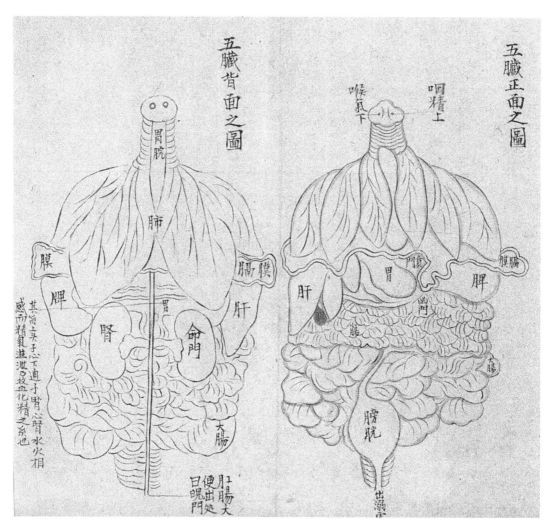

4.1 Front view (right image) and back view (left image) of the organs and viscera of a traditional Chinese anatomical scheme. Qing period (1644–1911). "Anatomical drawing: the five viscera, front and back, Chinese." Source: Wellcome Images. https://wellcomecollection.org/works/ctpj5frq. License: Creative Commons Attribution CC BY 4.0. https://creativecommons.org/licenses/by/4.0/

translation of the organs (*zang*) in *Suwen* as "depots", Paul Unschuld underlines the core medical precept that "the five *zang* store the finest *qi*, which they do not normally or usually release"; in a similar etymological turn, he views viscera (*fu*) as "palaces" in the "*fu-zang* antagonism of short-term and long-term storage, of transitory storage vs. fixed storage" with a subordinate position in the medical–political hierarchy.[9]

The brain, however, was missing from most anatomical representations of depots. It did not possess any dynamic physiological function, but derived its role from the kidneys, where the refined essence (Chinese: *jingqi*; Japanese: *seiki*) resided—technically, a kidney was only one and paired with a *mingmen*

(Gate of Life). This essence, also referred to as *shenjing* (literally, kidneys' essence) in the classical context, as Yanhua Zhang illustrates, is more commonly understood to be semen—and would, hence, explain the crucial link between kidneys and sexual vitality in men and the associated importance of the brain.[10] From Ilza Veith's translation of the *Suwen* on pulse and seasonality, "When man is tranquil and healthy the pulse of the kidneys flows as though it were panting and weary, as though it were alternately repressed and connected and very firm—and then one can speak of healthy kidneys."[11] With the kidneys as a source, the brain served as a repository of marrow (Chinese: *sui*; Japanese: *zui*) from the kidneys (Figure 4.2) and, by this logic, had the same *yin* property as the kidneys. "The brain, the marrow, the bones, the vessels, the gallbladder, and the female uterus, these six are generated by the *qi* of the earth. Their storing is associated with the *yin*; their image is that of the earth."[12] As the seventeenth-century (early Qing era) Chinese exegesis *Neijing zhiyao* (*Essentials of the Neijing*) explains, the *dumai* (the Governor conduit), a major acupuncture conduit, traced a route through the nervous and renal systems; but the pathway did not correspond with the channels familiar to modern anatomists.[13]

(*Neijing zhiyao*: "On the Synovial Cavities"; Y.C. Kong's translation)

The three of them [Du-mai + renal conduit + branch of the urinary bladder conduit] travel together up the posterior medial side of the thigh. They pass through the spinal column to link with the kidney. [A branch of the Du-mai] starts concurrently with the [podotelic] tai-yang [urinary bladder] conduit from the inner canthus of the eye. It goes up through the brow towards the vertex and crosses over its counterpart, sending branches into the brain. Coming out of the brain, it goes down the neck, and then the vertebral column until it reaches the lumbar region. There it sends out branches to traverse the paravertebral muscles to reach the kidney.

The kidneys, with a water nature, were subject to the laws of interdependence, which governed the relationships among organs and viscera and maintained them in a delicate equilibrium according to the five-phase theory of water, fire, soil, metal, and wood. The spleen, through its soil nature, would exert a hegemonic rule over the kidneys because soil subdued water, just as the kidneys kept the fire nature of the heart in check.[14] Under attack from noxious *qi* from the surroundings, illnesses arose within the body if one of the organs faltered in its assigned domination or suppression function, plunging the rest of them into a precarious state of imbalance.

(*Suwen*: "Treatise on the Precious Mechanism of the Viscera"; Veith's translation)

The evil winds contribute to the development of a hundred diseases. When the present wind is cold and it strikes man, it will cause his body hair to stand out straight and it will cause his skin to be stopped up, and man will become hot and feverish. At that time he can perspire and thus send forth (the evil influences within) . . .

Now one can repress the disease and can administer drugs. If a cure is not achieved the kidneys will pass on the disease to the heart. The muscles (sinews,

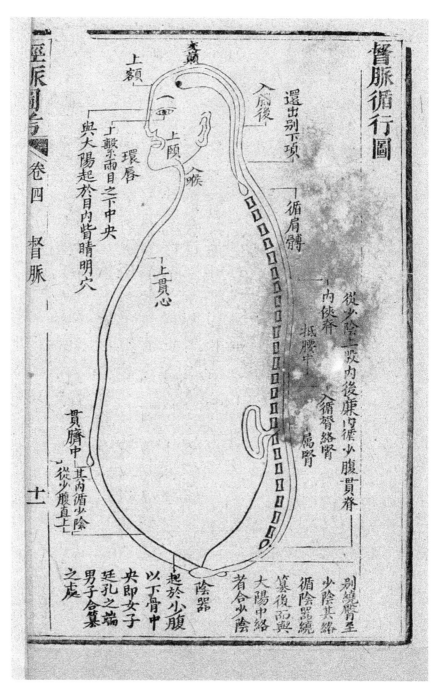

4.2 Anatomical map of the *dumai* conduit tracing the boundary of the body which connected the genitals to the kidneys and the brain (through the back of the brain); Qing dynasty Chinese medical illustration (ca. 1878). "Channel chart: dumai (Governor Vessel), Chinese woodcut." Source: Wellcome Images. https://wellcomecollection.org/works/c5k6a4jm. Accessed May 20, 2018. License: Creative Commons Attribution CC BY 4.0. https://creativecommons.org/licenses/by/4.0/

nerves) and the arteries (veins, pulse) will disunite from each other and an acute illness will develop, which is called convulsions. When at that time neither cauterization by burning moxa nor the application of drugs brings about a cure, then even after suitable treatment of fully ten days death will occur.

For, after the kidneys have infected the heart, the heart forthwith returns the infection and passes it on to the lungs, where it becomes manifest by chills and fevers; and death follows after three years. This is how the diseases strike the organs which are next in order.[15]

While the reservoir of marrow in the brain could provide some form of defensive buffer for the kidneys, the brain was itself dependent on the health of the kidneys and susceptible to depletion from noxious qi.[16] When the kidneys were failing, as Unschuld and Tessenow describe, the outward symptoms would manifest themselves in the head and bones: "The correlate of the kidneys are the bones; Their splendor is the hair on the head."[17] In cases involving the disordered flow of qi,

when the gallbladder moves heat to the brain, then [this results in] *xin-e* (bitter bridge of the nose) and *bi-yuan* (nose abyss). As for *bi-yuan*, that is turbid snivel flowing down without end. Further transmission causes nosebleed and blurred vision.[18]

Although the medical view about the brain's inert role—stemming from the *Neijing* commentarial tradition—endured in Japanese medical thought, the brain would come under further scrutiny in a different light in *rangaku* scholarship of the early modern period.

The Brain in *Rangaku* Works

The ascendancy of *rangaku* in Japan was not an isolated event. It grew out of the vibrant intellectual developments of the mid-Tokugawa period. Although the Dutch (mainly representatives of the Dutch East India Company) had an outpost at Dejima (Deshima) in Nagasaki, they were faced with tough constraints on their commercial ventures and personal interactions with the local Japanese communities. These restrictions were imposed as a result of the Tokugawa authorities' draconian persecution of Christian missionaries in the seventeenth century and the constant internal pressure to keep Europeans at bay and under surveillance to monitor threats to Tokugawa rule.[19] During the reign of shogun Tokugawa Yoshimune (shogunal rule: 1716–1745), the intellectual conditions were given an impetus for change through new policies that aimed at stimulating practical learning (*jitsugaku*). As Federico Marcon highlights, sanctions on the import of foreign books, particularly those dealing with the sciences, were eased in 1720, opening the path for Japanese translators of Dutch texts to play a greater role in facilitating the introduction of translated knowledge into local scholarly networks.[20]

The branch of science that benefitted immensely from Yoshimune's moderate political stance was nature studies (natural history) or *honzôgaku*, which had roots in earlier studies of materia medica in Ming dynasty China (1368–1644). Yoshimune had vested interests in sponsoring scholarly projects. As part of the broad agenda of carrying out agricultural reforms, he embarked on the ambitious task of compiling an exhaustive catalog of medicinal herbs, plants, and animal species. Through government official proxies at different levels of the political administration, he acquired encyclopedic knowledge about the lay of the land and the conditions of the natural environment—intimate knowledge that made him aware of the range of natural resources, many previously not surveyed and, thus, unrecorded, under his direct command.[21] The political thrust of these scientific enterprises, in Marcon's estimation, had the effect of concretizing and objectifying abstract content, within an epistemological framework that used direct observation (of an expert's eye) as an instrument for seeing universal categories through varied morphologies of species.[22]

Honzôgaku prefigured the new current of scholarship, with its focus on the working tools of epistemology, that expanded from the realm of pharmacology and natural history into anatomical studies. The defining moment in *rangaku* scholarship on the human anatomy was the revival of the practice of dissection. Sugita Genpaku (1733–1817)—widely regarded as a pioneer of *rangaku*—recounted his experiences as a *rangaku* scholar in *Rangaku kotohajime* (*The Beginnings of Rangaku*), a memoir written in his twilight years and edited by his leading disciple Ôtsuki Gentaku (1757–1827) to celebrate the coming of age of *rangaku*.[23] By his own admission, Genpaku was inquisitive about European forays into anatomical studies that he had learned so much about from the treatise *Zôshi* (*Records of the Organs*) by Yamawaki Tôyô (1705–1762), an eminent leader of the new school of "Ancient Formulas" (Kohô-ha).[24] Through a fortuitous meeting in 1771 with his *rangaku* peer, Nakagawa Jun'an (1739–1786), who procured a copy each of Johann Adam Kulmus's *Ontleedkundige tafelen* (*Analytical Tables (of the Anatomy)*) and Caspar Bartholin's *Anatomia Nova* (*New Anatomy*) from a Dutchman intermediary, Genpaku marveled at the alarming disparities between the drawings in the books and his own understanding of anatomy.[25] He concluded, then, that the drawings had to have been confirmed by an actual dissection. Later that same year, he received word from the local government office that a live dissection (*fuwake*) of an executed criminal—a 50-year-old woman who had committed a grave crime—would be scheduled.[26] Together with Maeno Ryôtaku (1723–1803), and armed with a copy of Kulmus's *Ontleedkundige tafelen* as a reference guide, he showed up at the site. In a revealing description, he wrote that as the dissection scene was unfolding before his eyes, he looked on in awe at the corpse as the executor routinely identified the entrails: they corresponded exactly with Kulmus's illustrations.

Genpaku's interest in dissection, though significant in itself, should be viewed in light of the broad shift in intellectual approaches that valued the kind of methodical empiricism evidenced in *honzôgaku*: the self-reflective re-

evaluation of the accepted modes and bases of knowledge, particularly those that were derived from the classical lore of Chinese wisdom. Amid the intellectual rejuvenation of *honzôgaku*, it is important not to overlook the significance of *rangaku*, as scholarship focused on *both* the actual endeavors *and* the fruits of discovery. Marius Jansen's critical analysis reveals that *rangaku* epitomized a complex undertaking by progressive scholars who found themselves swept along by the current of intellectual change—it was "the attitude and mind-set that produced *rangaku*."[27] Taking Tôyô as an example, as Trambaiolo demonstrates in a focused analysis of the new attitude toward evidential learning, Tôyô conceived of the body in its totality and particularity, "as a particular type of epistemic object, susceptible to investigation using the evidence provided by philology and direct observation."[28] While Tôyô's scholarship did not directly result in Genpaku's work, not in a strictly teleological sense, as Trambaiolo rightly notes, I argue that Genpaku's investigations should be regarded in the same vein of intense concerns by *rangaku* contemporaries about manifesting the relationships between concrete and abstract, physical and metaphysical, and universal and individual—not as separate categories, but overlapping in scope and intimately related in substance.

Rangaku scholars contributed to the information revolution in Tokugawa society, insofar as their ideas overturned long-standing bases of mainstream anatomy and reached wide audiences through print culture.[29] Genpaku's influential treatise *Kaitai shinsho*, which began circulating in print in 1774, was essentially a translation of Kulmus's *Ontleedkundige tafelen*. The composition of this work demonstrates that the practice of translation was as much an individual effort as it was a collective enterprise. As Genpaku reminisced in *Rangaku kotohajime*, he regularly confided in Hiraga Gennai (1728–1780), a *rangaku* scholar with eclectic tastes and interests; over time, he realized that *rangaku* textual scholarship could only be advanced through field research.[30] Among Genpaku's laments was the dearth of content or linguistic specialists in Edo, like the Nagasaki Dutch interpreters who would be of help in translating Dutch texts into Japanese. Genpaku's professional dealings with Gennai, as it turned out, proved to be indispensable for the publication of *Kaitai shinsho*. In his study, Terrence Jackson highlights that Suwaraya Ichibei, a major publisher based in Edo, had committed to publishing Genpaku's work; through Gennai's introduction, Genpaku participated in the intellectual gatherings organized by Ichibei—social venues where *rangaku* scholars like Genpaku expanded their contacts, spread their reputation, and sought out the latest developments in the field.[31] Genpaku had access to supplementary Dutch sources that had been made available to him through loans within the well-connected circles of *rangaku* intellectuals such as Katsuragawa Hoshû (1751–1809), who succeeded his father as a shogunal physician and participated in Genpaku's translation project.[32]

One logical question that arises from this discussion—and key to our reading of *Kaitai shinsho*—is this: How did the information from dissection restructure Genpaku's physical mapping of the body's inner universe? From

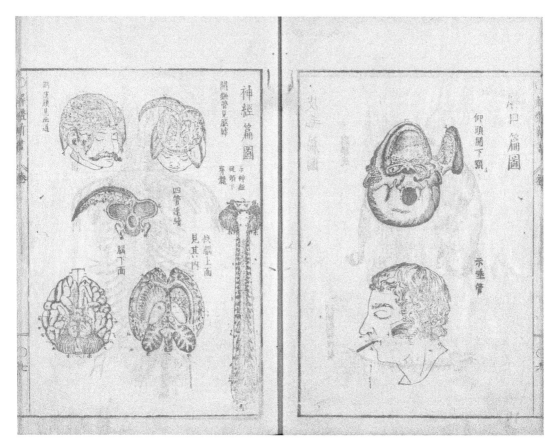

4.3 Left page of the frame: Representations of the brain and the spinal column in *Kaitai shinsho* (*A New Treatise on Anatomy*). Different cross-sections of the brain are shown here, beginning with the exfoliation of the head (at the top) and the top and bottom views of the dissected brain. Source: *Kaitai shinsho*, vol. 1, frame 23 (resized). National Diet Library Digital Collections. http://dl.ndl.go.jp/info:ndljp/pid/2558887/23

Genpaku's opening discourse in volume one, the reader is urged to reckon with the reality of dissection. It would seem intuitive, then, to agree with Genpaku, who believed that dissection was the only method for exposing the truths of the human anatomy. He emphasized that when it came to assessing the veracity of anatomical knowledge, there was nothing like cutting up a corpse and staring directly into it; lacking human dissection, a suitable alternative, albeit less desirable, was animal dissection.[33] The trained medical gaze of an anatomist, according to Genpaku, would be directed at the following parts: bones and joints, pulses and the paths of arteries and vessels (unlike the conduits of Sino–Japanese and Chinese medicine), sites and shapes of organs and viscera, and, among others, muscles and tendons, ducts and glands—mammary and secretory—and nerves.[34] Yet, Genpaku's textual exegesis, novel insofar as it expounded European concepts of the anatomy, would have been unintelligible to his contemporaries without illustrations to corroborate his points (Figures 4.3 and 4.4).[35]

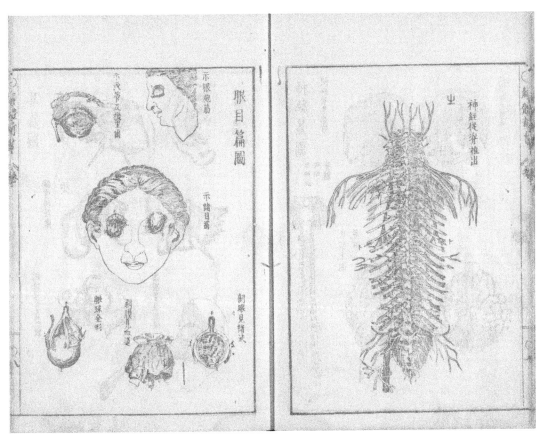

4.4 Right page of the frame: An illustration showing the discs and nerves along the spinal column in *Kaitai shinsho* (*A New Treatise on Anatomy*). Source: *Kaitai shinsho*, vol. 1, frame 24 (resized). National Diet Library Digital Collections. http://dl.ndl.go.jp/info:ndljp/pid/2558887/24

The task of producing illustrations for *Kaitai shinsho* fell upon Odano Naotake (1750–1780), a leading artist of the Akita *ranga* school of art who pioneered a genre inspired by the European style of Dutch paintings. A native of Akita domain, Naotake was trained according to the aesthetic standards of the influential Kano school and, through his early representative works, won the sponsorship of the domain lord Satake Yoshiatsu (1748–1785).[36] Naotake's participation in the *Kaitai shinsho* project began through his acquaintance with Gennai, who was invited by Yoshiatsu to survey the domain's mine deposits and provide an expert opinion about the productivity value. It was during a trip in 1773 to Akita that Gennai took an interest in Naotake's paintings and saw promise in the budding artist. As Haga Tôru explains, the ruling class of Akita domain would have envisioned long-term cultural and political gains through close ties with a prominent personality like Gennai; it would have increased the stature of the domain in the eyes of the Edo-based (present-day Tokyo) central administration and also brought the domain's scholars deeper

into the orbit of the intellectual hub at Edo.[37] After Gennai's return to Edo, Yoshiatsu appointed Naotake to the office of supervisor and inspector of the domain's mines—a pretext perhaps for continuing the relationship with Gennai and establishing credentials for the Akita-based *ranga* art. Naotake followed on the heels of Gennai and ended up in Edo, where he was tutored as Gennai's understudy in art and, more importantly, *rangaku* scholarship. It was in this formative stage of intellectual exchange that Naotake was introduced to Genpaku—probably because of his frequent contacts with Gennai—and commissioned as the medical artist for Genpaku's *Kaitai shinsho*.[38]

The medical illustrations, however, betrayed the rhetoric of dissection because of substantive similarities in representations from *Ontleedkundige tafelen* and related source materials, detracting from the expressed logic of direct observation. Naotake copied models of anatomical drawings, albeit modified with a conscious effort to create his personal style. The collaborative nature of making medical illustrations, as art and science, and, more importantly, the trend toward producing illustrations as statements of identity, are fittingly exemplified in *Kaitai shinsho*.[39] In general, as Hiroko Johnson highlights, Naotake displayed a preference for tracing outlines and showing depths with dense, compacted lines and dots instead of conforming to the dark and light shading techniques evident in Bartholin's original drawings of the skeleton and skull.[40] In his sketches of the arm, Naotake reproduced illustrations from Govert Bidloo's *Anatomia Humani Corporis* and possibly also William Cowper's *The Anatomy of Humane Bodies*; but consistent with his drawing style of lines and dots, he avoided the solidity and opacity of dark colors and opted for light tones that accentuated the bone structure through the interstices of the overlying muscular striations.[41] The idea of drawing what was *actually* seen in a dissection was, thus, subordinated to the tension between the mission of translation—the truthful representation of source images—and the artist's signature style.

In the brief description of the brain in *Kaitai shinsho*, we can begin to read into an example of the functions of translation—that is, while translation can be seen as an act of introducing foreign knowledge, it is a deliberate exercise, sometimes through neologisms, to reorganize old concepts to express new ones and couch foreign thought in a more familiar language. Genpaku's lexical choice of *shinkei* for nerves (a compound word made up of *shin* "spirit" and *kei* "conduit") shifted the discussion of the brain's function away from that of a standing repository of marrow, as traditional anatomy would have dictated, to one capable of refined thoughts—the dignified role of complex cogitation and cognitive distillation implied by "*shin*".[42] By drawing upon the term "*kei*", which would have usually referred to acupuncture conduits, in naming cranial and spinal nerves, he placed the brain at the nexus of nerve connections and indissociably interconnected with major organs through nerves emanating from different points along the spinal cord.[43] While Tôyô, in the framework of evidential learning, maintained the more traditional view of the kidneys as organs with conduits and channels (*seidô*) carrying refined

essence, Genpaku dissociated the brain's role from that of the kidneys and, hence, introduced a new reading of the brain within the nervous system.[44] For the first time, through prose and illustrative clarity, Genpaku restored the features of the brain which had lacked focus in its own right in most anatomical maps—even those that attempted to recreate the views from dissection from a precedent like Kawaguchi Shinnin's *Kaishihen* (*Corpse Dissection*).[45]

In Genpaku's illustrations, the archaeological folds beneath the surface of the head, peeled away and exposed, imparted a sense of volume to the brain and delicacy of boundaries. Encased within the skull and protected by it, the brain maintained a roundish shape and was made up of soft matter. Around the brain, as Genpaku explained, were three types of membranes: the outermost surface was what he called the strong membrane, wrapped around an inner layer ("the thin layer"); interlaid between them was a dense network of membranous branches that criss-crossed like spider webs.[46] The three membranes that he described would roughly correspond with the meninges in modern brain anatomy—made up of the dura mater on the surface, pia mater on the inside, and the arachnoid between them. Compacted together, the membranes prevented the cerebrospinal fluid (Genpaku referred to it as *shinkei-eki* "nerve fluid" or, more literally, "spirit-conduit fluid") from leaking out into other porous spaces. Genpaku appeared to have engaged in a discussion of the ventricles of the brain through a focus on *kan* ("pipes" or "channels") and the embedded structures of brain tissue—mainly the lobes, cerebellum, medulla oblongata, and the brain stem. The major ventricle, which he described as *renkan*, would likely have matched the third ventricle that intersected with the left–right lateral ventricles and joined with the fourth ventricle. Together, these four *kan* were fluid-filled spaces; Genpaku likened them to blood vessels with slow-moving blood that nourished the brain and kept it warm.

Although Genpaku paid more attention to the circuits, colors, and textures of the different parts than their individual functions—which he could not have known about if they were not included in the source texts—he factored in the limitations in formulating the anatomical designs. Through evidential learning, it was possible to peer into the depths of the human brain and represent what was "real" to the eyes. Illustrations, even if they were copied and modified from sources, did not undermine the reality of the body's finiteness or diminish the authenticity of the probing medical gaze; in fact, they were substitutes for actual dissections, much as they were representations deserving of study at the textual level.

Conclusion

The dissection which Genpaku witnessed, though discreet and shorn of the theatricality and audience-oriented performativity of early modern European dissections, was part of the revolution in Japanese anatomical

studies—unfolding quietly—that had consumed the energies and minds of the *rangaku* community. By marrying techniques of seeing with the naked eye with a critical attitude toward the appearances of tangible things to expose their underlying nature, the symbolic weight of dissection as a historical moment in intellectual history cannot be missed. To iterate the importance of the visual dimension of *Kaitai shinsho*, Genpaku's insistence on dissection—a shorthand for the primacy of direct observation—was an invitation to anatomists and readers to reimagine anatomical compositions: the reordering of the visual sense of the anatomist and the reader as a requisite for the reorientation of the epistemological framework.

The brain, one of the organs thrown into sharp relief through prose explanations and illustrations, adumbrated this new order of presentation that grew out of the interdependence of texts and images: by subscribing to claims about the characteristic features of the brain, *rangaku* scholars enfolded the currents of European medical thought into the broad discourse that was evolving beyond the pale of traditional classical Chinese medical models. To conclude with a reference to Ludmilla Jordanova's argument about the socially contingent terms of medical knowledge,

> The term 'knowledge' is hardly neutral, since it implies claims that have been validated in some way and foregrounds the cognitive dimensions of medical and scientific practice. It is a mistake to separate the knowledge claims of medicine from its practices, institutions, and so on.[47]

And, as with most emblems of adapted knowledge in the early gestational stages, the novelty of ideas surpassed expectations of their actual utility to the medical profession. Instead of ascribing any absolute epistemological value to the investigative output of *rangaku* scholars, this study emphasizes the relational compositions of ideas and practices, inflected by various source models, that made the Japanese intellectual milieu of the late eighteenth through early nineteenth centuries deserving of a worthy place in the long duration of medicine as cultural history.

Notes

1 Egmond and Zwijnenberg (2016), 5.
2 Rocca (2003), 17–47.
3 Siraisi (1997b). For a comparative case study of a scholar from the Renaissance period named Girolamo Cardano and his connections with Vesalius, see Siraisi (1997a), 93–118.
4 For recent scholarship on the history of Japanese psychiatry in the transitional modern period, see Hashimoto (2013); Nakamura (2014).
5 Trambaiolo (2013).
6 Veith (2016), 142.

7 Unschuld and Tessenow (with Zheng Jinsheng) (2011), 413. See also Andrews (2015), 113–114; Kuriyama (2002), 229–230.

8 Unschuld and Tessenow (2011), 168. *Suwen* listed nine organs and viscera. The Tang dynasty commentator Wang Bing argued for the logic of separation between physical and spirit depots, because the five organs encapsulated the purest elements that would constitute the soul and mind—the spiritual aspects of *qi*—as opposed to the viscera, which were involved in physical bodily processes.

9 Unschuld and Tessenow (2011), 17.

10 Zhang (2007), 37–38.

11 Veith (2016), 174.

12 Unschuld and Tessenow (2011), 203.

13 Kong (2010), 199–200.

14 Unschuld and Tessenow (2011), 185–186.

15 Veith (2016), 180–181.

16 Unschuld and Tessenow (2011), 550–551.

17 Unschuld and Tessenow (2011), 186.

18 Unschuld and Tessenow (2011), 573.

19 For a brief cultural history of the Dutch East India Company and, in general, the Dutch in Tokugawa Japan, see Forrer and Kobayashi-Sato (2014).

20 Marcon (2015), 128.

21 Marcon (2015), 150.

22 Marcon (2013), 201–202.

23 For an edition with Ôtsuki Gentaku's biography of Sugita Genpaku (preface), see Sugita Genpaku, *Rangaku kotohajime* (1890), images 10–12.

24 Sugita Genpaku, *Rangaku kotohajime* (1869), images 27–28. Proponents of the "Ancient Formulas" school retraced the authority of Sino–Japanese medicine to Zhang Zhongjing's *Shanghan lun* ("Treatise on Cold Damage"), compiled no later than the end of the Han dynasty, instead of the traditional *Neijing* canon.

25 *Rangaku kotohajime* (1869), images 25–26.

26 *Rangaku kotohajime* (1869), images 28–30.

27 Jansen (1984), 549.

28 Trambaiolo (2015), 90.

29 For an eloquent discussion of the links between the information revolution and the construction of national and cultural boundaries in Tokugawa Japan, see Berry (2006), 209–251.

30 *Rangaku kotohajime* (1869), image 26. For a discussion of Gennai's role in the intellectual developments of *rangaku* natural history, see Haga (2001), .

31 Jackson (2016), 75.

32 For a survey, see Jackson (2016), 124–125; Screech (2002), 18–21, 167–168.

33 Sugita Genpaku et al. (1774), *Kaitai shinsho*, vol. 1 (*kan-ichi*) images 2–3.

34 *Kaitai shinsho* (1774), vol. 1, image 3. See also Fujimoto Toyoaki (2009), 15.

35 See also Kuriyama (1992).

36 Nakahara (1993a), 97; Fujimoto (2009), 16–17.

37 Tôru (1996), 80–81.

38 For a full-length study of Odano Naotake and his work on *Kaitai shinsho*, see Washio (2006). The Satake clan was an accomplished group of artists. See Johnson (2005), 73–86.

39 Berkowitz (2015), 171–178.

40 Johnson (2005), 52.

41 Johnson (2005), 57–58; Nakahara (1993b), 91–96.

42 *Kaitai shinsho*, vol. 2, image 6.

43 *Kaitai shinsho*, vol. 2, image 11.

44 For a comparison with *Zôshi*, see Yamawaki (1759), vol. 1, image 15.

45 For a discussion of Kawaguchi Shinnin's place in *rangaku*, see Rosner (1989), 61–62. See also Kawashima (1989),

46 *Kaitai shinsho*, vol. 2, images 6–7.

47 Jordanova (2004), 339.

References

Primary sources

"Anatomical drawing: the five viscera, front and back, Chinese." Exact year unknown (1644–1912). Wellcome Images. https://wellcomecollection.org/works/ctpj5frq.

"Channel chart: dumai (Governor Vessel), Chinese woodcut." Circa. 1878. Wellcome Images. https://wellcomecollection.org/works/c5k6a4jm.

Sugita, Genpaku, et al. *Kaitai shinsho*, 5 vols. Muromachi (Tôbu): Suwaraya Ichibê, 1774. Waseda University Kotenseki Sôgô Database. http://archive.wul.waseda.ac.jp/kosho/ya03/ya03_01060/. Accessed May 26, 2017.

Sugita, Genpaku, et al. *Kaitai shinsho*, 5 vols. Tôbu: Suwaraya Ichibê, 1774. National Diet Library Digital Collections. http://dl.ndl.go.jp/info:ndljp/pid/2558887/23.

Sugita, Genpaku. *Rangaku kotohajime*. Tokyo: Tenshinrô, 1869. Waseda University Kotenseki Sôgô Database. http://archive.wul.waseda.ac.jp/kosho/bunko08/bunko08_a0212/. Accessed May 25, 2017.

Sugita, Genpaku. *Rangaku kotohajime*. Ed. Hayashi Shigeka. Tokyo: Hayashi Shigeka, 1890. National Diet Library Digital Collections. http://dl.ndl.go.jp/info:ndljp/pid/826051. Accessed May 25, 2017.

Yamawaki, Tôyô. *Zôshi*, 2 vols. Heian (Kyôto): Yôjuin, 1759. Waseda University Kotenseki Sôgô Database. http://archive.wul.waseda.ac.jp/kosho/ya09/ya09_00053/. Accessed May 30, 2017.

Secondary sources

Andrews, Bridie. "Blood in the History of Modern Chinese Medicine." In *Historical Epistemology and the Making of Modern Chinese Medicine*, edited by Howard Chiang, 113–136. Manchester, UK: Manchester University Press, 2015.

Berkowitz, Carin. "The Illustrious Anatomist: Authorship, Patronage, and Illustrative Style in Anatomy Folios, 1700–1840." *Bulletin of the History of Medicine* 89, no. 2 (2015): 171–208.

Berry, Mary Elizabeth. *Japan in Print: Information and Nation in the Early Modern Period*. Berkeley, CA: University of California Press, 2006.

Egmond, Florike and Robert Zwijnenberg, eds. *Bodily Extremities: Preoccupations with the Human Body in Early Modern European Culture*. New York: Routledge, 2016.

Forrer, Matthi, and Yoriko Kobayashi-Sato. "The Dutch Presence in Japan: The VOC on Deshima and its Impact on Japanese Culture." In *Mediating Netherlandish Art and Material Culture in Asia*, edited by Thomas DaCosta Kaufmann and Michael North, 239–244. Amsterdam, the Netherlands: Amsterdam University Press, 2014.

Fujimoto, Toyoaki. "Kaitai shinsho to fuzu o egaita Odano Naotake." *Kawasaki iryô tanki daigaku kiyô*, 29 (2009): 13–18.

Haga, Tôru. "Akita Ranga no fushigi: Odano Naotake to sono dôjidai sekai." *Bulletin of the International Research Center for Japanese Studies* 14 (1996): 65–102.

Haga, Tôru. "Dodonæus and Tokugawa Culture: Hiraga Gennai and Natural History in Eighteenth-Century Japan." In *Dodonæus in Japan: Translation and the Scientific Mind in the Tokugawa Period*, edited by W. F. Vande Walle; co-ed. Kazuhiko Kasaya, 242–255. Leuven, Belgium: Leuven University Press; Kyoto: International Research Center for Japanese Studies, 2001.

Hashimoto, Akira. "A 'German World' Shared among Doctors: A History of the Relationship between Japanese and German Psychiatry before World War II." *History of Psychiatry* 24, no. 2 (2013): 180–195.

Jackson, Terrence. *Networks of Knowledge: Western Science and the Tokugawa Information Revolution*. Honolulu, Hawai'i: University of Hawai'i Press, 2016.

Jansen, Marius B. "*Rangaku* and Westernization." *Modern Asian Studies* 18, no. 4 (1984): 541–553.

Johnson, Hiroko. *Western Influences on Japanese Art: The Akita Ranga Art School and Foreign Books*. Amsterdam, the Netherlands: Hotei, 2005.

Jordanova, Ludmilla. "The Social Construction of Medical Knowledge." In *Locating Medical History: The Stories and Their Meanings*, edited by Frank Huisman and John Harley Warner, 338–363. Baltimore, MD: Johns Hopkins University Press, 2004.

Kawashima, Junji. *Doi-han rekidai Ran'i Kawaguchi-ke to Kawaguchi Shinnin*. Tokyo, Japan: Kindai Bungeisha, 1989.

Kong, Y. C. *Huangdi Neijing: A Synopsis with Commentaries*. Hong Kong: Chinese University Press, 2010.

Kuriyama, Shigehisa. "Between Mind and Eye: Japanese Anatomy in the Eighteenth Century." In *Paths to Asian Medical Knowledge*, edited by Charles Leslie and Allan Young, 21–43. Berkeley, CA: University of California Press, 1992.

Kuriyama, Shigehisa. *The Expressiveness of the Body and the Divergence of Greek and Chinese Medicine*. New York: Zone Books, 2002.

Marcon, Federico. "Inventorying Nature: Tokugawa Yoshimune and the Sponsorship of *Honzôgaku* in Eighteenth-Century Japan." In *Japan at Nature's Edge: The Environmental Context of a Global Power*, edited by Ian Jared Miller, Julia Adeney Thomas, and Brett L. Walker, 189–206. Honolulu, Hawai'i: University of Hawai'i Press, 2013.

Marcon, Federico. *The Knowledge of Nature and the Nature of Knowledge in Early Modern Japan*. Chicago, IL: University of Chicago Press, 2015.

Nakahara, Izumi. "Kaitai shinsho no eshi: Odano Naotake." *Nihon shika ishi gakkai kaishi* 19, no. 3 (*tsûkan* 72; May 1993a): 97–102.

Nakahara, Izumi. "Kaitai shinsho no teashibô shutsuzu ibun," *Nihon shika ishi gakkai kaishi* 19, no. 3 (*tsûkan* 72; May 1993b): 91–96.

Nakamura, Ellen. "From the Netherlands to Japan: Communicating Psychiatric Practice in the 1830s." *History of Psychiatry* 25, no. 3 (2014): 350–363.

Rocca, Julius. *Galen on the Brain: Anatomical Knowledge and Physiological Speculation in the Second Century A.D.* Leiden, the Netherlands: Brill, 2003.

Rosner, Erhard. *Medizingeschichte Japans*. Leiden, the Netherlands: Brill, 1989.

Screech, Timon. *The Lens within the Heart: The Western Scientific Gaze and Popular Imagery in Later Edo Japan*. Honolulu, Hawai'i: University of Hawai'i Press, 2002.

Siraisi, Nancy G. *The Clock and the Mirror: Girolamo Cardano and Renaissance Medicine*. Princeton, NJ: Princeton University Press, 1997a.

Siraisi, Nancy G. "Vesalius and the Reading of Galen's Teleology." *Renaissance Quarterly* 50, no. 1 (1997b): 1–37.

Trambaiolo, Daniel. "Native and Foreign in Tokugawa Medicine." *Journal of Japanese Studies* 39, no. 2 (2013): 299–324.

Trambaiolo, Daniel. "Ancient Texts and New Medical Ideas in Eighteenth-Century Japan." In *Antiquarianism, Language, and Medical Philology: From Early Modern to Modern Sino–Japanese Medical Discourses*, edited by Benjamin A. Elman, 81–104. Leiden, the Netherlands: Brill, 2015.

Unschuld, Paul U., and Hermann Tessenow (with Zheng Jinsheng). *Huang Di Nei Jing Su Wen: An Annotated Translation of Huang Di's Inner Classic—Basic Questions*. Berkeley, CA: University of California Press, 2011.

Veith, Ilza. *Huang Ti Nei Ching Su Wen: The Yellow Emperor's Classic of Internal Medicine*. Berkeley, CA: University of California Press, 1975; reprint 2016.

Washio, Atsushi. *Fukkoku Kaitai shinsho to Odano Naotake*. Akita-shi: Mumyôsha Shuppan, 2006.

Zhang, Yanhua. *Translating Emotions with Chinese Medicine: An Ethnographic Account from Contemporary China*. Albany, NY: State University of New York Press, 2007.

When Sight Penetrates the Body:
The Use and Promotion of Stereoscopic Radiography in Britain, 1896–1918

Antoine Gallay

In December 1895, Conrad Willem Roentgen discovered what we now call X-rays.[1] In the space of a few weeks, everyone marveled at the images produced: one could now see *inside* the body! The invisible was made visible![2] X-rays were seemingly everywhere, in popular magazines and in amusement fairs. They had become a new and fashionable entertainment, part of the larger late nineteenth-century fascination with optical illusions and philosophical toys.[3]

For physicians, X-ray technology was a much more serious affair. The potential of radiography and fluoroscopy for medical diagnosis was immediately understood.[4] However, while some practitioners professed their enthusiasm, others criticized the pictures' lack of reliability.[5] As late as 1907, Mihran Kassabian complained that there were always "numerous shadows [. . .] that defy all efforts of interpretation."[6] The issue was notably due to the fact that the position of these shadows cannot be spatially recognized. Unlike a photograph, an X-ray image provides no occlusion cues and, thus, lacks any depth information. In other words, there is no way one can recognize, from two superimposed shadows, which of the two objects they represent is in front of the other.

A solution to this issue was quickly identified. A few months after Roentgen's discovery, the application of stereoscopy was suggested to show depth.[7] The use of an adequate instrument to see two pictures taken from a slightly different angle would enable the cognitive reconstruction of depth, the same way it works with the naked eyes in front of a real object.[8] With stereoradiography (Figure 5.1), it was thus possible to see the *inside* of the body, not as a flat map of shadows, but modeled "as a solid body, illuminated by transmitted light, transparent, like a crystal."[9]

During the second half of the nineteenth century, stereoscopic photography had met with extraordinarily popular success.[10] A few years after David Brewster displayed his stereoscope (Figure 5.2) in the 1851 Great Exhibition, nearly every middle-class family in Western countries seemed to have one of these small instruments at home. Hundreds of thousands of pictures, books and devices were manufactured by local producers as well as big companies devoted to the new craze.[11]

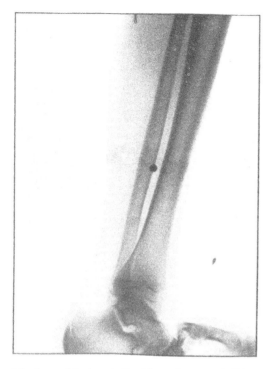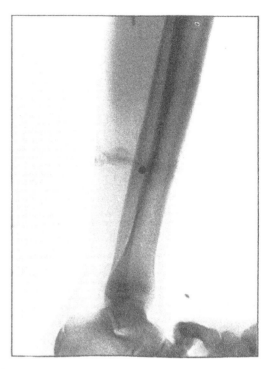

5.1　James Mackenzie Davidson, *Stereoscopic Skiagraph, by Mr. Mackenzie Davidson, of a case of bullet in the leg (Mr. Howard Marsh's case). The shade encircling the limb is a ring of bismuth on the skin. British Medical Journal* 2, no. 1979 (Dec. 3, 1898): n.p. (courtesy of the *British Medical Journal* and the Library of the University of Geneva).

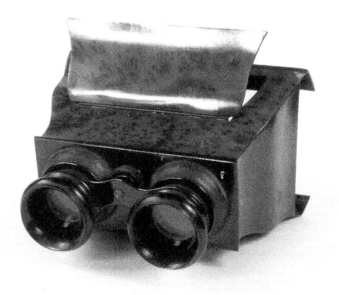

5.2　David Brewster (after), Lenticular stereoscope, ca. 1860 (London, Science Museum, inv. no. 1990-5036/6991).

5.3 Charles Wheatstone, Reflecting stereoscope, ca. 1850 (London, Science Museum, inv. no. 1884-0006).

It is now well known that stereoscopes did not originate as entertainment devices, but as laboratory tools. The first systematic studies on binocular depth perception were conducted by Charles Wheatstone in the 1830s, thanks to the large instrument he contrived (Figure 5.3).[12] However, while Wheatstone's work was of great importance in the development of physiological optics, it remained ignored outside a small community of physicists. The reflecting stereoscope remained confined to the laboratory, and its role as the model for Brewster's instrument remained largely unknown to the public.[13]

However, enthusiasm for Brewster's stereoscopes had waned by the 1870s. An early article on stereoradiography drew attention to the fact that, in the late nineteenth century, stereoscopy had "fallen so completely out of favor that, until comparatively recently, it had almost been forgotten."[14] Historians have notably argued that the commercial decline may have been due to the lack of standardization among different producers and the low level of innovation in the content of stereoviews.[15]

How then did stereoradiography come to light? While the medical need to provide precise three-dimensional modeling of the different shadows was clear, it is not the only explanation for the importance the medium took among early British radiographers. The practical utility of stereoradiography was obviously the main argument physicians used to promote the technique, but it cannot be easily separated from underlying functions. Stereoradiography is not only an instrument mediating between the surgeon's eyes and hands and the patient's body, it is also a method anchored in a specific social context—a

technique that was discussed, exhibited, criticized by some, and promoted by others. The stereoradiograph is, in turn, a social and visual object whose effective value in medical diagnosis (in modeling a virtual three-dimensional image) cannot be separated from the values constructed and communicated among medical practitioners.

Between Medicine and Entertainment: The Ambiguous Origins of Stereoradiography

Stereoradiography was introduced in Britain by Silvanus Thompson, professor of physics at Finsbury Technical College, during a lecture at the London Clinical Society in April 1896.[16] A few weeks earlier, however, an article on "Stereoscopic Roentgen pictures" by the American engineer Elihu Thomson had been published in the British periodical *The Electrician*.[17] Thomson mentions the trials he made with objects such as a block of wood full of nails or twisted metallic wires. He then expresses his hope that "the complete skeleton of a mouse, or other small animal may be recorded as to be seen in relief, each bone in its proper space relation to the others."[18]

Neither paper mentions a specific medical application. In fact, neither Thomson nor his British homologue was medically trained. One of the leaders of the General Electric Company, Elihu Thomson had achieved various improvements to the Crookes tube, hoping that the company would soon be able to manufacture X-ray apparatuses.[19] Meanwhile, Silvanus Thompson experimented with the chemical reactions of X-rays with various fluorescent substances in order to improve the sensitivity of radiographic plates.[20] Thomson and Thompson were both interested in the physical study of X-rays with a view towards their industrial potential. Consequently, stereoradiography did not appear in Britain to satisfy medical need, but, rather, as a technological improvement of radiography intended for commercial applications. These two preliminary works, therefore, had little impact on medical practice.

Shortly after Roentgen's discovery, radiography had indeed appeared especially useful to localize small objects lodged inside the body. In February 1896, James Mackenzie Davidson, an ophthalmic surgeon at the Aberdeen Royal Infirmary, had to remove a broken needle in a young girl's foot. As the traditional method of palpation gave no result regarding the localization of the needle, Davidson chose to use radiography.[21] The operation being successfully achieved, he concluded that "this case confirms the opinion that for the detection of metal in the body, the Roentgen rays will be of marked service."[22] During the following months, he frequently used radiography as an aid for diagnosis.[23] A year later, however, the main pitfall of this method was made clear: a single radiograph "has no relief," and consequently "give[s] no correct idea" of the "relative position" of the object.[24] In October 1897, Davidson, conjointly with William Hedley, published an article on a new method of X-ray localization that provided depth information.[25]

It might be expected that the recognition of this issue would have directly led to stereoradiography. However, the solution Davidson developed was a simple mechanical device based on parallactic displacement.[26] After the first exposure, the tube is moved up to a certain distance for a second exposure in order to impress on the plate a different shadow of the foreign body. By triangulation, then, it was possible to ascertain the distance from the skin to the object, and "these data give the surgeon all the information he can possibly desire."[27]

Stereoradiography remained virtually unexplored until it was revived, two years after Roentgen's discovery, in a more detailed article advancing a potential medical application.[28] The author, William Hedley, was a medical doctor and the head of the Electrical Department of the London Hospital where he established one of Britain's earliest radiography facilities.[29] His article was published in two different periodicals, *The Lancet* and *The British Journal of Photography*, ensuring a certain impact outside the field of medical practitioners. Not only was stereoradiography offered with a detailed methodological guidance—which I discuss later—but it was also ascribed a precise purpose: the localization of foreign bodies.[30] Indeed, Hedley made clear that the information given by Davidson's triangulation method, in spite of its relative precision, was not enough:

[The] radiographer is able to give the exact position of the foreign body with reference to certain artificial surface marks; *but such information cannot convey to the mind as sight does a clear conception of the various objects that go to make up the picture.* Yet this is what is chiefly wanted.[31]

Unlike the triangulation method, stereoradiography enabled "the surgeon to see with his own eyes at one glance [. . .] the *tout ensemble* of the region he is dealing with."[32] The ability to operate does not only depend on the precision of the information, it also depends on the way by which this information is conveyed to the mind. In other words, an abstract geometrical idea of the distance would not be as efficient as the seemingly direct visualization of the body's interior. Stereoradiography was, thus, seen as a direct improvement of the mechanical method, enabling the surgeon to work more efficiently and intuitively from a virtual three-dimensional representation of the body part concerned.

For his part, Davidson was skeptical of stereoradiography. A "beautiful method," he acknowledged in January 1898, stereoradiography was also "difficult and tedious to carry out" and it was "not precise enough for practical guidance in a surgical operation."[33] At the beginning of 1898, Davidson's position was strikingly at odds with Hedley's. By the end of the year, however, the surgeon had changed his tune: "A single skiagraph is often confusing, if not misleading, but with two properly taken and viewed in a stereoscope, the picture stands out in true relief, and shows clearly the relation of the parts."[34]

All the previously supposed difficulties of stereoradiography had vanished. Following Hedley's paper, Davidson may have been convinced that the

medium was actually helpful for the localization of foreign bodies, in addition to his own mechanical method.[35] As John Hall-Edwards, a close acquaintance of Davidson, later put it, stereoscopy "is of the greatest possible help, even *after* an exact localisation has been made" since "it shows the relative position of foreign bodies and neighbouring bones."[36] However, unlike his two colleagues, Davidson did not employ stereoradiography alongside his own triangulation method to improve localization. A closer read of the surgeon's article suggests that localization was only a secondary purpose. His primary use was the creation of visual models for medical training.

At the end of 1898, Davidson claimed to have used stereoscopic pictures "for years past [. . .] with the greatest benefit to myself and to students."[37] If stereoscopy had already been advocated as an educational tool since the middle of the nineteenth century, it was scarcely used for medical teaching until the 1900s.[38] Davidson was one of its earliest promoters. Although it remains unclear how exactly stereoscopic pictures were used by the surgeon, it is likely that the educational purpose remained closely connected to the fascination the image could have provoked among young medical students. In fact, it seems that the surgeon's interest in stereoradiography directly followed his use of stereoscopic photography.[39] Rather than relying on Hedley's work, Davidson used his own knowledge of stereoscopic photography to adapt it to radiography. His first trials having probably been unsuccessful, he thus remained little convinced about the utility of stereoradiography in the case of the localization of foreign bodies. He, however, considered another potential utility, directly drawn from his past use of stereoscopic pictures, for "recording and illustrating medical and scientific work."[40]

The display of four pairs of stereoscopic pictures in his article clearly supports this view. Only one pair is actually radiographic. Another one shows the face of a patient infected with smallpox, and the two remaining ones show the devices used to take and to display stereoradiography (Figure 5.4). These do not exemplify the actual advantages of stereoradiography in medical diagnoses; rather, they *illustrate* the technology behind the medium. Davidson's lengthy article deals with technical aspects: the various methods to enable good relief and the pitfalls one should avoid. There is no mention of a concrete application for accurate diagnosis. To Davidson's eyes, the medium appeared more relevant than its medical purpose. According to the article, Davidson actually took only the X-ray pictures; the surgery was left to another surgeon, Howard Marsh. The latter, indeed, acknowledged to have used "Mr. Mackenzie Davidson's stereoscopic process," to localize "with great exactness" a bullet "no bigger than a pea," lodged in a boy's leg.[41] While Davidson claimed to have made use of stereoradiography in more than 250 cases in the space of only two years, it is likely that he was in charge of taking the pictures and that he did not necessarily perform the surgeries themselves. Davidson's interest in these pictures was driven by a much more ambitious purpose. They were intended to be displayed during the numerous lectures he gave on the subject as pedagogical, visual aids.[42]

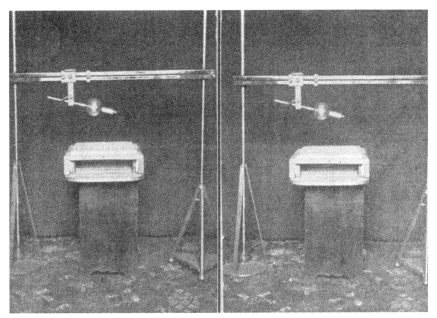

5.4 James Mackenzie Davidson, *After a stereoscopic photograph showing horizontal bar with Crooke's tube and "changing box" arranged for taking stereoscopic skiagraphs. British Medical Journal* 2, no. 1979 (Dec. 3, 1898): p. 1670 (courtesy of the *British Medical Journal* and the Library of the University of Geneva).

While these lectures obviously bore an instructional purpose, they also hide another function. Stereoradiography was indeed a fascinating medium for radiographers themselves, and the reviewers of Davidson's lectures sometimes mention the beauty of the pictures.[43] In another context, a physicist admired "a very beautiful collection of stereoscopic slides" and hoped they would have been "exhibited at the Roentgen or the Electro-therapeutic Society."[44] During the 1909 Amsterdam Congress of the Roentgen Society, "[a] large room in the exhibition was completely lined by these stereoscopic pictures, each one more beautiful than the last."[45] The image one sees has the solidity of a real body, yet an ethereal transparency, so that it looks like a "glass model" or a "mass of crystal."[46] Radiographers' amazement sometimes led to even more poetical language. For example, William Deane Butcher could admire a stereoscopic picture of a thorax whose heart appeared "like a bird within its living cage, [. . .] stilled for a brief moment between its lifelong fluttering." In a paroxysm of aesthetic emotion, he added "that no picture of the old masters can easily excel this in poetic beauty or in charm."[47]

The utility of the new medium for the localization of foreign bodies was undoubtedly quickly grasped, yet it had neither been invented for such purpose, nor was it widely promoted for such application. It seems that Davidson understood that stereoradiography could be valued as an aesthetic and pedagogical object even *before* it appeared it could be used as a diagnostic tool.

From Showman to Expert: The Function of the Instrument

The aesthetic features of stereoradiography did not, *a priori*, undermine its practical function: it could be, at the same time, a "beautiful and scientific method."[48] However, when William Deane Butcher applauded the "magnificent" stereoscopic X-ray pictures at the Amsterdam Congress, he immediately felt compelled to specify that "[t]hey were made not as scientific curiosities, but in the daily routine of hospital work."[49] While they recognized the beauty of stereoradiography, medical practitioners could definitely not tolerate the medium's association with the realms of entertainment and artistic practices, as Hall-Edwards emphasized:

The state of affairs in London and other large towns, where radiographs are accepted which have been produced at a side show at an exhibition, or by an ordinary professional photographer, is a disgrace; and it is to this practice almost alone that mistakes are due, and discredit is thrown upon an adjunct to surgery which for accuracy and usefulness has never been surpassed in the history of scientific progress.[50]

Stereoradiography was, thus, in a difficult position, since it combined two techniques whose epistemic values were endangered by the 'disgrace' that show business could bring upon them. While the beauty of the image was its most significant asset, it was also its main weakness. No medical radiographer could have afforded to be confused with a showman.

There was a quite simple way to get rid of most suspicions regarding stereoradiography's relationship to show business. If entertainers generally recommended the use of Brewster's small stereoscope for the view of stereoscopic photographs, Davidson stressed the necessity for professionals to use Wheatstone's unwieldy stereoscope when dealing with radiography.[51] He may have had a practical reason: compared to a Brewster lenticular stereoscope, a reflecting stereoscope was an instrument flexible enough to adapt to the peculiar physiological conditions of natural binocular vision, that is to say the constant relation between the accommodation of the crystalline lens and the convergence of the eyes. As Charles Wheatstone had already pointed out:

As the inclination of the optic axes corresponding to a different distance is habitually, under ordinary circumstances, accompanied with the particular adaptation of the eyes required for distinct vision at that distance, *it is difficult to disassociate these two conditions* [. . .][52]

Originally, one of the purposes of the Wheatstone stereoscope was to observe the effects produced by various artificial disjunctions between accommodation and convergence.[53] In consequence, the reflecting stereoscope could be adjusted as to retain the natural conditions of binocular vision and thus provide the 'true relief' of the body part represented.

However, such an argument was not expressed by Davidson. The latter never gave much importance to the conservation of the natural conditions of

binocular vision. In fact, he systematically neglected the relationship between accommodation and convergence in his methodological guidance. As a stereoscope was not always available, he even suggested a technique to produce a stereoscopic effect without any instrument, by slightly squinting so that each optical axis would fall on the proper picture.[54] A correct effect requires, as C. Fred Bailey later related, that "the accommodation must *not* be allowed to alter with convergence or the combined picture will be out of focus."[55] No such explanation is found in Davidson's work. While the surgeon claimed that the practice of stereoscopic vision by squinting was "not difficult to acquire," most radiographers disagreed.[56] They complained about headaches even if not realizing their distress was the result of altering their physiological condition.[57] Because of the difficulty and the lack of precision of his method, it seems that Davidson was certainly not looking for an exact reconstitution of the process of binocular vision. Neither was he concerned with creating a precise and accurate visual model. For Davidson, then, the visual quality potentially produced by the Wheatstone stereoscope when used correctly was beside the point.

What is striking is the importance the instrument took on in the early lectures Davidson gave on stereoradiography. Five reviews of his lectures published between 1898 and 1899 specify that a Wheatstone stereoscope was used to display the pictures.[58] There was no practical reason to explain this choice. The device was much larger and more complicated to use than a Brewster stereoscope. It could not have been used by more than one viewer, meaning the public had to stand up one by one in front of the instrument to see the pictures properly. By the end of the nineteenth century, anaglyphic or light polarized devices for stereoscopic projection were already available and would have allowed an entire audience to see the effect simultaneously.[59] As these are not mentioned, it must be assumed that the talk was preceded or, more likely, followed by the display of the pictures placed in the reflecting stereoscope for each individual attendee. During other lectures, it happened that Davidson exhibited stereoscopic pictures "with his mirror-stereoscope and gave demonstrations of his method and its value."[60] We should conclude that Davidson's lectures—including his participation in those of others—were not only to illustrate a medical case, but also an opportunity to exhibit a specific instrument and a particular visual medium.

During the 1900s, Wheatstone's apparatus became the standard instrument for the viewing of stereoscopic X-ray pictures. According to the American radiographer, James T. Case, it could have been seen in several London laboratories.[61] Devices specifically intended for radiography (Figure 5.5) were even manufactured around 1910.[62] The reflecting stereoscope was frequently advertised to be better than any other instrument.[63] However, Davidson himself claimed the opposite in his later works. In 1915, he asserted that, although Wheatstone's stereoscope was "one of the most convenient" methods, "it is much more satisfactory" to use an "ordinary lenticular stereoscope."[64] A similar change may be observed in *A Manual of Practical X-Ray*

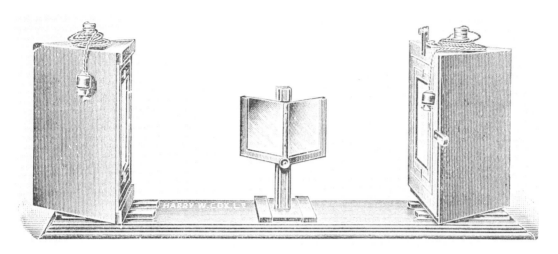

5.5 A Wheatstone stereoscope for X-ray picture, in Arthur, David, and John Muir. *A Manual of Practical X-ray Work*. New York: Rebman, 1909, p. 127 (courtesy of Columbia University Library).

Work. While the 1909 edition only mentions the reflecting stereoscope, the 1917 edition describes other devices including lenticular stereoscopes, which had shown "particularly valuable in localisation of foreign bodies."[65] Such a shift cannot be explained in terms of technological change, and, thus, suggests that the early emphasis on the Wheatstone stereoscope was neither due to its practicality nor to the quality of its pictures. It was, rather, due to the *scientific* connotation of the instrument from the standpoint of professional legitimacy.

Wheatstone's stereoscope indeed belonged to the laboratory environment, while Brewster's lenticular one remained an "optical" or "philosophical" toy. Although stereoradiography was, in practice, largely drawn from entertainment devices, its professionalization necessitated its distance from such base origins. This was especially important at the time, since a large number of medical practitioners remained dubious about the use of such instruments for diagnosis.[66]

The Wheatstone stereoscope was a way to distance radiography from entertainment, from the artistically beautiful 'crystalline' transparency of the medium. As Jonathan Crary stressed, while the Brewster stereoscope "conceal[ed] the process of production" and "allowed the viewer to believe that he or she was looking forward at something 'out there,'" the Wheatstone device created a "disjunction between experience and its cause."[67] Davidson might have highlighted such a disjunction, as he encouraged the "beginner" to pay attention to the cognitive combination of the two pictures:

[he might] pull the mirror towards him until he sees the two photographs side by side and overlapping; then, by gradually pushing the mirrors away, keeping the middle line of his forehead close to the apex, he will find that the images gradually approach each other, and finally fuse into one, whereupon this solid stereoscopic effect is immediately realized.[68]

During Davidson's lectures, the emphasis on the artificiality of the stereoscopic effect could have stressed the role of the operator as a performer—a showman—but the use of the Wheatstone instrument drove away any remaining associations with entertainment. Instead, Davidson became an *expert* in a *scientific* technique for medical imaging. Stereoradiography was as useful for medical diagnosis as it was for self-advertisement. After he moved from Aberdeen to London in 1897, Davidson might have figured out stereoradiography could be used as a key to enter the medical community and to win recognition as a professional radiographer. Thanks to his numerous lectures and publications on the topic, he came to be considered a true pioneer of stereoradiography in Britain; his works were systematically acknowledged while Thompson's and Hedley's earlier papers had fallen into oblivion.[69] Davidson had become one of the most successful radiographers in Britain. He was knighted in 1912, and remembered later as *the* "leading radiologist of this country."[70] It is not unlikely that stereoradiography was the catalyst of such a brilliant career.

When the Gaze Penetrates the Body: The Image of Stereoradiography

The complex and problematic relationship stereoradiography maintained with entertainment practices deeply affected the way the pictures themselves were seen at the beginning of the twentieth century. According to Crary's thesis, stereoscopy shows an essential dissemblance between stimulus and sensation.[71] The late nineteenth century 'observer' was confronted with a radical impossibility to reproduce what he sees: the myth of the perfect mimesis collapsed. Art historian Laura Schiavo has, however, suggested that such a pessimistic conception radically changed when stereoscopy slipped from physiological optics to entertainment practices.[72] Contrary to Crary's argument, Schiavo shows that the commercialization of stereoviews tended to dismiss such an epistemic gap, while simultaneously reaffirming the possibility of an absolute mimetic representation.[73] Grounded in the tenets of natural theology, as Richard Silverman stresses, the discourse on stereoscopy was no longer based on dissemblance: oppositely, the human visual apparatus became the model for the man-made machine.[74] Reaching back to Kepler's well-known analogy between the eye and the camera obscura, the stereoscopic camera "stand[s] truly for the two eyes," each objective being a crystalline lens, and each sensible plate a retina.[75] Historians have suggested that, as long as human vision was considered the "model for proper depiction," the illusion of three-dimensional reality was about the "imitation of the powers of the eyes."[76] The mimetic reproduction thus implies that one follows the configuration of human visual apparatus. Brewster notably insisted that the distance between the two lenses was to be similar to the interocular distance and that the aperture should have been as small as the pupil: a stereoscopic camera was like "a forehead with two eyes in it."[77] Stereoscopic photography

could, thus, recreate the visual process, provided that it reproduces the same triangulation the eyes would have in front of the real object. When this condition is met, the perception of reality and the perception of stereoscopic pictures conflate, leading the latter to be considered as the pinnacle of mimetic representation.

Such a limited view was not shared by all. Some authors quickly began to claim that the purpose of stereoscopy was not to imitate vision, but to *enhance* it. The distance between the two lenses could be increased in order to give more relief and more solidity to the apparent object. The aesthetic and heuristic possibilities of "telestereoscopy"—the term was coined by Hermann von Helmholtz—delighted its proponents, while the distortion induced by the technique was severely condemned by Brewster and his followers.[78]

The debate, especially vivid in artistic and entertainment photography, was never raised among medical practitioners. Telestereoscopy was implicitly condemned, since radiographers unanimously expressed their fear that "the relief is exaggerated or otherwise untrue."[79] For Hedley, it was vital "to ascertain [. . .] what are the physical and physiological considerations upon which the extent of this displacement must be made to depend."[80] In other words, the stereoscopic method should reproduce, to some extent, the physiological conditions of natural binocular vision in order to provide a true relief. Hedley relied on the laws of the "*stéréoscopie de precision*," a series of relatively simple equations developed by Louis Cazes in 1895 and adapted to radiography by the French physicians Théodore Marie and Henri Ribaut.[81] The "*stéréoscopie de précision*" was driven by the need to maintain the relation between accommodation and convergence (Figure 5.6). In natural stereoscopic vision (left), the

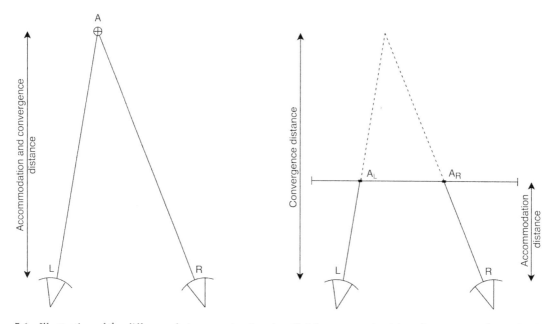

5.6 Illustration of the difference between natural and artificial stereoscopic vision. (Drawing by the author.)

eyes (L,R) always converge and focus at the same time on the object seen (A). In artificial stereoscopic vision (right), the eyes (L, R) converge on the virtual image (A_1) while they focus on the real pictures (A_L, A_R). The constant relationship between accommodation distance and convergence distance is, thus, defective. According to Cazes, there is, however, a "*tolérance*" in accommodation, such as it is possible to obtain a certain range of variation in convergence while accommodation remains the same. The range of variation was determined through experiments and enabled Cazes to provide a formula defining the maximal depth of the object in relation to the latter's distance from the observer.[82] By this alone, one could hope to obtain correct relief.

While its purpose was the same, Hedley's method appears to be quite far from the precepts of Brewster and his followers. Those were solely concerned with the triangulation of the two eyes and they neglected the relations between accommodation and convergence. However, Hedley's precision stereoscopy had little concern with the reproduction of the true dimensions of the human visual apparatus; it was motivated by considerations inspired by Helmholtzian physiological optics, accounting for the role of empirical acquisition in the development of the visual apparatus.[83]

Although it was undoubtedly more accurate than Brewster's approach, Hedley's method was little followed. Most radiographers continued to rely on Brewster's prescription. No mention was made about Ribaut and Marie in the following years, and even when James Case acknowledged their work in a 1912 article, he specified that he did *not* follow their method, but rather took a 6 cm distance.[84] The reproduction of the interocular distance appears to have been the only rule that was considered worthy of being followed. Once again, Davidson seems to have been at the origin of such a convention, although he did not give much importance to it. He first agreed that "[a]ny desired displacement [. . .] may be given to the tube" before he admitted it would be better "to displace it about 6 cm., which may roughly be taken as the distance between our eyes."[85]

Of course, Hedley's method might have been neglected because of its complexity. In the late 1910s, Davidson complained that stereoradiography was still considered a "difficult [. . .] process."[86] He clearly accused Hedley's followers who "complicate the subject by directions as to varying the displacement of the tube with its distance from the plate, and also with the thickness of the part to be radiographed."[87] However, even though Hedley's method was obviously quite impractical, that was not the reason it was neglected. Most radiographers favored Brewster's method because they considered it a way to reach a perfect mimetic representation.

Indeed, the integration of stereoscopy with radiography led to curious considerations about the 'realism' of the medium. While a reviewer marveled at "excellent and realistic stereoscopic X-ray photographs," one might wonder how could a picture be considered "realistic" when its main purpose was precisely to show what the eye *cannot* see.[88] When another author said, "[w]e are deceived into supposing we are directly viewing the object itself, and not two

representations of it," it eludes the fact that one did not actually see anything that looks like a real object—a real part of the body.[89] What was seen was, as I have already stressed, a "glass model" or "a mass of crystal," as James Case described it.[90] However, Case was himself confused by the nature of such a singular object. He claimed that the viewer of a stereoscopic X-ray picture "seems to be looking not merely *at* the organ, but *into* the organ."[91] The materiality of the picture disappears in favor of the object that is seemingly observed. It is tempting to consider that the viewer does not see a *representation* of a radiographed object, but a *real* object—a virtual model of three dimensions—into which his sight penetrates. In view of the pervasive analogy between stereoscopy and the visual process, sight became *something like* an emanation of X-rays, a "monstrous" sight—as Brewster might have said if he knew about it—that *"no eye and no pair of eyes ever saw or can see."*[92] Obviously, no one expressed such a fanciful idea, but the terminological ambiguities evoke the fundamental ambiguity that existed in the very heart of stereoradiography.

Such ambiguity would not have been possible if radiography had not maintained such a close relation to photography. Bettyann Kevles has indeed stressed that radiography was widely considered among the late nineteenth-century public "as the equivalent of taking a photograph with a flashlight inside the body."[93] Efforts to eliminate the confusion soon became necessary to radiographers.[94] Radiography was not to be compared with photography: it was just "a mere flat record of shadows," the "light and shade" being "nothing more than indications of relative opacity to the x rays."[95] And its visual mystery required professional interpretation.

However, if early radiographers repeatedly reassessed the peculiar status of X-ray pictures, it is likely they were themselves still struggling with the temptation to conflate the two media.[96] The integration of stereoscopy with radiography undermined the objective status of the latter by bringing it from the realm of material pictures to that of mental objects. It is only because the underlying assimilation of radiography to photography never completely disappeared that X-rays can be considered 'realistic'. If one could have said that stereoradiography "really ceases to be a shadow," it is because radiography itself has always been about more than shadows.[97]

Conclusion

In his short account on three-dimensional medical imaging, René van Tiggelen briefly asserted that stereoradiography "never had a great success" and "found itself overtaken by tomography."[98] While it is true that the precision of tomography made depth cues given by stereoscopy obsolete, it is difficult to observe any correlation between the rise of the former and the progressive decline of the latter. It should be stressed that there has never been a complete disappearance of the medium, despite the enormous technical progresses of tomography.[99]

The importance of stereoscopy for British radiography should be neither underestimated, nor reduced to its usefulness in medical diagnosis. Stereoradiography was also useful as a fashionable technique to collect and record information and to attract medical students and practitioners, as a means of self-promotion within the profession, and as a way to entertain and delight the eyes of even the most serious physicians. It satisfied the "desire to see beneath or around other bones and internal organs," one which, as Kevles has pointed out, could not have been fully satisfied with a flat picture.[100] Stereoradiography not only generated the three-dimensionality that X-rays were hitherto lacking, but also became an avatar of vision itself. The lack of interest radiographers had for understanding the physiological features of binocular vision explains why they were quite confident that stereoscopy was as "perfect as actual binocular vision" the same way an 1852 article could claim that stereoscopic vision "is but perfect vision."[101] Thanks to the pervading analogy between the human visual apparatus and the machine, stereoradiography seemed to provide something of a *truer* reality. Indeed, to make transparent the opacity of the human body, one needed an X-ray picture, but the latter remained a tangible object that mediated between sight and the tactile reality of the body's interior. One sees, at the same time, the picture as an object and the picture as a representation. On the contrary, stereoscopic pictures require an instrument for proper observation, in such a way that by peering *into* the device, the apparatus is itself unseen, as though no longer noticed. With stereoradiography, the apparatus has seemingly vanished, leaving one with the curious and fascinating impression that it is one's sight itself that penetrates the body, presaging our own comic-book fantasy of super-heroic X-ray vision as well as the real advancement and manifold application of virtual reality technology.

Notes

1 About Roentgen's discovery, see Glasser (1993), 1-46; Kevles (1997), 9–32.

2 Paraphrasing H. J. W. Dam to Roentgen, as cited in Natale (2011), 345. Lisa Cartwright has rightly stressed that the very significance of this discovery did not lie in the rays themselves, but in the images they could have produced. See Cartwright (1995), 111.

3 On the popularization of X-rays, see especially Kevles (1997); Natale (2011). About late nineteenth-century popular science, see notably Morus (2006); Morus (2010); Lightman (2012).

4 Numerous names were invented in English to describe the images produced by X-rays, such as roentgenography, skiagraphy, shadowgraphy, or radiography. While they were indifferently used until the late 1910s, the use of "radiography" progressively became the standard in Britain. See Glasser (1993), 231–232.

5 As a practitioner wrote in 1897, "[s]ight is a much more satisfactory agent of information than hearing or touch" (cited in Kevles (1997), 96). For a good, epistemologically oriented account on X-ray images, see Pasveer (2006).

6　Cited in Kevles (1997), 93. For an overview of the various cultural reasons explaining English practitioners' reticence toward the use of X-rays, see Lawrence (1985).

7　A list of the earliest articles on stereoradiography exemplifies how this solution arose in various countries at about the same time: Thomson (1896); Imbert and Bertin-Sans (1896); Czermak (1896); Mach (1896). The only valuable account on the early history of stereoradiography I have found is Lefebvre (1997). However, the following articles may shed further light: Van Tiggelen (2002); Keats (1964); Webb (1990), 94–103.

8　Of course, artificial stereoscopy can only approximately reproduce natural stereoscopy, as there are several factors featuring the latter that are not reproduced in the former—among them is the relationship between convergence and accommodation which is discussed later.

9　Case (1912b), 47.

10　About the history of nineteenth-century stereoscopy see notably Crary (1990), 116–136; Silverman (1993); Schiavo (2003), 113–138.

11　Gernsheim and Gernsheim (1969), 253–262; Gill (1969).

12　Wheatstone (1838),; Wheatstone (1852). About Wheatstone's physiological optics, see Bowers (2001), 44–54; Wade (1983), 29–39. On the prehistory of stereoscopic instruments, see Wade (1987).

13　Schiavo (2003), 129–130.

14　Anon (1898), 1697. See also Drouin (1896), 1.

15　Plunkett (2008), 239–240.

16　A short notice of the lecture appears in *The Lancet* 147, no. 3788 (April 4, 1896): 935. For Thompson's biography, see Thompson (1920); Burrows (1986), 30, 167–168.

17　Thomson (1896). The same article was also published in the American periodicals, *The Electrical Engineer* 21 (March 11, 1896), 256, and *The Electrical World* 27 (March 14, 1986), 280.

18　Thomson (1896).

19　Carlson (1991), 311–328. For a focus on the historical development of the X-ray tube, see Arns (1997).

20　Thompson (1920), 185.

21　Davidson (1896), 558. For Davidson's biographical elements, see Anon (1919), 338; Burrows (1986), 41, 98–99, 181–182.

22　Davidson (1896).

23　A short notice appears in *The Lancet* 147, no. 3786 (March 21, 1896): 795.

24　Davidson and Hedley (1897).

25　Ibid. Davidson and Hedley were acquainted at least since July 1897, as the former was a member of the editorial committee of the *Archives of the Roentgen Ray*, and the latter co-editor (*Archives of the Roentgen Ray* 2, no. 1 (1897): n.p.).

26　Davidson and Hedley (1897).

27　Ibid.

28 Hedley (1898).

29 Burrows (1986), 79.

30 Hedley (1898).

31 Ibid.

32 Ibid.

33 Davidson (1898a), 10.

34 Davidson (1898b), 1669–1671.

35 Davidson seems to have always considered that the two methods must be jointly used (see his later book, Davidson (1916)).

36 Hall-Edwards (1901b), 473 (my emphasis).

37 Davidson (1898b), 1669.

38 Anon (1898), 1697. In his 1926 book, Arthur W. Judge considers that the educational value of the stereoscope "is now becoming recognised" and "undoubtedly has a great future before it." (Judge (1926), 168).

39 Anon (1898), 1697.

40 Davidson (1898b), 1669.

41 Marsh (1898).

42 By 1900, Davidson claimed to have used stereoscopic pictures for no less than 250 cases. See Davidson (1900), 61. For reviews of the lectures, see notably *The Lancet* 151, no. 3898 (May 14, 1898): 1352; 152, no. 3909 (July 30, 1898): 302; 153, no. 3932 (Jan. 7, 1899): 29; 153, no. 3934 (Jan. 21, 1899): 163; 153, no. 3936 (Feb. 4, 1899): 304; 153, no. 3942 (March 18, 1899): 786; 153, no. 3952 (May 27, 1899): 1447; 157, no. 4054 (May 11, 1901): 1360; 159, no. 4112 (June 21, 1902): 1794; 161, no. 4148 (Feb. 28, 1903): 590.

43 A reviewer mentioned, "the beautiful stereoscopic method of Roentgen photography." (*The Lancet*, 161, no. 4148 (Feb. 28, 1903): 590).

44 Anon (1907).

45 Deane Butcher (1909), 219.

46 Deane Butcher (1909); Case (1912), 80.

47 Deane Butcher (1909), 219.

48 Shenton (1899), 18.

49 Deane Butcher (1909).

50 Hall-Edwards (1901), 1645.

51 "It is only necessary to look at two good stereoscopic skiagraphs in a *Wheatstone's stereoscope* to realise at once how thoroughly practical and important this method is in a surgical work." (Davidson (1898b), 1669).

52 Wheatstone (1852), 4 (my emphasis).

53 Wheatstone (1838).

54 Davidson (1898b), 1671. Kevles's statement that "the drawback of stereoradiology was the fact that many radiologists simply found it difficult to see through a stereopticon [so they] chose, instead, to simply cross their

eyes" (Kevles (1997), 69) is, as I hope this article will demonstrate, largely oversimplified.

55 Bailey (1912), 496 (my emphasis).

56 Davidson (1898b), 1671.

57 A reviewer mentioned the method in 1898 and admitted, "this is a knack which not everyone can acquire." (Anon (1898), 1698). Another said: "I can only say that I have tried in vain, and succeeded only in getting headache and a painful kind of ocular distress." (Cotton (1902), 28–29).

58 *The Lancet* 151, no. 3898 (May 14, 1898): 1352; 153, no. 3942 (March 18, 1899): 786; 153, no. 3936 (Feb. 4, 1899): 304; 153, no. 3932 (Jan. 7, 1899): 29; Anon (1899). The Wheatstone stereoscope was also represented in one of the four stereoscopic images in Davidson (1898b).

59 A whole chapter is dedicated to "Stereoscopes of Projection" in Drouin (1896), 81–89. For an account on stereoscopic methods of projection in the late nineteenth century, see Zone (2007), 53–72.

60 *The Lancet* 153, no. 3932 (Jan. 7, 1899): 29.

61 Case (1912a), 76. One may also find some mentions of the Wheatstone stereoscope in *The Lancet* 152, no. 3913 (Aug. 27, 1898): 558, and in Johnson (1902), 461; Cotton (1905), 218; Anon (1911), ; Knox et al. (1915), 7.

62 For the commercial adaptation, see notably the advertisements in the *Archives of the Roentgen Ray* 10 (1905): n.p.; 11 (1906): n.p.; 14 (1909): n.p.; 18 (1912): n.p.; and the reproduction in Judge (1926), 205.

63 According to James T. Case, "[t]he picture formed by the blending of the two images is more nearly life-size and life-like than with any available form of prism or lens stereoscope." (Case (1912a), 78).

64 Davidson (1915), 2. See also Davidson (1916), 19.

65 Arthur and Muir (1909), 127; Arthur and Muir (1917), 184.

66 Lawrence (1985).

67 Crary (1990), 129, 133.

68 Davidson (1916), 18–19.

69 Anon (1916), 164; Kaye (1918), 4. For other similar testimonies, see *The Lancet*, 161, no. 4148 (Feb. 28, 1903): 590; Hall-Edwards (1901a), 1646; Johnson (1902) 455; Judge (1926), 203. In his history of tomography, Steve Webb also maintains that Davidson was the "pioneer" of stereoradiography and the one who settled its "basic principles of viewing and measuring." (Webb (1990), 95, 102).

70 Anon (1919).

71 "The relation of the observer to the object is not one of identity but an experience of disjunct or divergent images" (Crary, 1990, 120). See also Crary's account on Johannes Müller's physiology (Ibid., 88–96)

72 Schiavo (2003).

73 Ibid., 116.

74 Silverman (1993), 734–42.

75 Cited in Ibid., 738.

76 Cited in Schiavo (2003), 126; Silverman (1993), 747.

77 Cited in Silverman (1993), 741.

78 Ibid., 747–754.

79 Hedley (1898).

80 Ibid.

81 Cazes (1895); Marie and Ribaut (1897).

82 Cazes (1895), 31–39.

83 Lenoir (1993), 109–153.

84 Case (1912a), 76.

85 Davidson (1898b), 1669. See also *The Lancet* 152, no. 3909 (July 30, 1898): 302; *The Lancet* 153, no. 3936 (Feb. 4, 1899): 304.

86 Davidson (1919), 340.

87 Davidson (1919), 340–341.

88 *The Lancet* 151, no. 3898 (May 14, 1898): 1352.

89 Cotton (1902), 28.

90 Case (1912a), 80.

91 Case (1912b), 47 (my emphasis).

92 Cited in Silverman (1993), 740 (my emphasis).

93 Kevles (1997), 95. See also Natale (2011), 349. According to Otto Glasser, this idea would have contributed to the early dismissal of radiography. See Glasser (1993), 43.

94 About early debates on the reliability of radiographs, see Golan (2004); Kevles (1997), 92–95.

95 Hedley (1898). See also *The Lancet* 161, no. 4148 (Feb. 28, 1903): 590; Bailey (1912),495; Cotton (1902), 26; Davidson and Hedley (1897); Halls-Dally (1903), : 1800; Case (1912a), 80.

96 Interestingly, in 1896, there was a terminological confusion: some of the first articles on radiography issued in *The Lancet* and *British Medical Journal* were entitled "new photography"(*The Lancet* 147, no. 3786 (March 21, 1896): 795–797; 147, no. 3787 (March 28, 1896): 875; 147, no. 3791 (April 25, 1896): 1159–1161; and *British Medical Journal* 1, no. 1840 (April 4, 1896): 874–876; 1, no. 1842 (April 18, 1896): 997–998).

97 Beck (1981), 890–891.

98 Van Tiggelen (2002), 266; Kevles (1997), 69.

99 Although most contemporary handbooks on medical imaging do not even mention stereoscopy, a few recent works have stressed the eventual benefits of the stereoscopic imaging. See Samei and Krupinski (2010), 87.

100 Kevles (1997), 107.

101 Cotton (1902), 28. As Davidson put it, with a stereoscope, the two retinal images "will combine (as usual) and give rise to a single image in perfect relief." See Davidson (1898b), 1671.

References

Anon. "Stereoscopic Photographs. The Application of Stereoscopy to Clinical Records." *British Medical Journal* 2, no. 1979 (December 3, 1898): 1697–1698.

Anon. "Skiagraphy and Stereoscopy." *The Lancet* 153, no. 3952 (May 27, 1899): 1447.

Anon. "Stereoscopic Skiagrams of the Coronary Arteries of the Human Heart under Normal and Pathological Conditions. By Professor F. Jamin and Dr. H. Merkel, of Erlangen. Published by Gustav Fisher, Jena [Review]." *Archives of the Roentgen Ray* 11, no. 11 (1907): 328.

Anon. "A Simple Method of Viewing Skiagrams Stereoscopically [Review]." *Archives of the Roentgen Ray* 16, no. 1 (1911): 39.

Anon. "The American Atlas of Stereoroentgenography [Review]." *Archives of Radiology and Electrotherapy* 21, no. 5 (October 1916): 164–165.

Anon. "Obituary: Sir James Mackenzie Davidson, M.B., C.M., Aberd." *Archives of Radiology and Electrotherapy* 23, no. 11 (April 1919): 337–340.

Arthur, David, and John Muir. *A Manual of Practical X-Ray Work*. New York: Rebman, 1909.

Arthur, David, and John Muir. *A Manual of Practical X-Ray Work*. London, UK: Heinemann, 1917.

Bailey, C. Fred. "Stereoscopic Radiography as a Routine Method of Examination." *British Medical Journal* 2, no. 2696 (August 31, 1912): 495–496.

Beck, Emil G. "Roentgenology 1910. Stereoscopic Radiography as Diagnostic Aid in Pulmonary Tuberculosis." *American Journal of Roentgenology* 137, no. 4 (January 10, 1981): 890–891 [originally published in *American Quarterly of Roentgenology* 2 (1910): 155–167].

Case, James T. "The Importance of Stereoradiography, Especially of the Alimentary Tract, with Demonstration of Plates." *Proceedings of the Royal Society of Medicine* 5 (1912a): 73–86.

Case, James T. "The Stereo-Roentgenography of the Stomach and Intestine." *Archives of the Roentgen Ray* 17, no. 2 (1912b): 46–48.

Cazes, Louis. *La Stéréoscopie de précision, théorie et pratique*. Paris, France: J. Michelet, 1895.

Cotton, William. "The True and the False Perspective of X-Ray Representation." *Archives of the Roentgen Ray* 7, no. 2 (1902): 25–34.

Cotton, William. "Twin X-Ray Representation and the Reflecting Stereoscope." *The Bristol Medico-Chirurgical Journal* 23 (1905): 216–222.

Czermak, P. "Prove stereoscopiche coi raggi di Röntgen." *Bullettino Della Società Fotografica Italiana* 8 (April 1896): 64–67.

Davidson, James Mackenzie. "The Position of a Broken Needle in the Foot Determined by Means of Roentgen's Rays." *British Medical Journal* 1, no. 1835 (February 29, 1896): 558.

Davidson, James Mackenzie. "Roentgen Rays and Localisation. An Apparatus for Exact Measurement and Localisation by Means of Roentgen Rays." *British Medical Journal* 1, no. 1931 (January 1, 1898a): 10–13.

Davidson, James Mackenzie. "Remarks on the Value of Stereoscopic Photography and Skiagraphy: Records of Clinical and Pathological Appearances." *British Medical Journal* 2, no. 1979 (December 3, 1898b): 1669–1671.

Davidson, James Mackenzie. "Observations on Practical X-Ray Work, With Exhibition of Apparatus and Stereoscopic Skiagrams." *Archives of the Roentgen Ray* 4, no. 3 (1900): 60–63.

Davidson, James Mackenzie. "The Principles and Practice of the Localization of Foreign Bodies by X Rays." *British Medical Journal* 1, no. 2818 (January 2, 1915): 1–5.

Davidson, James Mackenzie. *Localization by X Rays and Stereoscopy.* London, UK: H.K. Lewis, 1916.

Davidson, James Mackenzie. "Stereoscopic Radiography." *Archives of Radiology and Electrotherapy* 23, no. 11 (April 1919): 340–346.

Davidson, James Mackenzie, and William S. Hedley. "A Method of Precise Localisation and Measurement by Means of Roentgen Rays." *The Lancet* 150, no. 3868 (October 16, 1897): 1001.

Deane Butcher, William. "The Roentgen Society—The Amsterdam Congress." *Archives of the Roentgen Ray* 13, no. 8 (1909): 217–219.

Drouin, Félix. *The Stereoscope and Stereoscopic Photography.* Translated by Matthew Surface. Bradford, UK: Percy Lund, 1896.

Hall-Edwards, John. "The X Rays in the Diagnosis of Fractures." *British Medical Journal* 1, no. 2113 (June 29, 1901a): 1645–1646.

Hall-Edwards, John. "The Roentgen Rays in Military Surgery: Experiences in South Africa." *British Medical Journal* 2, no. 2121 (August 24, 1901b): 471–474.

Halls-Dally, J. F. "On the Use of the Roentgen Rays in the Diagnosis of Pulmonary Disease." *The Lancet* 161, no. 4165 (June 27, 1903): 1800–1806.

Hedley, William S. "Radiostereoscopy." *The Lancet* 151, no. 3888 (March 5, 1898): 639.

Imbert, Armand, and Henri-Jules Bertin-Sans. "Photographies stéréoscopiques obtenues avec les rayons X." *Comptes rendus des séances de l'Académie des sciences* 122 (March 30, 1896): 786.

Johnson, Alexander B. "Stereoscopic Radiography." *Annals of Surgery* 35, no. 4 (1902): 455–466.

Judge, Arthur W. *Stereoscopic Photography. Its Application to Science, Industry and Education.* London, UK: Chapman & Hall, 1926.

Kaye, G. W. C. "X-Rays and the War." *The Journal of the Röntgen Society* 14 (January 1918): 2–17.

Knox, Robert, W. Hampson, Freak Harwood-Hardmann, Thomas Clark, and A. C. Jordan. "Discussion on the Localisation of Foreign Bodies by X-Rays." *Journal of the Röntgen Society* 11 (January 1915): 6–20.

Mach, Ernst. "On the Stereoscopic Application of Roentgen's Rays." *The Monist* 6, no. 3 (April 1896): 321–323.

Marie, Théodore, and Henri Ribaut. "Stéréoscopie de précision appliquée à la radiographie." *Archives de physiologie normale et pathologique* [Serie 5] 9 (1897): 686–697.

Marsh, Howard. "A Case of Bullet Wound of the Leg, in Which the Bullet Was Located by Skiagraphy." *British Medical Journal* 2, no. 1979 (1898): 1671.

Samei, Ehsan, and Elizabeth Krupinski, eds. *The Handbook of Medical Image Perception and Techniques*. Cambridge, UK: Cambridge University Press, 2010.

Shenton, E. W. H. "A Simple Method of Localizing by Roentgen Rays." *Archives of the Roentgen Ray* 4, no. 1 (1899): 18–19.

Thomson, Elihu. "Stereoscopic Röntgen Pictures." *The Electrician* 36, no. 20 (March 1896): 661–662.

Wheatstone, Charles. "Contributions to the Physiology of Vision.--Part the First. On Some Remarkable, and Hitherto Unobserved, Phenomena of Binocular Vision." *Philosophical Transactions of the Royal Society of London* 128 (1838): 371–394.

Wheatstone, Charles. "The Bakerian Lecture--Contributions to the Physiology of Vision.--Part the Second. On Some Remarkable, and Hitherto Unobserved, Phenomena of Binocular Vision (Continued)." *Philosophical Transactions of the Royal Society of London* 142 (1852): 1–17.

Secondary literature

Arns, Robert G. "The High-Vacuum X-Ray Tube: Technological Change in Social Context." *Technology and Culture* 38, no. 4 (October 1, 1997): 852–890.

Bowers, Brian. *Sir Charles Wheatstone FRS, 1802–1875*. London, UK: Institution of Electrical Engineers, 2001 [originally published in 1975].

Burrows, Edmund H. *Pioneers and Early Years: A History of British Radiology*. St Anne, Alderney, Channel Islands: Colophon, 1986.

Carlson, W. Bernard. *Innovation as a Social Process: Elihu Thomson and the Rise of General Electric, 1870–1900*. Cambridge, MA: Cambridge University Press, 1991.

Cartwright, Lisa. *Screening the Body: Tracing Medicine's Visual Culture*. Minneapolis, MN: University of Minnesota Press, 1995.

Crary, Jonathan. *Techniques of the Observer: On Vision and Modernity in the Nineteenth Century*. Cambridge, MA: MIT Press, 1990.

Gernsheim, Helmut, and Alison Gernsheim. *The History of Photography from the Camera Obscura to the Beginning of the Modern Era*. London, UK: Thames & Hudson, 1969.

Gill, A. T. "Early Stereoscopes." *The Photographic Journal* 109 (1969): 546–559, 606–614, 641–651.

Glasser, Otto. *Wilhelm Conrad Röntgen and the Early History of the Roentgen Rays*. San Francisco, CA: Norman, 1993 [originally published in 1933].

Golan, Tal. "The Emergence of the Silent Witness: The Legal and Medical Reception of X-Rays in the USA." *Social Studies of Science* 34, no. 4 (August 1, 2004): 469–499.

Keats, Theodore. "Origins of Stereoscopy in Diagnostic Roentgenology." In *Classic Descriptions in Diagnostic Roentgenology*, edited by André Johannes Bruwer, 983–986. Springfield, IL: C. C. Thomas, 1964.

Kevles, Bettyann. *Naked to the Bone: Medical Imaging in the Twentieth Century*. New Brunswick, NJ: Rutgers University Press, 1997.

Lawrence, Christopher. "Incommunicable Knowledge: Science, Technology and the Clinical Art in Britain 1850–1914." *Journal of Contemporary History* 20, no. 4 (1985): 503–520.

Lefebvre, Thierry. "Les reliefs de l'invisible." *1895, revue d'histoire du cinéma* 1, no. 1 (1997): 83–92.

Lenoir, Timothy. "The Eye as Mathematician. Clinical Practice, Instrumentation, and Helmholtz's Construction of an Empiricist Theory of Vision." In *Hermann von Helmholtz and the Foundations of Nineteenth-Century Science*, edited by David Cahan, 109–153. Berkeley, CA: University of California Press, 1993.

Lightman, Bernard. "Victorian Science and Popular Visual Culture." *Early Popular Visual Culture* 10, no. 1 (2012): 1–5.

Morus, Iwan Rhys. "Seeing and Believing Science." *Isis* 97, no. 1 (2006): 101–110.

Morus, Iwan Rhys. "Worlds of Wonder: Sensation and the Victorian Scientific Performance." *Isis* 101, no. 4 (2010): 806–816.

Natale, Simone. "The Invisible Made Visible: X-Rays as Attraction and Visual Medium at the End of the Nineteenth Century." *Media History* 17, no. 4 (2011): 345–358.

Pasveer, Bernike. "Representing or Mediating. A History and Philosophy of X-Ray Images in Medicine." In *Visual Cultures of Science: Rethinking Representational Practices in Knowledge Building and Science Communication*, edited by Luc Pauwels, 41–62. Hanover, NH: Dartmouth College Press, 2006.

Plunkett, John. "Selling Stereoscopy, 1890–1915: Penny Arcades, Automatic Machines and American Salesmen." *Early Popular Visual Culture* 6, no. 3 (2008): 239–255.

Samei, Ehsan, and Elizabeth Krupinski, eds. *The Handbook of Medical Image Perception and Techniques*. Cambridge, UK: Cambridge University Press, 2010.

Schiavo, Laura B. "From Phantom Image to Perfect Vision: Physiological Optics, Commercial Photography, and the Popularization of the Stereoscope." In *New Media, 1740–1915*, edited by Lisa Gitelman and Geoffrey B. Pingree, 113–138. Cambridge, MA: MIT Press, 2003.

Silverman, Robert J. "The Stereoscope and Photographic Depiction in the 19th Century." *Technology and Culture* 34, no. 4 (1993): 729–756.

Thompson, Jane Smeal Henderson. *Silvanus Phillips Thompson, D.SC., LL.D., F.R.S.; His Life and Letters*. New York: E. P. Dutton., 1920.

Turner, Roy Steven. *In the Eye's Mind: Vision and the Helmholtz-Hering Controversy*. Princeton, NJ: Princeton University Press, 1994.

Van Tiggelen, René. "In Search for the Third Dimension: From Radiostereoscopy to Three-Dimensional Imaging." *JBR-BTR: Organe de La Société Royale Belge de Radiologie (SRBR) = Orgaan van de Koninklijke Belgische Vereniging Voor Radiologie (KBVR)* 85, no. 5 (2002): 266–270.

Wade, Nicholas J. *Brewster and Wheatstone on Vision*. London, UK: Experimental Psychology Society, 1983.

Wade, Nicholas J. "On the Late Invention of the Stereoscope." *Perception* 16, no. 6 (1987): 785–818.

Webb, Steve. *From the Watching of Shadows: The Origins of Radiological Tomography*. Bristol, UK: Adam Hilger, 1990.

Zone, Ray. *Stereoscopic Cinema and the Origins of 3-D Film, 1838–1952*. Lexington, KY: University Press of Kentucky, 2007.

Art in the Service of Medical Education:
The 1939 Dickinson–Belskie *Birth Series* and the Use of
Sculpture to Teach the Process of Human Development
from Fertilization through Delivery

Rose Holz

One might easily assume that our understanding of the body, health, and disease—or, in the present case, the start of life and the processes of embryonic development, pregnancy, and birth—are 'natural' processes revealed by scientific inquiry. It is, however, also constructed, (re)presented, and modeled by humans who use such constructs, representations, and models to disseminate it as knowledge. As this chapter makes clear, the set of sculptures known as *The Birth Series* (c. 1939, Figures 6.1–6.9), created by Dr. Robert L. Dickinson and Abram Belskie, participated in the shift from nineteenth-century conceptualizations of pregnancy to those that had emerged by the latter third of the twentieth. As Leslie Reagan has noted, the nineteenth-century notion of 'quickening'—the moment when a pregnant woman first feels movement inside her womb—as the start of life continued to hold sway well into the early twentieth century, despite the medical profession's efforts to convince women otherwise. Likewise, pregnancy was still largely regarded as a woman's experience with what grew inside her womb, not as two separate biological identities that existed from conception forward.[1] However, by the latter third of the twentieth century, both notions had eroded dramatically. As Sara Dubow noted in describing the rise of fetal medicine in the 1970s, pregnancy no longer involved only two people (doctor and woman)—a third (the fetus) had entered the equation, affecting the choices women had/made in their pregnancies as well as the care they received.[2]

Certainly, the reasons for this shift are complex and overdetermined, rooted equally in social, medical, and technological changes as historians such as Ziv Eisenberg have shown.[3] For the present volume, however, I will focus on how we have come to *visualize* the contents of a woman's womb. To that end, following the lead of Rosalind Petchesky and Barbara Duden, feminist scholars have pointed squarely to embryonic/fetal photography in the 1960s—appearing in such widely popular books as Geraldine Lux Flanagan's *The First Nine Months of Life* (1962) or Lennart Nilsson's *A Child Is Born* (1965)—as the moment when the visual shift first took hold.[4] As Lisa Wade wrote describing Nilsson's work,

His pictures made it possible for people to visualize the contents of a woman's womb independently of her body. Suddenly, the fetus came to life. It was no longer just something inside of a woman, no longer even in relationship to a woman; it was an individual with a face, a sex, a desire to suck its thumb.[5]

The visual process was, however, well under way before the 1960s and 1970s. *The Birth Series* sculptures, created by Dr. Robert L. Dickinson and Abram Belskie, debuted in 1939 and were widely reproduced and disseminated in the decades thereafter to lay and professional audiences in the United States and abroad. The imagery found in Flanagan's and Nilsson's photography was, therefore, not entirely new.

Furthermore, *The Birth Series* changed the visual narrative that had been in place in the 1930s. By then there was certainly already a long history of representing and displaying the contents of a pregnant womb. While Karen Newman traced this phenomenon back to religious/anatomical art of the ninth century, Nick Hopwood described the rise of wax and marble embryonic models in the nineteenth.[6] Additionally, Lynn Morgan and Catherine Cole uncovered the massive collection and display of *real* embryos and fetuses in public exhibits and medical teaching institutions in the USA during the first half of the twentieth century.[7] But, it was *The Birth Series* that introduced something entirely new—the product of Dickinson's missionary-like zeal to put "art in the service of medical education."[8]

Dickinson (1861–1950) was a prominent and well-published American gynecologist, obstetrician, and sexologist, who practiced from the late nineteenth through the early twentieth centuries. Although most usually known for his involvement in the early twentieth-century birth control movement (in the organization now known as Planned Parenthood), we have yet to appreciate fully the complexity of his long and productive career, despite the fact that such notable sexologists as Alfred Kinsey and Masters and Johnson considered themselves deeply indebted to him.[9] More significantly still, none of this scholarship examines directly the artistic aspect of his scientific legacy.[10]

This chapter seeks, therefore, to begin filling in these historiographic gaps, in part by examining Dickinson as a medical artist, highlighting not only his call for physicians to be trained in the art of drawing and illustration, but also his belief in the value of art in lay public health education. Then, as illustration of the significance of his artistic contributions, it turns to the culmination of Dickinson's career with the creation of his hugely influential *Birth Series*, a set of sculptures he made with Abram Belskie (1907–1988), which model the process of human development from fertilization through delivery. Commissioned by the Maternity Center Association for an exhibit on women's health and reproduction at the 1939–1940 World's Fair in New York City, the sculptures were immensely popular and subsequently reproduced in a variety of forms and sent out to health museums and medical teaching institutions across the nation and abroad for several decades after their debut.[11]

In telling this story, I illuminate the importance of twentieth-century artists in crafting, and then disseminating, new medical knowledge to professional

and lay audiences, a tale often reserved for medical artists of centuries past.[12] Although the sculptor Belskie has been much neglected by scholars, his collaboration with Dickinson—in *The Birth Series* in 1939 and *The Sculptured Teaching Models* collection produced in the ten years thereafter—helped shape modern day obstetrics and knowledge about sexual health and education.[13] Dickinson, too, was a deeply creative man. Although a physician and scientist, he sketched, colored, and painted obsessively. Not content to use art solely to enliven his private life, he also used it and advocated for its use to better the science and medicine in which he engaged. In short, for Dickinson there was no line that divided the scientific from the artistic, the written word from the pictorial representation. In this he was of similar mind to Dr. Jean-Martin Charcot (1825–1893), whose embrace of art and medical science is discussed at length by Natasha Ruiz-Gómez in chapter 9 of the present volume. For Dickinson, too, it all worked together seamlessly—and unapologetically. To appreciate him in this regard is to do justice to what he once said: "You see, I am really twins—doctor and artist—and I defy you to tell me apart."[14]

However, in telling this story, I also demonstrate how a dramatic new narrative about *in utero* human development was born. Indeed, in the generations preceding the sculptures' 1939 debut, depictions of this process embodied a tone of dispassionate science or grotesque morbidity, as they were often modeled after dissected cadavers. This was not so, however, with Dickinson and Belskie's sculptures. Instead, they represented a crucial shift in visualization of the process, from depicting figures modeled on the inert and dead, to ones modeled after alert and alive subjects, producing a compelling new story about human development that audiences loved. Part of the appeal was the practical story the series told about the mechanics of reproduction. Combining art with the latest in scientific knowledge and technology, Dickinson and Belskie gave audiences a view of something with which most were familiar but had never seen: what happens inside a pregnant woman's body from the moment of fertilization through delivery. The hidden mysteries of humans' biological bodies had become remarkably visible. However, there was something else buried within the aesthetic of *The Birth Series* that captivated audiences. The sculptures modeled a romantic story of *in utero* development that began at the moment of conception, featured a humanized fetus, and culminated in the birth of a sweet and innocent child. Thus, not only did Dickinson and Belskie shape modern gynecological education for aspiring practitioners while educating ordinary Americans in matters of public health and pregnancy, but they also inadvertently articulated over three decades in advance the imagery that would become the hallmarks of the modern pro-life movement.

Dr. Robert L. Dickinson: Physician, Scientist, Artist

Dr. Robert L. Dickinson was born in 1861 in Jersey City, New Jersey. He studied for four years in Switzerland and Germany before earning his medical degree

in 1882 from the Long Island College Hospital. Dickinson led a distinguished career in obstetrics and gynecology and in service to his profession. He also authored numerous books and articles—largely about contraception and sexuality—and he threw himself into a variety of causes around these two themes, most famously the birth control movement, eventually serving on Planned Parenthood's board of directors and as its vice president. Throughout his career, Dickinson was nonetheless deeply engaged in the arts. He illustrated walking guides for the state of New York and Palisades Park, designed book-plates for individuals and organizations, and even drafted the architectural design for his summer home on Long Island. In fact, when he was still a young man, Dickinson had turned down a position with a lithography firm to attend medical school. Moreover, while in medical school, his drawings so impressed one of his instructors, Dr. Alexander Skene, that he asked Dickinson to provide the illustrations that appeared in Skene's 1888 *Treatise on Diseases of Women*, a gynecology textbook that dominated the American market for a decade.[15]

Notably, throughout his career, Dickinson was interested in the intersection between medicine, science, and art, and as a gynecologist and obstetrician, he was a practitioner of all three. For example, during his forty years as a practicing physician, drawing was central to the thousands of case histories he recorded of the women who consulted him for their medical needs. In addition to written notes, Dickinson complemented each case history with sketches of his patients' sexual anatomy in which he noted the size, color, and shape of their genitalia as well as any anomalies he found. Later, to facilitate this process, he developed other techniques. First, he created a basic rubber stamp outline of women's sexual anatomy, which he could quickly individu-alize with additional sketching and coloring. He even turned to photography, and with a well-positioned camera secretly hidden in a flowerpot in his office, quickly captured the images he needed to supplement his written notes.[16] Today, such a camera technique would arouse more than a little controversy, and Dickinson did not mention it in the artistic advice he would later give his medical peers. He, nevertheless, managed to combine his artistic and medical interest in anatomy and sexuality without upsetting too many people. As historian James Reed noted, perhaps it was Dickinson's high standing in the medical and social community, as well as his "Christian gentleman" approach, that enabled him to carry out his work without the taint of salaciousness.[17] Furthermore, Dickinson sincerely believed he was simply doing his medical duty, using his skills as an artist to capture all that he observed as a scientist.

His publications, moreover, reflect a similarly visual inclination. *Control of Conception*, for example—his 1930s manual of reproductive technology that educated the medical profession on the birth control techniques then available—was replete with images. First published in 1931 and revised under another title thereafter, it not only illustrated the different kinds of birth control methods, but also gave visual representations of women's and men's reproductive anatomies.[18] Dickinson's *Human Sex Anatomy* was equally pictorial. First published in 1933 and revised in subsequent years, it provided

laboriously detailed drawings of women's and men's sexual anatomies—in all shapes, sizes, and varieties.[19]

Thus, by the mid-1930s Dickinson was devoted to bridging the worlds of science and art, and he was making it clear that the entire medical profession needed to follow his lead. To that end, he gave talks with titles like "What Medical Authors Need to Know About Illustrating," as he did before the Charaka Club in New York City. There he extolled the virtues of sketching, drawing, and coloring as important skills for doctors to have; he also offered advice in how best to develop these skills—and what pitfalls to avoid.[20] The use of art, he believed moreover, made better patients.[21] For example, when describing in a 1939 article in the *Journal of Contraception* the value of wall charts and models in teaching women how to insert a diaphragm, Dickinson was "struck by the intelligence of the questions" the female patients asked when such visual aids were available, and he marveled at their desire to practice repeatedly this new skill they were learning.[22]

Not surprisingly, the medical art he lauded was rather literal, hardly the expressionistic or abstract variety found among *avant garde* modernism of the 1920s and 1930s. In a 1933 issue of the *American Journal of Cancer*, Dickinson stressed the need for precision:

For sheer definitiveness, no record of physical findings competes with the diagram or picture made to scale. Words cannot equal pictures for visualizing conditions or for forcing the observer to be exact in his statements. Therefore, such use should be fostered. Diagrams should be life size. Entries should be the result of measurements. Colored pencils make for clarity. Reductions do not give adequate values. They are unconsciously misleading in bulk and dimensions. They are abstractions.[23]

He seemed equally convinced that drawing could capture an objective reality free from subjective interpretation. However, these are problematic assumptions to which we later turn.[24]

The Maternity Center Association, Abram Belskie, and the Birth of *The Birth Series*

It was during the 1930s when Dickinson's zeal to proselytize the educational power of science and art intersected with the Maternity Center Association's efforts to educate the public about women's health and reproduction. According to historians Laura E. Ettinger and Ziv Eisenberg, the Maternity Center Association (MCA) was a classic product of the Progressive Era movement for infant and maternal welfare reform. Founded in 1918 by obstetricians, social reformers, and public health nurses in New York City, its purpose was to provide maternity care education in the hopes of reducing the high infant and maternal mortality rates that plagued the nation. Its work had consisted of classes for expectant mothers, but, by the 1920s, the MCA began to publish maternity care handbooks. By the 1930s, it had established a nurse-midwifery clinic and

school and broadened its public educational efforts by setting up exhibits at two World's Fairs—Chicago in 1933 and New York City in 1939–1940.[25]

The MCA's first display at the 1933 World's Fair was designed to educate the public about what it called "the entire maternity period"—from the moment a woman was aware of her pregnancy through six weeks after she delivered. The goal was to encourage medical supervision throughout the pregnancy and not merely at the moment of delivery. As an illustration of the mindset the MCA hoped to change, the organization repeated a common refrain in its 1933 report, "My mother had eight children and never saw a doctor until the baby came." The exhibit, in turn, was to use visual aids to emphasize, and get people talking about, just how much happens inside a woman's body before birth takes place. To that end, it featured a series of 18 pictures demonstrating proper maternity care techniques and a quaintly decorated nursery complete with white organdy curtains, stenciled ducks, and a cabinet and bath table constructed from cardboard boxes. Declaring the installation a great success, the organization pronounced it "made a decided impression" on those "who are still whispering 'she's going to have a baby.'"[26] However, while earnest in its message, the Chicago exhibit offered little in the way of explaining the mechanics of reproduction. Indeed, it would be Dickinson's desire to depict "how babies come" that later stole the show at the 1939–1940 World's Fair in New York City.[27]

Whether he realized it or not, Dickinson had been working towards such a sculptural display for years, as is revealed in the extensive sourcebooks he meticulously kept for decades of his scientific research. Now rebound and housed in the Rare Book Room of the New York Academy of Medicine, they vividly demonstrate how, in addition to his interests in contraception and human sex anatomy, he was consumed with the study of embryonic development.[28] Like Charcot at Salpêtrière, as discussed by Ruiz-Gómez in Chapter 9, Dickinson was a prolific scrapbooker who supplemented the clinical data derived from his private practice patients with clipped articles from medical journals and notes taken on the images and information he found. He also drew extensively—contraceptive devices, women's and men's sexual and reproductive anatomies, as well as countless versions of *in utero* development. Moreover, tracing, in particular tracing over X-rays, was an important method in his scientific–artistic process, for it facilitated clear linear drawings, useful for illustrations and sculptural models of messy anatomical interiors.[29]

Consequently, when Dickinson was asked to serve on the planning committee for the MCA's exhibit at the 1939–1940 World's Fair in New York City, he was well poised to make his dramatic sculptural contribution.[30] A massive undertaking, however, this was not a task Dickinson could complete alone. He made the first five sculptures mostly on his own, but with some assistance from another physician–medical artist, Dr. Vladimir Fortunato, whose name appears on the fourth of these early figures. Done in bas relief, they begin with a visual representation of a woman's reproductive anatomy and then move on to illustrate the process of fertilization and early embryonic/fetal

development through the first four and a half months. It was at this point, though, that Dickinson sought additional help. This may, in part, have been because Fortunato could no longer assist due to failing health and/or death (Dickinson described him as "the late" Fortunato when crediting him in the *Birth Atlas*).[31] But it was certainly also true that Dickinson's grand vision was beginning to outmatch his own artistic ability and physical endurance. Not only did he lack formal training in sculpture, but the work is physically demanding and Dickinson was nearly 80.[32] Thus, the sixth sculpture marks the arrival of the sculptor Abram Belskie's talented, young hand—he having been introduced to Dickinson through a mutual friend, the master sculptor, Malvina Hoffman. The next few months saw Dickinson and Belskie—along with two other medical artists who assisted with sketching (Emily Freret and Frances Elwyn)—working feverishly to have the full series ready for the April 30th opening of the 1939 World's Fair.[33] They almost succeeded. By May 19, eighteen had been delivered and on display, three more were ready, and four "nearly finished," as Dickinson reported with characteristic exactitude to the MCA's director, Hazel Corbin.[34] With the arrival of Abram Belskie, *The Birth Series* had finally quickened.

Admittedly, Dickinson's research interests initially put off Belskie. As the sculptor recalled in an interview several years before his death,

> When I looked beyond the door [of Dickinson's New York Academy of Medicine office], my first impulse was to get the heck out of there. This was something that I never saw before. They were painting something to do with genitalia.[35]

Indeed, Belskie's path hardly prepared him for the subjects he would take on with Dickinson. He had been born Abraham Belskie on March 24, 1907, to Russian Jews who had settled in Scotland. Creative from the start, he earned his degree from the Glasgow School of Art. In 1929, the 22-year-old Belskie set sail for America, eventually landing in Closter, New Jersey, where he found work with several sculptors, among them John Gregory and Malvina Hoffman, who would later put Belskie and Dickinson together.[36]

Up until his collaboration with Dickinson, however, Belskie had little interest in medical art. He had worked with a handful of other artists creating a variety of works. Some depicted scenes from mythology, others from Shakespearean plays. His first publicly exhibited work was *The Christ Child* (1933).[37] Little wonder, then, his initial shock upon learning Dickinson's research interests. Nevertheless, he and Dickinson hit it off, despite Belskie's initial concern and Dickinson's reputation for being a notorious perfectionist. Indeed, it is a marvel what they managed to accomplish together, and so quickly: first *The Birth Series*, and then over 100 additional medical teaching models in the decade that followed. In short, a real camaraderie and a genuine creative trust existed between them. As Dickinson wrote in a letter to Belskie in 1945, "In the long lifetime of team-work and with some remarkable chiefs, colleagues, and assistants, I am wondering whether any of these numerous collaborations has been happier, more productive than our years together."[38]

However, while Dickinson relied heavily on Belskie's skills as a sculptor to carry out his artistic vision, Dickinson also made direct use of the latest technology, using X-rays to capture another essential feature to which five of *The Birth Series* sculptures were devoted, the active stages of delivery. As Dickinson well understood, previous knowledge about *in utero* development had been derived from the dead—pregnant cadavers as well as the embryonic and fetal remains of miscarriages, abortions, and hysterectomies.[39] Prompted by the brilliant suggestion made by the MCA's Hazel Corbin to include a birth sequence in the series, he found it necessary to replace the cadaverous sources with what he called "the alert upstanding tensions of the living." He enlisted the help of his colleagues at prominent hospitals (Johns Hopkins, Sloane, Bronx, Harlem, and New Haven), who allowed him to conduct thousands of X-rays on pregnant women, perhaps during their pregnancies, but certainly as they delivered their babies.[40] Of course, it is difficult to imagine today, but periodic X-rays on pregnant women were routine at the time, and it was not until 1956 that Dr. Alice Stewart sounded the alarm about their potentially ill effect on *in utero* development.[41]

In the end, it was a moment of creative, artistic inspiration—one born of many minds and carried out by many bodies. With X-rays in hand, tracings were made and sketches developed—whereupon *The Birth Series* sculptures were beautifully created and lovingly delivered. It is little wonder that 'the babies', as the sculptures were often called, looked so alive.[42]

The Birth Series as Visual Meditation

6.1 *Birth Atlas* (1940), Plate 3, *Travel of Egg: Ovulation to Nidation.*

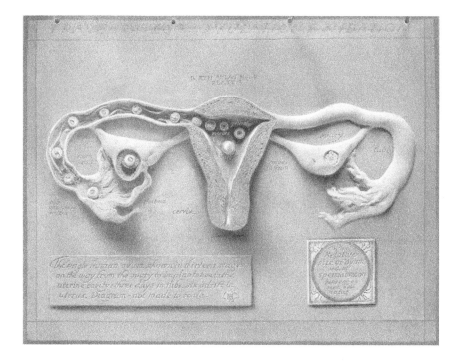

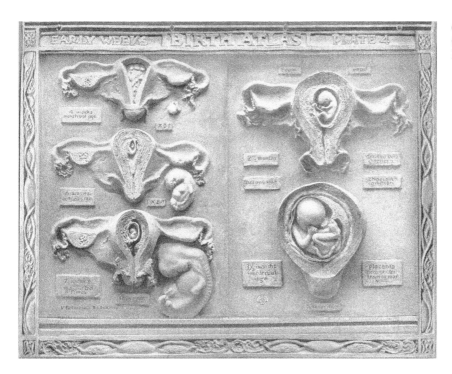

6.2 *Birth Atlas* (1940), Plate 4, *Early Weeks*.

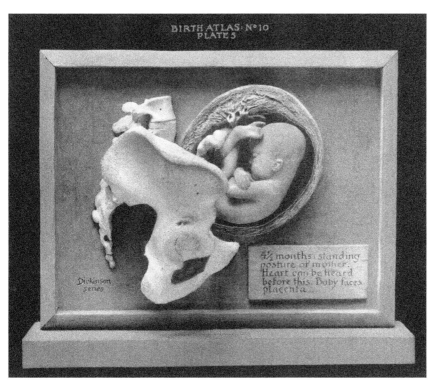

6.3 *Birth Atlas* (1940), Plate 5, *4½ Months, Standing Posture of Mother.*

6.4 *Birth Atlas*
(1940), Plate 7,
Seventh Month:
Placenta Opposite
Baby.

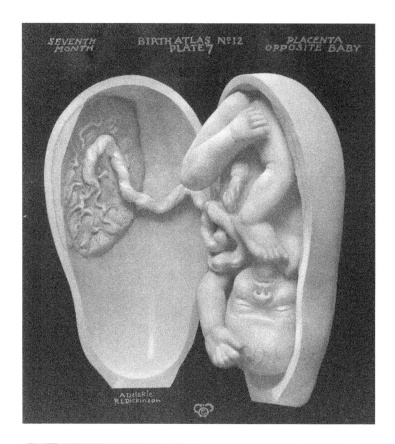

6.5 *Birth Atlas*
(1940), Plate 8,
Before Labor.

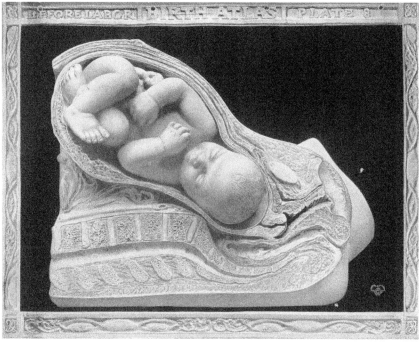

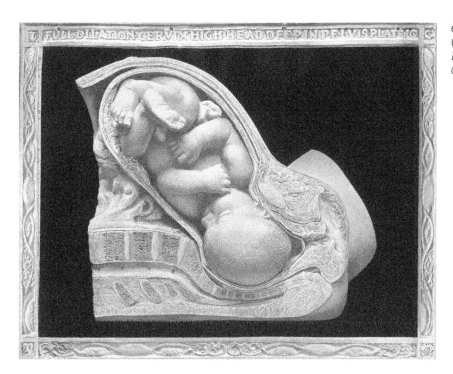

6.6 *Birth Atlas*
(1940), Plate 10,
*Full Dilation of
Cervix.*

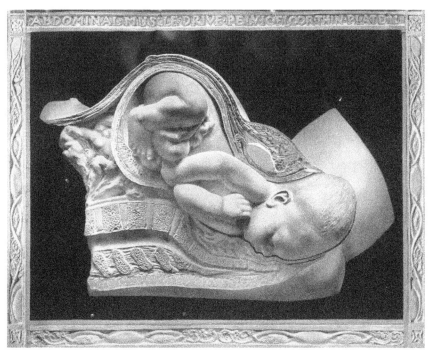

6.7 *Birth Atlas*
(1940), Plate 11,
*Abdominal Muscle
Drive.*

6.8 *Birth Atlas*
(1940), Plate 12,
Head Turns Upward.

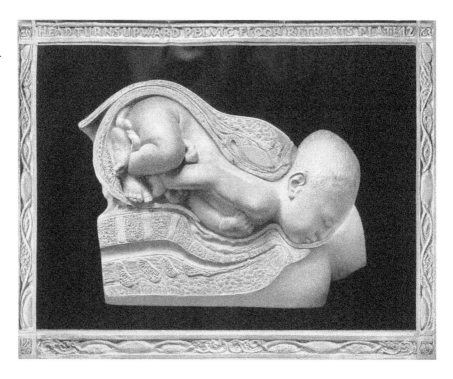

6.9 *Birth Atlas*
(1940), Plate 13
*Birth of Shoulders
Rotation.*

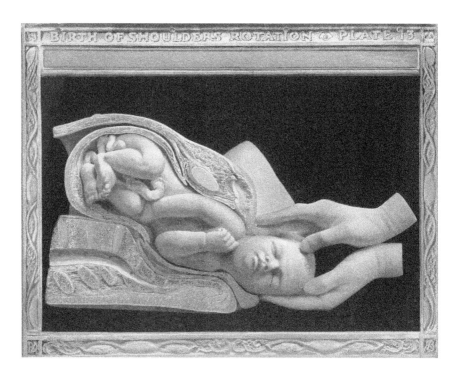

The Birth Series 1939 Debut and Their Mass Distribution in the Decades Thereafter

Much to the delight of the MCA, its exhibit at the 1939–1940 World's Fair in New York City, which now included the Dickinson–Belskie *Birth Series*, was far more successful than the one in Chicago in 1933. Housed in the "Hall of Man," it was accompanied by other exhibits, such as *The Transparent Man*, a model created in the 1920s by the world-renowned Deutsches Hygiene Museum that illustrated the workings of the human body through transparent skin and illuminated organ systems. Notably, such three-dimensional installations (including the one commissioned by the MCA) reflected the influence of the German visual health museum movement pioneered in the 1920s, which was increasingly popular among health educators and museums in 1930s America.[43] However, *The Birth Series* was, to use the MCA's words, the *pièce de résistance*. Wildly popular, the installation attracted long lines of visitors every day from ten in the morning to ten at night. Neither rain nor shine stopped the crowds from coming.[44] In fact, so well attended was the exhibit—700,000 people had viewed it in 1939 alone—that it prompted more than a few complaints from fair organizers and fellow exhibitors who claimed that the MCA installation prevented people from visiting other exhibits.[45] When reassembled in 1940 for the second year of the New York City World's Fair, the exhibit underwent several changes. However, *The Birth Series* sculptures (of which there were now two sets) remained the star attraction.[46]

The reaction from the fair-going crowds, moreover, was overwhelmingly favorable—much to the relief of the MCA. "It was not without qualms that we decided to display the sculptures," noted the organization. The MCA had good cause to be concerned. Only recently had the New York State Board of Regents banned the showing of the film *The Birth of the Baby*, deeming it "indecent, immoral, and tending to corrupt public morals," a decision that was upheld by the courts. But not so with the 1939–1940 New York City World's Fair exhibit that featured *The Birth Series*. As the MCA further remarked,

Mothers and fathers brought their children and explained to them the process of childbirth. They were extremely grateful to have finally found something that helped them to answer adequately their children's questions about babies. School teachers brought their pupils. Instructors in schools of nursing brought student nurses. Graduate students in public health administration courses at Columbia, Yale, and New York Universities came in groups to view the exhibit. Doctors sent their patients. Ministers sent their parishioners, young and old. Many of the men and women who saw the exhibit insisted that other members of their families come to see it.[47]

Similar enthusiasm was expressed when the sculptures were later exhibited elsewhere. For example, in 1941 Ruth Perkins Kuehn (Dean of the University of Pittsburgh's School of Nursing) noted how husbands and wives (expectant and otherwise), high-schoolers, college students, student nurses, practical nurses, doctors, teachers, clubwomen, and ministers had come to see the

sculptures in the university's "Dawn of Life" exhibit. She then described the many positive comments they had received. "Many women who have had babies were very much interested," she wrote. To which she added, "They could not understand how they could have had children without knowing how the process took place." Indeed, their many questions were decidedly practical. Among the questions that were frequently asked were, "What is the bag of water? Why is the baby's head out of shape when it is born? Why do the feet come first sometimes? Does the doctor shape the baby's head after birth? How do twins grow in the mother's body? How long is the cord? Why can some women not have babies? Does the baby change its position during the nine months before birth?"[48]

There were, of course, the few who disapproved. As Kuehn described, one woman "thought it was terrible to embarrass young girls who might wander into the exhibit with their boyfriends," only to find they were not embarrassed, thus prompting her to announce they "had no 'shame.'" Kuehn also recounted how another female teacher worked hard to keep the several dozen teenage girls she had brought to the museum from seeing the models and repeatedly "reprimanded" them. However, most appreciated what they saw and were deeply grateful for what they had learned.[49]

Hence, the purpose of *The Birth Series* sculptures once the 1939–1940 World's Fair was over: to be mass reproduced in a variety of forms to educate the lay public and medical professionals across the United States and the globe about the mechanics of human reproduction. Demand was great and orders placed in abundance. The sculptures themselves were much desired. During the winter months of the fair's offseason, the set displayed at the fair was exhibited at New York City's Museum of Natural History. Another set made its way to the offices of the MCA.[50] More sets went to medical and public health institutions across the country—in Flint (MI), Madison (WI), Cleveland (OH), and Chicago (IL).[51] By the 1950s still another set made its way to the University of Nebraska State Museum.[52] Even commercial interests saw use for *The Birth Series* sculptures.[53] So great was the demand for copies of *The Birth Series* sculptures (along with what was becoming the massive Dickinson–Belskie *Sculptured Teaching Models* collection) that the MCA handed the entire collection over to the Cleveland Health Museum to whom Dickinson had in 1945 granted all rights to reproduce and sell the sculptures, which it did for decades.[54]

However, most people's knowledge about, and use of, the sculptural imagery came through the *Birth Atlas*, a 22 × 17½-inch manual put out by the MCA that depicted the entire *Birth Series* using photography and line plate drawings.[55] Immensely popular, the *Birth Atlas* ultimately went through six editions (with many reprints of each) from 1940 through the 1960s.[56] In 1957, the MCA put out a smaller, updated follow-up, *A Baby Is Born: The Picture Story of Everyman's Beginning*, the central feature of which remained the photos of *The Birth Series*.[57]

In other words, whatever their form, *The Birth Series* sculptures were used seemingly everywhere—in medical schools, nurse-midwifery programs,

nursing schools, museums, university classrooms, high schools and elementary schools (public and parochial), marriage education classes, classes for expectant mothers and fathers, and classes for parents and children to learn about the process of reproduction together. They even made their way into an Amish community in Ohio.[58] Government agencies (including the US Navy) were also interested in them, as were such organizations as the American Red Cross, who Brailled its copy of the *Birth Atlas* for use in the parenting classes the organization offered for the blind. And this was in the United States alone; requests for information about, and orders for, *The Birth Series* in all its forms rolled in from countries across the globe—China, the UK, Canada, Japan, Mexico, Bolivia, Israel, New Zealand, South Africa, Switzerland, and India, to name just a few.[59] Because of the overwhelming interest from Central and South America, by the mid 1940s the MCA was working on a Spanish-language version of the *Birth Atlas*.[60] Even the global philanthropic organization UNICEF bought "increasingly larger quantities" over the years.[61] As late as the 1980s, orders for the *Birth Atlas* still came in to the MCA.[62]

Thus, the convergence of one organization, two men, two Worlds' Fairs, and a host of other contributors set into motion a massive phenomenon that reached into big cities and small towns across America and the globe, laying the foundation for grand new ways to see—grand new ways to imagine—the process of human reproduction.

Biological Bodies, Unfettered Imaginations

As beautiful as they are as works of art and as pedagogically useful as they once were in educating lay and medical audiences about the mechanics of human reproduction, embedded within *The Birth Series* are the complexities of what it means to use art and science to reveal and to model singular 'truths' about biological processes. At the time of their debut, there were already other visual narratives available about *in utero* development. Take, for example, Friedrich Ziegler's three-dimensional wax embryos, which were displayed at the 1893 World's Fair in Chicago. While beautifully crafted and arranged in ways that captured the Victorian aesthetic of categories, balance, and order, they were not particularly humanized. That the set also included cross-sections of the embryo's inner workings further made them into modeled specimens or objects for study rather than a baby to be tenderly loved.[63] The same holds true for the increasingly common practice in the early decades of the twentieth century of displaying *real* embryos and fetuses—which showed the progression of *in utero* development from roughly six weeks through nine months, using either complete specimens or slices. In fact, a set of these was also on display at the 1939 New York City World's Fair, in the same building as *The Birth Series,* albeit in a different exhibit.[64] Audiences appreciated these sorts of exhibits as well, viewing them with much curiosity and interest.[65]

Whether wax or real, however, such displays were nonetheless derived from sources that were either inert or dead, which explains Dickinson's desire to use the latest scientific technology to capture *in utero* development as a dynamic and living biological process. "These are not the cadaver obstetrics of . . . textbooks," he wrote in a 1941 issue of the *American Journal of Obstetrics and Gynecology* when describing the stages of labor sequence for which X-rays played a vital part. "This is life in action, life arriving, tense and not collapsed."[66] His medical peers were equally laudatory. "In my experience, no two dimensional teaching aids or mechanical models equal in instructional value these full scale sculptures depicting the process from the beginning of labor to the delivery of the shoulders," noted Allan C. Barnes, associate professor of obstetrics and gynecology at The Ohio State University Medical School. He added, "It is to this group of models that the students, both in medicine and in nursing, return most often for study."[67]

The Birth Series also differed in its lack of the grotesque. The plaster sculptures' pale whiteness, for example, (sometimes pale pink or creamy beige in subsequent reproductions) denied the messiness of blood and placental and other bodily fluids and excretions.[68] This was no accident; Dickinson had no interest in what one fair-goer called the "butcher shop color" found in other exhibits depicting the human body.[69] Instead, he believed in the power of "high art" to reach and to move mass audiences.[70] Indeed, Dickinson was also concerned with decorum regarding the representation of the unclothed, sexual body—especially to the lay public. Decrying what he called the "sprawling nakedness" found in some art, he complimented figures drawn by such anatomists and medical illustrators as William Smellie (1697–1763), William Hunter (1718–1783), and Max Broedel (1870–1941) as appropriate examples to follow.[71] In addition, across the series, the sculpted baby inside the woman's womb is the embodiment of an ideal, generalized depiction of the perfect baby, rather than directly based on any specific patient. It is never deformed, wrinkled or lumpy, mashed into weird shapes, or contorted into odd positions—not even when born breech as a later set of models would demonstrate.[72] In other words, the entire *Birth Series* represented the pregnancy process featuring an artistically idealized human developmental narrative that transpired with the union of sperm and egg. It is corrected in order to appear universal and timeless—the aspirational goal of classical sculpture.[73]

That said, Dickinson was certainly not oblivious to the complex reality of pregnancy. Miscarriage was common among women, and he would have known from his decades in medical practice that not all conceptions yielded such perfect results.[74] Nor was he lackadaisical about the scientific–artistic process. As he lamented in the early 1930s about the images created during one ill-fated doctor–artist collaboration, "The sacrum of some [obstetrical drawings] had three bones, of some two, while a mammoth coccyx might have six joints." He added further, the "babies on their way into the world were shown [to be] anywhere from five uterine months to two extra-uterine years in size."[75] Nonetheless, as he continued to work with Belskie, Dickinson

was increasingly content to ignore the unscientific embellishments that made their way into *The Birth Series*. Chief among them were the features embedded in the sculpture of *Twinning*. Reflecting a light-hearted whimsy, each of the three sets depicted the adage of "see no evil, speak no evil, hear no evil" by using their little fetal hands to cover their little fetal eyes, mouths, and ears. Audiences, lay and medical, loved it.[76] Not even Dickinson could avoid straying from his scientist's eyes when overcome with the joy of creation—artistic or human—which, as a deeply religious man, he believed to be divinely inspired.

Therein lies, however, the conundrum of Dickinson's intent and the final point upon which this chapter ends. Although he had set out to use the tools of science and art to explain with greatest accuracy the mechanics behind the process of human reproduction, much to his delight, the visual story he told captured so much more. As he wrote to his sculptor friend Malvina Hoffman in 1942, precisely when the mass reproduction and dissemination of *The Birth Series* was well under way:

[I]t was of no little interest that the teachers in Roman Catholic schools showed the earliest, and in some instances, the liveliest interest in these methods. It is my chief and most cherished comment, the one made by a Sister whom I found later was the head of a large institution, to this effect. I asked "Sister, why is it that you feel your girls will want these?" and she answered, "The children always ask, 'how is a baby born,' and this is the most *reverent* way of answering that question that I have seen.[77]

Dickinson had managed to capture what he understood to be the power and glory of God and the joy found in the divine creation of human life, which unfolded with the union of sperm and egg. Such imagery was later appropriated, long after his death, by the modern pro-life movement in the wake of *Roe v. Wade* (1973). As I demonstrate elsewhere, however, it was never Dickinson's intent to craft a visual message that would articulate a case against abortion. On the contrary, Dickinson firmly believed in the necessity of its practice, not *despite* his religious views but *because* of them. He then set out to make a religious case for the birth control movement and the provision of abortion.[78]

In sum, *The Birth Series* was a monumental scientific and artistic achievement, and to tell the story of its creation illuminates the importance of twentieth-century artists in crafting, and then disseminating, new medical knowledge to professional and lay audiences, a tale often reserved for medical artists of centuries past. But to tell this story also illustrates the ways in which knowledge about our biological bodies are not simply singular 'truths' to be revealed by science. Rather, such knowledge is also constructed and (re)presented by human beings. Thus, as this chapter makes clear, *The Birth Series* not only participated in the shift from nineteenth-century conceptualizations of pregnancy to those that had emerged by the latter third of the twentieth, but it also gave lay and professional audiences grand new ways to see—grand new ways to imagine—the process of human reproduction. That audiences would later draw such different conclusions about the meaning embedded within

the sculptures makes clear the subjectivity of the knowledge we create about our biological bodies.

Acknowledgements

Many grateful thanks to all those who helped me navigate some amazing museum and archival collections: Amy Hague (Sophia Smith Collection, Smith College, Northampton, MA); Wendy Wasman (The Cleveland Museum of Natural History, Cleveland, OH); George Corner, Patricia Freeman, Thomas Labedz, and Priscilla Grew (University of Nebraska State Museum, Lincoln, NE); Stephen Novak and Cameron Mitchell (Archives & Special Collections, Health Sciences Library, Columbia University, New York City, NY); Don and Mary Ann Farrell (Belskie Museum of Art and Science, Closter, NJ); Jack Eckert and Scott Podolsky (Boston Medical Library, Francis A. Countway Library of Medicine, Boston, MA); Dominic Hall (Warren Anatomical Museum, Francis A. Countway Library of Medicine, Boston, MA); and Arlene Shaner (New York Academy of Medicine Library, New York City, NY). For their financial support, I am indebted to UNL's College of Arts & Sciences for awarding me an Enhance Grant and to the Francis A. Countway Library of Medicine for selecting me as one of their 2015–2016 fellows. I am also grateful to UNL's Women's & Gender Studies Program and, again, to the College of Arts & Sciences for letting me steal a semester away to carry out my research. Thanks also to Edith Buhs, Peter Thomson, Wendy Thomson, Marc Woodman, Gail Bederman, Logan Burda, and the participants of the "Symposium on Art, Anatomy, and Medicine Since 1700" in South Carolina, especially its organizer, Andrew Graciano. I am also indebted to Lara Freidenfelds and Sarah Rodriguez who read earlier drafts. In fact, so generous has Sarah been that not only did she educate me about Dickinson's *Sex Atlas*, but she even let me lift whole passages about his biography from a talk on Dickinson we gave together in 2014. See Holz and Rodriguez (2014), "Spooning Between Ellis and Kinsey: Dr. Robert L. Dickinson—Gynecologist, Sexologist, Artist," Society for the Scientific Study of Sexuality Conference, Omaha, NE, 6 November 2014. Last, thanks to everyone who has listened to me ramble on about this project in the last few years. That means you, too, Eric Buhs. Address correspondence to Rose Holz at rholz2@unl. edu.

Notes

1 Reagan (1997), 8–14 and chapter 3.

2 Dubow (2011), chapter 4.

3 Eisenberg (2013).

4 Petchesky (1987); Duden (1993), 11–18, 20, 25. For others, see Stabile (1992); Berlant (1994); Michaels (1999). For a more recent analysis of Lennart Nilsson's work, see Jülich (2015). The rise of this new way of thinking in the 1960s about the unborn has also been connected to the fetal imagery in Stanley Kubrick's film *2001: A Space Odyssey* (1968). See Sofia (1984).

5 Wade (2014). See as well Lynn M. Morgan's discussion of how this continues to play itself out in more recent publications, such as Tsiaras and Werth's *From Conception to Life* (2002). In Morgan (2009), 217–221. Similar arguments are made about the impact of ultrasound in obstetrics by the 1970s. See again Petchesky

(1987). For more on the implications of prenatal testing through ultrasound/ sonogram and amniocentesis, see Taylor (2008); Boucher (2004); Rapp (1999).

6 Newman (2002); Hopwood (2012). For the histories of wax anatomical models and their makers more generally, see Maerker (2011); Messbarger (2010); Panzanelli (2008).

7 Morgan (2009); Cole (1993).

8 Dickinson (1935), 148. Talk delivered in 1933.

9 For Kinsey's acknowledgement of Dickinson's influence, see Kinsey et al. (1948), x; Kinsey et al. (1953), x. For acknowledgement by Masters and Johnson, see their 1966 publication, v. See also Reed (1978), 192–193.

10 Much of what we know about Dickinson comes through smaller discussions in larger works. In order chronologically, Gordon (1976); Reed (1978); McCann (1994),; Bullough (1994); Clarke (1998); Terry (1999); Tone (2002); Carter (2005); Holz (2005); Klein (2005); Carter (2007); Roach (2009); Creadick (2010); Hajo (2010); Holz (2012); Rodriguez (2014).

11 For brief mentions of *The Birth Series*, see Reed (1978), 186; Bullough (1994); Ettinger (2006), 96–97; and Creadick (2010), 23. For a fuller account, see Eisenberg (2013), 42, 105–129. In his thoughtful analysis of the Maternity Center Association's activities from 1918–1963, Eisenberg shares my view of the impact *The Birth Series* had in shaping modern understandings of pregnancy.

12 Despite renewed interest in the intersection between art and medicine, I would argue that the canon of anatomical art still privileges (particularly by name) pre-twentieth century medical artists. In contrast, discussion of twentieth century anatomy tends to focus less on the individual and more on the technology (such as X-ray, CT, and MRI). For examples of such emphases, see: Cazort, Kornell, and Robert (1996); Cunningham (1997); Petherbridge and Jordanova (1997); Rifkin and Ackerman (2006).

13 For the best (and perhaps only) account of Abram Belskie, see Demarest (2010). For discussion of Dickinson and Belskie's human sex anatomy sculptures, see Freeman (2008), 73–75. For discussions of their *Norma* and *Normman* sculptures, see Creadick (2010), and Carter (2007).

14 Quote from a eulogy given at Dickinson's memorial service, 9 December 1950, folder 30, box 12, Robert Latou Dickinson Papers, 1881–1972 (inclusive), 1883–1950 (bulk), B MS c72, Boston Medical Library, Francis A. Countway Library of Medicine, Boston, Mass. (hereafter cited as Dickinson Papers—CLM). Quote on 2.

15 "Dr. R. L. Dickinson, Gynecologist, 89," *New York Times*, 30 November 1950, and Reed (1978), chapters 11–13. His bookplates in Bookplate Material, A Scrapbook of Clippings and Sketches, New York Academy of Medicine Library, New York City, NY (hereafter cited as NYAML). His architectural drawings in folder 26, box 3, Dickinson Papers—CLM. For his involvement in the early birth control movement, including what ultimately became the Planned Parenthood Federation of America, see the "Birth Control Organizations" section on the Margaret Sanger Papers Project website at https://www.nyu.edu/projects/ sanger/aboutms/bc_organizations.php.

16 Reed (1978), 156–157 and Bullough (1994), 311.

17 Quote from Reed (1978), 160. See also Bullough (1994), 310.

18 Dickinson and Bryant (1931); Dickinson (1938); Dickinson and Morris (1940); Dickinson and Morris (1942); Dickinson (1950).

19 Dickinson (1933); (1949).

20 Dickinson (1935).

21 For an analysis of similar medical pedagogy in the twentieth and twenty-first centuries, see Macnaughton (2009).

22 Dickinson (1939), 153.

23 Dickinson (1933), 784.

24 For an in-depth study of objectivity in science and scientific imagery, see Daston and Galison (2007). For a brief, relevant critique of Daston and Galison's ideas, see Slipp (2017), 210–211.

25 Ettinger (2006), chapter 3; Eisenberg (2013).

26 Sarah Ward Gould, "Exhibits at Fairs: A Medium of Educating the People in Matters Pertaining to Maternal Health," folder 2, box 39, Maternity Center Association Records, Archives & Special Collections, Health Sciences Library, Columbia University, New York City, NY (hereafter cited as MCA Records—CU).

27 Quote from a conversation Dickinson had with a grandson over Christmas (typed from hand-written notes likely by Dickinson's daughter, Dorothy Barbour), folder 13, box 10, Dickinson Papers—CLM.

28 The general name of this collection is Medical Illustrations of Human Sex Anatomy, With Some Text, and Many Original Drawings (New York 1924–1940), NYAML. The specific folios I primarily relied upon include: The Living Vagina, Outlines and Case Records, Parts I and II; Topographical Anatomy of the Uterus, Tubes and Ovary, Parts I and II; Location of Embryo, Size of Fetus, Parts I and II; Shape and Size of Uterus and Its Cavity, Parts I and II; Topographical Anatomy of the Uterus, Tubes and Ovary, Parts I and II; and Vaginal Pessaries.

29 Dickinson was fond of this method of tracing over X-rays and mentioned it to the MCA's Hazel Corbin. See Dickinson to Corbin, 13 July 1945, folder 3, box 26, MCA Records—CU. But it was a technique he used for years, going back to at least the late 1920s, perhaps even earlier. See Dickinson to Dr. E.V. Schubert, 6 November 1929, in Medical Illustrations of Human Sex Anatomy, Vaginal Pessaries.

30 The group's name was the Sub-Committee on Maternal Health of the Advisory Committee on Medicine and Public Health for the World's Fair. Meeting minutes in folder 3, box 39, MCA Records—CU.

31 My analysis of the sculptures based on those reproduced in the first and second editions of the Birth Atlas (New York, 1940 and 1943). Again, note especially the following changes in the second edition in which a new sculpture replaces Plate 5 and Plate 17 (of twinning) has been added.

32 Belskie also mentioned that when they first met, Dickinson was "too tired to tackle the project himself." In Demarest (2009).

33 Dickinson had first approached Hoffman—a master sculptor of the human body in her own right—to assist him with his sculptures. Although she declined, she put him in touch with Belskie. For letter of introduction between Belskie and Dickinson, see Hoffman to Dickinson, 12 January 1939, folder 80, box 1, Dickinson Papers—CLM. For more on Hoffman's life and work, see Nochlin

(1984). For an in-depth analysis of what has since become her controversial "Races of Mankind" series commissioned in the 1930s by Chicago's Field Museum of Natural History, see Kunkel (2011); Schuessler (2016). As far as the other artists' work, starting in January and in the months leading up to the 1939 World's Fair: Emily Freret had logged in 91 days, Frances Elwyn 29, and Belskie 48. After the Fair opened, Belskie continued to work on additional models. See "Modeling Account" time sheets, unprocessed Abram Belskie Papers, Belskie Museum of Art and Science, Closter, NJ. Dickinson claimed to have worked a "single stretch as long as ninety continuous days." See Dickinson to Corbin, 23 May 1940, folder 8, box 39, MCA Records—CU. Notably, while Dickinson ensured the other artists/sculptors were paid, he did all his work free of charge.

34 Dickinson to Corbin, 19 May 1939, folder 8, box 39, MCA Records—CU. See Dickinson's attached list entitled, "List of Teaching Models Loaned to Maternity Center Association by R. L. Dickinson for Exhibit at World's Fair."

35 Oral history conducted by Dr. Kameci and transcribed in 1995 by Helynn Burns. In Demarest (2010).

36 Demarest (2010).

37 Demarest (2010).

38 Dickinson letter quoted in Demarest (2010).

39 See "Some Dickinson Claims for Priority," January 1947, folder 2, box 59, Planned Parenthood Federation of America Records I—SC (hereafter cited as PPFA Records I—SC). See also Hopwood (2000); Morgan (2009); Withycombe (2015).

40 Dickinson (1940), 662. Also, see the introduction to the *Birth Atlas*, 2nd ed. (1943). For Corbin's suggestion, see Anne A. Stevens to Dickinson, 27 November 1946, folder 8, box 39, MCA Records—CU.

41 For the routine practice of X-rays on pregnant women, as well as Dr. Stewart's call of alarm about its dangers, see van Dijck (2005), 102.

42 While Dickinson referred to them early on as such, Hoffman affectionately referred to them as "[Dickinson's] babies" and "Abie's babies." See, respectively, Dickinson to Hoffman, 1 February 1939 and Hoffman to Dickinson, 3 August 1939. Both in folder 80, box 1, Dickinson Papers—CLM. "The babies" is also how the curators and museum workers at the University of Nebraska State Museum refer to their set, in the past and present.

43 McLeary and Toon (2012). For more on the Transparent Man, see Vogel (1999); van Dijck (2001).

44 "Life Begins" (1939), Maternity Center Association, folder 6, box 59, PPFA Records I—SC. Quote on 19. Italics in original. For another mention of the exhibit's popularity from opening to close, see Corbin to Sylvia Carewe, 15 June 1939, folder 5, box 39, MCA Records—CU.

45 For 1939 attendance, see the photo caption on first page of "Life Begins." See also a letter by Dickinson in which he said exhibit attendance was five thousand per day: Dickinson to Mrs. Albert D. Lasker, circa December 1941, folder 4, box 59, PPFA Records I—SC. For complaints from fair organizers, see Homer N. Calvert to Corbin, 29 May 1939, folder 5, box 39. For complaints from fellow exhibitors, see Bryan Gray to the MCA, 23 October 1939 and Corbin to Bryan Gray, 24 October 1939, folder 6, box 39. All in MCA Records—CU.

46 According to Corbin, the plan was to remove the sugarplum tree and have two sets of *The Birth Series* on display to accommodate better the long lines of the previous year. Corbin to Bruno Gebhard, 4 March 1940, folder 6, box 39, MCA Records—CU. See also Dickinson's remark in March 1940 that there would be "twice as many (sculptures) as last year." Dickinson to Dr. Wilcox, 14 March 1940, Unprocessed Dickinson Papers— NYAML. Finally, changes made from the first edition of the *Birth Atlas* to the second reveal that the sculpture featured in Plate 5 (made by Dickinson alone) had been replaced by a more elaborate version made by Dickinson and Belskie together. The second edition also features the twinning sculpture.

47 "Life Begins." Quotes on 20. Note, too, that fair organizers were so concerned about the exhibit that they forbade the MCA from including the fair logo on the leaflets the organization distributed. See "RLD: An Appreciation," *Briefs: Official Publication of the Maternity Center Association* 14 (Winter 1950–1951): 1–5. Story recounted on 5.

48 Ruth Perkins Kuehn to Dickinson, 14 June 1941, folder 8, box 39, MCA Records—CU.

49 Kuehn to Dickinson.

50 "A Report of 'The First Year of Life:' An Exhibit at the New York World's Fair" (1939), folder 5, box 39, MCA Records—CU.

51 For other cities that immediately received *Birth Series* sets, see Dickinson to Corbin, 14 November 1940, folder 8, box 39, MCA Records—CU.

52 The University of Nebraska State Museum in Lincoln, NE, is where I first encountered them.

53 See Harper L. Schimpff to Horace Hughes, 14 September 1955 and Perry N. Zang to Horace Hughes, 28 December 1951. Both in folder 9, box 68, MCA Records—CU.

54 "The Dickinson–Belskie Collection . . . and Facilities for Its Multiple Reproduction," *Medical Times* (September 1945): 23. See also Gebhard, "The Birth Models: R. L. Dickinson's Monument," *Journal of Social Hygiene* 37 (April 1951): 169–74.

55 Maternity Center Association, Robert L. Dickinson, and Abram Belskie, *Birth Atlas* (New York, 1940).

56 Editions, according to OCLC Worldcat, can be found at http://www.worldcat.org/title/birth-atlas/oclc/6034148/editions?sdasc&refererdi&seyr&editionsViewtrue&fq. For an overview of editions and reprints through 1958, see "Birth Atlas," folder 9, box 68, MCA Records—CU.

57 Maternity Center Association, *A Baby Is Born: The Picture Story of Everyman's Beginning* (New York, 1957). This went through 11 editions, the last of which came out in 1978. *The Birth Series* sculptures, including a breech series not found in earlier versions of the *Birth Atlas*, remain a prominent feature of the book.

58 See Gebhard (1951); Barnes (1947), 261–262; Treat (1959); "RLD: An Appreciation." Mention of Amish community in Gebhard (1951), 173.

59 Requests in folders 7-10, box 68, MCA Records—CU. For the Braille version created by the Red Cross, see Gertrude Geiger Struble to the MCA, 23 March 1948, folder 8, box 68, MCA Records—CU.

60 For evidence of interest from Latin and South America, see Horace Hughes to
 Dr. Edward C. Ernst, 21 October 1943, folder 8, box 68, MCA Records—CU. For
 mention of Spanish-language version, see Hughes to Garst, 29 March 1949, folder
 9. In same box.

61 Quote in Ruth Watson Lubick to Angele Petros-Barvazian, 28 October 1982,
 folder 10, box 161, MCA Records—CU.

62 See materials in folder 10, box 161, MCA Records—CU.

63 Hopwood (2002).

64 "Man and His Health: New York World's Fair 1939" (1939), folder 3, box 39,
 MCA Records—CU. On 18–19. In fact, a set had also been on display at the 1933
 World's Fair in Chicago. See Cole (1993). Moreover, *The Birth Series* exhibit at
 the University of Nebraska State Museum also included an installation of real
 embryonic/fetal slices, with seven specimens ranging from six weeks to seven
 months.

65 For discussion of displays of fetal specimens before they became objects of
 controversy by the 1970s and after, see Cole (1993); Morgan (2009), 134–135 and
 156–158; Dubow (2011), chapter 2. Cole and Dubow also described several pro-
 life responses to such exhibits post *Roe v. Wade* (1973). For more on the popular
 interest in anatomy museums, see Michael Sappol (2002), especially chapter 9.

66 Dickinson (1941), 1077.

67 Barnes (1947), 261–262.

68 For various generations of the sculpture replicas, see the Dickinson-Belskie
 Collection, Warren Anatomical Museum, Francis A. Countway Library of
 Medicine, Boston, MA.

69 Dickinson (1939), 153.

70 Dickinson (1940), 662.

71 Dickinson (1935), 148.

72 For quick visual access to the Breech models, see *A Baby Is Born*, 53–57. The
 sculptures themselves are on display at the Belskie Museum of Art and Science,
 Closter, NJ.

73 The conflict between specificity and generalized detail, particularly among
 anatomists and artists, is a leitmotif of much of the present volume. At its core
 is the debate about the role of art with regard to Nature—whether art should
 'correct' imperfections or copy faithfully.

74 Reagan (2003).

75 Dickinson (1935), 142.

76 *Birth Atlas*, 2nd ed. (1943), Plate 17. For audience reactions to the twinning
 sculpture, see Gebhard (1951), 171.

77 Dickinson to Hoffman, 30 December 1942, folder 80, box 1, Dickinson Papers—
 CLM. Underline in the original has been replaced with italic. To ease flow of
 reading, spelling errors have been corrected.

78 Holz (2018).

References

Barnes, Allan C. "The Use of the Dickinson Models in Obstetric and Gynecologic Education." *Journal of the American Association of Medical Colleges* 22 (April 1947): 261–262.

Berlant, Lauren. "America, 'Fat,' the Fetus." *Boundary 2*, 21 (Autumn 1994): 145–195.

Boucher, Joanne. "Ultrasound: A Window to the Womb? Obstetric Ultrasound and the Abortion Rights Debate." *Journal of Medical Humanities* 25 (Spring 2004): 7–19.

Bullough, Vern L. "The Development of Sexology in the USA in the Early Twentieth Century." In *Sexual Knowledge, Sexual Science: The History of Attitudes To Sexuality*, edited by Roy Porter and Mikuláš Teich, 303–322. Cambridge, UK: Cambridge University Press, 1994.

Carter, Julian B. "On Mother-Love: History, Queer Theory, and Nonlesbian Identity." *Journal of the History of Sexuality* 14 (January / April 2005): 107–138.

Carter, Julian B. *The Heart of Whiteness: Normal Sexuality and Race in America, 1880–1940*. Durham, NC: Duke University Press, 2007.

Cazort, Mimi, Monique Kornell, and K. B. Robert. *The Ingenious Machine of Nature: Four Centuries of Art and Anatomy*. Exhibition catalogue, Ottawa, Canada, 1996.

Clarke, Adele E. *Disciplining Reproduction: Modernity, American Life Sciences, and The Problems of Sex*. Berkeley, CA: University of California Press, 1998.

Cole, Catherine. "Sex and Death on Display: Women, Reproduction, and Fetuses at Chicago's Museum of Science and Industry." *Drama Review* 37 (1993): 43–60.

Creadick, Anna G. *Perfectly Average: The Pursuit of Normality in Postwar America*. Boston, MA: University of Massachusetts Press, 2010.

Cunningham, Andrew. *The Anatomical Renaissance: The Resurrection of the Anatomical Projects of the Ancients*. Aldershot, UK: Ashgate, 1997.

Daston, Lorraine, and Peter Galison. *Objectivity*. New York: Zone Books, 2007.

Demarest, Robert J. *Abram Belskie, Sculptor and the Famous American Sculptors with Whom He Worked* (2010). First published as an essay in *Journal of Biocommunication* 35 (2009): e58–e66.

Dickinson, Robert L. "Life Size Outlines for Gynecological Cancer Records." *American Journal of Cancer* 17 (March 1933): 784–789.

Dickinson, Robert L. *Human Sex Anatomy*. Baltimore, MD: Williams and Wilkins, 1933.

Dickinson, Robert L. "What Medical Authors Need to Know about Illustrating." *Proceedings of the Charaka Club* 8 (1935): 141–148.

Dickinson, Robert L. *Control of Conception: An Illustrated Medical Manual*. 2nd ed. Baltimore, MD: Williams and Wilkins, 1938.

Dickinson, Robert L. "Wall Charts and Models in Clinic Instruction." *Journal of Contraception* 4 (August–September 1939): 152–153.

Dickinson, Robert L. "The Application of Sculpture to Practical Teaching in Obstetrics." *American Journal of Obstetrics and Gynecology* 40 (October 1940): 662–670.

Dickinson, Robert L. "Models, Manikins, and Museums for Obstetrics and Gynecology." *American Journal of Obstetrics and Gynecology* 41 (June 1941): 1075–1078.

Dickinson, Robert L. *Human Sex Anatomy*. 2nd ed. Baltimore, MD: Willliams and Wilkins, 1949.

Dickinson, Robert L. *Techniques of Conception Control*. 3rd ed. Baltimore, MD: Williams and Wilkins, 1950.

Dickinson, Robert L., and Louise Stevens Bryant. *Control of Conception: An Illustrated Medical Manual*. Baltimore, MD: Williams and Wilkins, 1931.

Dickinson, Robert L., and Woodbridge Edwards Morris. *Techniques of Conception Control*. Baltimore, MD: Williams and Wilkins, 1940.

Dickinson, Robert L., and Woodbridge Edwards Morris. *Techniques of Conception Control*. 2nd ed. Baltimore, MD: Williams and Wilkins, 1942.

Dubow, Sara. *Ourselves Unborn: A History of the Fetus in Modern America*. New York: Oxford University Press, 2011.

Duden, Barbara. *Disembodying Women: Perspectives on Pregnancy and the Unborn*. Cambridge, MA: Harvard University Press, 1993.

Eisenberg, Ziv. "The Whole Nine Months: Women, Men, and the Making of Modern Pregnancy in America." Ph.D. dissertation: Yale University, 2013.

Ettinger, Laura E. *Nurse-Midwifery: The Birth of a New American Profession*. Columbus, OH: Ohio State University Press, 2006.

Freeman, Susan K. *Sex Goes to School: Girls and Sex Education before the 1960s*. Urbana, IL: University of Illinois Press, 2008.

Freidenfelds, Lara. *The Modern Period: Menstruation in Twentieth-Century America*. Baltimore, MD: Johns Hopkins University Press, 2009.

Gebhard, Bruno. "The Birth Models: R. L. Dickinson's Monument." *Journal of Social Hygiene* 37 (April 1951): 169–174.

Gordon, Linda. *Woman's Body, Woman's Right: Birth Control in America* (1976); revised 3rd edition published as *The Moral Property of Women: A History of Birth Control Politics in America*. Urbana, IL: University of Illinois Press, 2002.

Hajo, Cathy Moran. *Birth Control on Main Street: Organizing Clinics in the United States, 1916–1939*. Urbana, IL: University of Illinois Press, 2010.

Holz, Rose, "The 1939 Dickinson–Belskie Birth Series Sculptures: The Rise of Modern Visions of Pregnancy, the Roots of Modern Pro-Life Imagery, and Dr. Dickinson's Religious Case for Abortion." *Journal of Social History* 51, no. 4 (2018): 980–1022.

Holz, Rose. *The Birth Control Clinic in a Marketplace World*. Rochester, NY: University of Rochester Press, 2012.

Holz, Rose. "Nurse Gordon on Trial: Those Early Days of the Birth Control Clinic Movement Reconsidered." *Journal of Social History* 39 (Fall 2005): 112–140.

Hopwood, Nick. "Producing Development: The Anatomy of Human Embryos and the Norms of Wilhelm His." *Bulletin of the History of Medicine* 74 (Spring 2000): 29–79.

Hopwood, Nick. *Embryos in Wax: Models from the Ziegler Studio*. Cambridge, UK: Cambridge University Press, 2002.

Hopwood, Nick. "A Marble Embryo: Meanings of a Portrait from 1900." *History Workshop Journal* 73 (2012): 5–36.

Jülich, Solveig. "The Making of a Best-Selling Book on Reproduction: Lennart Nilsson's *A Child Is Born*." *Bulletin of the History of Medicine* 89 (Fall 2015): 491–525.

Kinsey, Alfred A., Paul H. Gebhard, Wardell B. Pomeroy, Clyde E. Martin et al. *Sexual Behavior in the Human Male*. Philadelphia, PA: W. B. Saunders, 1948.

Kinsey, Alfred A., Wardell B. Pomeroy, Clyde E. Martin, Paul H. Gebhard et al. *Sexual Behavior in the Human Female*. Philadelphia, PA: W. B. Saunders, 1953.

Kline, Wendy. *Building a Better Race: Gender, Sexuality, and Eugenics from the Turn of the Twentieth Century to the Baby Boom*. Berkeley, CA: University of California Press, 2005.

Kunkel, Marianne. *Races of Mankind: The Sculptures of Malvina Hoffman*. Urbana, IL: University of Illinois Press, 2011.

Macnaughton, Jane. "Flesh Revealed: Medicine, Art and Anatomy." In *The Body and the Arts*, edited by Corinne Saunders, Ulrike Maude, and Jane Macnaughton, 72–86. Basingstoke, UK: Palgrave Macmillan, 2009.

Maerker, Anna. *Model Experts: Wax Anatomies and Enlightenment in Florence and Vienna, 1775–1815*. Manchester, UK: Manchester University Press, 2011.

Masters, William H., and Virginia E. Johnson. *Human Sexual Response*. Boston, MA: Little, Brown, 1966.

McCann, Carole R. *Birth Control Politics in the United States, 1916–1945*. Ithaca, NY: Cornell University Press, 1994.

McLeary, Erin, and Elizabeth Toon. "'Here Man Learns About Himself:' Visual Education and the Rise and Fall of the American Museum of Health." *American Journal of Public Health* 102 (July 2012): e27–e36.

Messbarger, Rebecca. *The Lady Anatomist: The Life and Work of Anna Morandi Manzolini*. Chicago, IL: University of Chicago Press, 2010.

Michaels, Meredith W. "Fetal Galaxies: Some Questions About What We See." *Fetal Subjects and Feminist Positions*, edited by Lynn M. Morgan and Meredith W. Michaels, 113–132. Philadelphia, PA: University of Pennsylvania Press, 1999, 113–132.

Morgan, Lynn M. *Icons of Life: A Cultural History of Human Embryos*. Berkeley, CA: University of California Press, 2009.

Newman, Karen. *Fetal Positions: Individualism, Science, Visuality*. Stanford, CA: Stanford University Press, 1996.

Nochlin, Linda. "Malvina Hoffman: A Life in Sculpture." *Arts Magazine* 59 (September–December 1984): 106–110.

Panzanelli, Roberta, ed. *Ephemeral Bodies: Wax Sculpture and the Human Figure*. Los Angeles, CA: Getty, 2008.

Petchesky, Rosalind Pollack. "Foetal Images: The Power of Visual Culture in the Politics of Reproduction." In *Reproductive Technologies: Gender, Motherhood, and Medicine*, edited by Michelle Stanworth, 57–80. Minneapolis, MN: University of Minnesota Press, 1987.

Petherbridge, Deanna, and Ludmilla Jordanova. *The Quick and the Dead: Artists and Anatomy*. Berkeley, CA: University of California Press, 1997.

Rapp, Rayna. *Testing Women, Testing the Fetus: The Social Impact of Amniocentesis in America*. New York: Routledge, 1999.

Reagan, Leslie J. "From Hazard to Blessing to Tragedy: Representations of Miscarriage in Twentieth-Century America." *Feminist Studies* 29 (Summer 2003): 356–378.

Reagan, Leslie J. *When Abortion Was a Crime: Women, Medicine, and Law in the United States, 1867–1973*. Berkeley, CA: University of California Press, 1997.

Reed, James. *From Private Vice to Public Virtue: The Birth Control Movement in American Society Since 1830*. Princeton, NJ: Princeton University Press, 1978.

Rifkin, Benjamin A., and Michael J. Ackerman. *Human Anatomy: From the Renaissance to the Digital Age*. New York: Harry N. Abrams, 2006.

Roach, Mary. *Bonk: The Curious Coupling of Science and Sex*. New York: W. W. Norton, 2008.

Rodriguez, Sarah B. *Female Circumcision and Clitoridectomy in the United States: A History of a Medical Treatment*. Rochester, NY: University of Rochester Press, 2014.

Sappol, Michael. *A Traffic of Dead Bodies: Anatomy and Embodied Social Identity in Nineteenth-Century America*. Princeton, NJ: Princeton University Press, 2002.

Schuessler, Jennifer. "'Races of Mankind' Sculptures, Long Exiled, Return to Display at Chicago's Field Museum." *New York Times*, 20 January 2016, www.nytimes.com/2016/01/21/arts/design/races-of-mankind-sculptures-long-exiled-return-to-display-at-chicagos-field-museum.html.

Slipp, Naomi. "International Anatomies: Teaching Visual Literacy in the Harvard Lecture Hall." In *Bodies Beyond Borders: Moving Anatomies, 1750–1950*, edited by Kaat Wils, Raf de Bont, and Sokhieng Au, 197–230. Leuven, Belgium: Leuven University Press, 2017.

Sofia, Zoë. "Exterminating Fetuses: Abortion, Disarmament, and the Sex-Semiotics of Extraterrestrialism." *Diacritics* 14 (Summer 1984): 47–59.

Stabile, Carole A. "Shooting the Mother: Fetal Photography and the Politics of Disappearance." *Camera Obscura* 28 (1992): 178–205.

Taylor, Janelle S. *The Public Life of the Fetal Sonogram: Technology, Consumption, and the Politics of Reproduction*. New Brunswick, NJ: Rutgers University Press, 2008.

Terry, Jennifer. *An American Obsession: Science, Medicine, and Homosexuality in Modern Society*. Chicago, IL: University of Chicago Press, 1999.

Tone, Andrea. *Devices and Desires: A History of Contraceptives in America*. New York: Hill and Wang, 2002.

Treat, David B. "Reproduction Education." *The Family Life Coordinator* 8 (September 1959): 3–8.

Van Dijck, José. *The Transparent Body: A Cultural Analysis of Medical Imaging*. Seattle, WA: University of Washington Press, 2005.

Van Dijck, José. "Bodyworlds: The Art of Plastinated Cadavers." *Configurations* 9 (Winter 2001): 99–126.

Vogel, Klaus. "The Transparent Man: Some Comments on the History of a Symbol." In *Manifesting Medicine: Bodies and Machines*, edited by Robert Bud, Bernard S. Finn, and Helmuth Trischler, 31–61. Amsterdam, the Netherlands: Harwood Academic, 1999.

Wade, Lisa. "How Fetal Photography Changed the Politics of Abortion." *Sociological Images* (November 7, 2014), https://thesocietypages.org/socimages/2014/11/07/visualizing-the-fetus/.

Withycombe, Shannon K. "From Women's Expectations to Scientific Specimens: The Fate of Miscarriage Materials in Nineteenth-Century America." *Social History of Medicine* 28 (2015): 245–262.

Plate P.1 Ercole Lelli, Anatomical wax figures of surface to deep musculature and bone structure. Wax and bone. Courtesy of Museo di Palazzo Poggi, Università di Bologna.

Plate P.2 Ercole Lelli, Écorché demonstrating muscles. Wax and bone. Courtesy of the Museo di Palazzo Poggi, Università di Bologna.

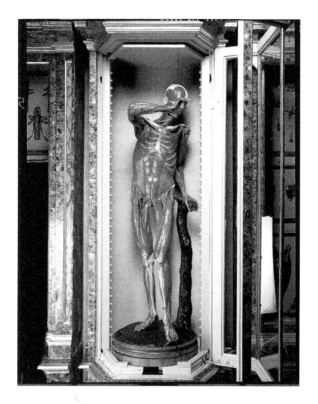

Plate P.3 Anna Morandi and Giovanni Manzolini, forearm and deep musculature, wax and bone. Courtesy of Museo di Palazzo Poggi, Università di Bologna.

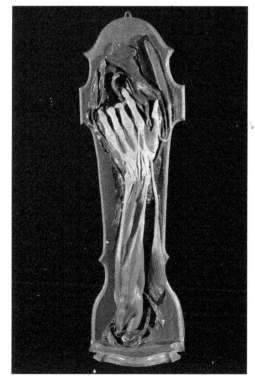

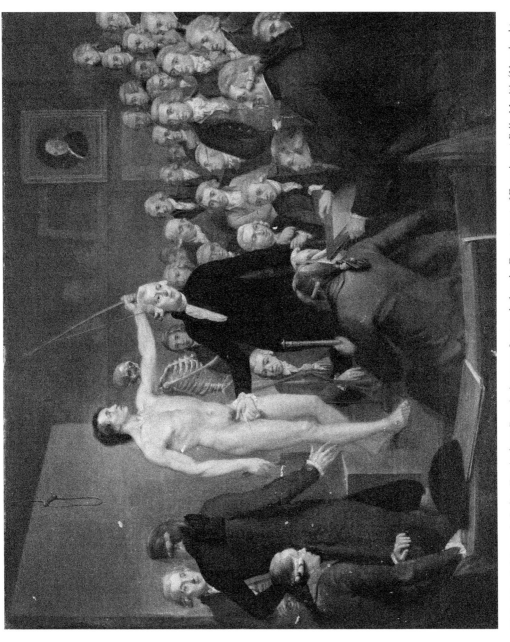

Plate 1.1　Adriaan de Lelie, Dr. Andreas Bonn's Anatomy Lecture before the Department of Drawing at Felix Meritis (*Voordracht over de anatomie door Andreas Bonn voor het departement der Tekenkunde van Felix Meritis*), 1792. Amsterdam Museum.

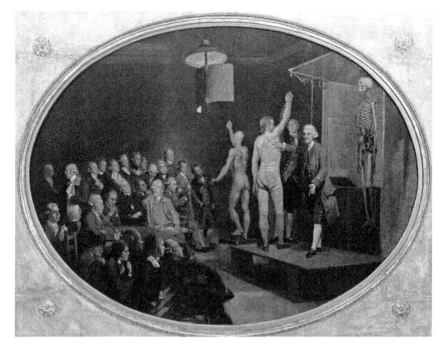

Plate 1.2 Johann Zoffany, *William Hunter Lecturing* (ca.1770–1772). © Royal College of Physicians.

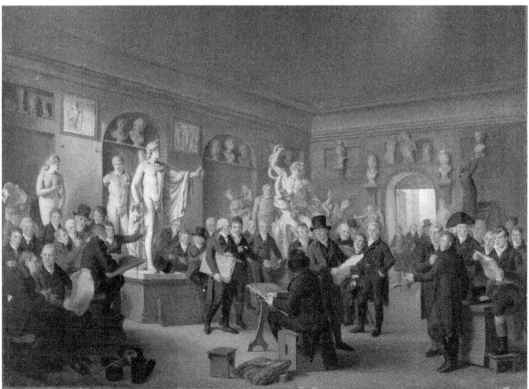

Plate 1.3 Adriaan de Lelie, *The Sculpture Gallery of Felix Meritis Maatschappij* (*De Beeldenzaal van Felix Meritis*), 1806–1809. Rijksmuseum, Amsterdam.

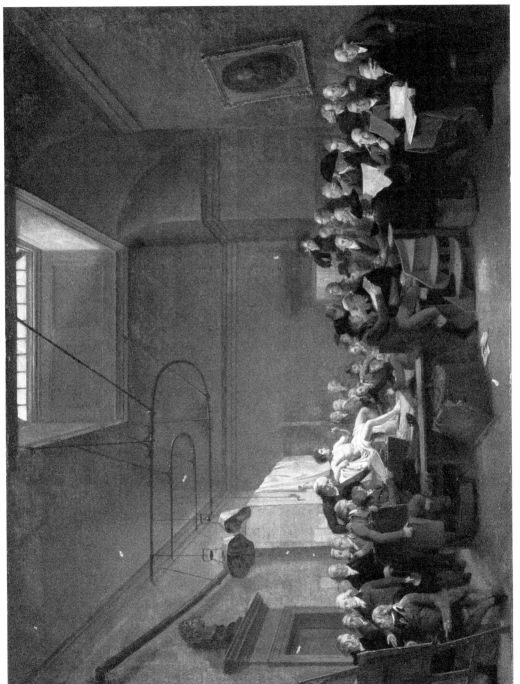

Plate 1.4 Adriaan de Lelie, *The Drawing Room at Felix Meritis* (1801). Amsterdam Museum.

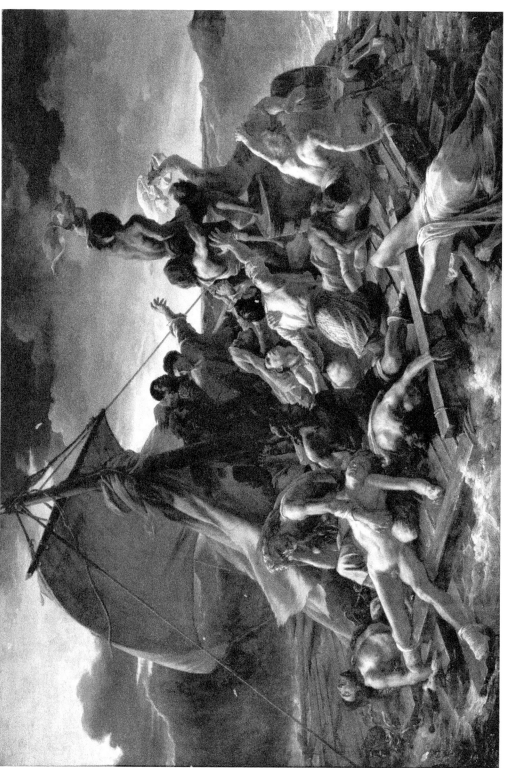

Plate 2.1　Théodore Géricault, *The Raft of the Medusa*, 1819, Musée du Louvre Erich Lessing / Art Resource, New York.

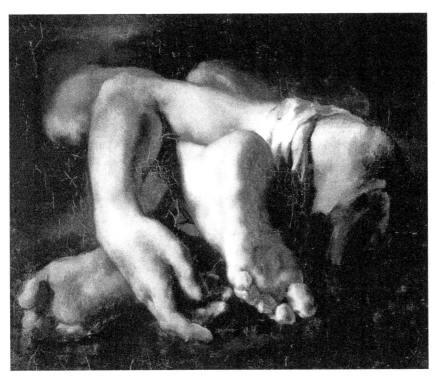

Plate 2.2 Théodore Géricault, *Severed Limbs*, 1818/1819, Musée Fabre, Montpellier.
Photo: Jacques de Caso.

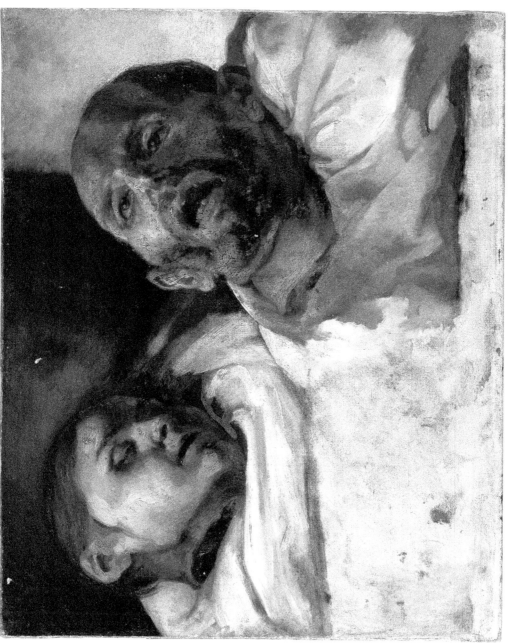

Plate 2.3 Théodore Géricault, *Severed Heads*, 1818/1819, Nationalmuseum, Stockholm. Photo: Nationalmuseum, Sweden.

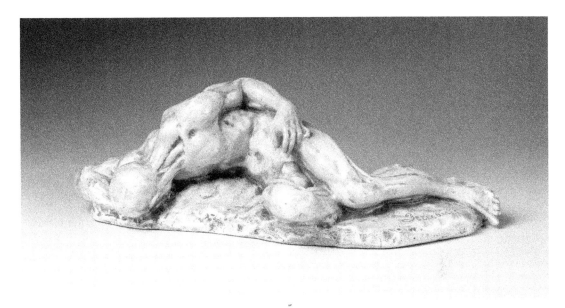

Plate 2.4 Théodore Géricault, *Dying Figure,* plaster, 1818. Wallraf Richartz Museum and Foundation, Cologne. Photo: Rheinisches Bildarchiv, rba c018949.

Plate 3.1 John Flaxman, *Anatomical study of the muscles of the right arm and torso*, 1780s?, pencil and red chalk on cream laid paper, 290 mm x 440 mm. Photograph © Royal Academy of Arts, London; Photographer Prudence Cuming Associates Ltd.

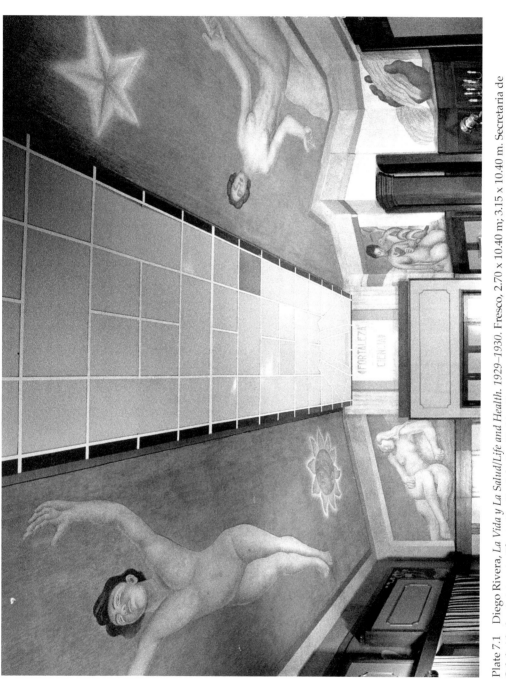

Plate 7.1 Diego Rivera, *La Vida y La Salud/Life and Health*. 1929–1930. Fresco, 2.70 x 10.40 m; 3.15 x 10.40 m. Secretaría de Salubridad y Asistencia. Photo Credit: Schalkwijk / Art Resource, New York. © 2018 Banco de México Diego Rivera Frida Kahlo Museums Trust, Mexico, D.F. / Artists Rights Society (ARS), New York.

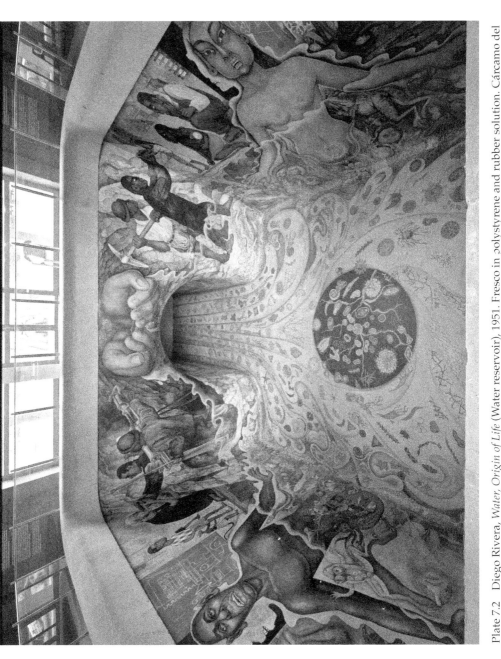

Plate 7.2 Diego Rivera, *Water, Origin of Life* (Water reservoir), 1951. Fresco in polystyrene and rubber solution. Cárcamo del Río Lerma, Chapultepec Park. Photo Credit: Schalkwijk / Art Resource, New York. © 2018 Banco de México Diego Rivera Frida Kahlo Museums Trust, Mexico, D.F. / Artists Rights Society (ARS), New York.

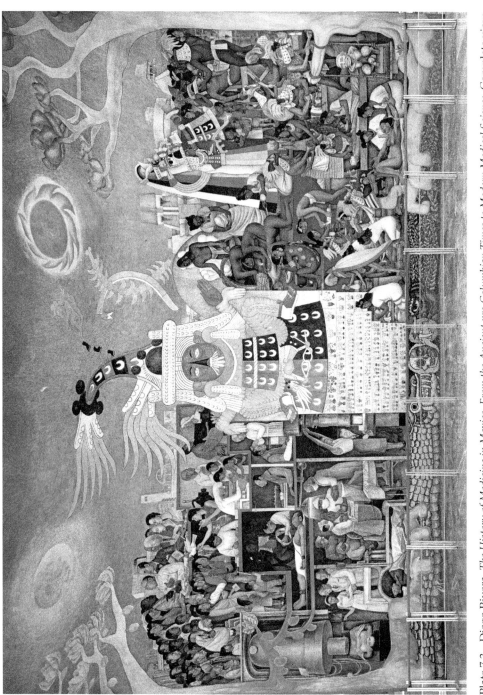

Plate 7.3 Diego Rivera, *The History of Medicine in Mexico. From the Ancient pre-Columbian Times to Modern Medical Science.* Complete view. At center is the goddess Tlazolteotl, or "goddess of repulsive things," 1953. Fresco ca. 7.4 × 10.8 m. Hospital de la Raza. Photo Credit: Alfredo Dagli Orti/Art Resource, New York © 2018 Banco de México Diego Rivera Frida Kahlo Museums Trust, Mexico, D.F./Artists Rights Society (ARS), New York.

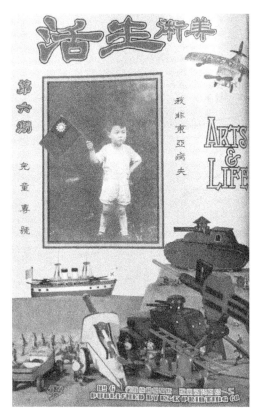

Plate 8.1 "I am not the Sick Man of Asia," *Arts & Life Magazine* 6 (September 1934): cover.

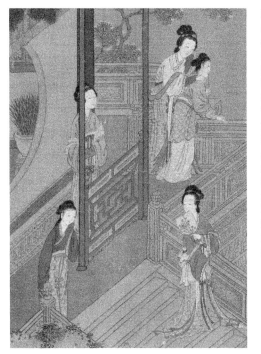

Plate 8.2 Qing-dynasty example of the traditional feminine ideal. Detail of *Palace Ladies*, 1644–1911. Copy after Qiu Ying (Chinese, 1494–1552). Handscroll, ink and color on silk; overall: 36.2 × 454.4 cm (14¼ × 178⅞ in.). The Cleveland Museum of Art, Gift of I. Theodore Kahn 1954. 369.

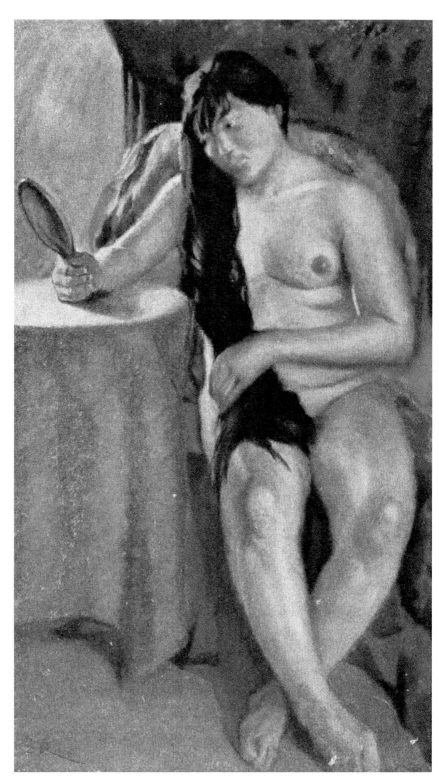

Plate 8.3 Pan Yuliang, *Reflection*, *The Ladies' Journal* Department of Education National Art Exhibition Special Issue 15(7) (July 1929): frontispiece. Online edition: "Chinese Women's Magazines in the Late Qing and Early Republican Period", http://womag.uni-hd.de

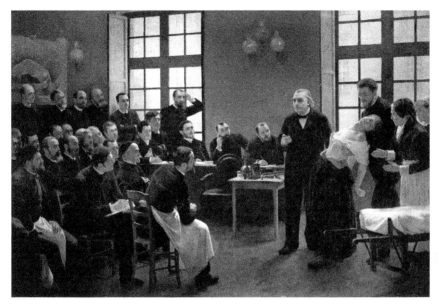

Plate 9.1 Pierre-André Brouillet, *A Clinical Lesson at the Salpêtrière*, 1877. Oil on canvas, 290 × 430 cm. Paris, Musée d'Histoire de la Médecine, inv. no. F.N.A.C. 1123. Photo: © akg-images/Erich Lessing.

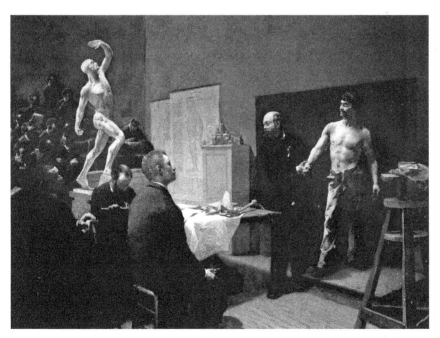

Plate 9.2 François Sallé (France, 1839–1899), *The Anatomy Class at the École des beaux-arts*, 1888. Oil on canvas, 218 × 299 cm. Syndey, Art Gallery of New South Wales. Purchased 1888, inv. no. 728. Photo: AGNSW, Diana Panuccio.

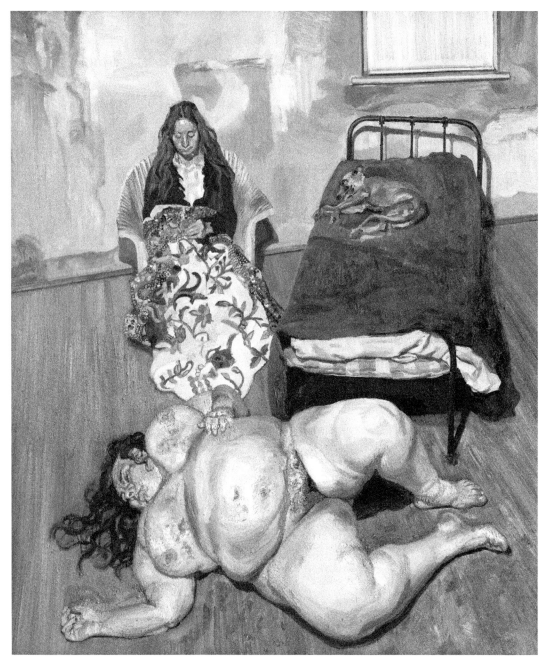

Plate 10.1 Lucian Freud, *Evening in the Studio*, 1993 (oil on canvas), Private Collection/© The Lucian Freud Archive/Bridgeman Images.

PART III
MODELING PUBLIC HEALTH:
THE HEALTHY BODY IN ART AND PROPAGANDA

Painting the Revolutionary Body:
Anatomy and the Remaking of Mexican History in the
Murals of Diego Rivera

Niria E. Leyva-Gutiérrez

The bold Mexican painter, Diego Rivera (1888–1957), is well known for his monumental, complex murals that visualize the Mexican Revolution's ideals, the celebration of Mexico's indigenous past, and the overt indictment of capitalists and clerics, who were popular targets of the artist's visual mockery.[1] These are the themes that are most often associated with the artist. Rivera, however, was also deeply fascinated by science—medical science, in particular, including cellular biology, fertility and reproduction, and the origins of life. And, while his politics were liquid at times—he was accused consistently of capitalist opportunism while identifying as a Marxist, Stalinist, and Trotskyite during various moments of his life—his belief in the superiority of science (especially over religion) and steadfast promotion of universal healthcare were unwavering ideals and constants in his life and art. For Rivera, and apologists of the Revolution, Mexico was responsible for the well-being of all its citizens, for creating a modern body politic, self-possessed and self-aware, in command of its sexuality and its health.[2]

In this chapter, I examine some of Rivera's most fascinating and neglected murals within the context of public health in Mexico over four decades.[3] Recurrent in these murals are the themes of fertility, regeneration, health, and hygiene, as well as medical research and practice. Thus, while the works are often couched in political rhetoric, these murals of the revolutionary body are about life in its simplest and purest forms.

In order to understand the murals better, it is useful to highlight briefly the state of public health in post-revolutionary Mexico.[4] One of the salient issues related to the question of public welfare was sexual health and the treatment of venereal diseases. In a 1926 speech, delivered to the Pan American Sanitary Congress in Washington, DC, the chief of the Ministry of Health in Mexico City, Dr. Bernardo Gastélum, cited syphilis as *the* principal health problem concerning the government, contending that, despite the country's progress in developing social welfare programs, two-thirds of the Mexican population was infected with this insidious venereal disease.[5] According to Gastélum, the Catholic Church's culture of 'false modesty' was largely to blame for causing rampant clandestine promiscuity and creating a dangerous double standard

that privileged masculine power and reinforced feminine subjugation. Reformers maintained that the church's propagation of such outmoded moralizing ideals about the body and human sexuality fostered sexual ignorance and shame, which prevented Mexicans from both detecting disease and, more importantly, from seeking treatment.[6]

A year after his speech, the Ministry of Health launched its first large-scale propaganda campaign to educate Mexican society about sexually transmitted diseases. The poor working classes were specifically targeted in these campaigns, since the highest incidences of venereal disease were concentrated among these groups.[7] Public health employees took to the streets, distributing hundreds of thousands of pamphlets and guides that outlined disease symptoms, treatment options, and personal hygiene.[8] Among the most popular visual aids were those advertising Neo-Salvarsán, a drug discovered by the German immunologist Paul Ehrlich. Considered an effective treatment for the open lesions caused by syphilis, the pharmaceutical was promoted as an international remedy with good results.[9] Several WPA posters from the United States were produced around the same period with similar goals, underscoring the global nature of the health campaigns dedicated to eradicating the venereal disease.[10]

Under Gastélum's leadership, the Ministry of Health became the mouthpiece for the advancement of public health.[11] In 1929 the ministry's chief commissioned Rivera to execute a series of frescoes for the Ministry's conference room in support of his goals.[12] Rivera's mural represents six monumental female nudes, personifying *Health, Life, Purity, Knowledge, Strength*, and *Moderation* (Plate 7.1).[13] Beneath the figure of *Health* are large, dark hands, signifying those of the Mexican worker, alternately holding a budding plant—symbol of fertility and growth—and grain—representing the plentiful earth. Pictured against a celestial blue background, *Health* is accompanied by a luminous star and looks up to the heavens. She displays a strong, lean, and decidedly healthy body, the muscles in her torso and arms well defined and her hands large and able. Accompanied by a smiling sun, *Life*, on the left, glides above the conference room and is also an image of self-possession. But, in contrast to *Health*, or perhaps as her complement, *Life* is lyrical and graceful, an image of serene well-being and beauty. Flanking *Health* are *Purity* and *Knowledge*. Sitting easily, *Purity* receives the clean, cool waters that flow from behind her. She is a figure nourished by the earth, cleansed and reborn. *Knowledge*, on the other hand, gazes tenderly at the open blossom in her hand. Her swelling belly and rounded forms evoke fecundity and abundance. Next to her, a tree symbolizes the renewal of the earth's vegetation and, around it, a snake is coiled, recalling the staff of Asclepius.[14] Together, they represent fertility, wisdom, and knowledge.[15] Opposite *Knowledge* and *Purity*, are *Fortitude* and *Moderation*. *Fortitude*, unencumbered and unadorned, monumental and firm, self-assuredly reclines against a barren landscape. Her large, closed fists symbolize strength and courage—martial qualities often associated with the revolution. *Moderation*, more muscular in form, is pictured reclining languidly in a semi-sensuous manner, allowing a large snake to slither through her legs

7.1 Diego Rivera, *La Continencia/Continence*, 1929–1930. Fresco, 2 × 2.98 × 1.45 m. Secretaria de Salubridad y Asistencia. Photo Credit: Schalkwijk/Art Resource, New York. © 2018 Banco de México Diego Rivera Frida Kahlo Museums Trust, Mexico, D.F./Artists Rights Society (ARS), New York.

(Figure 7.1). She is the picture of self-restraint—eyes closed, clutching the head of the slinky reptile to arrest its eroticizing movement.

The somewhat masculine quality of these women, especially in the case of *Moderation*, has been noted by scholars.[16] Indeed, *Moderation* recalls Michelangelo's *Eve* from the Sistine Chapel ceiling at her most ideal—before the fall. Not that Rivera was unable or unwilling to paint curvaceous women—one need only recall his sensuous images of women in Chapingo Chapel from a few years earlier—but his choice to depart from the canonical image of female sexuality was here a deliberate one. *Moderation*'s body transcends the sexual, the feminine—she is a worker—her body is displayed not for sexual enticement, but to commemorate public health initiatives by modeling one of the ministry's goals.

Women figured prominently in the modern discourse of public health—knowing how their bodies worked and understanding the ramifications of a diseased body made their role in the politics of sexual health critical.

Furthermore, women bore the responsibility of birthing and raising healthy children for the nation. Learning how to control the slithering snake, as it were, ensured the health of future generations of Mexicans. Together, then, these feminine figures serve as emblems of the building's function and model the goals of Gastélum's campaign: the celebration of the human (public) body through learning, strength, discipline, and cleanliness.

It should be noted, moreover, that Rivera painted two additional frescoes on the walls of the vestibule near the Microbiology and Bacteriology Laboratory (Figure 7.2). These panels are, essentially, enlarged microscopic views that visualize the medical research undertaken by modern public health reformers.[17] The murals feature bacteria related to tuberculosis, anthrax, typhoid, and tetanus; and microbes linked to pneumonia, meningitis, streptococcus, and syphilis. They not only visually illustrate the specialized scientific work undertaken in the laboratories, but also pay homage to the Revolution's pro-

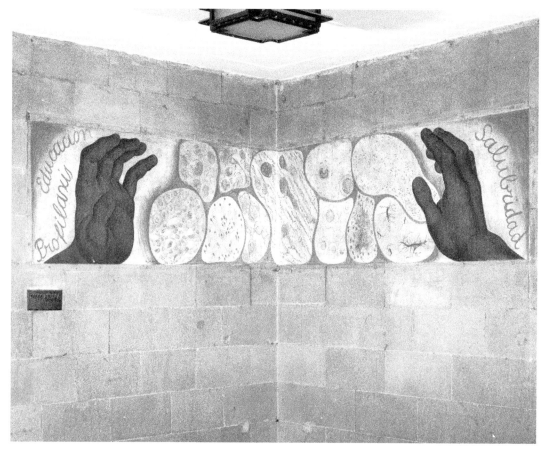

7.2 Diego Rivera, *Flora Microbriana/Microbiotic Flora*, 1929–1930. Fresco, 81 × 211 cm. Photo Credit: Schalkwijk/Art Resource, New York. Secretaria de Salubridad y Asistencia. Photo Credit: Schalkwijk/Art Resource, New York. © 2018 Banco de México Diego Rivera Frida Kahlo Museums Trust, Mexico, D.F./ Artists Rights Society (ARS), New York.

active approach to the study of disease and its prevention. The panels are ded-
icated to the Spanish physician Dr. Francisco Javier Balmis, who introduced
the smallpox vaccine to colonial Mexico in 1803. Though his work was of
extraordinary value, toward the middle of the century efforts to continue it fell
by the wayside, owing to a lack of resources, poor training, and outbreaks of
other diseases, such as cholera. In addition to these, an even greater challenge
was parental distrust of government officials resulting in mass refusal to inoc-
ulate children. During the Revolution, however, Balmis's work was revived
through the systematic creation of public health institutions.[18] Thus, when
Rivera includes the worker's hands bracketing disease, he is not only honor-
ing Balmis, but also crediting the Revolution for advancing health initiatives.[19]

The artist revisited the theme of inoculation again in 1932 for the walls of
the Detroit Institute of Arts. The murals, funded by Henry Ford's son, Edsel,
were intended to celebrate the city's industrial achievements.[20] Totaling 27
panels, they depict the unity of science, technology, and humanity. For the
purpose of the present volume, I discuss only a few panels related to science
and medicine. On the north wall is a controversial panel entitled *Vaccination*
(Figure 7.3). Depicted in the mural's foreground is a child being immunized
for smallpox. A nurse tenderly holds the child while a doctor steadies a needle
in preparation for inoculation. Surrounding the trio are the animals funda-
mental to the production of vaccines—a horse, a sheep, and a cow.[21] Behind
the vaccination scene are three scientists working in their lab, symbolic rep-
resentations of the pioneers of bacteriology and germ theory.[22]

Despite the panels' secular theme, *Vaccination* enraged local church offi-
cials, who believed that the artist had mockingly represented the scene of
the Nativity. Indeed, the visual associations seem plain—there is Joseph (the
doctor); Mary (the nurse); Christ (the child); the animals in the manger; and
the three wise men (scientists) in the background. When asked about the func-
tion of his mural, however, Rivera maintained:

> The key to the biological research panel . . . is the anaesthetized dog . . . whose
> death may provide the knowledge, which will preserve human life. It is a panel
> of animals . . . the traditional beasts of the modern scientist who uses them in
> his war against disease. The woman, the child, the horse, the sheep, the bull are
> not the figures of a Nativity in a Florentine church, but the accurate symbols of a
> science which regards the allegories of Florence with respectful disbelief.[23]

Despite his mollifying comments, Rivera, a staunch anti-cleric and professed
atheist, certainly familiar with the history of art and iconography, would
certainly have realized the group recalled innumerable artistic depictions
of nativities. Clearly, he intended to create a new Holy Family—removing
the sacred trio from Biblical time and space and remaking them within that
of modern medical research and practice, where the miracle of medical (not
spiritual) salvation is celebrated.

A further tribute to scientific knowledge and female reproduction exists
just beneath the *Vaccination* panel. In a small scene called *Healthy Human*

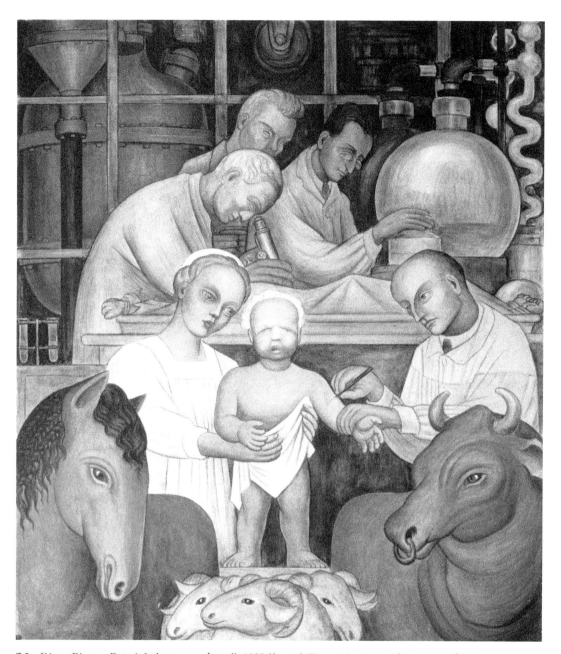

7.3 Diego Rivera, *Detroit Industry*, north wall, 1933 (fresco), Detroit Institute of Arts, USA / Bridgeman Images. © 2018 Banco de México Diego Rivera Frida Kahlo Museums Trust, Mexico, D.F. / Artists Rights Society (ARS), New York.

Embryo, an embryo in its sac is shown cradling an egg—its original life source. Surrounding the sac are multiplying chromosomes, red and white blood cells, and the disease-causing bacteria related to tetanus, anthrax, typhoid, diphtheria, cholera, and tuberculosis.[24] As the panel demonstrates, Rivera had

become fascinated by the study of complex cell development. In Detroit, he was known for spending hours sketching bacteria and cell forms, sending his assistant to local hospitals to make sketches of the dissection room and laboratory equipment. In his apartment, he had a microscope and slides of cells, as well as medical books for reference, so that he could produce the cells with accuracy.[25] One such drawing shows samples of typhoid bacteria filling the page. Another sketch shows some of these microscopic cells and includes the inscription "Microbe Hunters," which is a reference, of course, to Paul de Kruif's classic medical text on the history of microbiology.[26] The particular bacteria depicted are also related to the work of the three scientists from the *Vaccination* panel, whose research provides protection for the embryo, ensuring that it will grow into a healthy child to be inoculated in the future.

Another embryo appears on the east wall—this time the origin of human life is represented by an infant, sheltered in the bulb of a plant. To prepare for this work, called *Germ Cell*, Rivera examined the cultivation and production of beets, exploring how a plant begins as a seed, develops into a network of roots, and receives nourishment from the soil. The final mural, however, is not a portrayal of plant growth—the bulb is substituted with a human embryo, which, like a plant, is sustained through a network of veins and arteries connected to a life-giving womb.

Dorothy McMeekin, who has written about this mural, points out that Leonardo da Vinci, through his studies of plant life, had concluded that the major veins of the body came from the heart and not the liver, as had been previously believed. This root–circulation metaphor is used by Rivera here at once as an homage to artist–scientist Leonardo *and* as a powerful image of both biological and cultural growth and their dependence on the physical and social environment, respectively.[27] For Rivera, scientific discovery was linked to art and to the creative mind—he once compared *Germ Cell* to the state of the museum, maintaining that, like the human circulatory system, art supplied the essential nutrition for the human central nervous system.[28] The artist, then, functioned as veins and arteries, bringing nourishing blood to the human mind. Pleasing his patrons and acknowledging his own role as creative researcher of medical information, Rivera promoted science and art as both natural and necessary for humanity.

Also included on the east wall are monumental female nudes that, like the figures in the Ministry of Health, though more robust, are pictures of vigor and wellness. Fruits and grains are pictured cradled in the arms of the women, symbolizing abundance and fertility. Thus, the women, in their reproductive primes, give birth metaphorically to the land's resources. Pictured above the germinating embryo, they function as mother–earth–nature and scientific knowledge—the origin of life in its various forms.

Perhaps it was Rivera's grasp of contemporary medicine, demonstrated on the walls in Detroit, that persuaded the Rockefeller family in 1934 to commission a mural for the RCA Building in Rockefeller Center. The Rockefellers were not only great patrons of the arts, but also notably dedicated to the

cause of public health, especially in Central and South America. Between 1916 and 1929, officers of the Rockefeller Foundation conducted surveys in 15 Latin American countries, assessing their medical, scientific, and public health conditions.[29] The surveys were often followed by the Rockefellers' philanthropic contributions to fund research and improvements in the areas of sanitation and medicine. In 1923, a survey was conducted in Mexico, which led the Rockefeller Foundation to launch and finance a massive campaign to protect soldiers against yellow fever in the Yucatán area. Controlling yellow fever was of paramount importance to revolutionary leaders, who promoted these campaigns as integral to the advancement of universal healthcare. The Rockefeller Foundation's support for these programs helped legitimize Mexico's revolutionary ideals and offered a public health model for other countries, especially in Latin America.[30]

But the relationship between the American philanthropists and the Mexican revolutionary government would eventually grow tenuous. Invested, literally and figuratively, in issues related to Mexican public health, the Rockefellers' connection to Mexico was a paternalistic one, which the Mexican government saw as imperialist. In short, such philanthropic insertion into the social welfare structure of a vulnerable, fledgling government was not always met with great support.

Nonetheless, Rockefeller patronage of Rivera in 1933 was neither arbitrary nor unusual, and the mural the artist was commissioned to paint, *Man at the Crossroads*, now seems particularly foretelling. The work is known today primarily for the controversy it caused when it received such negative publicity because of Rivera's refusal to remove the depiction of V. I. Lenin's likeness, which led ultimately to the mural's destruction. (Rivera, however, made a similar mural some years later for the Palacio de Bellas in Mexico.) Explaining their idea for the mural to the artist, the Rockefellers indicated that the theme should represent: "New Frontiers . . . inward and upward . . . the cultivation of man's soul and mind, the coming into a fuller comprehension of the meaning and mystery of life . . ."[31] In one panel on the mural's far left, biological evolution resulting from the natural selection of inherited variations is represented. As the ultimate 'Man of Science,' Charles Darwin functions here as the liberator of minds clouded by superstitions—his finger extended in the direction of the monkey, artistically recalling and subverting Michelangelo's representation of *The Creation of Adam* on the Sistine Chapel ceiling. It is another example of Rivera's substitution of the sacred with secular; but here, each living creature is linked, underscoring the universality of evolution and the interdependence of living organisms—perhaps an idea that Michelangelo himself may have embraced.

In the central panel, Rivera again includes references to the inner workings of the generation of life. Plants bloom, not as beautiful miracles, but as part of a cycle of rebirth that begins with the germination of a seed and the cultivation of soil. Unlike the female forms that Rivera associated with reproduction in past murals, here, it is a man who presides over the growing plants and fruits

and aids in the process of fertilization. This man is the dominating figure of the Worker, who functions as the literal manipulator of two spheres of science, represented on the right by the telescope and on the left by the microscope. As in many of Rivera's murals, the worker is the conduit of energy and the vital instrument in the advancement of knowledge and scientific investigation. Looking closely at the propellers in the center, we notice their function as oppositional axes separating not only the astral from the cellular, but also setting the capitalists on the left against the communists on the right.

On closer inspection, the cells directly above the bridge-playing socialites are, in fact, the diseased cells associated with syphilis, gonorrhea, gangrene, and tetanus. In contrast, those on the right side are mostly reproductive cells subdividing. Most scholars have seen Rivera's juxtaposition of the diseased and healthy cells as contrasting an indictment of the wealthy with a celebration of socialism. But, while it is true that the diseased spores are placed directly above the oblivious women, it may be too tidy an explanation to suppose that they reflect the behavior of these women or of their particular social class. While their placement is certainly suggestive, we recall that the Rockefellers, who belonged to the same class as these *haute bourgeois* socialites, were directly involved in public healthcare campaigns dedicated to eradicating the very diseases that are represented. Perhaps Rivera intended to pay homage to the Rockefellers' (and other philanthropic benefactors') public health initiatives. After all, he also included a telescope on the 'diseased' side, which would never be interpreted to suggest that astronomy or the celestial heavens were associated with illness. In fact, the inclusion of the telescope would have resonated with the patrons of the mural, whose foundation had helped fund solar astronomer George Ellery Hale's groundbreaking project of developing a 200-inch reflecting telescope and observatory at the California Institute of Technology.[32] The telescope, then, may indicate the Rockefellers' macro view of the world and of their own philanthropy, as opposed to the microscope, which shows a micro and specific, local view of particular cells/ diseases, which was but one aspect of their philanthropic mission.[33]

Politically, on the other hand, it was during this period that Mexican physicians began to resent the Rockefellers' involvement in local medicine. According to one doctor speaking out against the philanthropists,

> The fever that devastates us is not just yellow but golden. It is not stegomyia that produces the virus, but the Oil Companies and the institutions working with them, not in the form of mosquitoes but in the form of doctors . . .[34]

Perhaps, then, it was an effort to ingratiate himself with his own country's nationalists, who often accused him of being a social opportunist who kept strange ideological bedfellows when it financially suited him. Rivera was neither indicting capitalism, *per se*, nor the Rockefellers themselves, by associating them with venereal disease, but, rather, specifically criticizing the Foundation's public health campaigns in Mexico. The mural's multivalence was the result of Rivera's deliberate choices that allowed him simultaneously

to celebrate the Rockefellers' views about scientific progress while indicting them for their paternalistic approach to Latin America. Whatever the external factors that led to the Rockefeller–Rivera debacle, and surely there were many, the core of the mural remains man and his relationship—in mind and body—to medical and public health matters.

The period of the 1940s in Mexico coincided with the Second World War and with a modification in revolutionary culture. With the dissolution of the staunch nationalist and anti-foreign policies that had characterized the 1920s and 1930s, the new cultural and intellectual atmosphere was geared toward fulfilling the demands of a growing modern, political, industrial, and technical society. During this period, Mexico's new president, Manuel Ávila Camacho (1940–1946) resumed close connections with the United States and other European countries in order to project a more cosmopolitan profile. To this end, a new phase of construction that included the building and decoration of Public Works was launched and Diego Rivera was again called upon to execute some of the most ambitious murals of his career.

In 1943, Rivera was commissioned by Ignacio Chávez to decorate two panels for the important National Institute of Cardiology.[35] Chávez, the Institute's dynamic director, and Rivera were long-time friends. Ten years earlier, serving as Director of the Medical School of the Universidad Autónoma de México (today the Palace of Medicine), he had commissioned from Rivera cartoons for the school's staircase. The subject was the "Apotheosis of Medicine," but the project was never realized, since, after a few years, Chávez resigned from his position.[36] After assuming his new post at the Institute of Cardiology, which was arguably one of the most important institutions in the history of Mexican medicine, Chávez turned to Rivera once again. While the Institute's initial purpose was to serve as a public clinic, over time it established a thriving research center thanks to the Rockefellers, who donated a total of $110,100 between 1944 and 1954.[37] For its part, the Mexican government was equally committed to the Institute, providing a subsidy of one million Mexican pesos (or $200,000) toward the construction of an outpatient clinic, laboratories, and a hospital with 120 beds and a staff of 45 physicians, 14 of whom were full-time.[38] Indeed, the Institute was promoted as the first of its kind—bringing together patient hospital care with advanced scientific research.[39]

It was during this time that Rivera was charged with documenting the history of cardiology from its beginnings in the pre-Christian era in China, Egypt, Greece, and Rome to the mid twentieth century.[40] Through a winding series of portraits, Rivera pays homage to the past and celebrates the future of cardiac medicine in Mexico (Figure 7.4). According to Chávez, the idea for the murals was to chart the history of cardiology and document its influence on the fields of investigation and teaching. In the director's own words, he chose Rivera "not only because of his talent in the use of fresco technique, but because he believed that only Rivera could convert the cold climate of science into elements of plastic beauty."[41]

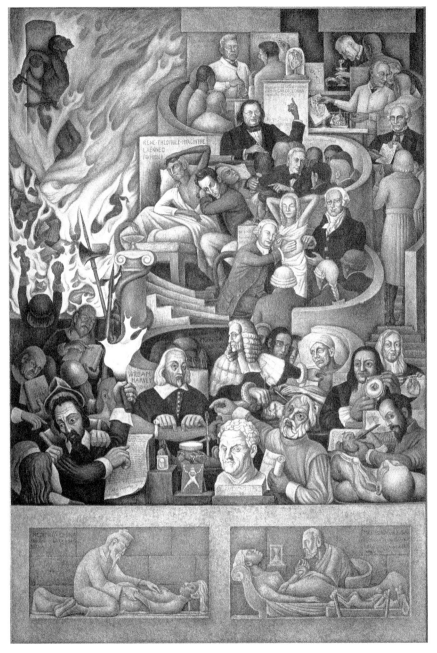

For the project, Chávez specified the iconography and provided Rivera with extensive notes on the history of cardiology. In these notes, Chávez discussed the universalism of science, an idea that Rivera methodically reflected by way of 47 portraits that represented a 'who's who' in cardiac medicine. The portraits were divided into two panels: one for anatomists, physiologists, and clinicians associated with the heart and a second one for investigators. In their

original setting, the panels were facing one another. Each figure is carefully labeled with his name and date and appears in period clothing. Often a doctor is shown with an attribute symbolic of his specialty. The figures are assembled in various groups according to discipline and then chronologically.[42] In his comments to the artist, Chavez elucidates his vision for the murals, advising that they

> should indicate the ascending trend of knowledge and if possible should express how slow and difficult has been the advance, how each of these men had to fight routine prejudice, ignorance and fanaticism . . . [If] you could find the way, it would be beautiful to paint this group of men moving, striving in an upward march![43]

Rivera responded by assembling the portraits as visual encyclopedic tributes to progress. Indeed, the entire mural ascends upward, the figures culminating with the image of the National Institute of Cardiology itself, pictured at the top of the second panel.

The grisaille vignettes at the bottom record samples of pre-Christian medicine from China, Egypt, Africa, and Mexico. However, in true fashion, the one potentially narrative sequence in the mural is reserved for Miguel Servet, whose scientific discoveries on the circulation of blood were considered sacrilegious (see Figure 7.4).[44] In this passage, occupying the fiery corner at the top of the 'Anatomists' panel, Servet, the sixteenth-century Spanish theologian and anatomist, is shown sacrificed at the stake by order of John Calvin. Once again, Rivera overtly chides Christianity for what he saw as backward thinking. Rivera's work for Ignacio Chávez, while not a particularly inspired synthesis of pictorial expression, functions nonetheless as a visual medical manifesto lauding the history of healing and the future of investigative science in the functioning laboratories and classrooms of Mexico's National Institute of Cardiology.

By the late 1940s and early 1950s, Miguel Alemán, Mexico's next president, continued promoting Mexico as a fully modernized country. During his tenure, the national economy flourished, owing to the building of transportation communication networks; the improvement of the built environment, and the establishment of social institutions dedicated to public works of sanitation and health care. In 1951, Rivera received what he called the "most fascinating commission" of his career.[45]

The Mexican government began work in the 1940s on a sophisticated aqueduct system to relieve a dangerous water shortage. The system consisted of tunnels meant to tap into the underground mountain sources of the Lerma River system. Rivera was asked to decorate the tank and tunnels with a mural celebrating the universal importance of water to the human race—its uses, its role in the origin of mankind, and its relationship to ancient Mexico. The waterworks project consisted of two parts: murals for the floor, tunnel, and walls of the cistern basin and a massive earth sculpture of the ancient rain god Tlaloc for the exterior water reservoir. Rivera's

interior murals were divided into stages. First, on the walls and tunnel of the cistern basin, the artist explored the origins of life itself beginning with the first cellular and mineral elements (Plate 7.2). In this magnified microscopic imagery, Rivera shows how electrical energy produced the first life: the cell. The cell, in turn, divides, subdivides, and multiplies, forming colonies of complex life. Rivera's depiction of the origins of life is based on the theories of Russian scientist Alexander I. Oparin, whom Rivera met in 1927 while visiting the Soviet Union.[46] Oparin proposed that life was the result of a long process that took place in the lukewarm waters of the ocean, where electricity gave life to small organisms that then evolved. The various forms of aquatic life—amoebae and starfish—pictured at the bottom of the basin, are consonant with Oparin's theories. In Rivera's mural, the giant life-giving hands, cupped in a gesture of bounty, decorate a tunnel arch from which water flows. These hands are symbolic of the vitalizing hands of Tlaloc and connect the exterior to the interior of the mural. Around the mouth of the tunnel are people from all social classes enjoying the benefits and life-giving properties of water—refreshing, sanitary, and available for bathing, drinking, and irrigation.[47] Directly across from the mouth of the tunnel is a frieze of 24 heroic portraits memorializing the project's planners, engineers, directors, and workers.

As one moves up the walls, the forms become more complex, evolving from depictions of amoebae to plants, animals, and, finally, humans.[48] On the walls to the right and left of the tunnel are the more advanced forms of life, culminating in monumental, strong, lithe, nude male and female figures that face one another. These represent the Asian and African races and are part of a larger polemic on the origin of life that was circulated during this period as well as the artist's attack on a recent resurgence of Fascist pro-Aryan ideas.[49] In both images, the reproductive aspects of humankind are emphasized—the woman's connection to biology is made through visual allusions to growing embryos and the monumental African man shows his reproductive capacity through the representation of flowering plants and a general upward mobility of forms. Rivera considered this project a unique opportunity to bring together his knowledge of science, his interest in the evolution of life, and his political activism. The work visually connects Mexico's past with its present, since the Mexican worker inherited the role of the Aztec rain god by bringing water to his people. Man, composed of water, essentially offered of himself to others, thus participating in its life-giving properties. Together, Rivera's figures model notions of the modern, healthy, fecund human.

In 1953, Diego Rivera began work on what was to be his final fresco: *History of Medicine in Mexico: People's Demand for Better Health* for the Hospital La Raza, the country's leading medical institution (Plate 7.3).[50] In the artist's own words, the mural was to show

... the entire Mexican community, its medical past in order to assure them of its future. That this is in no way a gift from anyone; instead it is result of evolution— from the ancient Aztec herbalists to the extraordinary physicians of today.

Mexicans, like everybody else, are a people thirsting for security. The government does well to provide it through the establishment of public institutions.[51]

To be sure, the painting is a visual homage to free medical service. By juxtaposing the egalitarian system of the ancient indigenous Mexicans (albeit historically romanticized) with the country's modern, newly reorganized national system of socialized healthcare, Rivera created a history painting that celebrated at once the indigenous past and the universal, quality health care of the present. For example, in the upper left hand corner of the mural, the painter documents the transition from private to public healthcare. A large group of Mexicans floods the clinic and is met by officials, who, citing new Social Security laws, inform the people that they will be treated cost-free. Behind the physicians, are the for-profit doctors who lament the new changes in public health.

The entire left-hand side of the mural is dedicated to modern medicine. Moving along the painting, the viewer is treated to a visual account of the progress in scientific method. For example, in a detail from the center, doctors stitch up a patient, monitoring recovery with electrical equipment and the latest in technology. The physicians and nurses are shown on the job, working to save lives. Another detail shows a doctor and nurse tending to a sophisticated cobalt scanning treatment—a reference to Rivera's first-hand experience with such treatments for his own prostate cancer. The panel recalls the *Vaccination* panel in Detroit, which also prominently features a nurse. Here, however, the nurse is more educator than compassionate bystander. Dressed in uniform, she looks directly toward the doctor as she prepares to operate the sophisticated machine. Notably absent are the smooth golden waves and highly stylized face that characterized the Detroit figure—instead, this nurse wears a simple, practical hairstyle, suitable for a full day of work. In another detail, Rivera pays homage to the advancements made in sterilization in childbirth that significantly reduced the mortality rate of newborns and their mothers.

But, in this final work by Rivera, modern medical science is in no way a replacement of ancient practices; rather, it is part of a seamless narrative of centuries of progress. On the right side of the mural, the artist meticulously depicts pre-Colombian medical practice as a noble man at the bottom points to his heart, indicating where he feels pain, a midwife assists in childbirth, and healers provide massages, steam baths, and other soothing medical practices. In addition, the primitive Aztec cranial operation, trepanation, is also represented.[52] Presiding over these highly organized and egalitarian scenes is the goddess Izcuitl, who functions as an intercessor for the people's medical care. At the far right, Rivera includes a large tree, in the form of a nude woman who nourishes the child below with her four plentiful breasts. Reminiscent of the baby in the earlier *Vaccination* panel, this child is similarly nourished by the earth and sustained through modern medicine.

For Rivera and the program of public health in revolutionary Mexico, healthy children signified a healthy nation.[53] The artist's continual inclusion

of children in his murals recalls the ideas promoted by hygienist Dr. Alfonso Pruneda, who held several positions within the Department of Health and stated the "the child is the link between social institutions . . . He is the vector of the teachings and practices he acquires there such that he can modify domestic conditions."[54] In a similar way, the nursing mother and child to the right of the portrait of Lenin in Rivera's *Man, Controller of the Universe* (opposite the lithe female athletes located on Lenin's left), are model participants in the proletarian program for public health and sex education.[55]

For Rivera, the healthy child is the antidote to society's ills—it is society's future and its blood. The large tree, along with a red-stemmed one on the left side of the mural, bracket the painting and function as massive networks of circulation bringing blood to and from the Mexican population, past and present. The trees recall imagery of the so-called Tree of Life, described in the *Popol Vuh*, the Mayan story of creation. It is likely a representation of the ceiba tree, whose branches are filled with a reddish resin that looks like blood and mythologically justified blood-letting practices, ritual warfare, and human sacrifice as tributes to the rain god in Mayan and later cultures; blood and water serving as the essential elements of human existence.[56]

But it is the central image of the Goddess Tlazoltéotl who dominates the mural and unites the two scenes. Taken directly from the sixteenth-century *Codex Borbonicus*, the figure is the goddess of 'repulsive things'—she who cleanses the body of filth.[57] She is also considered the guardian of childbirth. Below her, Rivera pays homage to another codex, carefully reproducing illustrations from the 1522 *Badianus Manuscript*, a repository of traditional medicinal knowledge and the oldest surviving record of ancient American plants used for hundreds of afflictions. An Aztec healer, who rose to the position of physician during the sixteenth century, made the manuscript's illustrations. In yet another detail, a woman consults the manuscript's illustrations and, according to Rivera, uses tortillas, papaya, and mushrooms to create an ancient penicillin.[58] Thus, the history of the Mexican healthcare provider begins not in the twentieth century, but four centuries earlier.[59]

In this final mural, Rivera synthesized years of public health awareness, hours of research dedicated to studies of anatomy and medicine, and his genuine and unwavering interest in the universality of health and healthcare for future generations. In a large-scale tribute to his country's medicinal history, Rivera sews the threads of collective health that have supposedly existed since pre-Columbian times. Mexico's ancient medicine is presented as a precursor to modern health science; thus, for Rivera, the twentieth-century Mexican doctors are the *curanderos* and *hierberos* descended from the pre-Columbian past.

Throughout his career, science occupied an important and steady place and served as inspiration for some of Rivera's most remarkable and successful murals. Recurrent in the works discussed are the universal themes of regeneration and rebirth, production and reproduction, the relationship of man to the world around him, and the merging of the mind and the body toward an

understanding of modern progress in science and public health. The modern man/woman was healthy, sexually aware, disease-free, and a believer in science, medicine, and technology. While Rivera's political ideology was subject to convenience, his enthusiasm for scientific progress and high standards of public health was steadfast and certain. Although their analysis is often couched in the inevitable political rhetoric for which the artist is best known, I have demonstrated that these murals undoubtedly reflect Rivera's consistent commitment to the role of scientific progress in the betterment of humanity.

Notes

1 An early version of this paper was presented at the University of South Carolina Symposium, "Art, Anatomy and Medicine since 1700," Columbia Museum of Art, organized by Dr. Andrew Graciano. The research grew out of my time as a graduate student at the Institute of Fine Arts, NYU, in a class on Diego Rivera with Dr. Edward Sullivan. I wish to thank both Edward Sullivan and Andrew Graciano for their critical feedback and support.

2 Article 73 of the 1917 Constitution provided for the government's protection of public health in Mexico. See Bliss (2006), 197.

3 The topic of Diego Rivera and his long-time relationship to public health is rarely, if ever, discussed in literature dedicated to the artist. To date, the only initial treatment of the subject can be found in the book edited by Roger Díaz de Cossío (1986), which is a compilation of writings on some of Rivera's murals dedicated to issues of health. This publication is also the only one to reproduce in color some of the artist's lesser-known murals. Another essay dedicated to this topic is that of Kumate (1986), which offers an introduction to the topic and details related to the commission. Neither essay, however, considers Rivera's murals from an art historical perspective or within the broader context of public health in revolutionary Mexico.

4 The scope of public health activities in Mexico at the end of the nineteenth century and through the early years of the twentieth, especially during the years of the Porfiriato, reflected the Mexican state's near obsession with modernity. In the eyes of the Porfirian elites, public health was as essential as railroads were in the formation of a truly modern Mexico. Nevertheless, unlike the revolutionary programs following 1910, the Porfirian plans were limited, concerned mostly with issues of developing the national infrastructure. Where the Porfiriato spent its resources on improving sewage systems and on developing municipal garbage collections, the Revolution would seek to create the 'New Man' armed with public health and hygiene. For a good introduction to the general state of public health in Latin America, see Abel (1996).

5 For a comprehensive treatment of venereal disease in Mexico and the Revolution's commitment to reform in regard to disease containment, see Bliss, 2006, 196–217 and Bliss (1999). Social welfare programs were outlined in Article 123 of Mexico's 1917 constitution. For information on these programs, see Arena (1988), especially 41–46.

6 Bliss (1999), 2.

7 In 1917, federal deputy Arturo Higareda of Jalisco addressed the legislature, commenting on the degenerate moral state of the poor. Blaming the Catholic Church and the Porfirian government for the lack of health education among the poor, Higareda remarked: "the majority of the representatives listening know that there are three things that have degenerated our poor classes: first, the clergy, which hides the truth and which exploits the poor; second, the government, which, being tyrannical, deprives them of learning, which is the bread of understanding and fountain of spirit; and in the third place, vices, which keep them from working." See ibid.

8 Ibid., 11.

9 In order to encourage the poor to seek treatment for venereal disease, the Departamento de Salubridad established virtually cost-free, anonymous venereal disease treatment clinics in lower-class neighborhoods. Between 1921 and 1925, thousands of patients sought weekly injections of Neo-Salvarsán over several months as part of their treatment plan. Ibid., 10.

10 During these early years after the Revolution, Mexican reformers often looked to United States' social legislation as a model for their burgeoning social welfare programs. See Abel (1996), 6–18.

11 The goals of this public campaign are outlined in documents found in the Archivo Histórico de la Secretaría de Salubridad y Asistencia, Mexico City, Salubridad Pública (AHSSA-SP), Servicio Jurídico, box 43, file I. Cited in Bliss (1999), 11.

12 Gastélum was no doubt familiar with Rivera's work since his past duties included serving as Associate Secretary of Education to José Vasconcelos, who helped launch the government-supported Mexican Mural movement of which Rivera was an integral part. In 1943, the Departamento de Salubridad became the Secretaría de Salubridad y Asistencia and, in 1984, the name was changed again to Secretaría de Salud. See Kumate (1986), 78. For information on the building, commission, and on Gastélum's patronage and tenure as Health Minister, see: O'Rourke (2014). O'Rourke's article is the first to treat comprehensively this important commission and examines the work within the context of the Ministry's social and scientific program.

13 In his autobiography, the artist described the commission thus, "These panels, done in the building's Assembly Hall and covering over 350 square feet of wall and ceiling, comprised six large female nudes symbolizing Purity, Strength, Knowledge, Life, Moderation and Health itself. Purity sat on the ground near a stream of clear water flowing over her hand. On the ceiling above her, looking downward, flew Life. Strength rested on the ground, full-bosomed, with sturdy thighs and powerful hands. Knowledge sat with her feet doubled under her, dreamily gazing at an open blossom in her hand. Near her and almost touching her face, was a snake coiled around a tree. Health was a seated figure with hands raised. Moderation was a tall, big-boned woman lying down, her eyes closed. In her hand, she gripped a snake below the head from which darted its forked tongue; its body was clasped between her knees." Rivera with Gladys March (1991), 96–97.

14 O'Rourke (2014), 25.

15 Ibid., 26. O'Rourke correctly observes that here the staff, symbolizing modern medicine, replaces divine with scientific knowledge. The snake, as pointed out by artist Carlos Mérida in Diaz de Cossio (1986), 30, is also associated with

the goddess Ishtar, the Biblical Eve, and Minerva, ancient goddess of War and Wisdom.

16 Ibid., 27. O'Rourke points specifically to the figures of *Life* and *Health*.

17 Kumate (1986), 79. See also O'Rourke (2014), 22–23. O'Rourke also explains how Rivera's murals, decidedly clinical in appearance, replaced Fernando Leal's originals, which were destroyed for being too sensual.

18 One of the most important of these institutions was the establishment in the 1920s of the important medical research center known as the National Hygiene Institute, which was also charged with providing vaccines. O'Rourke (2014), 20–21.

19 For information on Balmis and his expeditions, see Thompson (1993), 443–446. Smallpox vaccinations were administered to children between 1806 and 1820.

20 Rivera's focus on assembly line production was in sync with the ideals of socialist economics. For a detailed examination of these ideas, see Lomas (2007. See also Rosenthal (2015), 66.

21 The National Hygiene Institute in Mexico, commissioned by the Health Ministry, also included a Bacteriological Museum that housed samples of microbes visible through microscopes. In addition, the Institute, in its capacity to produce vaccines, had shelters to care for and dispose of the animals, like those depicted here, used for making vaccines.

22 McMeekin (1985), 22. McMeekin identifies the figures, from left to right, as: Louis Pasteur, Ilya Metchnikoff, and Robert Koch.

23 The artist in "Industrial Detroit. A Selection from the frescoes now in process of completion in the Detroit Institute of Arts," Detroit 1932. Located in the Museum of Modern Art (MOMA), New York, artist file.

24 These bacteria and cell images recall the panels in the Ministry of Health and thus show Rivera's continued preoccupation with, and knowledge about, the concepts of cell growth and cell disease. See McMeekin (1985), 26.

25 Downs (1999), 113. Downs's book is the most comprehensive treatment of this mural to date.

26 De Kruif (1926).

27 McMeekin (1985), 22.

28 Downs (1999), 69.

29 See Cueto (1994b), 1.

30 See Solorzano (1994).

31 Lozano (1999), 232.

32 See Paquette (2017), 130, 154, 232.

33 Thanks to Andrew Graciano for sharing this observation.

34 Solorzano (1994), 56.

35 These works are in Tlalpan, near Mexico City in the Universidad Ibero-Americana. They are located in the foyer of the auditorium of a multi-building complex, that includes a hospital and research and training centers for advanced study in the treatment of heart disease. They were originally commissioned for

the Instituto Nacional de Cardiología, Mexico City, which is now part of the Centro Médico Nacional.

36 See Chávez (1986).

37 Cueto (1994b), 135–136.

38 Ibid.

39 Lomas (2007), 473.

40 For the most comprehensive study to date on this mural, see Lomas (2007).

41 Chavez (1986), 40.

42 For a list of the portraits in these panels see Helms (1986), 314–315.

43 Quoted in Lomas (2007), 470.

44 In 1553 Servet wrote his treatise *De Christianismi Restitutio*. See Lomas (2007), 472.

45 See Rivera with March (1991), 166. See especially Rivera (1986a).

46 Ovando (1999), 18–20. To date, Ovando's text remains the most comprehensive treatment of this mural.

47 The man who offers a woman a cup of water is identified as Daniel Hernández, the project's engineer. Ovando, p. 25.

48 The floor's iconography is drawin from Ernst Haeckel's *General Morphology of Organisms* (1885) and Dr. A. E. Brehm's *Creation: National History* (1883), two texts owned and valued by Rivera. See Juan Rafael Coronel Rivera, "The Origin of Live," in Lozano and Rivera (2008), 547.

49 Ovando (1999), 18–20.

50 Just one year before, David Alfaro Siqueiros had completed a mural for the Hospital foyer with the theme of "Victory of Science over Cancer." Siqueiros's work functioned as an allegory of public health that protected man from the hazards of industry, represented by a dead worker.

51 Rivera, (1986b) 68.

52 Nicholson (1999), 54.

53 The public health politics that cause certain ideal bodies to be visualized (in art) as, and understood to be, models of national (political and social) health are also discussed by Amanda Wangwright in Chapter 8 of the present volume, but in relation to Republican-era China.

54 Pruneda, quoted in Bliss (2006), 206.

55 Ibid., 203. In this way, the presence of the mother and child pictured opposite the capitalist socialists to the right of the central figure of the worker may take on additional significance. According to Public Education Secretary Ignacio García-Téllez, a move from the rich metropolis to the proletarian country underscored the "link between the exploiters who foment ignorance and the vices of the oppressed." In Téllez's view and those working alongside him, the main exploiters were the capitalists and clergy. Thus, in his mural for the Rockefellers, Rivera at once celebrates the capitalists' role in supporting health campaigns in Latin America and cites them as the perpetuators of the vices afflicting the oppressed classes.

56 I wish to thank Andrew Graciano for sharing this observation. See *Popol Vuh*, trans. Dennis Tedlock (New York: Simon and Schuster, 1985).

57 Helms (1986), 321.

58 Rivera (1986b) 70.

59 Badianus was the translator of the text into Latin. For an interesting and informative discussion of these herbs, see Nicholson (1999), 54–58.

References

Abel, Christopher. *Health, Hygiene and Sanitation in Latin America c. 1870–c. 1950.* London, UK: Institute of Latin American Studies, 1996.

Arena, Santiago Zorilla. *50 Años de política social en México de Lázaro Cárdenas a Miguel de la Madrid.* Mexico: UNAM, 1988.

Bliss, Katherine E. "The Science of Redemption: Syphilis, Sexual Promiscuity, and Reformism in Revolutionary Mexico City," *The Hispanic American Historical Review* 79, no. 1 (February 1999): 1–40.

Bliss, Katherine E. "For the Health of the Nation: Gender and the Cultural Politics of Social Hygiene in Revolutionary Mexico." In *The Eagle and the Virgin. Nation and Cultural Revolution in Mexico, 1920–1940*, edited by Mary Kay Vaughan and Stephen E. Lewis. Durham, NC: Duke University Press, 2006.

Chávez, Ignacio. "Diego Rivera. Sus frescos en el Instituto Nacional de Cardiología." México: Sociedad Mexicana de Cardiología, 1944. In *Diego Rivera y la Salud*, edited by Roger Díaz de Cossío. Mexico, 1986.

Cueto, Marcos, ed. *Missionaries of Science: The Rockefeller Foundation and Latin America.* Bloomington, IN: Indiana University Press, 1994a.

Cueto, Marcos. "Visions of Science and Development: The Rockefeller Foundation's Latin American Surveys of the 1920s." In *Missionaries of Science: The Rockefeller Foundation and Latin America*, edited by Marcos Cueto. Bloomington, IN: Indiana University Press, 1994b.

De Kruif, Paul. *Microbe Hunters.* New York: Houghton Mifflin Harcourt, 1926, reprinted 1996.

Díaz de Cossío, Roger, ed. *Diego Rivera y la salud.* Mexico, 1986.

Downs, Linda Bank. *Diego Rivera. The Detroit Industry Murals.* Detroit, MI: Detroit Institute of Arts, 1999.

Helms, Cynthia Newman, ed. *Diego Rivera: A Retrospective.* Exhibition catalog. London, UK: Founders Society, Detroit Institute of Art, 1986.

Kumate, Jesús. "Diego Rivera: la medicina y el arte." In *Diego Rivera hoy: simposio sobre el artista en el centenario de su natalicio.* Mexico City, Mexico: Instituto Nacional de Bellas Artes, 1986.

Lomas, David. "Remedy or Poison? Diego Rivera. Medicine and Technology." *Oxford Art Journal* 30, no. 3 (2007): 456–483.

Lozano, Luis-Martin. *Diego Rivera: Art and Revolution.* Exhibition catalog. Mexico, 1999.

Lozano, Luis-Martin, and Juan Rafael Coronel Rivera. *Diego Rivera: The Complete Murals*. Cologne, Germany: Taschen, 2008.

McMeekin, Dorothy. *Science and Creativity in the Detroit Murals*. East Lansing, MI: The Michigan State University Press, 1985.

Nicholson, Rob. "Az-Tech Medicine." *Natural History* 108, no. 10 (December 1999): 54–59.

O'Rourke, Kathryn E. "Science and Sex in Diego Rivera's Health Ministry Murals." *Public Art Dialogue* 4, no. 1 (2014): 9–40.

Ovando, Claudia. *Diego Rivera: el agua, órigen de la vida*. Mexico, 1999.

Paquette, Catha. *At the Crossroads. Diego and his Patrons at MoMa, Rockefeller Center, and the Palace of Fine Arts*. Arlington, TX: University of Texas Press, 2017.

Rivera, Diego. "Inegración plástica en la cámara de distribución del agua del Lerma, Tema Medular: el agua órigen de la vida en la tierra," *Espacios 9* (February 1952). In *Diego Rivera y la Salud*, edited by Roger Díaz de Cossío. Mexico, 1986a.

Rivera, Diego. "El pueblo en demanda de salud." Interview with Diego Rivera by Ortega Colunga in *Siempre* (January 30, 1954). In *Diego Rivera y la Salud*, edited by Roger Díaz de Cossío. Mexico, 1986b.

Rivera, Diego with Gladys March, *My Art, My Life. An Autobiography*. New York: Dover, 1991 [1960].

Rosenthal, Mark, ed. *Diego Rivera and Frida Kahlo in Detroit*. New Haven, CT: Yale University Press, 2015.

Solorzano, Armando. "The Rockefeller Foundation in Revolutionary Mexico: Yellow Fever in Yucatan and Veracruz." In *Missionaries of Science: The Rockefeller Foundation and Latin America*, edited by Marcos Cueto. Bloomington, IN: Indiana University Press, 1994.

Thompson, Angela T. "To Save the Children: Smallpox Inoculation, Vaccination, and Public Health in Guanajuato, Mexico, 1797–1840." *The Americas* XLIX, no. 4 (April 1993): 431–455.

The Sick Man of Asia and the Anatomically Perfect Woman: Remodeling Republican China's (Body) Image through the Visual Arts

Amanda S. Wangwright

There is some debate about whether China has a tradition of picturing the nude figure. The late James Cahill argues in his final monograph that awkward depictions of female bodies in late imperial painting were deliberate aesthetic choices on the part of the artists, and the assumption that the Chinese lacked an understanding of the female form is disparagingly inaccurate.[1] Regardless of Cahill's assertion, however, it is relatively safe to say that traditional Chinese art produced few examples of the nude outside of medical illustrations or erotic imagery. The same could *not* be said of modern Chinese art by any stretch of the imagination. The nude—and, in particular, the female nude—proliferated in twentieth-century media from the periodical press to art photography and cinema. What can account for the sudden emergence and popularity of a genre heretofore largely ignored in the Chinese imaginary?

In this chapter, I explore how the overwhelming interest in the female nude in both the art community and larger popular culture stems from a newfound embrace of Western anatomy and medicine. I argue that anxiety about the health of the nation led artists to advocate for the realistic depiction of a perfected body image that was simultaneously informed by the prevailing medical discourse and based on the Western aesthetic ideal. Early twentieth-century interest in human anatomy spanning from the scientific community to the pages of popular pictorials fixated on the Chinese body as evidence of racial degradation and site of potential national reform. At the same time, the implementation of China's new art school curriculum—with its educational focus on the anatomical precision of the Euro-American life-drawing tradition—led to a preoccupation with the physical proportions of a fuller-figured female nude. As the producers of these images, modern Chinese artists clung to a promise of national revitalization that could be realized through empirical observation of the natural world—more precisely, through realistic images of a perfect Chinese female body.

The Sick Man of Asia

By the late nineteenth century, Chinese intellectuals and politicians bemoaned the country's global image and advocated social, political, and educational changes on a national scale. An impotent late Qing empire (1644–1911) had reduced the nation to a shadow of its former glory and the modern era heaped humiliating political concessions on top of the repeated incursions of multiple foreign armies. At the twilight of what was to be China's final dynasty, government officials introduced dramatic reforms, as China sought to compete with—or at least measure up to—the colonial powers in medicine, science, and technology. Whereas China had long rejected Western medicine and anatomy, preferring instead its own traditional understanding of the body and its medical treatment,[2] in the late Qing the so-called "Self-Strengthening Movement" (1861–1895) established government-funded schools built on a bedrock of Western learning. In schools with curricula heavily focused on Western languages, technology, and science, Chinese students also took art classes in which they learned technical drawing, vanishing-point perspective, and chiaroscuro.[3] When the shock of China's defeat in the Sino–Japanese War (1894–1895) led some in the intellectual community to conclude that the recent reform efforts had failed, reformers such as Liang Qichao 梁啟超 (1873–1929), rather than abandon Western learning, viewed the Chinese empire as an ailing body and redoubled their efforts to administer a course of occidental remedy. Liang voiced his disappointment and frustration about China's unfortunate predicament by labeling his homeland the "Sick Man of Asia" (*dongfang bingfu* 東方病夫).[4] As the pejorative implies, Liang's and his contemporaries' understanding of their country, its people, and its disadvantaged international standing was deeply rooted in metaphors of the body and in a preoccupation with health, be it individual, societal, or national. For the remainder of the empire's final years, Liang and his fellow reformers continued to look toward Euro-American pedagogical models and established academic institutions, often with an emphasis on the study of anatomy and biomedicine.

With a Westernized educational model firmly in place by the start of the Republican period (1911–1949), educators and the scientific community of the early twentieth century began negating traditional Chinese scientific and medical knowledge to suit the modern political agenda of nation building and the legitimization of the new state. Reformers disregarded and systematically undermined China's traditional sciences and medicine, as well as its conservative philosophical beliefs and cultural practices, while "accept[ing] the West as the universal starting place of all science."[5] Influential members of the medical community, such as the Chinese Ministry of Education representative and Japanese-trained physician Tang Erhe 湯爾和 (1878–1940), deemed indigenous approaches to understanding and picturing the human body and its biological processes as incompetent and dangerously ignorant. Tang's and his peers' unrelenting commitment to the re-picturing of the human body among the medical community of his home country has led historian David

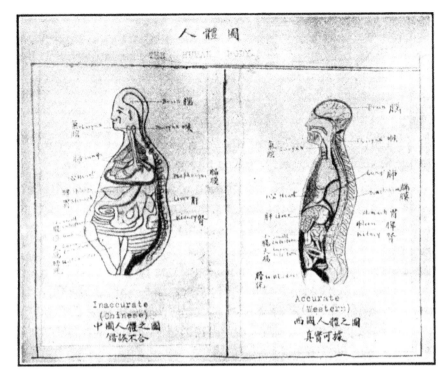

8.1 "The Human Body: Inaccurate (Chinese); Accurate (Western)," *National Medical Journal* 1:1 (1915): 51–52. Courtesy of The New York Academy of Medicine Library.

Luesink to observe that "[t]he fundamental basis of the critique of Chinese medicine was its perceived lack of anatomical knowledge."[6] Indeed, the first issue of the *National Medical Journal of China* expressed bitter dismay at the state of the medical field in China, particularly in comparison with the West, and forcefully argued that an empirically grounded medical practice based on anatomically precise knowledge was crucial to the survival of the Chinese people.[7] To underscore this point, the article produced a literal re-envisioning of the human body with side-by-side reproductions of traditional Chinese and modern Western anatomical drawings (Figure 8.1). Labeling the Chinese version 'inaccurate' (in Chinese, "erroneous and incoherent," *cuowu buhe* 錯誤不合) and the Western 'accurate ("the reliable truth," *zhenshi keju* 真實可據), the journal sought to redefine the very appearance of health by assigning a new visual model to which to aspire. Encouraging government oversight of the medical profession, influential leaders such as Tang pushed for the state-enforced standardization and institutionalization of scientific and medical training.[8] These men, who also maintained close ties to the May Fourth movement and its advocates,[9] had direct bearing on China's educational system.

Every bit as dire as the indigenous methods of scientific analysis that reformers deemed so lacking, the Chinese body itself literally failed to measure up to expectations. Jia-Chen Fu's recent study on the widespread practice of anthropometrics in the Republican period documents how the Chinese medical

community's systematic measurement of the bodies of regional populations of men, women, and children—and the subsequent comparison of these measurements to those of Japanese and Euro-American societies—arose from national anxieties about the perceived inferiority and threatened existence of the race.[10] For its practitioners, anthropometrics implied a rational and methodical study of the nation's most pressing problem and additionally promised the betterment of the Chinese people. Perceived deficiencies in the measurements of Chinese bodies were attributed to environment rather than to genetic predetermination.[11] Thus, the data collected through such pseudo-medical studies could be analyzed and used to develop methods—targeted diet and exercise campaigns, for example—to strengthen the populace. In this way, China's medical and scientific community channeled commonly held fears about the fate of the nation into proactive plans to study and expose widespread weaknesses and to implement reform. As Fu argues, "[s]elf-scrutiny was a form of self-assertion."[12] Such self-scrutiny and obsession with measurements eventually extended well beyond the intellectual class, however, as even popular magazines printed articles and photo-essays comparing the physical characteristics and proportions of different races and prescribing methods of attaining physiques more aligned to the Western ideal (Figure 8.2).

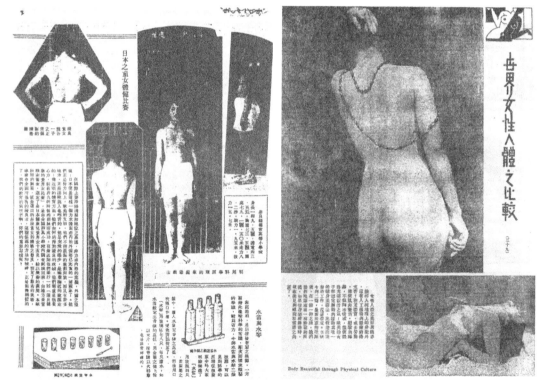

8.2 "Body Beautiful through Physical Culture," *Modern Miscellany* 1:5 (1930). The Chinese-language title on the right-hand page states, "Comparison of the bodies of the women of the world," while the Chinese title on the left-hand page may be translated as, "Japan's young girls' physical health competition."

Despite, or perhaps because of, the methodical application of Western medical practices and anatomical standards, the perception of China as the Sick Man of Asia persisted well into the Republican period and was disseminated widely across popular culture. Fiction writers, such as Zhou Shoujuan 周瘦鵑 (1894–1968), used bodily metaphors to express their utter dissatisfaction with the slow progress of national reform. In an essay published by the major Shanghai newspaper *Shun Pao* (*Shenbao* 申報) in 1928, Zhou allegorized the nation as a sickly 17-year-old, whose health and well-being had suffered tragically from the maltreatment of unscrupulous elders (the author's characterization of conservative proponents of traditional values) and a vicious neighbor (an obvious reference to Japan).[13] Other serials expressed optimism by turning their hopes to the promised vitality of the next generation. Featuring a young boy with a healthy physique and waving the national flag, the cover of *Arts & Life Magazine* (*Meishu shenghuo* 美術生活) inserts military toys in the margins and captions the photograph of the boy with the simple phrase "I am not the Sick Man of Asia" (*Wo fei dongya bingfu* 我非東亞病夫) to suggest the nation's youth would grow up to be strong and healthy fighters (Plate 8.1).[14] It is in this context of a national anxiety manifest through the image of the human body that educational reformers developed the art curricula for the numerous public and private schools newly opening across the nation.

From the Medical Text to the Easel: Studying the Body and Reforming the Nation in the Art Studio

It is no coincidence that national reform efforts targeting the proper analysis, depiction, and reform of the body quickly filtered into the visual art classroom. The early twentieth-century fascination with the perceived objectivity of the scientific gaze permeated all forms of art in China, including the practice of traditional ink painting, by now identified as *guohua* 國畫 ("national painting").[15] Moreover, the perceived accuracy of Western-style painting (*xiyanghua* 西洋画) and its early association with science and engineering especially predisposed its media and techniques as ideal for capturing verisimilitude. While the techniques employed in Western drawing and painting had been taught in schools since the late nineteenth century, with educators promoting naturalistic styles that incorporated perspective and chiaroscuro as objective tools to be used for the improvement of the nation, early twentieth-century reformers specifically viewed Realism as the antithesis of conservative Chinese tradition and an antidote for stagnant thinking. In contrast to the avant-garde artistic trends of early twentieth-century Europe, many of China's modernist artists clung fervently to Academic Realism, which they perceived and employed as a modern aesthetic in so much that its style and practice—such as drawing or painting the nude figure from life—emphatically broke with Chinese painting tradition.[16]

In the first decades of the twentieth century, art educators introduced the practice of life-drawing to the curriculum of the newly established educational institutions, where it became a vital component of formal training in Western artistic styles and techniques. Interest in the nude model stemmed in no small part from the actions of one particularly ambitious reformer of education, Cai Yuanpei 蔡元培 (1868–1940). Cai wielded considerable influence over the development of art education in China, first as the new Republic's inaugural Minister of Education in 1912 and later as the chancellor of Peking University (*Beijing daxue* 北京大學) from 1917 to 1926. Best remembered today for advocating aesthetic education as a replacement for religion, he formulated strong ties between Western learning and the visual arts. His 1912 essay on aesthetic education (*meigan jiaoyu* 美感教育) calls on Kantian philosophy—Cai had returned the year before from studies at the University of Leipzig in Germany—to position art as a mechanism for elevating national character and bettering society.[17] That same year, Cai appointed Lu Xun 魯迅 (1881–1936) to a position in the newly created Office of Social Education. Following a brief period of study at a medical school in Japan, Lu had returned to Shanghai in 1909 to become a prominent supporter of the arts and the founder of China's woodcut art movement. In his new position, Lu immediately gave a series of lectures dedicated to the arts and the following year published an essay proposing to recreate in China the Euro-American vision of a civil society culturally enriched through the dissemination of art via public institutions.[18]

Years later, Cai Yuanpei remained equally committed to the elevation of the arts and the reform of Chinese education in the Western image, evidenced in a 1919 lecture he presented for the Painting Styles Research Group (*Huafa yanjiuhui* 畫法研究會) at Peking University. Criticizing the Chinese tradition of copying, his talk again called for China to follow the Western model through the application of scientific observation in the natural sciences and life sketching. To justify his proposal, Cai cited the words and actions of Western philosophers Aristotle, Francis Bacon, and Johann Wolfgang von Goethe.[19]

Cai's enthusiasm for Western science and empirical evidence, along with his training and endorsement of artists such as Li Shutong 李叔同 (Hong Yi 弘一, 1880–1942) and Liu Haisu 劉海粟 (1896–1994) catapulted the art nude to canonical status in the new art school curricula.[20] Li Shutong, who initially studied under Cai Yuanpei at the Nanyang Public School (*Nanyang gongxue* 南洋工學) in Shanghai and then trained in Western painting at the Tokyo School of Fine Art, became the first educator to implement the practice of life-drawing in a Chinese academic setting when he began employing a nude model for classes at the Zhejiang First Normal College (*Zhejiangsheng diyi shifan xuexiao* 浙江省立第一師範學校) in Hangzhou.[21] Similarly, Liu Haisu, who received support from, and collaborated with, Cai over multiple decades,[22] incorporated the nude model in life-drawing classes, eventually introducing the female model in 1920.[23] While working from a nude model in the studio art classroom became the target of some degree of controversy

in the mid 1920s, it nonetheless stood as standard practice for several institutions of higher learning throughout most of the Republican period.[24]

Under the tutelage of art academy faculty, young artists learned and experienced the theory and practice of drawing and painting the nude figure. Thanks to the rhetoric of China's leading art theorists and educators, the nude was credited as the harbinger of an incipient renaissance, a great cultural florescence that promised to propel China out of the spiraling decline that the country continued to endure under warlord rule and semi-colonization. One of the first to claim explicitly and vigorously that the artistic nude signified cultural enlightenment was an instructor in the Western painting department, Ni Yide 倪貽德 (1901–1970). In addition to his faculty position at the Shanghai Academy of Art (*Shanghai meishu zhuanke xuexiao* 上海美术专科学校), Ni actively participated in the avant-garde painting community. Beyond creating and exhibiting paintings of the female nude, he penned an essay in defense of the subject entitled "Considering Nude Art," which imparts a clear sense of the modernist idealism invested in the act of painting the nude.[25]

In his indignant essay, Ni Yide lays forth the challenges that the genre faced, and establishes the criteria to which a painting of a nude should adhere and by which it should be evaluated. Drawing a comparison to socialism and its revolutionarily benefits, he argues that the art of the nude was similarly misunderstood by his countrymen. He fervently believes that opposition to the nude in art posed a dire threat to China's art world.[26] Those who see nude images as pornography he labels as moralists, who, despite their strict Confucian ethics, are truly hypocrites and degenerates. Broadening his discussion to a larger worldview, he writes that, whereas Western art took the body as a center of study, Eastern religious thought traditionally viewed interest in the body as immoral. Ni goes on to champion 'free love' (that is, relationships based on romance rather than arranged marriage) and a society unfettered by conservative restrictions. It is clear that he embraced the nude in art as anti-traditionalist and that he advocated a new view of the human body as a way to overthrow outdated Confucian morality. Somewhat paradoxically, however, the nude held in his estimation both the potential to usher in a research-based cultural revival *and* the promise of a return to the "spirit of the primeval ages" that allowed for an innocent and natural freedom of expression.

Ni Yide's essay, and, indeed, the majority of the discourse on the nude in art, genders the model as female, and he precisely delineates the logic behind his and his contemporaries' focus on women's forms. He felt that rather than fixating on technique, modern artists should concentrate on conveying the coloration (*secai* 色彩), dimensionality—or what he calls "roundness" (*yuanwei* 圆味) —and sensuality (*rougan* 肉感) of the nude body. That is, he advocated the very characteristics that distinguished the Western figure painting tradition from that of China's, in which beauties typically possessed milky white skin of even tone and slight figures defined by the outlining of forms rather than by volumetric shading (Plate 8.2). In particular, Ni Yide discusses at

length the voluptuousness of the female form and it seems that he is capti-
vated by the image of the full-figured female nude, much like those he would
have seen in the paintings of the European masters. To him, it is basic human
nature to find beauty in soft and gentle things, be it a light breeze, fragrant
flower, or the body of a young woman. In many areas, Ni's article echoes the
words of Cai Yuanpei and is revealing of both the senior educator's influ-
ence and the pervasiveness of a rather standardized rhetoric throughout the
Chinese modern art community. A simple comparison to Cai's 1917 speech,
"Replacing Religion with Aesthetic Education," highlights similar conceptu-
alizations of primitive innocence and a universally recognized Beauty, as well
as an unquestioning acceptance of the absolute primacy of Greco-Roman and
Renaissance art and the ability of nudes from the Western artistic tradition to
inspire appreciation without generating lust.[27]

Modeling the Ideal: The Female Body as Site of National Reform

Ni Yide's and his contemporaries' theories were so highly influential that repro-
ductions of paintings and sculptures of the female nude—both contemporary
Chinese and canonical Western examples—abound in the periodical press
of the day. While paintings of nude male figures are not completely absent,
such works were greatly outnumbered by images of female nudes. It might be
tempting to assume that the painters of these images were simply catering to
the male gaze. Closer investigation of the imagery and discourse circulated in
print media, however, reveals the female figure in particular offered unprece-
dented opportunity for commentary on issues of national and contemporary
importance. Moreover, women were included among the assumed audience
for fine art images of the female nude, as indicated by the number of such
images found in an issue of *The Ladies' Journal* that is discussed below.[28]

If China self-identified as the Sick *Man* of Asia, then it was *women's* bodies
that held the potential to rehabilitate its international standing by modeling
the opposite. In response to the nation's image crisis, popular culture turned to
the female form and layered upon it a diverse range of symbolism. To a great
extent, the national fixation on the reformation of the Chinese body unfolded
from the pages of mainstream periodicals. In media of the day, women's
bodies came to illustrate a litany of China's social ills, such as the perceived
sexual depravity of the cosmopolitan Modern Girl (*modeng gou'er* 摩登狗兒).[29]
Conversely, an encyclopedic survey of nude photographs of women from
around the world could allow the "scientific study" of the "mothers of the
human race," as an advertisement from the China Art Publishing Society
promised.[30] In one example, a pictorial's full-page, composite photograph
projects an inescapably nationalistic tone (Figure 8.3). Unclothed and supine,
the woman personifies the defenseless modern-day motherland, while the
troops superimposed above her body insinuate the current vulnerability of
the nation and the trauma of the ongoing Japanese military assault.

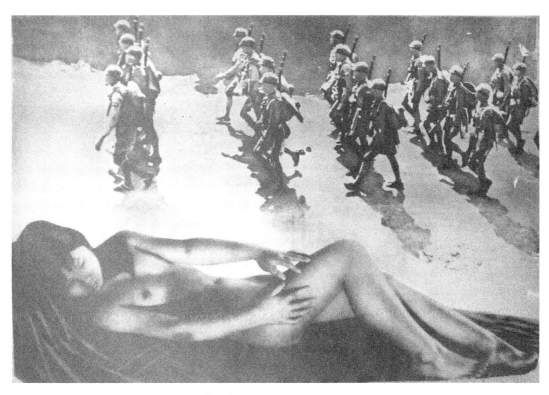

8.3 Untitled image, *Modern Miscellany* (1933).

As Japan's aggressive actions towards a feeble mainland continued to esca-
late, nearly all of the mainstream pictorials replaced their depictions of sultry
Modern Girls with the robust countenances of athletic beauties in swimsuits
or track shorts. The latter images served as cultural icons and cover girls while
satisfying a nationalistic imperative to activate the masses and invigorate the
nation.[31] By the mid 1930s, a burgeoning physical education movement pro-
duced plentiful photographs of national athletes as well as didactic articles
that promoted the ideal of a healthy beauty (or *jianmei* 健美) in keeping with
international standards.[32] For instance, a 1936 issue of a weekly magazine offers
readers a visual comparison of Soviet, American, and Chinese athletic beau-
ties, as if to confirm that the women of China finally measure up to models of
the modern ideal. Article after article enthusiastically rationalizes the medical
benefits of the modern *jianmei* lifestyle. As one female essayist testifies,

Our nation's women have always sat around, just keeping an eye on the home,
and not being accustomed to movement. . . . I started to understand that a body's
features and look are not unchangeable, that one can use one's own power to
change oneself. My soul was extremely moved.[33]

Beyond the manipulative modeling of the female body for visual metaphors,
the physical fitness and the healthy reform of women's own bodies allowed

female citizens not only the opportunity for self-improvement, but also a defining role in the betterment of society.

Though fashion and lifestyles changed as the appeal of the *risqué* Modern Girl gave way to the *jianmei* athlete, one crucial aspect remained consistent between the two archetypes; both were thoroughly modern women. With their unbound feet and exposed skin, these women and girls rejected Confucian tradition and modeled modernity by asserting their active roles outside the confines of the home. By turning away from the historical ideal of a frail beauty pining away in the inner quarters, these women of the modern era modeled the bodily perfection achieved through medical science and physical education.

In the socio-political ferment of China's early twentieth-century art world, this nationalist pseudo-medical discourse centering on the female body conflated with leading modernist art theories and gave rise to a nude painting boom. A special issue of the women's magazine *The Ladies' Journal* provides particular insight into how these parallel concerns informed artists' artistic practices.[34] The issue was dedicated to China's First National Art Exhibition in 1929, a monumental presentation of hundreds of artworks and a source of pride for the nation. In the special issue, women artists contributed reproductions of their meritorious artworks and several of these women provided articles expounding artistic theory and practice. One such article is "Women's Physical Development and the Techniques of Figure Painting," which was written by Tao Cuiying 陶粹英 (n.d.), the art director of the School of General Education at Central University (*Zhongyang daxue* 中央大學).

In light of her occupation, it is not surprising that Tao's essay is thoroughly instructive. In it, she contrasts historical notions of beauty in the West and East, evaluates the medical significance of the model's physique, prescribes corrective behavior, and outlines the techniques used to depict a human figure accurately. After briefly observing that the artists of "golden-age" Greece depicted two types of human beauty, namely the muscular male and the fecund female, she devotes the remainder of the article to the female figure. The ancient Westerners selected the most beautiful and voluptuous of women, she states, and, in so doing, placed greater emphasis on the female model's entire body rather than merely the face. China, the author reasons, is the very opposite; Chinese aesthetics judge a woman's beauty solely on the basis of her face and are more concerned with facial expressiveness than the health of her overall body. Here, Tao is addressing the feminine body ideal of traditional Chinese painting, which for centuries had accentuated perfectly white and oval faces and concealed slight figures beneath voluminous robes. These willowy and docile women, who had well fit Confucian moralists' expectations of obedient wives and filial daughters, were now viewed as the antithesis of the national imperative. Suddenly, artists of the Republican period such as Tao sought to paint comparatively buxom and full-hipped women modeled after the plump beauties found in masterpaintings of the Western tradition.

Tao Cuiying's article, in its call for the consideration of the entire body's aesthetic properties, documents the author's wholehearted subscription to the Western artistic tradition, but also her firm belief in the promise of anthropometrics and the reform (or remodeling) of the body for the national good. Her article goes on to assert that the most important requirement for any beautiful figure is good health, followed by balanced proportions and the general functionality of the body. She proposes that all three of these beauty requirements can be achieved through a proper regimen of exercise and nutrition. Such a regimen holds the potential to remedy a whole range of ailments, including eye disorders, acne, and short legs. But Tao maintains that the women of China have only just awakened to the benefits of diet and exercise. And she laments that, because the beauty of Chinese women was in a state of early development, it is still difficult to find a perfectly healthy beauty in China. According to her, the models available to figure painters are all sick and deformed, with sallow complexions and ugly proportions.

At this point, Tao assures the reader that, regardless of artistic ability, an artist cannot create a beautiful figure painting based on an ugly model. Nonetheless, she implores that although it is impossible to find a truly healthy model in China, at the very least, the artist should select a woman who is well developed and free of any obvious signs of sickness. Therefore, it is essential that the model be a pretty, young woman who enjoys exercise. Continuing her directive to the artists, Tao Cuiying discusses in turn proper bodily proportions (providing diagrams for her readers' reference), suitable coloration of the body, and the need to convey three-dimensionality and a sense of movement (Figure 8.4). One cannot but notice that the female form of the diagram is heavily proportioned.

Focusing on the youthful female nude as the appropriate model for figure painting, Tao Cuiying, much like Ni Yide, is preoccupied with the presentation of perfection. Tao, however, is even more emphatic that the artist represent women who model at least an approximation of the Westernized image of physical health. Tao turns to the nude painting genre specifically and a discussion on women's health issues as a means of elevating Chinese women's positions. She chastises traditional Chinese figure painting's emphasis on frail physical forms, and considers the introduction of Western painting an opportunity to liberate women from unhealthy body ideals.[35] Her advice to models on how to cultivate a healthy body could just as easily be directed to any woman, even the female artist herself. According to Tao's logic, by choosing to depict attractive women who engaged in regular exercise, artists created models of public health that improved the lives of all Chinese women and, by extension, China itself.

If articles such as Tao's provide insight into artists' theoretical objectives when painting the female nude, the full-page, color frontispiece to the issue demonstrates the application of their theories. *Reflection* (*Guying* 顧影), a pastel painting by the renowned female artist Pan Yuliang 潘玉良 (1895–1977), depicts a seated nude gazing into a mirror (Plate 8.3). Rather than portraying

8.4 Tao Cuiying,
"Women's Physical
Development and
the Techniques of
Figure Painting,"
The Ladies' Journal
"Department of
Education National
Art Exhibition
Special Issue" 15:7
(July 1929): 35.

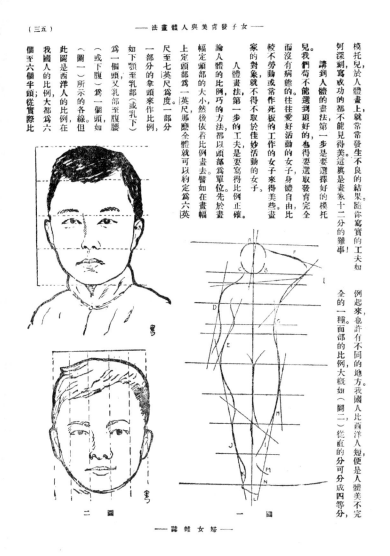

（三五）　　　　　　—— 法畫體人與美育發子女 ——

—— 講縫女婦 ——

the Western trope of vanity or voyeurism,[36] Pan captures an emotional state of reflection and introspection. The figure appears neither vain nor seductive, but, rather, conveys a relatable moment of a woman at ease while lost in thought. The title, which references an idiom describing a state of self-pity, further divorces this depiction from any suggestion of narcissistic primping.[37] Intriguingly, an editor of the issue, Li Yuyi 李寓一 (n.d.), reads into the image an act of self-affirmation. In an accompanying short text praising the image, Li opens with the bold line, "Others do not cherish me, I cherish myself!", suggesting Pan Yuliang's pastel of a female nude encourages self-reflection and confirmation.[38] He then compares the image to the *Mona Lisa* and applauds

the artist's ability to convey profound sentiment. Li Yuyi also observes that the beauty of Pan's paintings rests in the factual description of the body rather than in adherence to stylistic convention. To the contemporary critic, the faithful rendering of the "conflict of the model's warm blood and cold *qi* in the rendering of color" was a successful synthesis of Western anatomical learning and the traditional Chinese view of the body. For Li, Pan's artistic practice was patriotic. Pan Yuliang had received her artistic training in Europe, but Li asserts that after having returned from overseas she derived inspiration from her homeland and its "national arts" (*gongyi* 國藝). Thus, the national cause, ever at the forefront of public discourse, factors into even this brief art critique, the author implying that Pan created her image of a female nude as a service to her nation.

When Pan Yuliang's painting is paired with Tao Cuiying's article, it becomes evident that the special issue positions the female nude as an impassioned appeal to women that they reflect upon and improve their own self-image. In the eyes of women artists, the female nude turns accountability back onto woman herself, asking her to value herself and to take charge of her future. Just as in the anthropometric campaigns of the medical field, visual scrutiny of the body—whether in the hands of artists or the mirrors of women readers of the magazine—served to affirm the citizen's sense of self and assured the possibility of progress.

Conclusion

At a time when interest in the female nude stemmed from national anxiety about the health of the nation, the focus on fuller female figures in art imaged the national aspiration. Quite simply, Republican-period artistic depictions of the female nude were taken as models, but not as just one, singular model. Rather, paintings of female nudes simultaneously modeled a variety of ideals. In terms of artistic practice, painting the nude from life in a conspicuous studio setting stood as the polar opposite to received convention and signaled the abandonment of tradition. Additionally, an emphasis on the anatomically accurate depiction of the model as she appeared before the artist implied a Realism informed by the objective, empirical, scientific gaze, and was perceived by artists as the laying of groundwork for the blossoming of China's own Renaissance. Looking specifically to the model herself, we find that the nude female figure modeled both modernity and vitality. The women selected as nude models were modern, healthy women, and, by extension, symbolized the potential for a revitalized and robust nation. Thus, by working within this genre of painting, artists understood themselves to be participating in the advancement of the arts while also contributing to the national agenda by promoting healthy Chinese bodies.

Artistic depictions of the female nude began to fall out of favor even before the founding of the People's Republic of China; in fact, not long after the

8.5 Yu Feng, cartoon. *Modern Sketch* 24 (Dec. 20, 1935). Courtesy of the estate of Yu Feng. Caption reads:
Artist: Oh, what a pity there really are no fleshy curves! What I mean to say is, to be a model you should be a bit fatter!
Model: Sir! You'll find that only if you go look among the ladies living in mansions!

rise of the *jianmei* movement. In a 1935 issue of *Modern Sketch* (*Shidai manhua* 時代漫畫), the female artist Yu Feng makes continued use of the female nude as metaphor, but she twists the otherwise familiar scenario of an artist painting the life model in the studio into a socialist retort (Figure 8.5). In the background, a plaster cast of a classical nude, with full bust and hourglass silhouette, starkly contrasts with the skeletal physique of the artist's nude model. Yu Feng's critique exposes the class distinctions at work in the generation of paintings of nudes during the Republican period, the easel marking the frequent economic divide between affluent artist and exploited working class model. As calls for a social realism in art suitable for the national war effort rang ever more urgent, artists increasingly turned away from the nude model and from art for art's sake in general.

Notes

1 Cahill's comments respond to disparaging assertions that the Chinese traditionally lacked interest in or understanding of the female form. Cahill (2010), 191–197.

2 China selectively incorporated Western anatomical knowledge when it correlated to traditional Chinese concepts, such as *qi*. Elman (2014), 17.

3 Kao (2003), 147–148.

4 Liang Qichao coined this phrase from his translation of an article that had run that year in the English-language Shanghai newspaper, *North China Daily News* (*Zilin xibao* 字林西報). Wang (2014), 151.

5 Elman (2014), 33

6 Luesink (2015), 162.

7 The article, which appeared in *Zhonghua Yixue Zazhi* 中華醫學雜誌 [*National Medical Journal of China*] 1.1 (1915), is insightfully critiqued by Luesink. He notes that the journal's audience would have consisted of similarly-trained physicians who were already in perfect agreement with the anonymous author. Ibid.

8 Ibid., 163–164.

9 For example, in the very issue where Lu Xun first published his *Diary of a Madman* and Cai Yuanpei outlined his intentions for educational reforms, *New Youth* editor and founder of the Chinese Communist Party, Chen Duxiu, shared his correspondence with Tang Erhe, a conversation in which the latter criticized the Chinese scholarly community for its incompetence in comparison with the West. Ibid., 168–169.

10 Fu (2016). Even if Liang Qichao's coining of Sick Man of Asia originated as a translation from a Western-language publication, the literal application of the phrase and fixation on the comparative condition of Chinese bodies appears to have originated and propagated primarily in the discourse of China's own anxious reformers. Wang, *Never Forget National Humiliation*, 151.

11 Fu (2016), 646.

12 Ibid., 653.

13 Xiaobing Tang (2008) briefly discusses Zhou Shoujuan's essay in his monograph on the Republican-period woodcut movement.

14 Fu (2016, 657) also has observed a popular turn towards the discussion of children in media of the late 1920s and 30s "in which the child is figured as an agent of national redemption."

15 For a discussion of the impact of the scientific gaze on *guohua*, see Claypool (2015).

16 For a concise discussion of Academic Realism as a Chinese modernist statement, see Dal Lago (2009). For a study of Chinese modern artists' counter-culture use of nude figure painting, see Clarke (2005).

17 Cai studied at the University of Leipzig from 1908 to 1911. Kao (2003), 153.

18 Kao notes that the treatise, published in 1913, reflects the content of the lectures of the previous summer. Ibid., 155.

19 Claypool (2015), 1–2, 41.

20 Cai Yuanpei also befriended Xu Beihong (1895–1953), whom he hired to the faculty of Peking University in 1918. Andrews and Shen (2012), 39.

21 Sullivan (1996), 29. Andrews and Shen (2012), 31–32.

22 In 1918, Liu Haisu published an essay largely echoing Cai Yuanpei's argument for aesthetic education and the following year Cai commented approvingly on Liu's increased authority as a result of the artist's research trip to Japan. Liu visited Cai in Beijing in 1921 and later Cai became a trustee of the Shanghai Academy of Art. The two jointly proposed the First National Art Exhibition in 1922 and over a decade later worked together on the Chinese Contemporary Painting exhibition in Berlin in 1934. Andrews and Shen (2012), 40, 56, 64, 67, 109.

23 Finding life models proved difficult at first and all Shanghai Academy of Art models were men until 1920, when the school finally secured its first female model. For more information on art education and the nude art debate see Andrews (2001), 125–129; Andrews (2005). Andrew's and Shen's recent textbook (2012, 67) provides a lucid summary of her important findings. See also Wu Fangcheng (2004); Chen Zui (2006).

24 In the mid 1920s, asserting that the activities of such classes constituted morally offensive behavior, government officials questioned the artistic value of drawing the human form from life and sought a ban on nude models. The issue came to a head when Liu Haisu famously launched a publicity campaign against the proposed ban. In the fall of 1925, he published letters of protest and broadcast his dissent over the radio. He lost the battle; nude models were officially banned from July 1926 until Shanghai underwent a change in power in April 1927. Yet, Liu Haisu otherwise very successfully manipulated the ideological fight for his own ends, crafting his reputation as a rebel artist and at the same time publicizing the Shanghai Academy of Art as a school of choice for students inclined towards the avant-garde. Andrews (2005), 368–370.

25 Ni Yide (1924);. Ni published a slightly modified version of his essay in the Beijing periodical *Chenbao fukan* in 1925 and reprinted the original version in 1928. See: Ni Yide (1925); Ni Yide (1928). More recently, the essay was published in an anthology of important primary texts on modern Chinese art theory. Ni Yide (1999).

26 Ni wrote his article in response to the censorship of a Shanghai Academy of Art alumnus' exhibition in the fall of 1924. This exhibition appears to be the event

that sparked the larger debate involving Liu Haisu and the Shanghai Academy of Art the following year. The arguments presented by both artists share many of the same rhetorical devices, but Ni's initial article predates Liu's public agitation. For more information on Liu Haisu and the nude model debate see Andrews (2005), 343. See also Wu Fangcheng (2004), 87–89.

27 In particular, for Cai's thoughts on the abilities of prehistoric people to appreciate Beauty and of all men to respond to Greek sculptures with a love of female beauty that remained devoid of lust, see Cai Yuanpei (1996), 184, 187.

28 In her recent essay, Sun (2018) rightly cautions against making assumptions about the gender(s) of the readers and producers of women's periodicals. However, whereas Sun situates the distribution of images of nudes within the context of the commercial interests of a male editor, in this essay I examine both male and female artists as makers of female nude images within a context of national anxiety.

29 The Modern Girl was a popular subject in early twentieth-century China and fair amount of recent scholarship focuses on analyses of her image. See for example, Stevens (2003), Tze-lan D. Sang (2008). More broadly, the Modern Girl was a worldwide phenomenon and there have been several studies of this new type of womanhood in other countries. See, Weinbaum and Modern Girl Around the World Research Group (2009).

30 This advertisement appears on the back covers of *Modern Miscellany* 1.4 (Jun 1930) and *Modern Miscellany* 2.5 (Mar 1, 1931).

31 Cultural historian Joan Judge observes a dramatic shift in the visual depiction of women on the covers of popular Chinese periodicals; the sexpot cover girl of the 1920s giving way to "new, more ideologically strident models of womanhood." Judge gives the example of robust fieldworkers on the cover of *Xin Zhongguo funü* 新中国妇女. However, Judge does not reference the *jianmei* movement or anthropometric trends of the mid 1930s that are central to my argument. Judge (2010).

32 For information on the *jianmei* movement see Gao (2007), 104–137; Gimpel (2006), (2008).

33 Dai Mengqin (1931), 535. Translated and quoted in Morris (2014), 107.

34 Tao Cuiying (1929).

35 Like many Japanese art critics in the early twentieth century, Tao Cuiying disparages Asian women's natural features and feels them to be typically unsuited for the nude painting genre.

36 Pan Yuliang had studied in Europe for seven years and was certain to have been aware of Western tradition of such conventional tropes.

37 *Guying* is half of the idiom *guying zilian* 顧影自憐, which can mean either to admire one's own reflection or to look at one's shadow sorrowfully.

38 Li Yuyi, *The Ladies' Journal* (*Funü Zazhi* 婦女雜誌), 15.7 (July 1929). Li Yuyi further observes that the beauty of Pan Yuliang's paintings rests in the factual description of the body rather than in adherence to any stylistic convention.

References

Andrews, Julia Frances. "*Luotihua lunzheng ji xiandai Zhongguo meishushi de jiangou* 裸体论 证及现代中国美术史的建构 [The Nude Debate and the Construction of Modern Chinese Art History]." In *Haipai huihua yanjiu wenji* 海派绘画研究文集 [*Studies on Shanghai School Painting*], 117–150. Shanghai Shi: Shanghai shuhua chubanshe, 2001.

Andrews, Julia Frances. "Art and the Cosmopolitan Culture of 1920s Shanghai: Liu Haisu and the Nude Model Controversy." *Chungguksa Yon'gu*, 35 (April 2005): 323–372.

Andrews, Julia Frances, and Kuiyi Shen. *The Art of Modern China.* Berkeley, CA: University of California Press, 2012.

Cahill, James. *Pictures for Use and Pleasure: Vernacular Painting in High Qing China.* Berkeley, CA: University of California Press, 2010.

Cai Yuanpei. "Replacing Religion with Aesthetic Education." In *Modern Chinese Literary Thought: Writings on Literature, 1893–1945*, edited by Kirk A. Denton, translated by Julia Frances Andrews. Stanford, CA: Stanford University Press, 1996.

Chen Zui 陈醉. "Zhongguo Luoti Yishu Fazhan Licheng 中国裸体艺术发展历程 [Chinese Nude Art History]." *Wenyi Yanjiu* 文艺研究, 1 (2006): 130–136.

Clarke, David. "Iconicity and Indexicality: The Body in Chinese Art." *Semiotica* 155, no. 1/4 (2005): 229–248.

Claypool, Lisa. "Beggars, Black Bears, and Butterflies: The Scientific Gaze and Ink Painting in Modern China." *Cross-Currents: East Asian History and Culture Review* 4, no. 1 (2015): 189–237.

Dai Mengqin, "*Jianshen jianguo de tujing* 健身健國的途徑 [The Way to Build a Healthy Body and a Healthy Nation]." *Shenghuo zhoukan* 生活周刊 [The Life Weekly] 6, no. 26 (June 20, 1931).

Dal Lago, Francesca. "Realism as a Tool of National Modernization in the Reformist Discourse of Late Nineteenth and Early Twentieth Century China." In *Crossing Cultures: Conflict, Migration and Convergence: The Proceedings of the 32nd International Congress of the History of Art*, edited by Jaynie Anderson and Comité international d'histoire de l'art. Carlton, Australia: Miegunyah Press, Imprint of Melbourne University, 2009.

Elman, Benjamin A. "Toward a History of Modern Science in Republican China." In *Science and Technology in Modern China, 1880s–1940s*, 15–38. Boston, MA: Brill, 2014.

Fu, Jia-Chen. "Measuring Up: Anthropometrics and the Chinese Body in Republican Period China." *Bulletin of the History of Medicine* 90, no. 4 (2016): 643–671. https://doi.org/10.1353/bhm.2016.0102

Gao, Yunxiang. "The Nationalist and Feminist Discourses on 'Jianmei' (Fit/Robust Beauty) during China's 'National Crisis' in the 1930s." *Gender and History* 18, 3 (2006): 546–573. Reprinted in *Translating Feminisms in China*, edited by Dorothy Ko and Wang Zheng, 104–137. Oxford, UK: Blackwell, 2007.

Gimpel, Denise. "Freeing the Mind through the Body: Women's Thoughts on Physical Education in Late Qing and Early Republican China." *Nan Nü* 8, no. 2 (2006): 316–358.

Gimpel, Denise. "Exercising Women's Rights: Debates on Physical Culture since the Late Nineteenth Century." In *Beyond the May Fourth Paradigm: In Search of Chinese Modernity*, edited by Kai-Wing Chow, Tze-Ki Hon, Hung-Yok Ip, and Don C. Price, 95–130. New York: Lexington Books, 2008.

Judge, Joan. "The Modern Shanghai Visual Imaginary: Magazine Cover Girls and New Cultural Possibilities in the Early Twentieth Century." Lecture, University of California, Berkeley, 2010. www.youtube.com/user/calcommunitycontent#p/c/3B4BC26C0768B4E2/11/xGb3PaZWMAU

Kao, Mayching. "Reforms in Education and the Beginning of the Western-Style Painting Movement in China." In *A Century in Crisis: Modernity and Tradition in the Art of Twentieth-Century China*, edited by Julia Frances Andrews and Kuiyi Shen. New York: Guggenheim Museum, 2003.

Li Yuyi, ed. *The Ladies' Journal (Funü Zazhi* 婦女雜誌) 15, no. 7 (July 1929).

Luesink, David. "State Power, Governmentality, and the (Mis)Remembrance of Chinese Medicine." In *Historical Epistemology and the Making of Modern Chinese Medicine*, edited by Howard Chiang, 160–187. Oxford, UK: Manchester University Press, 2015.

Morris, Andrew D. "The Me in the Mirror: A Narrative of Voyeurism and Discipline in Chinese Women's Physical Culture, 1921–1937". In *Visualizing Modern China: Image, History, and Memory, 1750–Present*, edited by James A. Cook, Joshua Goldstein, Matthew D. Johnson, and Sigrid Schmalzer, 107–125. Lanham, MD: Lexington Books, 2014.

Ni Yide. "*Lun luoti yishu* 論裸體藝術 [Considering Nude Art]." *The China Times (Shishi xinbao* 時事新報). December 14, 1924, Shanghai. China: A Daily Supplement of China Times (312) edition, sec. Yishu [Art] no. 82.

Ni Yide. "*Luoti yishu zhi zhenyi* 裸體藝術之真義 [The True Meaning of Nude Art]." *Chenbao Fukan* 晨報副刊 [*Morning News Supplemental*]. September 17, 1925, 1274 edition.

Ni Yide. "*Lun luoti yishu* 論裸體藝術 [Considering Nude Art, Reprint]." In *Yishu mantan* 藝術漫談 [*Art Chat*]. Shanghai, China: Guanghua shuju, 1928.

Ni Yide. "*Lun luoti yishu* 论裸体艺术 [Considering Nude Art, Reprint]." In *Ershi Shiji Zhongguo Meishu Wenxuan (I)* 二十世纪中国美术文选（上卷）[*20th Century Chinese Art Literary Selections*], 123–129. Shanghai, China: Shanghai shuhua chubanshe, 1999.

Sang, Tze-lan D. "Failed Modern Girls in Early-twentieth-century China." In *Performing "Nation": Gender Politics in Literature, Theater and the Visual Arts of China and Japan, 1880–1940*, edited by Catherine Yeh, Doris Croissant, and Joshua Mostow, 179–202. Leiden, the Netherlands: Brill Academic, 2008.

Stevens, Sarah E. "Figuring Modernity: The New Woman and the Modern Girl in Republican China." *NWSA Journal* 15, no. 3 (2003): 82–103.

Sun, Liying. "Engendering a Journal: Editors and Nudes in Linloon Magazine and Its Global Context." In *Women and the Periodical Press in China's Long Twentieth Century: A Space of Their Own?*, edited by Michel Hockx, Joan Judge, and Barbara Mittler, 57–73. Cambridge, UK: Cambridge University Press, 2018.

Sullivan, Michael. *Art and Artists of Twentieth-Century China*. Berkeley, CA: University of California Press, 1996.

Tang, Xiaobing. *Origins of the Chinese Avant-Garde: The Modern Woodcut Movement.* Berkeley, CA: University of California Press, 2008.

Tao Cuiying, "*Nüzi fayu mei yu renti huafa*" 女子發育美與人體畫法 [Women's Physical Development and the Techniques of Figure Painting]. *The Ladies' Journal* (*Funü Zazhi* 婦女雜誌) 15, no.7 (July 1929).

Wang, Zheng. *Never Forget National Humiliation: Historical Memory in Chinese Politics and Foreign Relations.* New York: Columbia University Press, 2014.

Weinbaum, Alys Eve, and Modern Girl Around the World Research Group. *The Modern Girl around the World: Consumption, Modernity, and Globalization.* Durham, NC: Duke University Press, 2009.

Wu Fangcheng 吳方正. "*Luode liyou - ershi shiji chuqi Zhongguo renti xiesheng wenti de taolun* 裸的理由－－二十世紀初期中國人體寫生問題的討論 [The Reason for the Nude: Questions Concerning Nude Figure Drawing in China at the Beginning of the Twentieth Century]." *Xin shixue* 新史學 [*New Studies in History*] 25, no. 2 (June 2004): 55–110.

PART IV
MODELING DISEASE:
THE PATHOLOGIZED BODY IN ART AND MEDICINE

The Model Patient:
Observation and Illustration at the Musée Charcot

Natasha Ruiz-Gómez

I urge you to continue sketching: it is a good way to occupy one's spare time;
science and art are allies, two of Apollo's children.

<div style="text-align: right">Jean-Martin Charcot[1]</div>

In 1885, the art critic and novelist Octave Mirbeau characterized his era as "the century of nervous diseases" because they motivated its events and were the focus of its scientific obsession.[2] For him, science predominated over literature and politics: "[I]t will perhaps not be the century of Victor Hugo nor the century of Napoleon, but the century of Charcot."[3] Mirbeau declared that a painting of Dr. Jean-Martin Charcot (1825–1893) in his amphitheater should be made as a pendant to Rembrandt's *Anatomy Lesson of Dr. Nicolaes Tulp* (see Figure 1.1, Mauritshuis, 1632).[4] The young and ambitious Realist painter André Brouillet (1857–1914) fulfilled Mirbeau's wish with an almost life-size work, exhibited at the Paris Salon two years later.

Une Leçon clinique à la Salpêtrière (*A Clinical Lesson at the Salpêtrière*) (1887, Paris, Musée d'Histoire de la Médecine) modernizes Rembrandt's painting by depicting Charcot teaching in front of a *living* model. In so doing, it celebrates the theatricality of his lectures, as well as his renown (Plate 9.1).[5] Charcot, one of the founders of modern neurology, had already run the medical service of the Salpêtrière Hospital for a quarter-century and had made it famous as the site of his theorization of hysteria. Brouillet's painting memorializes Charcot discoursing dispassionately on hysteria before a crowd that includes well-known doctors, writers, and politicians of the day.[6] His protégé, Dr. Paul Richer (1849–1933), is also portrayed, either taking notes or sketching at Charcot's right, behind a table where the most modern medical technology is conspicuously displayed. The young Dr. Joseph Babinski (1857–1932) looks sympathetically at the hypnotized Blanche Wittmann (1859–1913) in his arms (she was known at the time as the "Queen of the Hysterics"), while Nurse Marguerite Bottard (1822–1906) holds out her hands to ease the swooning patient onto the awaiting stretcher. A large drawing by Richer of a hysteric in the *arc-de-cercle* pose is affixed to the back wall of the room, anticipating and validating Wittmann's attitude in the foreground of the painting. Brouillet's

canvas attests to Charcot's groundbreaking use of visual aids, such as photographs, sculptures, diagrams, graphs, lantern slides, and especially patients, to dazzle his audiences.[7]

Art historian Anthea Callen has rightly highlighted the resemblance of Charcot's lecture to a lesson for fine arts students (Plate 9.2), identifying the dependence of François Sallé's *The Anatomy Class at the École des beaux-arts* (1888, Sydney, Art Gallery of New South Wales) on Brouillet's canvas.[8] In both paintings, a partially dressed model is displayed at the front of a room for a male audience. In the Sallé painting, the muscular arm of the virile *poseur* is being examined by the École's Professor of Anatomy, Mathias-Marie Duval (1844–1907), while the Brouillet canvas instead presents its viewers with a model of pathology.[9] In both, we have students with pencils in hand, gazing up at the model; given the emphasis on drawing as a practice under Charcot's direction, the medical students are just as likely to be sketching the model as taking notes on the clinician's lecture.[10] Wittmann's awkward pose, illuminated by tall windows, is reminiscent of those often taken by studio models in French academies, who also required assistance in order to sustain their unbalanced postures.[11] Moreover, Charcot himself compared the hospital patient to the artist's model; during one lesson, he assured his audience that the naked patient under examination was comfortable because the room was "properly heated, as a painter's studio would be."[12]

Like the teachers at the École, Charcot believed that observing the naked body was critical to his practice. He would have patients brought to him, then undressed, while he silently observed them. He might ask that other patients with the same condition be brought in so that he could examine several individuals at the same time to determine common presentations of pathology. Such observation famously allowed Charcot to make innovative diagnoses, with autopsies later confirming or disproving his theories.[13] In a lesson in which his visual analysis leads him to correct another physician's diagnosis, Charcot expounds on the need to examine 'the nude':

In reality, [. . .] we physicians should know *the nude* as well and even better than painters do. A flaw in drawing by a painter or sculptor is serious, no doubt, from the point of view of art, but all in all, from a practical point of view, it has no major consequences. But what would you say about a physician or surgeon who takes, as happens too often, a normal bump or contour for an abnormality or vice versa? . . . This digression may be enough to highlight once again the need for the physician, and for the surgeon, to attach a great importance to the medico-surgical study of the NUDE [*sic*].[14]

Here, the clinician is compared to the artist and the patient to the model. In fact, Charcot makes the claim that the clinician's need to study the naked body is even more urgent. His pretensions to art are hinted at here by the reference to the fine art category of the 'nude'—that is, the idealized human body. Art historian Susan Waller argues that the *académie* or study of the live model was originally conceived to "prepare the [fine art] student to negotiate the discrepancies between the flawed shape of the individual live body and the ideal."[15]

However, like William Hunter, another *savant-artiste*, Charcot instead encouraged his protégés at the Salpêtrière to take note of what they saw. Rather than idealize, they were to focus on the 'flaws' visible in the pathological body. In his painting, Brouillet seems to attempt a reconciliation of the two. He has idealized Wittmann's face and body, which are more elegantly proportioned than in the photographs of her in the *Iconographie photographique de la Salpêtrière*.[16] With her arched back and the contracture of her left hand, however, her body displays the 'stigmata' of hysteria—an illness Charcot believed was based in the nervous system.[17] Given the potential erotic charge of this pose, which thrusts the body's erogenous zones forward, it is unsurprising that hysterics, like the female models who posed for artists in the nineteenth century, were sexualized in the popular imagination. Indeed, *fin-de-siècle* salons saw an epidemic of "broken backs," indicative of a circularity in artistic and scientific imagery in the nineteenth century.[18]

Charcot gave primacy to the visual and pursued artistic interests throughout his life. Forced by his father to choose a profession in either art or medicine, he unsurprisingly incorporated artistic imagery into his medical career and encouraged his students to do the same.[19] In fact, his student Achille Souques wondered whether Charcot studied nervous diseases specifically because of the perceived visibility of their symptomatology: "One may wonder whether the physical deformations, so visible and so common in nervous diseases, had not led him to study and privilege this branch of pathology."[20] He nurtured that focus on the visual especially in one of his most important students, Paul Richer, whose natural talents as an artist led him to Charcot's attention in the first instance.

As historian Ludmilla Jordanova has argued, prolonged looking at an individual is rarely sanctioned in society, but exceptions include the acts of examining portraits and examining patients.[21] We could add to this the sustained attention of artists on the live model. Like a life-drawing class at the École, the collective gaze of the men on the left of Brouillet's canvas is fixed on the female 'model'. Here, however, this gaze thematizes the late nineteenth century's obsession with medical voyeurism, which was equally visible in the period's anatomical museums. Significantly, and not coincidentally, Charcot himself founded a museum of pathological anatomy at the Salpêtrière in the late 1870s to complement the "living pathological museum" comprising its patients, suggesting that they were animate exhibits of pathology on display among the hospital grounds.[22] He proposed the creation of a museum to the *Assistance publique* (the administrative body that ran Paris's hospitals) in 1875, reasoning that "[t]he clinical and anatomo-pathological riches that [the Salpêtrière] holds are, so to speak, inexhaustible. But, unfortunately, they are not utilized as widely as they deserve to be."[23] By 1879, he could thank the administration for the hospital's new photography studio and electrotherapy room, as well as "an anatomo-pathological museum, perfectly arranged, [and] very elegantly decorated."[24]

Like the Brouillet painting, which actually reveals little about hysteria, except a visible (and, some argue, invented) bodily attitude that signified the

disorder,[25] the so-called Musée Charcot offered a partial and idiosyncratic vision of nervous disease. If illumination was the presumed goal of anatomical museums since the Enlightenment, the exhibits here more often resulted in the obfuscation of pathology. This chapter focuses on two largely unknown and unpublished albums from the Musée Charcot's collection that, I argue, replicate the museum's methodology in miniature. In them, accomplished drawings and enigmatic photographs complement more 'objective' graphs and diagrams to represent the pathologies seen at the Salpêtrière. In their groundbreaking study, *Objectivity*, Lorraine Daston and Peter Galison posit that scientific endeavors in the late nineteenth century were dominated by a paradigm of "mechanical objectivity," in which the "scientific subjective self" was suppressed and denied in favor of "objective" mechanical media, such as photography.[26] The authors claim that at the time "[t]he scientific self [. . .] was perceived by contemporaries as diametrically opposed to the artistic self, just as scientific images were routinely contrasted to artistic ones."[27] The images in the Musée Charcot albums resist this paradigm. Instead, many of them collapse the distinction between the scientific and the artistic and privilege a personal (subjective) vision of pathology—either that of the patients who modeled or, more typically, that of the *savants-artistes* who represented them.

The Musée Charcot

The most complete description of the Musée Charcot comes from Belgian philosopher and psychologist Joseph Delboeuf. He recounted a visit to the Salpêtrière alongside the historian Hippolyte Taine in the mid 1880s to witness the experiment rendered in the painting by Brouillet: the hypnosis of Blanche Wittmann. Delboeuf reported,

[The session] took place in a large room, a kind of museum, whose walls, even the ceiling, are decorated with a considerable number of drawings, paintings, engravings, photographs sometimes showing scenes with various individuals, sometimes a single patient naked or clothed, standing, sitting or lying down, sometimes one or two legs, a hand, a torso, or another part of the body altogether. All around, cupboards with skulls, spines, tibias, humeri showing this or that anatomical feature; all over the place, on tables, in vitrines, a pell-mell of jars, instruments, machines; the image in wax, not yet completed, of an old woman, nude and lying on a kind of bed; busts, including that of [Franz] Gall, painted green.[28]

The only known photograph of this museum shows a curious group of objects and images, which coalesce under the umbrella of medical evidence (Figure 9.1). Other "objects" not visible in the photograph could be included in this eclectic mix. For instance, Delboeuf described Wittmann as "a real living laboratory specimen" as she wandered hypnotized through the museum, echoing Charcot's claim that the hospital itself was a "living pathological museum." Delboeuf continued, "With her, one can explore the human body as meticu-

9.1 Photograph of the Musée Charcot, ca. 1894. Photo © Musée de l'Assistance Publique—Hôpitaux de Paris.

lously and more demonstratively than with a cadaver," inadvertently forging a link between the anatomy classes of the hospital and the École.[29]

The scientific riches offered by the live patient complemented the museum's human remains, wax casts, and artistic renderings. According to medical historian Michael Sappol, in the nineteenth century, "[m]embership in the [medical] profession was consolidated by a common culture of collectorship." He specifies that "[i]n formal medical discourse the specimen was accounted as an educational aid [. . .]. Informally, there was the pleasure of acquisition and possession and a connoisseur's appreciation of the artistry of the preparation."[30] This connoisseurial spirit was made manifest in the wooden armchairs, striped rug, and dark-paneled walls of the lavishly appointed room that housed the museum at the Salpêtrière. Reproductions of famous artworks were displayed on the walls, and the polychrome wax sculpture of a contemporary artist, Henry Cros, covered several of the room's wooden supports.[31] A visitor to the museum derided this element of the eccentric decor: "Let us note [. . .] the garish ornamentation that has been daubed on the beams protruding from the ceiling."[32] This museum resembled less a clinical

space than the physician's study or indeed Charcot's own home, the "magic castle in which [Charcot] lives," according to a dazzled Sigmund Freud who attended one of the receptions hosted by the Charcot family every Tuesday evening from October through May.[33]

Sappol notes, "Collection was a quasi-erotic quest. [. . .] The collector prided himself on his erudition and acumen, [and] cultivated a love of the grotesque, beautiful, and obscure."[34] The "quasi-erotic" act of voyeurism, visible in the painting by Brouillet, is also implicit in this space of nude bodies, revealed organs, and concretized pathology. Seeing, knowing, touching, and classifying were all at the core of the cabinet of curiosities, as well as of the medical museum, which has been called its successor.[35] To these, Charcot and his students added observing, sketching, photographing, and illustrating. All of these modes of gaining knowledge were in operation in the albums collated by Charcot and his students and can be seen as microcosms of the Musée Charcot.[36] Disparate images that detail the minutiae of patients' bodies during life and after death are pasted onto the albums' faded, stained, and sometimes mutilated blue pages. They include delicately drawn disfigured hands in red chalk; pencil sketches that capture the different phases of movement in the style of a chronophotograph; dissections rendered with colored pencils; graphs measuring epileptic seizures; photographs of excised bones next to drawings of deformed legs; sketches of young boys held upright in cage-like constraints; a highly finished drawing that captures a woman's awkward step; and photographs of men and women naked from the waist down. The mixture of living and lifeless, indexical and artistic, was typical of clinical practice at the hospital.

Most of the drawings in the Musée Charcot albums are unsigned, and a wide variety of styles and hands is evident. There are early drawings by Charcot that are pasted on the pages of albums alongside images from decades later, indicating that these books were "living" documents that could be consulted, amended, or updated as necessary. They contain very little explanatory text—only a few images have captions indicating diagnoses, the names of patients, or references that reveal more details about particular cases. What is clear is that the doctors of the Salpêtrière made equivalences between different modes of observation—between drawings, photographs, graphs, and so on—both in the museum and in the albums. Callen has observed that

it is not the image *per se* which is more—or less—objective: it is the scientist (or artist) who, as the embodiment of 'objective truth,' designates the objectivity of his material in his appropriation and re-presentation of it. For Charcot and the Salpêtrière School, the scientist's sight constitutes 'truth.'[37]

In other words, these different kinds of "evidence" stood on equal footing, through an emphasis on the visual and through the purportedly objective vehicle of the clinician. Charcot famously asserted, "I am absolutely nothing but the photographer [at the Salpêtrière]; I register (*inscris*) what I see."[38] And while this professed objectivity is seemingly in keeping with Daston

and Galison's premise of the "scientific self grounded in a will to willessness [*sic*]," the albums themselves tell a different story about the role of individual agency and artistry in medical imagery.[39]

The Scientific and Artistic Self

Album number AP 2005.0.27.1 is fairly typical. The volume opens with two small, sepia-toned photographs glued above a drawing (Figure 9.2). The photographs, overexposed and out of focus, show a young man in a suit, sitting on a chair in a hastily configured studio: the rug under his feet bubbles up behind him where it meets the backdrop. His hands are on his knees, but the left sleeves of his jacket and shirt have been pulled up, exposing his arm to the elbow and highlighting the unnatural torsion of his wrist. In the photograph on the left of the page, more of the chair is visible; the angle of the turned wood legs matches that of the man's exposed arm, while his torso mirrors the angle of the chair's back. He and the chair thus appear oddly fitted together. Only his uplifted chin and direct stare hint at his character and add a subtle note of defiance to the image, undermining the presumed status of objectivity granted to the image by its placement in a medical album. The unnatural gesture of the patient's left hand is unexplained—perhaps the pathology was considered to be self-evident.

The page is devoid of text save for the name of the female patient perfunctorily written on the drawing below the photographs: "Mme Beau." While the photographs invariably capture the "that-has-been," the sensitively worked drawing gives the impression of being done from life.[40] The focus here is on Beau's face and hands, traditionally the body's principle sites of expression. The former is foreshortened; the sitter's full cheeks and wide nose are rendered in shadow as her head is bent down towards a large book or journal held awkwardly on her lap with her contorted hands. The irises of her eyes are just visible, especially her right; they stare intently, giving a heightened sense of Beau's inner life. They also lead our gaze to her hands, the other focal point of the composition. Like the suited man in the photographs, her hands betray her status as patient. Pressing against the pages on her lap, her fingers do not work in tandem, with some bending unnaturally at a sharp angle from their first joint. The insistent pressure they bring to bear on the object on her lap suggest that Beau may be feeling the paper in order to read words printed in Braille.

Hatching creates the planes and volume of her head, arms, and torso while freely drawn lines add a more abstract note to the patient's skirt and, simultaneously, to the bottom edge of the sheet of paper. Similarly, the back of her chair is no more than a cursory sketch. Like an artist's life drawing, the picture focuses our attention on the face and body, as well as on the draughtsman's skill in capturing the foreshortened visage. Here, however, it is not Beau's likeness that is of interest, but her illness. The patient models not only for

9.2 Page
from a Musée
Charcot Album.
Paris, Musée
de l'Assistance
Publique—
Hôpitaux de
Paris, Inv. no.
AP 2005.0.27.1.
Author's
photograph,
courtesy of
the Musée de
l'Assistance
Publique—
Hôpitaux de Paris.

a *savant-artiste*, but also for the medical community at the Salpêtrière who would study her image for signs of pathology in one of the museum's albums.

The accomplished drawing of Mme Beau is likely the work of Paul Richer, who joined the Salpêtrière in January of 1878 and became its most important artist.[41] The albums of the Musée Charcot hold a spate of unsigned but skilled drawings dated that same year, suggesting that Richer filled page after page as soon as he arrived at the hospital. He may have been interested in Beau in particular, as his drawings of hands had brought him initially to Charcot's attention. As a medical student, Richer illustrated a friend's thesis on hand deformities and was "discovered" at its defense where Charcot, the principal examiner, exclaimed: "You could make a diagnosis from these drawings!"[42] Charcot immediately offered Richer an internship at the Salpêtrière in 1878, his fourth year of studies.

Richer appears to have been an auto-didact; drawing lessons as a child in his hometown of Chartres seem to have been the extent of his schooling in art.[43] He began sculpting around the age of forty and submitted his first sculpture to the Salon in 1890, regularly exhibiting there in subsequent years.[44] Critics immediately recognized that, like Brouillet, who gave Richer a place of prominence in *Une Leçon clinique,* Richer's artistic practice was invested in Realism, a movement committed to depicting contemporary life.[45] Gustave Larroumet, for example, in response to five sculptures that Richer submitted to the Salon of 1892, noted his "Realist spirit."[46] Richer's fine art, in other words, attempted to capture modern existence as 'objectively' as possible, and he likely saw his naturalistic depictions of laborers—sower, harvester, black-smith, and so on—on a continuum with his medical practice. In a text entitled "Dialogues sur l'art et la science" ("Dialogues on Art and Science") from 1897, Richer (through an interlocutor named Pamphile) argues that there are strong affinities between the work of the artist and that of the scientist: these include creativity and the careful observation of nature. Science reveals as much about the scientist as art reveals about the artist. He writes: "If [the scientist's] work belongs to everyone and becomes a part of our joint heritage, it is no less true that it comes from his mind and bears the stamp of his personality."[47]

This "careful observation of nature" that "bears the stamp of [the scientist's] personality" is visible in another drawing in the same album from the Musée Charcot that appears to be by Richer's hand. It shows the same attention to the patient's face and the same facility with creating planes and volumes through hatching. The artist carefully sketched the visage of the unconscious 82-year-old Marie Désirée Argentin (Figure 9.3). Her face is viewed at an angle, her head propped up by a pillow and adorned with a cap. Her open, toothless mouth is a dark void around which her features and bed are carefully defined. Again, casually drawn lines on the sheet below Argentin's head and shoulders suggest a body underneath a cover, but also add an almost abstract flourish. Here the artist—not the clinician—is dominant, inflecting the drawing with his individual touch. Charcot explicitly encouraged his medical students to draw—the epigraph for this chapter is taken from an undated letter to his son,

9.3 Unsigned drawing from a Musée Charcot Album (by Paul Richer?). Paris, Musée de l'Assistance Publique—Hôpitaux de Paris, Inv. no. AP 2005.0.27.1. Author's photograph, courtesy of the Musée de l'Assistance Publique—Hôpitaux de Paris.

Jean-Baptiste, who was studying medicine at the Salpêtrière and is pictured in Brouillet's canvas.[48] Apollo, of course, was the god of medicine but also of art, and his name was invoked more than once by Charcot and Richer in their published work.[49] Charcot *père*, then, nurtured the skills of observation and drawing in his students, even though the letter indicates that, in combining science with art, drawing muddied the supposedly clear waters of objectivity with individual perception.[50]

Beneath the drawing, a square of paper containing a timeline of events reveals that Argentin was asleep all day on February 17, 1878, the day the

drawing was made. It also notes that she died at 11 a.m. two days later, which would explain the other pieces of paper glued to the drawing's right. They illustrate diagrammatic sections of the human brain, highlighted with yellow to show, in this case, the parts of Argentin's brain that had degenerated. What, then, did Richer's drawing contribute to Argentin's diagnosis or prognosis? In other words, why was it made by a clinician and then kept in the album of a museum of pathological anatomy? Charcot and the members of the Salpêtrière School iterated repeatedly the power of images to describe more clearly and forcefully than text. "[K]nowing that images speak more strongly to the mind than words," Souques noted, "[Charcot] gave images a prime position."[51] Yet, this drawing reveals no more and no less than the words *"somnolence toute la journée"* written below it. Instead, it betrays an obsession with the image *tout court*. The drawing illustrates a patient, mute both literally and figuratively—in this case, the surface of the body tells us nothing about the illness that will shortly kill Argentin. Taken together, the drawing, text, and diagrams are meant to represent her fatal disease—the patient is only a vehicle to an increased understanding about pathology—but little is revealed. This accumulation of "evidence" is also a reminder that the bodies of the Salpêtrière's patients became the property of the hospital after death or, in this case, as death approached.[52] Argentin was simply a "willing" sitter for the *savant-artiste*—*qui tacet consentire videtur.*

Most of this album contains printed sections of brain, colored and marked to highlight pathology in various cases, and others drawn in freehand, cut out and pasted onto its pages. The names of patients and their pathologies have a sameness that ultimately diminishes their individuality: Jambon, "left hemiplegia for 2 years"; Galien, "left hemiplegia for 4 years"; Roger, "right hemiplegia, aphasia."[53] The consistency of the case histories described in this album suggests that it is principally dedicated to this particular pathology: hemiplegia is a complete paralysis of one half of the body and is caused by an injury to, or an infection in, the brain. A child born with hemiplegia can often gain some control over the affected side of the body. Are the photographs of the man showing us his left arm a case of hemiplegia from childhood? If so, the album, when viewed as a totality, might begin to explicate some of the images.

Across from Roger's case, a black graph with almost illegible markings takes up a whole page. What it was originally measuring—perhaps the strength of hysterical coughing, the violent shaking of a bicep during an epileptic seizure, or the jerky movements typical of chorea—is now lost.[54] However, its coldly calculated and mechanically rendered zigzags and lines are a reminder of the purportedly objective intent of *all* of the images in the album. In relation to representations of hysteria, cultural historian Sander Gilman has argued that the most

consistent image of the hysteric is that of the scientific reduction of the sufferer and the disease to schematic representations. [. . .] This fantasy of reducing the complexity of hysteria to statistics or charts rests on a notion of nineteenth-century science that everything is reducible to nonverbal form.[55]

We can see this creation (and re-creation) of the hysterical patient as an "image" in Brouillet's painting, where Wittmann's pose re-enacts Richer's drawing (see Plate 9.1). Of course, Georges Didi-Huberman has famously claimed that the hysterical body was constructed as an image in the theatrical stagings in Charcot's amphitheatre, as well as in the photographs, etchings, and sculptures produced in the sophisticated laboratories of the Salpêtrière.[56] In the Musée Charcot album, the photographs, drawings, schematic representations, and graph are treated as equivalent in providing an "image" of disease, confirming Gilman's point about the "reducibility" of disease to "nonverbal form." Yet, as we have seen, the information these different kinds of "evidence" convey is always partial.

One page of the album, comprising the contribution of an American neurologist, brings this point to bear. A letter by Royal Wells Amidon (b. 1853 or 1854–?) addressed to Charcot is pasted alongside a photograph and its brief caption.[57] Sent in 1884, the letter includes regards to Mme Charcot and "John" (presumably Jean-Baptiste Charcot), as well as a nostalgic reference to an earlier time in Paris, making it clear that Amidon had spent time at the Salpêtrière and in the Charcot family home. The enclosed cabinet card captures, in his words, "the result, the fruit, you may say, of one of the few 'cases' we sometimes meet in the course of our dreary existence over here in New York." It shows the brain of a patient who suffered from, as the caption reads, "'word deafness' or 'word blindness' with no paralysis, or true aphasia" (Figure 9.4).[58] The autopsied organ, in profile, rests on a frayed cloth laid on top of another textile, the rough texture of which fills the rest of the image. The abnormal brain is framed tightly at the center of this vertical photograph, a format more typical of, and better suited to, a portrait. But, of course, this *is* a portrait of a patient, and the name of the photographer who took it is printed along its bottom edge: "Thomas, 717 6th Avenue." The photographic studio of S. A. Thomas was only a few blocks away from Amidon's home on 41 West 20th Street in Manhattan. An obituary printed in *The Photographic Times and American Photographer* in 1894 states that Thomas "made a specialty of the portraits of children."[59] In this case, presumably an anomaly in his oeuvre, Thomas took a "portrait" of Amidon's dead patient, whose illness—and, seemingly, essence—was captured, self-evidently for Amidon and presumably Charcot, in this photograph.

Moreover, Thomas made a habit of stamping promotional messages onto the back of his cabinet cards; one reads "photographic artist" while another is in the shape of a painter's palette on which is written the photographer's name and address, along with the words "Rembrandt effects."[60] Thomas clearly prided himself on the artistry of his photographs, and this sepia-toned cabinet card is no exception. Such stamps bring to the fore the impossibility of removing individual interpretation from the results of this supposedly "objective" medium, even in a photograph of an internal organ. This cabinet card is especially intriguing as it was presumably taken in order to share visualized medical knowledge between specialists in nervous diseases. This was also

9.4 S. A. Thomas cabinet card from a Musée Charcot Album. Paris, Musée de l'Assistance Publique— Hôpitaux de Paris, Inv. no. AP 2005.0.27.1. Author's photograph, courtesy of the Musée de l'Assistance Publique— Hôpitaux de Paris.

the function of the medical museum, where rare or 'signature' illnesses were visually displayed to edify and excite the (medical) visitor. Thomas's cabinet card stands as a *mise-en-abyme* of the tangled relationship between art and medicine concretized in the albums, exhibited in the museum, and cultivated by Charcot.

Charcot *Artiste*[61]

9.5 Photograph from a Musée Charcot Album. Paris, Musée de l'Assistance Publique—Hôpitaux de Paris, Inv. no. AP 2003.7.1.5. Author's photograph, courtesy of the Musée de l'Assistance Publique—Hôpitaux de Paris.

Album AP 2003.7.1.5 mainly comprises photographs. Men, a few women, and a child model pathologies that are now difficult to read. None of the photographs is labeled with a patient's name or illness, and, as in the album described above, most are surprisingly inarticulate.[62] A shirtless, mustachioed man stands with his arms at his sides (Figure 9.5). He seems to look at, or just beyond, the camera. With his chin tucked in, his eccentric hairstyle has more prominence. The light coming from his proper right strikes the triangular pouf of hair that juts out from his head, forming a diagonal line with the deformed arm that pulls away from his body on his left. A woman with sloping shoulders gazes disarmingly and distrustfully at the lens. Her left arm cuts slightly across her torso, which is visible to the waist. Another photograph in the album shows her again; taken from a few steps further away, the image reveals her deformed left hand pointing accusingly at her other, seemingly "normal," hand (Figure 9.6). A young man, suited and seated, presents his wrinkled brow and direct gaze to the camera, the contour of his pointed pate outlined against the dark background (Figure 9.7). His striking visage seems to betray consternation. Given the absence of accompanying clinical information, the photographs' *raisons d'être* are difficult to ascertain, but the individual agency of the patient models comes through clearly in their unconventional postures and expressions. The photographs also hint at, to use Gilman's words, "the usually invisible lines of social power in the world of medicine."[63] An inadvertent fingerprint on the photograph of the bald man serves as a poignant reminder of the clinician's power, holding the man's fate, so to speak, in his hands.

While many of the images in this album are enigmatic, striking, and even troubling, the most curious is perhaps the final one: a creased reproduction of Frans Hals' *Laughing Cavalier* (1624, London, Wallace Collection), pasted horizontally to make it fit on the page (Figure 9.8). The *Laughing Cavalier* conveys a strong sense of inner life.[64] Indeed, Joshua Reynolds, first president of the Royal Academy of Arts, complimented exactly that quality in Hals' portraits.[65] It is a trait shared by many of the Salpêtrière patients in these albums, who like Hals' 26-year-old model, look directly at the viewer, albeit without the jauntily cocked head and sly smile. The painting, reproduced in a low-

9.6 Photograph from a Musée Charcot Album. Paris, Musée de l'Assistance Publique— Hôpitaux de Paris, Inv. no. AP 2003.7.1.5. Author's photograph, courtesy of the Musée de l'Assistance Publique— Hôpitaux de Paris.

quality print, stands in contrast to the medical photography shown in this album. Photography at the Salpêtrière was supposed to illustrate the visible and static symptoms of nervous disease—this was, as Souques claimed, the reason Charcot probably "privilege[d] this branch of pathology" in the first place. The tensed arm, the accusing hand, the wrinkled brow: these "signs" of dis-ease written on the body are remarkably inarticulate. Nevertheless, something of the personalities of the sitters is captured more successfully in the photographs. Wielding a paintbrush instead of a camera, Hals, too, seems to penetrate the body's surface, but with the intention of expressing character rather than pathology.

9.7 Photograph
from a Musée
Charcot Album.
Paris, Musée
de l'Assistance
Publique—
Hôpitaux de
Paris, Inv. no. AP
2003.7.1.5. Author's
photograph,
courtesy of
the Musée de
l'Assistance
Publique—
Hôpitaux de Paris.

Art historian Seymour Slive has described Hals' sitter as "one of the most familiar characters in the history of Western painting."[66] Charcot may have first encountered the painting as a reproduction in the *Gazette des beaux-arts* in 1865, in an article that discussed the Pourtalès sale in Paris in which it was being auctioned;[67] the astronomical price paid for it by Lord Hertford in a bidding war with Baron James de Rothschild likely stoked the public's interest in the work.[68] The *Laughing Cavalier* may display a pathological symptom relevant to the clinicians at the Salpêtrière; they published many "medico-artistic" case studies in the *Nouvelle Iconographie de la Salpêtrière* (NIS) in which they diagnosed figures in past artworks, though neither the *Laughing Cavalier* nor any other of Hals' works are ever discussed.[69] Charcot and Richer also published two popular books on the "possessed" (read, "hysterical"), deformed, and

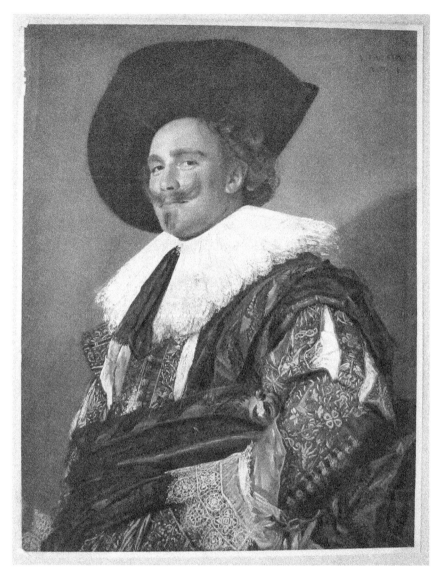

9.8 Reproduction of Frans Hals' *Laughing Cavalier* (1624) from a Musée Charcot Album. Paris, Musée de l'Assistance Publique—Hôpitaux de Paris, Inv. no. AP 2003.7.1.5. Author's photograph, courtesy of the Musée de l'Assistance Publique—Hôpitaux de Paris.

ill in art in which they chart the "invasion of pathology into art," but Hals is not included in these volumes either.[70] In *Les Difformes et les malades dans l'art* (The Deformed and Ill in Art) (Paris, 1889), they claim that "science and art are nothing more than two manifestations of the same phenomenon, two faces of the same object," echoing the sentiment that Charcot shared with his son.[71] In Charcot and Richer's view, both science and art were united in a concern with knowledge and, specifically, with nature. This attention to nature was also a well-known characteristic of seventeenth-century Dutch painters like Hals, whose "realism" was touted by historians and artists in France during Charcot's time.[72] Charcot's personal art collection included paintings by Hals' contemporaries: Gabriël Metsu, Ludolf Bakhuizen, and Jan Steen. He owned

significant works by the latter, including the *Marriage at Cana* (1676, Pasadena, Norton Simon Museum), and Steen's paintings were used more than once to illustrate articles in the NIS.[73] The style of Hals' painting would certainly have been to Charcot's taste, and he may have felt a kinship with the Dutch master, who was also a keen observer.

Charcot's focused attention while staring at the patient's body was similar to the close looking required by the artist sketching a model or by the connoisseur studying a work of art. The neurologist believed that one of the keys to accurate diagnosis was to view the (nude) body, which, as mentioned earlier, he often did in silence while patients were paraded before him.[74] According to his student Henry Meige, Charcot exhorted clinicians "[t]o look, to look again and to look always, it is only thus that one comes to *see*"—not unlike a teacher of the fine arts.[75] Significantly, it was in examining *The Miracles of Saint Ignatius of Loyola* (ca. 1615–1616, Kunsthistorische Museum, Vienna) by the seventeenth-century Flemish painter Peter Paul Rubens (1577–1640) that Charcot identified the historic belief in demonic possession as a sort of misdiagnosis of hysteria. In *Les Démoniaques dans l'art* (The Possessed in Art) (Paris, 1887), Charcot and Richer acclaim not only Rubens's "scrupulous observation of nature" but also his ability to "copy" it.[76] Since Rubens's works were productive for both science and art, according to the authors, it is unsurprising that his study of a woman possessed by the devil had already been included in a Salpêtrière publication intended for a medical audience.[77]

The reproduction of the *Laughing Cavalier*, along with other examples from these albums, evinces an engagement with contemporary artistic practices and discourses, as well as with the history of art, that is incongruous in a clinical setting at the end of the nineteenth century. These images point to a mistrust of capturing the visual signs of pathology through mechanical means (i.e., the camera) alone and run counter to Daston and Galison's argument on objectivity. Many of the images in these albums are more successful at eliciting pathos than depicting pathology;[78] these words' shared origin in the emotions points to the Salpêtrière School's delight, or thrill, in the compulsive representation of sick bodies that is also at odds with our conventional understanding of "objectivity" at the end of the nineteenth century. Art historian Mary Hunter affirms this point: "Although medical men and artists emphasized the objectivity and reason of their realistic objects, whether in paint, wax, photography, or print, pleasure and subjectivity were a vital component of creating and collecting bodies."[79] The albums in the Musée Charcot showcase the evident pleasure in the collecting, categorizing, observing, rendering, and illustrating of illness, which was only made possible by the patients who modeled, willingly or not, at the Salpêtrière.[80]

In a letter from 1879 sent to his wife from Italy, Charcot made it very clear that he felt his love of art was in tension with his talent for medicine: he wrote, "For sure, if I had doctors in my family, I also had some painters. My heart is torn between the two."[81] And while one could argue that the images in the Musée Charcot album similarly show a tension between artistry and medical

"objectivity," it might be more accurate to say that they testify to the fluid and often permeable boundaries between the two disciplines.

The Salpêtrière at the École des beaux-arts

Like the artists of the École des beaux-arts, Charcot and clinicians of the Salpetrière School sketched their models, utilized photographs as *aides-mémoire*, and studied the Old Masters. Paul Richer especially bridged the worlds of medicine and art by exhibiting sculptures at the Salon while creating "scientific artworks" in his atelier on the grounds of the Salpêtrière.[82] In the first years of the twentieth century, he concretized the link between the two fields when he succeeded Mathias Duval to become Professor of Anatomy at the École des beaux-arts. There, in addition to teaching art students for the next two decades, he crafted sculptures of athletic male bodies in action, photographed hundreds of men and women in a variety of poses while also keeping measurements of their bodies, created a canon of human proportions to rival Leonardo da Vinci's, and sculpted an *écorché* that was meant to improve upon Jean-Antoine Houdon's.[83] Nonetheless, he insisted that at the École he was simply continuing the research he had started at the Salpêtrière.

Almost twenty years after the first exhibition of Brouillet's *Une leçon clinique à la Salpêtrière*, Richer would see his likeness on the walls of a Parisian Salon once again, this time in a painting by Georges Leroux, one of his students at the École (Figure 9.9).[84] The work serves as the right panel of a triptych entitled *Les Études classiques de la peinture* (1904, location unknown), in which Leroux asserts the fundamental importance of the study of antiquity, the live model, and the cadaver for the art student. In the center panel, a nude female model dominates a life-drawing class at the Acadèmie de la Grande Chaumière; on the left, a female student copies an antique bust at the Louvre while, on the right, Richer discourses over a partially dissected corpse at the École. He holds forth on anatomy in the same amphitheater depicted in Sallé's painting of Duval, but here the handsome, muscular model is now a cadaver. Like Tulp, he lectures to students while pinching a flayed arm with a metal tool. And, like Charcot in Brouillet's canvas, Richer captures his audience's attention, his right hand caught mid-gesture as he makes a point. Leroux, however, in depicting Richer in profile, echoes God's pose on the Sistine Chapel ceiling: he extends his right hand to animate not the lifeless body on the table before him, but the minds of the art students who gather at the cadaver's side. Richer's pointing hand is partially silhouetted against the dark clothing of a female student, who is positioned prominently at the front of the group, standing next to the corpse. She stares at the body from up close, her sketchbook and pencil held in gloved hands. This art student participates in the collective gaze directed at the partially dissected corpse. The model in this painting is not the young woman, as in the canvas by Brouillet, but the male cadaver laid out for viewing.

9.9 Postcard
of right panel of
Georges Leroux's,
*Les Études classiques
de la peinture,*
1904. Collection
of Jacques Marie.
Courtesy of
Jacques Marie.

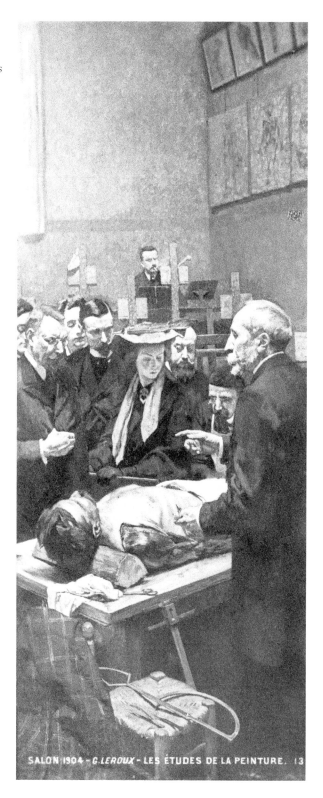

SALON 1904 - *G.LEROUX* - LES ÉTUDES DE LA PEINTURE. 13

This work by Leroux, then, calls to mind the anatomy lesson in Rembrandt's painting of Tulp, Brouillet's portrait of the Salpêtrière School, and Sallé's earlier depiction of the École. Richer's post at the École des beaux-arts could be seen as the apotheosis of the Salpêtrière School's desire to bridge the worlds of medicine and art. In contrast, some claimed that Charcot's artistic legacy eventually overshadowed his clinical reputation. Léon Daudet wrote, almost thirty years after Charcot's death, that "[t]he great artist is favored over the great scientist."[85] While Charcot's brilliant neurological discoveries and experimental diagnostic tools earned him worldwide renown during his life, many of his theories would fall into disfavor.[86] After his death in 1893, the Musée Charcot's intimate association with its controversial and mythic founder only hastened its own demise, and the museum's artifacts gradually disappeared from view.[87]

Acknowledgements

I am grateful to Andrew Graciano for including me in this volume, for his insightful comments, and his patience; the Leverhulme Trust for the Research Fellowship that gave me time away from teaching and administrative duties; Jean-François Minot, who introduced me to the albums of the Musée Charcot at the Musée de l'Assistance Publique-Hôpitaux de Paris, and Dominique Plancher-Souveton, who gave me unfettered access to them; Philippe Comar and Olivier Walusinski who have generously shared their knowledge of Richer; and Keren Hammerschlag, Tania Woloshyn, and Raffi Yegparian for their criticisms and kindnesses.

Notes

1 "Je t'engage à continuer les croquis: c'est une bonne façon d'occuper ses loisirs: la science et l'art sont alliés, deux enfants d'Apollon." Undated letter from Charcot to Jean-Baptiste Charcot, Charcot family archives; quoted in Bouchara (2013), 2.

2 "[L]e siècle des maladies nerveuses"; Mirbeau (1995), 121.

3 "Il ne sera peut-être ni le siècle de Victor Hugo, ni le siècle de Napoléon, mais le siècle de Charcot"; Mirbeau (1995), 121.

4 Mirbeau (1995), 121.

5 For a detailed discussion of this painting, see Hunter (2016), esp. 166–241. The following exhibition catalogue attempts to put the painting in context: Musée de l'Assistance Publique—Hôpitaux de Paris, *La Leçon de Charcot. Voyage dans une Toile*, exhibition catalogue (Paris: Musée de l'Assistance Publique, 1986), 15–16. For more information on Brouillet, see Bata et al. (2000). For Charcot's biography, see Guillain (1959); Goetz, Bonduelle, and Gelfand (1995). For a detailed discussion of his artistic output, see Bouchara (2013).

6 The members of the audience include Jules Claretie, Paul Arène, Philippe Burty, and Victor Cornil. For the full list, see Goetz, Bonduelle, and Gelfand (1995), 92–93.

7 For an analysis of Charcot's performances, see Marshall (2016).

8 Anthea Callen (2003), 672. For more on the life-drawing class at the École des beaux-arts, see Schwartz (1997), 12–23.

9 For more on Duval's tenure at the École, see Comar (2008), esp. 51–56.

10 These include Henry Berbez and Paul Berbez; the latter wrote a thesis on hysteria with drawings by Richer that was published the same year the Brouillet painting was exhibited. Berbez (1887).

11 Examples can be found in Schwartz (1997).

12 "Justement chauffée comme le serait un atelier de peintre"; Charcot (1889), 22.

13 Meige (1925), 15.

14 Emphases in the original. "En réalité [. . .] nous autres médecins, nous devrions connaître *le nu*, aussi bien et même mieux que les peintres ne le connaissent. Un défaut de dessin chez le peintre et le sculpteur, c'est grave, sans doute, au point de vue de l'art, mais en somme cela n'a pas, au point de vue pratique, des conséquences majeures. Mais que diriez-vous d'un médecin ou d'un chirurgien qui prendrait, ainsi que cela arrive trop souvent, une saillie, un relief normal pour une déformation ou inversement? . . . Cette digression suffira peut-être pour faire ressortir une fois de plus la nécessité pour le médecin comme pour le chirurgien d'attacher une grande importance à l'étude médico-chirurgicale du NU." Charcot (1889), 20–21.

15 Waller (2002), 45. For more on drawing instruction at the École des beaux-arts, see Boime (1971), esp. 24–36. See also Brugerolles, Brunel, and Debrabant (2013).

16 See Bourneville and Regnard (1879–1880), Plates i–x.

17 For a full discussion of Charcot's theories of hysteria in the context of his time, see Goetz, Bonduelle, and Gelfand (1995), 172–216.

18 Dijkstra (1986), 105–109. See also Ruiz-Gomez (2013).

19 Gilles de la Tourette (1893), 241; Meige (1925), 7–8.

20 "On peut se demander si les déformations physiques, si visibles et si communes dans les maladies nerveuses, n'avaient pas dirigé ses études vers cette branche préférée de la pathologie"; Souques (1925), 697.

21 Jordanova (2011).

22 Charcot (1890), 4. On the next page, he states, "Nous possédons un *musée anatamo-pathologique* auquel sont annexés un *atelier de moulage* et de photographie." Emphases in the original; Charcot (1890), 5.

23 "Les richesses cliniques et anatomo-pathologiques qu'elle renferme sont pour ainsi dire inépuisables. Mais, par malheur, elles ne sont pas utilisées aussi largement qu'elles méritent de l'être"; "Hospice de la Salpétrière [sic]" (1875), 718.

24 "un musée anatamo-pathologique, parfaitement aménagé, très élégamment décoré"; "Hospice de la Salpêtrière" (1879).

25 Charcot was accused of this during his lifetime. See Didi-Huberman (2003) for an art-historical analysis of this issue.

26 Daston and Galison (2007), 34.

27 Daston and Galison (2007), 37.

28 "Elle [la séance] eut lieu dans une grande salle, espèce de musée, dont les murailles, voire le plafond, sont ornés d'un nombre considérable de dessins, de peintures, de gravures, de photographies figurant tantôt des scènes à plusiers personnages, tantôt un seul malade nu ou vêtu, debout, assis ou couché, tantôt une ou deux jambes, une main, un torse, ou toute autre partie du corps. Tout autour, des armoires avec des crânes, des colonnes vertébrales, des tibias, des humérus présentant telle ou telle particularité anatomique; un peu partout, sur des tables, dans des vitrines, un pêle-mêle de bocaux, d'instruments, d'appareils; l'image en cire, non encore achevée, d'une vieille femme nue et étendue dans une espèce de lit; des bustes, parmi lesquels celui de Gall, peint en vert." Delboeuf (1886), 122–3.

29 "une véritable pièce de laboratoire vivante" and "on peut faire avec elle une exploration du corps humain aussi minutieuse et plus démonstrative qu'on ne peut le faire avec un cadavre"; Delboeuf (1886), 259.

30 Sappol (2004).

31 "Hospice de la Salpêtrière" (1879).

32 "Notons [. . .] des ornementations de mauvais goût qui ont été barbouillées sur les poutrelles saillantes du plafond"; Guillemot (1887), 371.

33 Letter dated January 20, 1886 in Sigmund Freud, *The Letters of Sigmund Freud*, ed. Ernst Freud (New York: Basic Books, 1975), 194; cited in Silverman (1992), 103. Charcot lived in the *hôtel* of the Prince de Chimay on the quai Malaquais until it was sold to house part of the École des beaux-arts; Pont-Calé (1890), 3. He then moved to, and combined, 217 and 219 Boulevard Saint-Germain, which now houses the Maison de l'Amérique Latine.

34 Sappol (2002), 276.

35 See Baudrillard (1994).

36 These albums are now housed at the Musée de l'Assistance Publique-Hôpitaux de Paris (M'AP-HP). They were first brought to my attention by Jean-François Minot, former Responsable des collections médicales of the M'AP-HP. Later, Dominique Plancher-Souveton, who became Responsable des collections of the M'AP-HP, allowed me priceless access to them. I am very grateful to them both.

37 Callen (1995), 53.

38 "je ne suis absolument là que le photographe; j'inscris ce que je vois"; Charcot (1888), 178.

39 Daston and Galison (2007), 38.

40 Barthes (1982).

41 I am grateful to Dr. Olivier Walusinski for confirming the date when Richer arrived at the Salpêtrière. Personal communication with the author, April 26, 2017. For more on Richer's life and work, see Blanchard (1906); Jean-Baptiste Charcot (1934); Comar (2008), esp. 56–60; Meige (1934); Ruiz-Gómez (2013); Ruiz-Gómez (2017); Walusinski (2011), esp. 78–82.

42 "On ferait le diagnostic sur ces dessins!"; Desprez (1987), 10. The thesis was: Henri Meillet, *Des Déformations permanentes de la main au point de vue de la séméiologie médicale.* (Thèse pour le doctorat en médecine. Présentée et soutenue le 9 mars 1874.) (Paris: A. Parent, Imprimeur de la Faculté de médecine, 1874). Richer's drawings were etched in three plates.

43 Desprez (1987), 10. He may have received drawing instruction in medical school, as it was part of anatomy training for surgeons; Jean-François Minot, personal communication with author, June 14, 2013.

44 Richer's sculptural oeuvre will be explored in my forthcoming book, *The Scientific Artworks of Dr. Jean-Martin Charcot and the Salpêtrière School: Visual Culture and Pathology in fin-de-siècle France*, as part of a larger investigation into Charcot and the Salpêtrière School's engagement with contemporary artistic practices and discourses, as well as the history of art.

45 For more on Realism, see: Cohen and Prendergast (1995); Lenoire (1889); Levine (1993); Nochlin (1971); Solomon-Godeau (2001); Weisberg (1982); Weisberg et al. (2010); Weisberg (1980).

46 "esprit réaliste"; Larroumet (1892), 98.

47 "Si son oeuvre achevée appartient à tous et entre dans le patrimoine commun, il n'est pas moins vrai qu'elle procède de son cerveau et qu'elle porte le cachet de sa personnalité"; Richer (1897), 54.

48 Jean-Baptiste Charcot is pictured just to the left of the left-hand window in the painting. He became a famous polar explorer.

49 For example, Richer (1902), 3.

50 Jane Macnaughton writes that life-drawing is being used in modern medical education to both improve anatomical understanding and manual skills but also to increase the students' appreciation of the beauty of the human body. See Macnaughton (2009), 78.

51 "sachant que les images parlent plus vivement à l'esprit que les paroles, il donna aux images une place de premier ordre"; Souques (1925), 697. This is a trope in the discourse around medical photography since at least the time of Hugh Diamond, who emphasized the particular efficacy of the photograph to "confirm[] and extend[]" any written or verbal description in the middle of the nineteenth century; Diamond (1976), 21.

52 In the nineteenth century, "unclaimed" cadavers, as well as those of the poor, criminal, and insane were often appropriated for medical research. For an extensive discussion of this practice in England, see Richardson (1987), esp. 104–106.

53 "hémiplégie gauche datant de 2 ans"; "hémiplégie gauche datant de 4 ans"; "Hémiplégie droite, Aphasie."

54 These examples are taken from another Musée Charcot album, which is made up solely of graphs. Inv. no. AP 2003.7.2.3, Paris, M'AP-HP.

55 Gilman (1993), 402.

56 Didi-Huberman (2003).

57 R[oyal] W[ells] Amidon, b. 1853 or 1854, was an American neurologist and author of the *Student's Manual of Electro-Therapeutics: Embodying Lectures Delivered in the Course on Therapeutics at the Women's Medical College of the New York Infirmary* (1888).

58 Emphasis removed.

59 *The Photographic Times and American Photographer* (1894).

60 The collection of the George Eastman Museum has several of Thomas's cabinet cards with these stamps. Personal communication with the author, Rachel E.

Andrews, Assistant Collection Manager, Department of Photography, George Eastman Museum, Rochester, New York, May 17, 2017. As this photograph is glued down in the Musée Charcot album, it is impossible to determine if it too bears one of Thomas's promotional stamps.

61 This subheading is taken from the title of Meige's essay (1898).

62 There are a few images of a sectioned brain, annotated "G. Burckhardt-de Waldau-près Berne," presumably from either Gottlieb Burckhardt himself, director of the Waldau Psychiatric Clinic from 1875–1882, or from one of his publications. In the 1880s, Burckhardt, the first modern psychosurgeon, wrote about traumatic hysteria; Burckhardt (1886). Coupled with the letter sent to Charcot by Amidon, these images signal the importance and extent of international communication in the field of medicine in the late nineteenth century.

63 Gilman (1995), 16.

64 Many years later, Richer would use another painting presumed to be by Hals, the portrait of René Descartes, as the foundation of his scientific–artistic exercise in creating a portrait of Descartes from a cast of the skull presumed to be his; see Ruiz-Gómez (2017), 243–244.

65 Reynolds is quoted without a reference in Liedtke (2011), 32–33.

66 Slive (1970), *Vol. I*, 21.

67 Mantz (1865).

68 Slive (1974), *Vol. III*, 19.

69 For a bibliography of their articles up to 1903, see *Nouvelle Iconographie de la Salpêtrière* (1903). A painting by Frans Hals the Younger (1618–1669) appears in Meige (1895), Plate 48.

70 Charcot and Richer (1889), iii. Their other popular book was Charcot and Richer (1887).

71 Charcot and Richer (1889), iii.

72 See ten-Doesschate Chu (1974).

73 For the artworks in his personal collection, see the auction catalogue after Mme Charcot's death: *Catalogue des objects d'art et d'ameublement . . .*, 6–9 July 1900 6–7, lot 12. Bouchara notes that Charcot particularly loved seeing the paintings of Hals and Steen while on holiday; Bouchara (2013), 97.

74 Achilles Souques and Henry Meige, "Jean-Martin Charcot," *Les Biographies médicales* (May–June–July 1939): 333; cited in Goetz, Bonduelle, and Gelfand (1995), 137.

75 Emphasis in the original. "Regarder, regarder encore et regarder toujours, c'est ainsi seulement que l'on arrive à *voir*"; Meige (1925), 15.

76 "une scrupuleuse observation de la nature"; Charcot and Richer (1887), xi, 56.

77 Charcot and Richer (1887), 64. For the illustration, see Bourneville and Regnard (1877), plate XL.

78 "pathos, n." OED Online (March 2018).; and "pathology, n." OED Online (March 2018). My thanks to Andrew Graciano for this observation.

79 Hunter (2016), 244.

80 Sappol also writes that the cabinet of curiosity and the anatomical museum
 "responded to and fostered a pleasure principle. [. . .] It is also worth noting
 that, even in the most elite and scientific eighteenth- and nineteenth-century
 museums, a portion of what was collected was purely curious, not scientific at
 all." Sappol (2002), 276

81 Allart-Vallin-Charcot Archives, cited in Goetz, Bonduelle, and Gelfand (1995), 8.

82 For more on the pathological sculptures Richer created, see Ruiz-Gómez (2013).

83 For more on some of these works, see Callen (2003); Comar (2008); Ruiz-Gómez
 (2017).

84 The work was exhibited at the Salon des artistes français in 1904. For a brief
 biographical sketch of Leroux, see Aumasson and Pigallet (2013), 126. I am
 grateful to Jacques Marie for generously providing information on Leroux, as
 well as for sharing images. According to Callen, Richer is also present in Sallé's
 The Anatomy Class. See Callen (2003), 22.

85 "Le grand artiste est plus favorisé [. . .] que le grand savant"; Daudet (1922), 242.

86 Goetz (1988).

87 For more on the dispersal of the Musée Charcot collection, see Ricou, Leroux-
 Hugon, and Poirier (1993).

References

Amidon, R[oyal] W[ells]. *Student's Manual of Electro-Therapeutics: Embodying Lectures
 Delivered in the Course on Therapeutics at the Women's Medical College of the New York
 Infirmary*. New York: G. P. Putnam's Sons, 1888.

Aumasson, Pascal, and Mathilde Pigallet. *Les Peintres de Pont-Aven et les Nabis*.
 Exhibition catalogue. Brest, France: Musée des beaux-arts de Brest métropole
 océane, 2013.

Barthes, Roland. *Camera Lucida: Reflections on Photography*. London, UK: Jonathan
 Cape, 1982.

Bata, Philippe, et al., *André Brouillet, 1857–1914*. Exhibition catalogue. Poitiers, France:
 Musées de la Ville de Poitiers, 2000.

Baudrillard, Jean. "The System of Collecting." In *The Cultures of Collecting*, edited by
 John Elsner and Roger Cardinal, 7–24. London, UK: Reaktion Books, 1994.

Berbez, Paul. *Hystérie et traumatisme: Paralysies, contractures, arthralgies, hystéro-
 traumatiques*. Paris, France: Bureaux du progrès médical and Delahaye et
 Lecrosnier, 1887.

Blanchard, Raphaël. *Hommage à M. le Docteur Paul Richer à l'occasion de son election à
 l'Académie des beaux-arts (22 Juillet 1905)*. Paris, France: Académie des beaux-arts,
 1906.

Boime, Albert. *The Academy and French Painting in the Nineteenth Century*. New Haven,
 CT: Yale University Press, 1971.

Bouchara, Catherine. *Charcot. Une Vie avec l'image*. Paris, France: Philippe Rey, 2013.

Bourneville, Désiré-Magloire, and Paul Regnard. *Iconographie Photographique de la Salpêtrière*. 3 vols. Paris, France: Bureau du Progrès médical and Adrien Delahaye et Cie, 1877–1880.

Brugerolles, Emmanuelle, Georges Brunel, and Camille Debrabant, eds. *The Male Nude: Eighteenth-Century Drawings from the Paris Academy*. London, UK: Paul Holberton for the Wallace Collection, 2013.

Burckhardt, Gottlieb. "Contribution à l'étude de l'hystérie traumatique." *Revue médicale de la Suisse Romande* 6 (1886): 735–746.

Callen, Anthea. *The Spectacular Body: Science, Method, and Meaning in the Work of Degas*. New Haven, CT: Yale University Press, 1995.

Callen, Anthea. "Doubles and Desire: Anatomies of Masculinity in the Later Nineteenth Century." *Art History* 26, no. 5 (November 2003): 669–699.

Callen, Anthea. "Masculinity and Muscularity: Dr Paul Richer and Modern Manhood." *Paragraph* 26, no. 1–2 (March/July 2003): 17–41.

Catalogue des objects d'art et d'ameublement . . . 6–9 July 1900. Paris, France: Chevallier and Hémard, 1900.

Charcot, Jean-Baptiste. "Paul Richer." *Paris Médical* 92 (1934): 316–320.

Charcot, Jean-Martin. *Leçons du mardi à la Salpêtrière, Policlinique 1887–88. Notes de cours de MM. Blin, Charcot et H. Colin*. Paris, France: Progrès médical and A. Delabaye et Emile Lecrosnier, 1888.

Charcot, Jean-Martin. *Leçons du mardi à la Salpêtrière, Policlinique 1888–1889*. Edited by MM. Blin, Charcot, and Henri Colin. Paris, France: Progrès médical and E. Lecrosnier & Babé, 1889.

Charcot, J[ean]-M[artin]. *Oeuvres Complètes. Leçons sur les maladies du système nerveux. Vol. III*. Paris, France: Aux Bureaux du Progrès médical/Lecrosnier et Babé, 1890.

Charcot, Jean-Martin, and Paul Richer. *Les Démoniaques dans l'art*. Paris, France: Lecrosnier et Babé, 1887.

Charcot, Jean-Martin, and Paul Richer. In *Les Difformes et les malades dans l'art*. Paris, France: Lecrosnier et Babé, 1889.

Cohen, Margaret, and Christopher Prendergast, eds. *Spectacles of Realism: Body, Gender, Genre*. Minneapolis, MN: University of Minnesota Press, 1995.

Comar, Philippe, ed. *Figures du corps. Une leçon d'anatomie à l'École des beaux-arts*. Exhibition catalogue. Paris, France: Beaux-Arts de Paris, 2008.

Daston, Lorraine, and Peter Galison. *Objectivity*. New York: Zone Books, 2007.

Daudet, Léon. *Les Oeuvres dans les hommes*. Paris, France: Nouvelle Librairie Nationale, 1922.

Delboeuf, J[oseph Rémi Léopold]. "Une Visite à la Salpêtriere." *Revue de Belgique* 54 (1886): 139–147, 258–278.

Desprez, Catherine. "Paul Richer: 1849–1933: un médecin à l'école des Beaux Arts." M.D. dissertation, Caen, France, 1987.

Diamond, Hugh W. "On the Application of Photography to the Physiognomic and Mental Phenomena of Insanity." In *The Face of Madness: Hugh W. Diamond and the Origin of Psychiatric Photography*, edited by Sander L. Gilman, 17–24. Secaucus, NJ: Citadel Press, 1976.

Didi-Huberman, Georges. *Invention of Hysteria: Charcot and the Photographic Iconography of the Salpêtrière*. Translated by Alisa Hartz. Cambridge, MA: MIT Press, 2003.

Dijkstra, Bram. *Idols of Perversity: Fantasies of Feminine Evil in Fin-de-Siècle Culture*. New York: Oxford University Press, 1986.

"Editorial Notes." *The Photographic Times and American Photographer*, 25 (July 27, 1894): 60.

Gilles de la Tourette, [Georges]. "Jean-Martin Charcot." *Nouvelle Iconographie de la Salpêtrière* 6 (1893): 241–250.

Gilman, Sander L., ed. *The Face of Madness: Hugh W. Diamond and the Origin of Psychiatric Photography*. Secaucus, NJ: Citadel Press, 1976.

Gilman, Sander L. "The Image of the Hysteric." In *Hysteria Beyond Freud*, edited by Sander L. Gilman et al. Berkeley, CA: University of California Press, 1993.

Gilman, Sander L. *Picturing Health and Illness: Images of Identity and Difference*. Baltimore, MD: Johns Hopkins University Press, 1995.

Goetz, Christopher G. "The Salpêtrière in the Wake of Charcot's Death." *Archives of Neurology* 45, no. 4 (April 1988): 444–447.

Goetz, Christopher G., Michel Bonduelle, and Toby Gelfand. *Charcot: Constructing Neurology*. New York: Oxford University Press, 1995.

Guillain, Georges. *J.-M. Charcot, 1825–1893. His Life — His Work*. Edited and translated by Pearce Bailey. London, UK: Pitman Medical, 1959. Originally published as *J.-M. Charcot, 1825–1893: sa vie, son oeuvre*. Paris, France: Masson et Cie, 1955.

Guillemot, Maurice. "A la Salpêtrière. II." *Paris Illustré* (October 1, 1887): 371–373.

"Hospice de la Salpêtrière [sic].—Conférences cliniques de M. Charcot." *Le Progrès Médical*, 3 année, no. 49 (December 4, 1875): 718–719.

"Hospice de la Salpêtrière.—M. Charcot." *Le Progrès Médical*, 7 année, no. 47 (November 2, 1879): 913.

Hunter, Mary. *The Face of Medicine: Visualising Medical Masculinities in Late Nineteenth-Century Paris*. Manchester, UK: Manchester University Press, 2016.

Jordanova, Ludmilla. Opening Remarks. "Case Studies of Medical Portraiture Workshop." King's College London, UK. June 2, 2011.

Larroumet, Gustave. *Le Salon de 1892*. Paris, France: Boussod, Valadon & Cie, 1892.

Lenoire, Paul. *Histoire du Realisme et du Naturalisme dans la poesie et dans l'art depuis l'antiquite jusqu'à nos jours*. Paris, France: Quantin, 1889.

Levine, George, ed. *Realism and Representation: Essays on the Problem of Realism in Relation to Science, Literature, and Culture*. Madison, WI: University of Wisconsin Press, 1993.

Liedtke, Walter. "Frans Hals: Style and Substance." *Metropolitan Museum of Art Bulletin* (Summer 2011): 5–48.

"L'Oeuvre medico–artistique de la Nouvelle Iconographie de la Salpêtrière." *Nouvelle Iconographie de la Salpêtrière* 16 (1903): 413–429.

Macnaughton, Jane. "Flesh Revealed: Medicine, Art and Anatomy." In *The Body and the Arts*, edited by Corinne Saunders, Ulrika Maude, and Jane Macnaughton, 72–83. Basingstoke, UK: Palgrave Macmillan, 2009.

Mantz, Paul. "La Galerie Pourtalès." *Gazette des beaux-arts* 18, no. 104 (February 1, 1865): 97–117.

Marshall, Jonathan W. *Performing Neurology: The Dramaturgy of Dr Jean-Martin Charcot*. New York: Palgrave Macmillan, 2016.

Meige, Henry. "Les Peintres de la médecine (Écoles flamande et hollandaise). Les operations sur la tête." *Nouvelle Iconographie de la Salpêtrière* 8 (1895): 291–322.

Meige, Henry. *Charcot Artiste*. Paris, France: Masson et Cie, 1925. Originally published in *Nouvelle Iconographie de la Salpêtrière* 11 (1898): 489–516.

Meige, Henry. "Paul Richer et son oeuvre." *La Press médicale* 42, no. 6 (January 20, 1934): 123–126.

Mirbeau, Octave. "Le siècle de Charcot." In *Chroniques du diable*, edited by Pierre Michel, 121–127. Paris, France: Les Belles Lettres, 1995.Originally published under the pseudonym Le Diable in *L'Événement*, May 29, 1885.

Musée de l'Assistance Publique—Hôpitaux de Paris. *La Leçon de Charcot. Voyage dans une Toile*. Exhibition catalogue. Paris, France: Musée de l'Assistance Publique, 1986.

Nochlin, Linda. *Realism*. Harmondsworth, UK: Penguin, 1971.

Oxford English Dictionary Online. "pathology, n." March 2018. Oxford University Press. http://0-www.oed.com.serlib0.essex.ac.uk/view/Entry/138808?redirectedFrom=pathos; and "pathology, n" [accessed May 4, 2018].

Oxford English Dictionary Online. "pathos, n." March 2018. Oxford University Press. http://0-www.oed.com.serlib0.essex.ac.uk/view/Entry/138808?redirectedFrom=pathos; and "pathology, n" [accessed May 4, 2018].

Pont-Calé. "Le Professeur Charcot." *Les Hommes d'aujourd'hui* 7, no. 343 (1890): 1–3.

Richardson, Ruth. *Death, Dissection and the Destitute*. London, UK: Routledge & Kegan Paul, 1987.

Richer, Paul. "Dialogues sur l'art et la science. I. Des Rapports de l'art et la science." *La Nouvelle Revue* (July 1, 1897): 41–54.

Richer, Paul. *L'Art et la Médicine*. Paris, France: Gaultier, Magnier & Cie., 1902.

Ricou, Philippe, Véronique Leroux-Hugon, and Jacques Poirier. *La Bibliothèque Charcot à la Salpêtrière*. Paris, France: Éditions Pradel, 1993.

Ruiz-Gómez, Natasha. "The 'Scientific Artworks' of Doctor Paul Richer." *Medical Humanities* 39, no. 1 (June 2013): 4–10.

Ruiz-Gómez, Natasha. "A Hysterical Reading of Rodin's *Gates of Hell*." *Art History* 36, no. 5 (November 2013): 994–1017.

Ruiz-Gómez, Natasha. "Shaking the Tyranny of the Cadaver: Doctor Paul Richer and the *Living Écorché*." In *Bodies Beyond Borders. Moving Anatomies, 1750–1950*, edited by Kaat Wils, Raf de Bont, and Sokhieng Au, 231–257. Leuven, Belgium: University of Leuven Press, 2017.

Sappol, Michael. *A Traffic of Dead Bodies: Anatomy and Embodied Social Identity in Nineteenth-Century America*. Princeton, NJ: Princeton University Press, 2002.

Sappol, Michael. "'Morbid Curiosity': The Decline and Fall of the Popular Anatomical Museum." *Common-Place* 4, no 2 (January 2004). www.common-place.org/vol-04/no-02/sappol/ [accessed April 4, 2011].

Schwartz, Emmanuel. *L'Art du nu au XIXe siècle: le photographe et son modèle*. Exhibition catalogue. Paris, France: Bibliothèque nationale de France, 1997.

Silverman, Debora L. *Art Nouveau in fin-de-siècle France: Politics, Psychology, and Style*. Berkeley, CA: University of California Press, 1992.

Slive, Seymour. *Frans Hals*. Vols. I–III. London, UK: Phaidon, 1970–1974.

Solomon-Godeau, Abigail. "Realism Revisited." *Self and History: A Tribute to Linda Nochlin*, edited by Aruna D'Souza, 69–75. London, UK: Thames & Hudson, 2001.

Souques, A[chille]. "Charcot intime." *La Presse médicale* 42 (May 27, 1925): 693–698.

ten-Doesschate Chu, Petra. *French Realism and the Dutch Masters: The Influence of Dutch Seventeenth-Century Painting on the Development of French Painting between 1830 and 1870*. Utrecht, the Netherlands: Haentjens Dekker & Gumbert, 1974.

Waller, Susan. "Professional Poseurs: The Male Model in the Ecole des beaux-arts and the Popular Imagination." *Oxford Art Journal* 25, no. 2 (2002): 43–64.

Walusinski, Olivier. "Keeping the Fire Burning: Georges Gilles de la Tourette, Paul Richer, Charles Féré and Alfred Binet." In *Following Charcot: A Forgotten History of Neurology and Psychiatry*, edited by Julien Bogousslavsky, 71–90. Basel, Switzerland: Karger, 2011.

Weisberg, Gabriel. *The Realist Tradition: French Painting and Drawing, 1830–1900*. Exhibition catalogue. Cleveland, OH: The Cleveland Museum of Art in cooperation with Indiana University Press, 1980.

Weisberg, Gabriel P. *The European Realist Tradition*. Bloomington, IN: Indiana University Press, 1982.

Weisberg, Gabriel P. et al. *Illusions of Reality: Naturalist Painting, Photography, Theatre and Cinema, 1875–1918*. Exhibition catalogue. Brussels, Belgium: Mercatorfonds, 2010.

The Fat Body as Anatomical and Medical Oddity
Lucian Freud's Paintings of Sue Tilley

Brittany Lockard

Medicalization of the Fat Body[1]

It is no secret that the fat body has long been pathologized (i.e., seen and treated as diseased and/or abnormal) in Western culture. One need only look to the abundance of research facilities and medical journals devoted to large bodies to ascertain this fact. It includes (but is not limited to): *Obesity Journal, Obesity Research and Clinical Practice Journal, International Journal of Obesity, Obesity Research Open Journal, BMC Obesity, SciFed Journal of Obesity Research, Journal of Obesity and Metabolic Research, Obesity Management, Iranian Journal of Diabetes and Obesity* (not to be confused with the *Journal of Diabetes, Metabolic Syndrome, and Obesity* or the *Journal of Diabetes and Obesity*), *Childhood Obesity, International Journal of Pediatric Obesity*, the Diabetes and Obesity Research Institute at Cedars-Sinai, the National Diabetes and Obesity Research Institute, the Mississippi Center for Obesity Research at the University of Mississippi, Yale University's Program for Obesity, Weight, and Eating Research (POWER), the Centre for Obesity Research at the University of Birmingham (UK), the Association for the Study of Obesity (UK), etc.

The medicalization of fatness rests on several basic assumptions. First, it assumes that thinness is the natural state of the human body and fatness is an aberration, rather than a natural part of human biodiversity, like height variation or differing skin colors. Second, it predicates that being fat is inherently unhealthy. Third, it takes for granted that losing weight in and of itself would confer upon fat people the same health benefits enjoyed by thin people. Last, it presumes that all fat people could become thin if they so desired (the conventional wisdom being that fat people can and should do this by eating less and/or moving more). Although all of these propositions are currently being challenged,[2] both from within medicine itself and through the burgeoning fields of Health at Every Size (HAES) and Fat Studies, my purpose in this essay is to examine the ways in which medicalized discourse has been firmly adopted in Western, specifically British, culture and has influenced and was expressed in Lucian Freud's paintings of a sitter named Sue Tilley. I will argue that Freud's Tilley paintings exoticize and 'other' her body (and even fetishize

her fatness itself), while abjecting[3] her and associating her with inanimate objects to suggest her immobility.[4]

Picturing Sue Tilley

Freud met Sue Tilley, who worked at the Islington Labour Exchange, through the best known of his fat models—the Australian-born performance artist Leigh Bowery,[5] perhaps most famous today as the inspiration for the main character in the musical *Taboo*. In fact, the reason that Tilley stopped modeling for Freud was to write a biography about Bowery, entitled *The Life and Times of an Icon*.[6] She began modeling for Freud in the mid 1990s; he produced four paintings and several works on paper depicting Tilley. There is no question about the popular consensus that Tilley is fat: in both the scholarly and popular press, she is most commonly referred to by the moniker of "Big Sue," and many articles include details about her weight.[7] The medicalization of fatness clearly influenced, and is expressed in, the reception of Freud's images of Tilley. Critics and the public focused not on the art, but insistently on the model's body, which modeled obesity and ill health in the general view.

Freud's first painting of Tilley, *Evening in the Studio* (Plate 10.1), is the only one in which she appears with another model and it has the most complex composition in the series.[8] A nude Tilley sprawls on the floor in the foreground, her body tilted toward the viewer in an exceedingly uneasy pose, legs akimbo and head turned. She pitches so steeply it appears as though her spine must hover above the floorboards. A bed, occupied by a sleeping greyhound, and a chair (in which another woman sits, fully clothed and covered by a patterned blanket, reading) are located behind the nude model.

Tilley's position in the foreground makes her the focal point of the image, and, as is characteristic of his work, Freud emphasizes the oddities in her graceless pose. Besides the strange balancing of her weight on her hip, rather than her spine, Tilley seems to be missing a few body parts. Her left arm, which rests on her belly, appears disproportionate—bizarrely shrunken next to her ballooning stomach, out of which it seemingly grows, because the pose obscures the shoulder and upper arm while sharply foreshortening the forearm. Additionally, the weight of her breasts draws them toward her face, which obscures the neck completely and makes her head look as though it emerges directly from her cleavage.

Freud depicts Tilley in a completely unidealized manner. Her thighs and stomach form irregular lumps, and her swollen belly falls asymmetrically, especially the portion around her belly button, which seems to be melting off her body. This irregularity could be attributable to many causes, from an uneven distribution of body fat, to the lumpy underlying organs showing through (herniated), if the artist faithfully rendered Tilley's form here. Freud's bruise-like shadowing and impasto, encrusting Tilley's skin like a malignant disease, enhances the unflattering elements of the likeness. The paint is

largely built up beneath her breasts, in what appear to be a series of infected sores or deep tissue bruises, below her belly button in some type of burn or rash, and on her inner thighs, which sport similarly ambiguous markings. Altogether, Tilley's body reads as ill or even decomposing, an effect enhanced by the previously mentioned position of her stomach, which one may imagine to be rotting off her bones.

The juxtaposition of Tilley with the fully-clothed thin model and the relaxed body of the sleeping greyhound, a lean dog bred for running, only exacerbates her embodiment of illness or death. The fact that both of the other figures occupy furniture draws attention to the incongruity of Tilley's lolling sprawl on the floor (the location where we would expect to find a lifeless body) just as the clothing and blanket of the seated woman serve as foils to Tilley's nudity. Moreover, the animation of the seated figure—her upright pose, her active engagement in reading or sewing—contrasts with Tilley's inactivity, as the laxity of the sleeping dog contrasts with her unnatural rigidity and torsion. The contrast in facial coloring and expression is particularly intense; the seated figure looks down and her skin appears tan, with highlights on the forehead and nose, as in a traditional portrait. Freud depicts Tilley, on the other hand, with completely loose facial features (e.g., the way the flesh of her cheek seems to puddle against her hair) and highlights the area around her mouth and jaw with crusty-textured paint. The crustiness repeats in her lower cheek, in an area that would presumably fall into the shadow of her nose, making it read less as light falling on skin and more as diseased or rotting flesh.

However, Tilley's pose is not entirely cadaverous. The tightened muscles of her left leg seem to arch her back a little, as though she were about to roll over. The tension this causes in her body makes the pose awkward, but very life-like—that is, anatomically logical. Much of the abject quality and the charge of disgust or horror in this image come from Tilley's aura of disease and dirt, the threat of pollution and contagion. In this case, the dark shading implies dirt as much as it evokes contusions, and the red spots easily indicate infected, festering pustules. Moreover, Tilley's placement on the floor and her nudity contribute to her abjection—hair, dust, grime, crumbs, etc. collect on the ground.[9]

Evening in the Studio, unlike Freud's other pictures of Tilley, as we shall see later in this essay, possesses the explicit sexualization common in traditional female nudes. The viewer stands over Tilley, looking down on and at her exposed flesh. Freud particularly exposes her pubic triangle, which Tilley's spread-legged posture leaves open and thrust towards the viewer. Her long, falling hair also stands as a conventional sign of feminine eroticism, seen in such works as Cabanel's *Birth of Venus* (1863). However, the rest of the composition challenges this reading. While it is true that additional clothed figures and animals appear in several canonical female nudes with titillating atmospheres (e.g., Édouard Manet's *Olympia* (1863)), *Evening in the Studio* makes some significant compositional and narrative departures from its predecessors. For instance, rather than reclining on a bed as if waiting to receive a lover, Tilley sprawls on the floor in an unseductive pose while a dog

claims the mattress. The clothed figure here serves no clear narrative purpose; she does not appear to be a maid, for instance. Moreover, the room itself lacks the lush seductiveness of similar works. The walls appear water-stained and moldy, the furniture seems cheaply made, and the narrow bed looks uncomfortable with its thin, lumpy mattress. There are no fancy linens, luxurious pillows, or beautiful bouquets in this space.

However, Freud crafts an additional eroticism of flesh in this image—a sensual fascination with the very size and tactility of Tilley's body. He plays with the roundness of Tilley's form, making repeated circular forms throughout her figure: he emphasizes the circle of her knee and repeats it in the thigh of her upraised leg; he marks her lower leg with a broad circle across the thigh and calf; he fashions a series of widening circular forms in her belly, beginning with the oblong oval of her navel; and he inserts myriad other small circles in her body, such as her nipples, the round of her heel, her head, etc. Moreover, Freud's absorption in Tilley's size leads him to accentuate it through his compositional choices. He juxtaposes her against an exceptionally thin and frail model and a very lean, athletic breed of dog, both posed with an interiority or introverted attitude that opposes Tilley's openness. He further magnifies the effect by placing Tilley closest to the picture plane, making her seem proportionally all the larger. The austere decor also enhances her size, especially the flat, narrow bed frame, which seems too fragile to support Tilley's bulk. Such displacement of traditional sexualization onto a fetishization of Tilley's flesh is germane to the discussion of the medicalization of fat bodies, because such emphasis on the round and swollen appearance of Tilley's body both helps to other her (as does pathologized language about fatness) and encourages the viewer visually to linger over her form, absorbing all the brushwork, impasto, and color choices Freud uses that mark Tilley as diseased and abject.

If, as I have argued here, Freud's depiction of Tilley in *Evening in the Studio* visually figures the model's body as a site of disease and abjection, we must then inquire about what influences may have led the artist to frame her in this light?

Fat Context

Freud's series of paintings of Sue Tilley captured a certain timely interest in the subject of fatness.[10] During their production, the fat body was very much in the news and on the minds of London locals. Although fat acceptance groups have long been a part of American culture, with the largest group, the National Association to Advance Fat Acceptance (or NAAFA), formed in the 1960s, in the UK such groups were only in their infancy in the 1990s. And they were being born just as Lucian Freud turned to Tilley as a model for his paintings. In early 1992, Mary Evans Young founded "Dietbreakers," a group meant to encourage women to stop dieting and begin to accept their own bodies. As Young says:

I started [the program] in the spring of '92 after seeing a television programme where women were having their stomachs stapled. One woman had split the staples and was in for her third op. And then a young girl of 15 committed suicide because she 'couldn't cope' [with] being fat. She was a size 14 . . . I decided somebody had to stand up and try and stop this bloody madness and in the absence of anybody else, I decided it would be me. So I sent out a press release titled "Fat Woman Bites Back."[11]

Dietbreakers attracted a significant amount of press attention, even receiving its own episode on the BBC2 program *Open Space* in November 1992. In collaboration with Charlotte Cooper, Young also opened Planet Big-Girl—a plus-size disco at the London club Equinox.[12] And Young attracted more media attention by founding "International No Diet Day" in May 1992. Rain prevented the event from taking place outdoors that year, but in 1993, she garnered the interest of the press by taking a group of large women to eat publicly at a picnic in Hyde Park.[13] These events received publicity, especially in London.[14] Whether or not Freud was aware of these specific events—and as a long-time London resident, it seems likely that he would have been—his interest in painting Tilley is part of a larger cultural phenomenon demonstrated by the heightened awareness of the fat body in London in the early 1990s. However, Freud's paintings, with their mixture of fascination and repulsion toward Sue Tilley's body, express and elaborate upon, not the fat-positive attitudes of Dietbreakers, but the popular and medical (negative) conceptions of fatness.

These conceptions are demonstrated by the actions taken by the British government, particularly those segments that deal with health care. In 1993, the British government's chief medical officer responded to concerns about overall health in the UK, especially relating to obesity, by providing a list of changes people could make in their everyday life to increase their overall health. Although some of the changes relate to common sense rather than to weight loss specifically (e.g., "Don't drink and drive") the majority seem to be aimed at making people thin. Among the list: "Watch how much you eat—think twice before seconds," and "Try fresh fruit instead of cake or biscuits," both common refrains in dieting manuals.[15] In 1994, when Freud was in the midst of his series of Tilley paintings, the Office of Health Economics issued a report stating that obesity cost British taxpayers £200 million per year and characterizing it as the "most preventable" cause of ill health. And that same year, a study of Irish doctors found that one in five would give treating an obese patient a lower priority than treating a slim patient, even if the patients had the exact same medical problems.[16]

These cultural biases against fat appeared not only in public health writing, but also in forms such as job discrimination. In 1989, *What Diet and Lifestyle* magazine reported the results of a survey in which 86% of the participants responded that they felt fat people were discriminated against.[17] This was borne out in actual life scenarios. In one 1988 incident, for example, a school dinner server named Jane Meachem was fired on the recommendation of the

medical officer, who felt that her obesity put her at risk for cardiac and muscular problems, as well as making her an economic liability, believing fat people take more time off due to illness. Meachem's story was featured in newspaper articles and on a television show, eventually forcing Staffordshire County Council to retract her lay-off. However, Meachem declined the offer, and took a job with a cleaning firm—which also made weight loss a condition of her employment, despite the fact that Meachem was in good health and walked and swam regularly.[18] The recommendation that Meachem lose weight to increase her likely productivity also underlines the economic and political positionalities behind the seemingly benevolent guise of 'preventative medicine', both here and in the National Health Service guidelines, and which are intertwined with the pathologization of the fat body. The assumptions made about Meachem's level (lack) of physical activity find a counterpoint in Freud's paintings of Tilley: as we shall see, his insistence on associating her with static, lifeless furniture suggests a similar presumption that she cannot and does not easily move.

Just as Tilley was beginning to model for Freud, in June of 1992, UK magazine *Slimmer* published the results of their survey on job discrimination. Certain professions were found to screen out "overweight" applicants automatically, among them flight attendants and nurses. As the article says, "the implication seems to be that as a rule, overweight people are sloppy individuals who don't care enough about their appearance."[19] British employees have little protection against such discrimination—then, as now, the Equal Opportunities Commission will only take cases in which the discrimination is based on age, race, gender, sexual orientation, physical disability, and religion.[20]

Freud's eroticization of Tilley's flesh, emphasis on her roundness, and association of her with overstuffed, inanimate objects (as we shall see) also has its counterpart in popular culture. Columnist Lynda Lee-Potter, writing at essentially the same moment that Freud painted Tilley, expressed some of the latent hostility harbored by the British toward the fat body in a series of columns sparked, innocuously enough, by an incident on a television program. In the series, a character played by actress Judi Dench was abandoned by her husband, which Lee-Potter claimed was justified because of Dench's weight. Lee-Potter's attitude prompted anger from some of her readers, which she belittled, saying, "Letters from outraged fatties have poured in," but assuring us that she would "bravely continue to do [her] worst."[21]

But it was Lee-Potter's response to the possibility of the American anti-dieting organization NAAFA spreading to the UK that really revealed the cultural absorption of medical assumptions about the fat body. According to Lee-Potter, NAAFA executive member Sally Smith characterized the message of the organization as "Women['s] size is not their fault."[22] Lee-Potter mocked this assertion, saying, "I don't know whose fault it is then, since it's the fatties who control their intake of doughnuts, éclairs, Mars Bars, hamburgers, and suet dumplings."[23] She also implied that NAAFA members can't enjoy the beach, or go "running through the surf in a swimsuit if [they are] so hefty [they] look as though [they] could kick-start a Concorde."[24] Again, Lee-Potter's

statement matches some of the elements in Freud's paintings—the association of the fat body with inanimate objects, the emphasis on its large size.

What is important about the articles discussed above is not so much a single journalist's discussion of fatness, but the underlying and pervasive cultural attitudes that her viewpoint reveals. The operative assumptions of Lee-Potter's columns are the same as those expressed by the medical community: that every woman could be slim if she wanted to be (and would be thin if enough "pressure" were put on her); that fat people are fat because they sit around all day eating fatty foods like "doughnuts, éclairs, [and] Mars Bars"; that fat women are aesthetically and sexually unattractive and deserve to be dumped for slim women; and that fat women cannot enjoy outdoor activities, like riding a bike (mentioned elsewhere in the article) or going to the beach. In the following section, we will see many of these ideas given visual form in Freud's paintings.

Big Sue's Big Nudes

In addition to *Evening in the Studio*, Freud produced three subsequent paintings of Tilley: *Benefits Supervisor Resting* (Figure 10.1), *Benefits Supervisor*

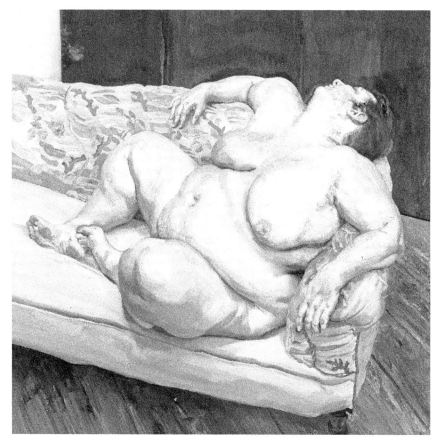

10.1 Lucian Freud, *Benefits Supervisor Resting*, 1994 (oil on canvas), Private Collection/© The Lucian Freud Archive/ Bridgeman Images.

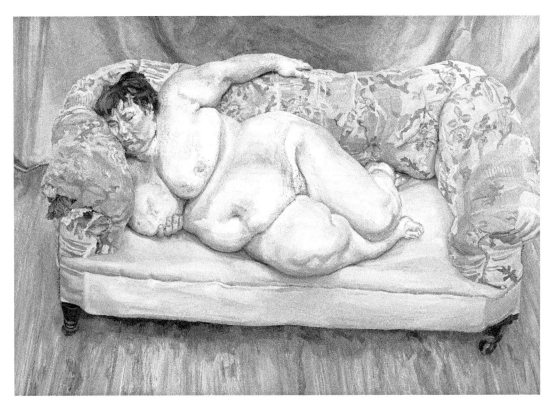

10.2 Lucian Freud, *Benefits Supervisor Sleeping*, 1995 (oil on canvas), Private Collection/© The Lucian Freud Archive/Bridgeman Images.

Sleeping (Figure 10.2), and *Sleeping by the Lion Carpet* (Figure 10.3). These three works share very similar characteristics. In all three, Tilley sleeps on either a couch or a chair; she is roughly centered in the canvas; the room behind her is somewhat ambiguous and mostly unadorned (with the exception of the lion carpet in *Sleeping by the Lion Carpet*). In all three works, Freud chooses a viewing angle that makes Tilley's pose seem awkward or precarious, an effect enhanced by limbs jutting beyond the edge of the furniture in *Benefits Supervisor Resting* and *Benefits Supervisor Sleeping*.

In all three works, Freud emphasizes and exaggerates Tilley's form in ways that encourage us to read disease onto his model, demonstrating the pervasive influence of medicalized discourse about the fat body. In *Benefits Supervisor Resting*, for instance, several areas of Tilley's body—especially her feet and hands—display bruise-like mottling and impart the abject sensibility of infection and disease. The sole of Tilley's right foot, in particular, looks less shadowed and dirty and more putrefied or mangled. This effect is enhanced by the gritty paint texture, which provides the illusion that her skin is in the process of chaffing off her body. Likewise, in *Benefits Supervisor Sleeping*, there are two areas that seem particularly abject: the veins in Tilley's breasts, which appear on the surface of her skin, rather than beneath it, and look like mold or

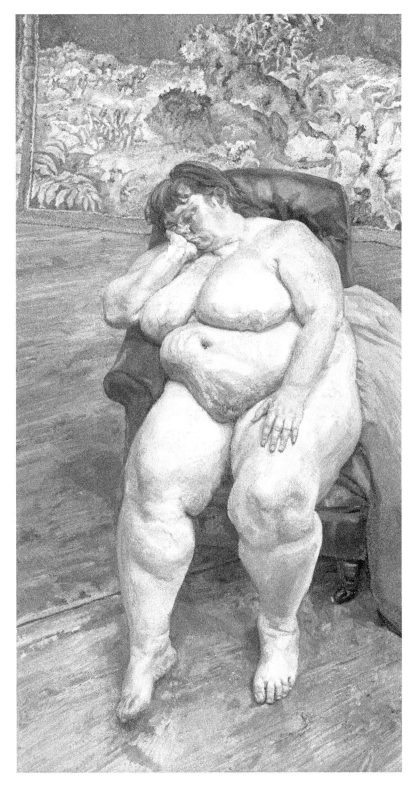

10.3 Lucian Freud, *Sleeping by the Lion Carpet*, 1996 (oil on canvas), Private Collection/© The Lucian Freud Archive/Bridgeman Images.

scrapes, and the emphatic redness of her compressed right shoulder, which, combined with the heavy impasto of the image, mimic the texture and color of raw meat. Freud treats the veins in Tilley's breasts and forearms in a nearly identical fashion in *Sleeping by the Lion Carpet*.

Unlike *Evening in the Studio*, *Benefits Supervisor Sleeping* and *Benefits Supervisor Resting* do not contrast Tilley with spindly furniture to emphasize her size, but instead visually associate her with the furniture she occupies, suggesting that she is likewise large and unmoving (fitting neatly within larger cultural conceptions of fatness as expressed in Lee-Potter's words). That is, rather than juxtaposing Tilley's ample body against a thin person or spindly chair in order to make her size appear more exaggerated, instead Freud visually echoes the forms of the furniture in Tilley's position and body shapes in ways that associate her with the qualities of those objects. In *Benefits Supervisor Resting*, Tilley's skin nearly matches the tone of the couch on which she sits, her right arm echoes the horizontal of the door or window behind it, and the plant-like, organic decoration of the couch rhymes with Tilley's posture where it is nearest her body. For instance, beside her right leg, the green lines follow its arch, and below her dangling left hand, a patch of green mimics her hanging fingers, mirrored in reversal. Likewise, in *Benefits Supervisor Sleeping*, the back of the sofa echoes the rounded thrust of Tilley's hip in its back, and also in its lumpy, overstuffed arms. Her form rhymes with the swells and undulations of the curtain behind her, which bows out just as her pendulous stomach does. All of this suggests that, like the room around her, Tilley is a landscape to be surveyed, rather than a woman to be desired.[25] Moreover, visually equating Tilley to the sofa implies that she, too, is "cushioned," heavy, and unmoving.

In all three works, rather than using conventional viewpoints or poses to sexualize Tilley's body in a traditional way, Freud denies the viewer the pleasure of imagined visual possession or penetration and instead eroticizes or even fetishizes Tilley's adiposity. In *Benefits Supervisor Resting*, unlike *Evening in the Studio*, Freud gives us a closed view of Tilley's body. Although here, too, her legs spread out as if to frame her genitals, we see her from the side so that her billowing stomach and jutting knee obscure them. Freud positions Tilley away from the surface of the picture plane, far enough for the viewer to see the floor beneath the sofa, and so that there is no danger of (imaginary) contact between her protruding knee and his legs. Once again, the viewer looks down on the sleeping figure, and Tilley's averted face invites voyeurism—she does not confront or challenge the viewer's gaze, which tacitly allows her body to be examined like an object. Natasha Ruiz-Gomez discusses in the preceding chapter a similar notion of voyeurism and objecti-fication, within the context of medical examination and visualized pathology, in relation to Dr. Jean-Martin Charcot's examination of nude patients at the Salpêtrière hospital. However, the way that Tilley's feet meet and her flesh blocks her genitalia from view creates a sense of closure, a denial of visual penetration. Without visible genitalia, the emphasis in the painting shifts to

Tilley's pale, mushroom-like stomach and drooping breasts, to the fetishized surface and volume of her form.

Although Tilley poses quite differently in *Benefits Supervisor Sleeping*, once again Freud sets her away from the viewer and her closed-off posture denies any glimpse of her genitalia. The effect is heightened even further in *Sleeping by the Lion Carpet*, where the strange perspective places the viewer in the position of hovering above Tilley's inert form, at a greater distance than in *Benefits Supervisor Sleeping*. And this time, the sharply rising floor makes the viewer's position as unstable and ambiguous as the sitter's, as if one might topple forward onto her lap. The drooping folds of her belly form a triangle that sinks toward her leg and are infused with a rosy blush tint, replacing her genitalia. This fits with Freud's emphasis on the curving swirls of Tilley's flesh in the other paintings of her, and displaces any sexual interest in Tilley's body into an erotics of flesh. Three darker comma-shaped brushstrokes beneath Tilley's right breast emphasize the ballooning shape of her stomach and echo the outlines of her pendulous breasts. Freud iterates these comma-like swells in Tilley's legs—in her right calf and left knee, and in the curve of her right flank and shoulder. Freud further exaggerates Tilley's roundness by contrasting her with the rest of her surroundings; the flatness and hardness of the wooden floor beneath her only makes her seem softer and more bulbous.[26] Freud's insistent fetishization of Tilley's body and its roundness, coupled with his exaggeration of its surface, mark her as other and encourage viewers to interrogate Tilley's flesh for signs of illness.

Big Sue in Freud's Words

If, as I have argued here, the formal choices in the Tilley series visually frame her in ways that align with both medical (the fat body as diseased) and popular (the fat body as stationary and undesirable) discourse, Freud's own comments about working with Tilley underscore that he perceived her in the same way as he painted her. When Freud relates his impressions of Tilley, echoes of this medicalized rhetoric ring in his words, making it clear that he views her in a different light to his other models—as anomalous. He said, after working with Tilley for a few months, "I have perhaps a predilection towards people of unusual or strange proportions, which I don't want to over-indulge."[27] He also described the process of seeing Tilley in some detail. In his words, he was,

initially . . . very aware of all kinds of spectacular things to do with her size, like amazing craters and things one's never seen before, my eye was naturally drawn round to the sores and chafes made by weight and heat.[28]

He even compared his work with Tilley to a series of paintings of court dwarfs painted by Velázquez.[29]

Although elsewhere Freud has said that he is "not interested in cripples or freaks,"[30] the language he uses to describe Tilley emphasizes that he sees

her as "unusual or strange," perhaps even "freakish," to use his language. Comparing his paintings of her to Velázquez's court dwarfs works to other both fat women and little people, and his description of Tilley as having "strange" proportions suggests an assumption that thin is the "natural" state of the human body, thereby marking Tilley as "unnatural." This denaturalization of the fat body continues in the rest of Freud's description, as he uses adjectives like "spectacular," and "amazing," and in particular, calls her physiognomy "[something] one's never seen before." This language works to exaggerate Tilley's otherness viz. Freud's thinner models and also to dehumanize her. In the description, the painter sounds as though he is discovering a heretofore unknown continent, rather than viewing an ordinary woman.

Press and Critical Response to Freud's Nudes

The paintings of Sue Tilley received surprisingly little attention in the media at the time of their completion. The situation has changed since the painting *Benefits Supervisor Sleeping* sold at auction in 2008 for over £21 million (US $33 million) and made Freud the most expensive living artist until his death in 2011.[31] However, reading what *was* written about these paintings of Tilley in the press supports the idea that Freud's renderings expose medical and cultural attitudes about fatness. The critics and reviewers read nothing in the works past an interest in Tilley's "abnormal" size. For instance, Waldemar Januszczak offers the most extended discussion of any of the paintings of Tilley (in this case, *Sleeping by the Lion Carpet*) but he characterizes her as undesirable, freakish, and other. In the article, "Large as life, and up there with Titian," he writes:

Lucian Freud's grotesquely fat nudes are a mix of cor-blimey fascination and ambitions to take on the old masters . . . Big Sue is not the kind of woman who generally takes her clothes off in public . . . Sue is the first of [Freud's models] to be extremely fat . . . Women of Sue's size are much rarer in art. After all, they are neither reliably sexy models nor handily versatile symbols. As objects of desire they are an exceptional taste. So, if you are not actually having a relationship with one of them, why paint them? . . . Freud was always an admirer of the unusual; has he now become a fan of the freakish?[32]

The thrust of Januszczak's questions is telling. He evinces no interest in the *way* that Freud paints Tilley; he is only interested in *why* Freud would bother to paint someone of Tilley's size.

Januszczak asserts that Tilley (who never gets a last name in the article—she is always "Sue" or "Big Sue," although he respectfully refers to Leigh Bowery by surname in later sections of the article) is "not the kind of woman who generally takes her clothes off in public . . ." and then explains that this is because she is "extremely fat" and not an object of desire. Her body, in addition to being "freakish" and undesirable is also not as "versatile" as a regular nude—where a thin nude can hold a variety of meanings, Tilley's body is

mired in its physicality. The immanence of her fatness restricts her ability to act as a symbol—in his opinion, she, unlike a thin model, can never transcend her body and enter the ideal realm of the symbolic.

Other authors, like the art historian William Feaver, give very similar readings of these paintings of Tilley. Feaver writes:

> Nobody's victim and nobody's fool, Big Sue proved a vivid resource; her body, in *Benefits Supervisor Resting* 1994, yields nothing in its baroque loops and contortions . . . *Sleeping by the Lion Carpet* transforms her body mass into resplendent monumentality, the folds and curves shining against the fuzzy half-light of the silken safari scene hung behind the chair. Big Sue could dream of being a Diana, or a Callisto, but no mythology is needed to sustain her, no glorifying allusion.[33]

Here again, we have the reduction of Tilley to an object by labeling her as "Big Sue," a labeling done once again by an author who writes of Leigh Bowery as "Bowery." Moreover, the insistence on Tilley as a purely corporeal being continues throughout the discussion. She is "resplendent monumentality," her most "vivid resource" is her body, and although she "could dream" of being a mythological goddess, the allusion falls flat in juxtaposition to her sheer mass. Perhaps most telling is the way Feaver characterizes her body. It "yields nothing," it is forthright in a way that is incautious, abrupt, and unrelenting. For Feaver, as for Januszczak, Tilley cannot go beyond her body, to yield the inner workings of her mind or anything else.

After Freud's record-breaking sale price, the popular press turned its attention to his Tilley series, particularly *Benefits Supervisor Sleeping*. And it was not just the painting that was the focus of media attention, but Tilley herself, who became a popular interview subject. The media perception of the model echoes closely the tone of the previously discussed articles about the Tilley paintings. For example, in an interview with Stephanie Theobald, Tilley asserts her belief that Freud chose her as a model because of her "ordinariness."[34] Yet, from the very title of the piece—"How Big Sue became art's biggest muse"—Theobald asserts the opposite: that Tilley's size makes her strange and unusual. Within the first two sentences of the article, Theobald repeats this theme, calling Tilley "twenty-stone" and "bulky."[35] She also iterates Waldemar Januszczak's surprise that Freud would want to paint Tilley at all, saying "she seems an unlikely choice of muse to one of Britain's greatest living artists"[36]—because as a model she seems to exhibit something unusual, pathological, unattractive (to Januszczak and others like him).

In fact, these articles seem even less able to move beyond Tilley's size than those published before the breakthrough sale occurred. Now there is no hint of interest in the meaning of the picture, no sense of a narrative being constructed in the work other than a sort of freak-show fascination with an abnormally sized woman. At a certain point, the articles become so repetitive that endless and nearly indistinguishable quotes outlining this theme could be included here. One article iterates, "at 20 stone she seemed an unlikely choice of muse for an artist,"[37] while another describes Tilley as "the grotesquely fat woman

who posed naked,"[38] and another calls the image "a life-sized painting of a rotund Job Centre manager."[39]

There is, however, one positive aspect to these articles. Because of their focus on Tilley as the subject and model, rather than Freud as the artist, they do include more humanizing details about Tilley's life. They often mention her association with Bowery, the inclusion of a character based on Tilley in Boy George's musical, *Taboo* (called, incidentally, Big Sue) and her biography of Bowery.[40] And, in fact, the press gives the occasional hint that Freud's paintings of Tilley might be read in a fat-positive way, as in an article that describes her as "abundantly, gloriously fleshy," and goes on to say, "*Benefits Supervisor Sleeping* is a mighty thing, in every possible sense."[41]

Conclusion

Freud's images of Tilley and the critical response to them demonstrate and elaborate upon the alternately fascinated and censorious attitude of the British public and medical establishment toward the fat body in the early 1990s. Despite the efforts of groups like Dietbreakers, in the 20-plus years since Freud painted Tilley, the gaze that he turned on her body has become the same eye that the British populace has turned on their neighbors and themselves. Fear, hostility, and loathing directed toward the fat body have become increasingly ingrained and are expressed with increasing openness. And while the societal message that fat is unhealthful, unaesthestic, undesirable, and morally repugnant is trumpeted to both men and women, it is women who have historically been singled out for their bodies, and women who have more invested in trying to meet beauty standards. Freud's portraits of Sue Tilley give visual expression to these unfortunate attitudes.

Notes

1 Throughout this essay, I will use the adjective "fat" to describe large bodies, as the terms commonly considered neutral in the West in fact reinforce the pathologization of fatness. "Overweight" and "obese" are both medical terms used to indicate bodies presumed to have higher than normal morbidity or mortality rates; fat merely describes body size.

2 The literature on this topic is too extensive to list exhaustively here, but see for instance: Aphramor and Bacon (2014); Bacon (2010); Berg (1995); Campos (2004); Ernsberger and Haskew (1987); Gaesser (2002), et al.

3 I use the term "abject" throughout this essay in the Kristevan sense (see Kristeva (1982). However, fat bodies are doubly abject, as they are always already perceived as dirty and polluted; see, for instance, LeBesco (2004). LeBesco argues that Western culture links dirt and fat together (consider the trope of the "fat slob," for instance). Dirt (and fat) are dangerous because they threaten to pollute

otherwise stable categories ("purity" or "thinness"). Only by rejecting dirt and fat can individuals (and society) maintain order.

4 For an examination of the difference in treatment between Tilley and Freud's thinner subjects, see Chapter One of my dissertation: Lockard (2012).

5 This essay does not address the Bowery paintings in detail, as they are worthy of close scrutiny on their own merits. It is also difficult to draw a one-to-one comparison between the two sitters due to disparities in gender and relative body size. It is revealing, however, to consider the differing levels of respect paid to the two sitters by authors; even those that consistently use the moniker "Big Sue" refer to Bowery by his last name, a point that is also addressed in the final section of this essay.

6 Richardson (2001), 334–335.

7 See, for instance: Alberge (2008); Mallan (2008); Malone (2008); Roche (2008).

8 In this case, the second model is Leigh Bowery's seamstress and wife (Nicola Bateman), who also appeared in a number of Freud's paintings. For a complete listing of the works in which she appears as well as analysis of them, see: Feaver (2007).

9 This neatly meshes with contemporary understandings of fat as disgusting. For more on the revulsion engendered by fat and its tactile qualities, see Forth (2011).

10 For a discussion regarding the way in which Freud's interest in Tilley also aligns with larger British interest in unidealized bodies, see Postle (2009).

11 Mary Evans Young (2011).

12 Harris (1992).

13 *USA Today* (1993).

14 See, for instance: Banks-Smith (1992); Bedell (1992); Dodd (1993); Hamilton (1992); Leake (1993); Lewis-Smith (1992); Nicholson-Lord (1993); Orvice (1992); Louisa Young (1993). However, not all of this attention is positive; in particular, see the Lewis-Smith article.

15 Brindle (1993).

16 Hall (1994).

17 As cited in Bovey (1994), 35.

18 Bovey (1994), 37. Bovey also recounts several personal incidents of discrimination against herself, including being told "that [her] size precluded [her] from being considered as a newsreader" (38) as well as events reported to her by other British women as she was researching her book. See Chapter Two of her book for further instances.

19 As cited in Bovey (1994), 41.

20 For more information, see the Equality and Human Rights website (UK): www.equalityhumanrights.com/en/yourrights/equalityanddiscrimination/pages/equalityhome.aspx

21 Lee-Potter (1989).

22 Lee-Potter (1992).

23 Ibid.

24 Ibid.

25 In *Sleeping by the Lion Carpet*, Freud actually visually associates Tilley with the landscape in the lion tapestry behind her, rather than with furniture in the room, by placing her head inside its boundary. Because Tilley's form echoes that of the lions, she becomes associated with the natural and the animal, rather than with inanimate furniture. This lends an additional aspect of abjection to the painting. As LeBesco points out, fatness is frequently associated with animal-like qualities. She notes that, "Work on social stigma reports that stigmatized individuals are typically depicted as a composite of three overwhelming characteristics: animalistic, hypersexual, and overvisible . . . it takes little imagination to conjure up 'pig' or 'cow' as a popular term of insult for fat people." The visual link between Tilley and the lions can call to mind these associations for the viewer, could suggest that Tilley can no more control her appetites (be they alimentary or sexual) than can the lions above her. Second, the association with the lion carpet exoticizes her. The location of the lions in a savannah-like environment, so different from the cooler clime of the United Kingdom, gives them a tramontane appeal. Their visual rhyme with Tilley can be seen to imply that Tilley is just as unusual as the animals above her head. LeBesco (2004), 86–87.

26 It is important to note that the lack of a traditional form of sexualization in these paintings is not necessarily a bad thing. In fact, Tilley's resistance to sexual objectification can be interpreted as a revolutionary position for a female nude. Moreover, the issue of sexual attractiveness and the fat body has become one of the central debates in fat theory and one that many fat women feel conflicted about. It is easy to sympathize with the feelings of shame and low self-worth engendered in fat women by the failure to achieve society's primary demand of women (to conform to social standards of beauty), while at the same time, the fat body's inherent inability to meet that standard provides the opportunity to underscore its cultural construction and larger implications. However, this chapter argues that Freud still objectifies Tilley and even fetishizes her fat; in this case, by associating her with literal inanimate objects like sofas and carpets, so that even though Tilley is not traditionally sexualized, she is still not accorded subjectivity. This failure to imagine the possibility that Tilley might be sexually attractive adds an additional dimension to Freud's absorption of larger cultural discourses about the fat female body at play in the UK in the late 1990s, along with his emphasis on a sickly or diseased portrayal of Tilley that syncs with the pathologization of fatness. For a perceptive discussion of the problematic relationship between fatness and sexual desirability, see Murray (2008).

27 Feaver (2002), 45.

28 Ibid.

29 Ibid.

30 Richardson (2001), 335.

31 *Daily Mail* (2008).

32 Januszczak (1996).

33 Feaver (2002), 45.

34 Theobald (2002).

35 Ibid.

36 Ibid.

37 Alberge (2008).

38 Malone, "Slim . . . on Humour."

39 *Daily Mail* (2008).

40 See, for example: Davies (2008); Damien (2008).

41 Kent (2008).

References

Alberge, Dayla. "Freud's Naked Civil Servant to Smash Auction Record for Living Artist." *The Times* (London), April 12, 2008.

Aphramor, Lucy, and Linda Bacon. *Body Respect: What Conventional Health Books Get Wrong, Leave Out, and Just Plain Fail to Understand about Weight.* New York: BenBella Books, 2014.

Bacon, Linda. *Health at Every Size: The Surprising Truth about Your Weight.* New York: BenBella Books, 2010.

Banks-Smith, Nancy. "Television: Pole to Pole, Open Space, News at Ten." *Guardian*, November 12, 1992.

Bedell, Geraldine. "Slim Pickings." *Independent*, June 21, 1992.

Berg, Frances. *Health Risks of Weight Loss.* 3rd ed. North Dakota: Healthy Weight Journal, 1995.

Bovey, Shelley. *The Forbidden Body: Why Being Fat Is Not a Sin.* London, UK: Pandora, 1994.

Brindle, David. "Healthier Lifestyles Are Offset by a Sharp Rise in Obesity." *Guardian*, July 2, 1993.

Campos, Paul. *The Obesity Myth: Why America's Obsession with Weight Is Hazardous to Your Health.* New York: Gotham Books, 2004.

Daily Mail. "21.6m for Freud Nude." May 15, 2008.

Damien. "Sue Tilley." *London Kicks* (blog). Last accessed May 13, 2008. www.londonkicks.com/go/art/Sue_Tilley

Davies, Caroline. "Don't Ask Me to Strip." *Observer*, May 18, 2008.

Dodd, Celia. "Compulsive Eaters Come Out of the Closet." *Independent*, July 11, 1993.

Equality and Human Rights website (UK). Last accessed July 15, 2008.

www.equalityhumanrights.com/en/yourrights/equalityanddiscrimination/pages/equalityhome.aspx

Ernsberger, Paul, and Peter Haskew. *Rethinking Obesity: An Alternative View of Its Health Implications.* New York: Human Sciences Press, 1987.

Feaver, William. *Lucian Freud.* London, UK: Tate, 2002.

Feaver, William. *Lucian Freud.* New York: Rizzoli, 2007.

Forth, Christopher. "Materializing Fat, Historicizing Disgust." Unpublished paper accompanying a lecture. University of Kansas: Lawrence, KS, February 28, 2011.

Gaesser, Glenn A. *Big Fat Lies: The Truth about Your Weight and Your Health.* Carlsbad, CA: Gürze Books, 2002.

Hall, Celia. "Obesity Costs Health Service Pounds 200m a Year." *Independent*, July 18, 1994.

Hamilton, Alan. "Diet Dictators Face Stout Resistance." *The Times* (London), May 6, 1992.

Harris, Sarah. "Welcome to Planet Big-Girl." *Guardian*, December 12, 1992.

Januszczak, Waldemar. "Large as Life, and up There with Titian." *Sunday Times* (London), June 30, 1996.

Kent, Melissa. "'Big Sue' Set to Fetch Big Bucks and Top Record." *Sunday Age*, April 13, 2008.

Kristeva, Julia. *The Powers of Horror: An Essay on Abjection*. Translated by Leon S. Roudiez. New York: Columbia University Press, 1982.

Leake, Christopher. "Diet 'Cons' Pounded." *Mail on Sunday*, April 11, 1993.

LeBesco, Kathleen. *Revolting Bodies? The Struggle to Redefine Fat Identity*. Boston, MA: University of Massachusetts Press, 2004.

Lee-Potter, Lynda. Lynda Lee-Potter Column. *Daily Mail*, March 22, 1989.

Lee-Potter, Lynda. "Expansive Message that Spells a Fat Load of Nonsense." Lynda Lee-Potter Column. *Daily Mail*, April 15, 1992.

Lewis-Smith, Victor. "A Canter with the Calories." *Evening Standard*, November 12, 1992.

Lockard, Brittany. "Size Matters: Imagery of the Fat Female Body in the Art of Lucian Freud, Jenny Saville, Joel-Peter Witkin, Laurie Toby Edison, Leonard Nimoy, and Laura Aguilar." Ph.D. dissertation. University of Kansas: Lawrence, Kansas, 2012.

Mallan, Caroline. "Weighing in with Big Sue." *Toronto Star*, June 23, 2008.

Malone, Carole. "Slim . . . on Humour." *News of the World*, May 18, 2008.

Murray, Samantha. *The 'Fat' Female Body*. London: Palgrave Macmillan, 2008.

Nicholson-Lord, David. "Slimming Aids Firms 'Should Be Prosecuted'." *Independent*, April 8, 1993.

Orvice, Vikki. "Breaking the Dieting Habit." *Daily Mail*, May 7, 1992.

Postle, Martin. "Pygmalion, Painted Flesh, and the Female Body." In *The Body and The Arts*, edited by Corinne Saunders and Ulrika Maude, 165–185. London: Palgrave Macmillan, 2009.

Richardson, John. *Sacred Monsters, Sacred Masters*. New York: Random House, 2001.

Roche, Elisa. "Katie Apology over 'Fat Sue'." *Express*, May 15, 2008.

Theobald, Stephanie. "How Big Sue Became Art's Biggest Muse." *Guardian*, June 23, 2002.

USA Today. "Being Tubby Is a Good Thing." *USA Today* (International Edition), May 4, 1993.

Young, Louisa. "Fat Fights Back." *Marie Claire* (UK), September 1993.

Young, Mary Evans. "How INDD Began." *Largesse, the Network for Size Esteem*. Last accessed August 1, 2011. www.eskimo.com/~largesse/INDD/origin.html

Index

Page numbers in *italics* indicate illustrations, n an endnote